Homosexuality in Early Modern France

A Documentary Collection

EDITED BY

Jeffrey Merrick
University of Wisconsin-Milwaukee

Bryant T. Ragan, Jr.
Fordham University

New York Oxford
OXFORD UNIVERSITY PRESS
2001

Oxford University Press

Oxford New York
Athens Auckland Bangkok Bogotá Buenos Aires Calcutta
Cape Town Chennai Dar es Salaam Delhi Florence Hong Kong Istanbul
Karachi Kuala Lumpur Madrid Melbourne Mexico City Mumbai
Nairobi Paris São Paulo Singapore Taipei Tokyo Toronto Warsaw

and associated companies in
Berlin Ibadan

Copyright © 2001 by Oxford University Press, Inc.

Published by Oxford University Press, Inc.,
198 Madison Avenue, New York, New York 10016
http://www.oup-usa.org

Oxford is a registered trademark of Oxford University Press

Library of Congress Cataloging-in-Publication Data

Homosexuality in early modern France : a documentary collection / Jeffrey Merrick and
Bryant T. Ragan, editors.
 p. cm.
 Includes index.
 ISBN 0-19-510257-6 (pbk.)
 1. Homosexuality—France—History—16th century—Sources. 2.
Homosexuality—France—History—17th century—Sources. 3.
Homosexuality—France—History—18th century—Sources. I. Merrick, Jeffrey. II. Ragan,
Bryant T., 1960–

HQ76.3.F8 H645 2001
306.76′62′0944—dc21 99-087275

Printing (last digit): 9 8 7 6 5 4 3 2 1

Printed in the United States of America
on acid-free paper

Dedicated with love to our parents,
Sally and Wayne Merrick and
Bryant and Sandra Ragan

CONTENTS

II. REPRESSION

III. REPRESENTATION

IV. REVOLUTION

INTRODUCTION

In 1996, we published a collection of essays on homosexuality in France from the eighteenth to the twentieth century. That project was inspired mainly by the lack of scholarly work on both sides of the Atlantic on French gay and lesbian history at a time when academics and the public at large in the United States were coming to recognize the importance of "homosexuality" in understanding fundamental questions about identity and community, masculinity and femininity, relations between public and private spheres, and connections between gender and political culture. This neglect seemed surprising, inasmuch as France decriminalized sodomy before any other Western state and provided refuge at various times to foreign homosexuals who were harassed or even persecuted in their own countries. Despite their innovative and influential work in social history and cultural studies, French scholars have proved uncharacteristically reticent about investigating this part of their national past and present. Anglophone scholars, meanwhile, have naturally been more interested in exploring the history of sexuality in the United Kingdom and the United States. Of those who have worked on France, most have been literary scholars interested in celebrated modern authors such as Proust, Gide, Colette, and Yourcenar.

We have both taught courses on lesbian and gay history, so we are well aware of the difficulty of locating representative primary sources about same-sex relations from a wide range of cultures and centuries. While doing research for our own contributions to the previous volume, we were impressed by the wealth of documentation on early modern France, so we decided to produce a collection of translated and annotated sources in order to illustrate the variety of materials that exists in manuscript and published form and to enable scholars, students, and lay readers to evaluate samples of such materials for themselves. We have generally opted for complete texts or sections rather than shorter passages and, with a few exceptions, for documents that are not already available in English or readily accessible in French.

The sources included in this volume provide empirical evidence about the ways in which same-sex relations were condemned by theologians, jurists, and doctors, experienced by people of both sexes and different walks of life, regulated by police and magistrates, and represented and manipulated by a variety of contemporaries for a variety of purposes. They shed light on how sodomites and tribades thought about themselves and what others thought about them, as well as the ways in which the theme of same-sex sexuality was used in discussions of religious, political, and social issues. Many of the texts contain sexual accusations about specific individuals, but we have not made it our business to compile information about celebrities who may or may not have been sexually involved with persons of the same sex. We have attempted instead to supply readers with

material that will allow them to understand and investigate questions about subcultures and identities that are at the heart of current debates among historians of sexuality.

These questions are both numerous and significant. It is our responsibility as editors not to answer them here but rather to encourage readers to think about them as they make their way through this collection. To begin with, do men and women attracted to members of their own sex share the same history? It should not be assumed that early modern French sodomites and tribades believed that they were kindred spirits or that the society in which they lived regarded them in the same way. Although women are underrepresented in some kinds of sources, most notably police records, we have located more than enough material about them to allow for comparisons between the behaviors and characteristics reported in or imputed to males and females. Some of the texts included in the following pages address the issue explicitly.

Who did what with whom in the past? Because different cultures have sanctioned and structured sexual activities in different ways, every culture must be explored for conformity to and deviation from known patterns. Our information about same-sex sexual activities in early modern France may be mediated by unsympathetic authorities and commentators, but it does provide evidence about a variety of sexual practices, such as mutual masturbation, anal and oral intercourse, active and passive roles, and the use of phallic substitutes, as well as a variety of social markers, most notably class, age, and marital status.

Did the individuals involved in same-sex relations constitute a subculture? In Paris, as in London and Amsterdam, men developed homosexual networks by the early eighteenth century. They knew where to go and what to do in order to meet other men interested in sexual relations. Historians can debate the appropriateness of the word "subculture," but contemporaries clearly believed that the numbers of men and women sexually attracted to members of their own sex were increasing. This heightened visibility may well have had something to do with one critic's hostile reaction to the statue of Ganymede and Zeus exhibited by Pierre Julien (1731–1804) in 1785 and reproduced on the cover of this volume. Unlike his sixteenth-century predecessors, who read the story as an allegory, this eighteenth-century critic dismissed it as a "scandalous anecdote" and "obscene fable" unworthy of representation, perhaps because it brought to mind what the police described, in misleading terms, as the corruption of youths by adult males in Parisian parks.[1]

Did the individuals involved in same-sex relations have a distinctive sense of identity? Although humans have engaged in homosexual behavior throughout history, the modern concept of "homosexuality" as a category of identity was only developed in the last decades of the nineteenth century. The historical specificity of the concept should discourage us from applying it to previous centuries but not, as David Halperin has reminded us, from investigating connections between sexual acts and sexual subjectivity in premodern times.[2] French sodomites and tribades did not describe themselves, and were not described by others, in the same way as modern "homosexuals," but that fact in and of itself does not mean that they were not regarded as somewhat different from their contemporaries because of their sexual inclinations. Studies of other European societies have suggested that important transformations in the construction of same-sex relations took place during the early modern period. At one end of our period, Michael Rocke has shown that large numbers of males had sex with other males in fifteenth-century Florence without having any sense that they constituted a different category of people.[3] At the other end, Randolph Trumbach has argued that a specific category of men and women

defined by exclusive sexual interests and inverted gender characteristics emerged in England in the course of the eighteenth century.[4] This collection will allow readers to compare the patterns of continuity and change in France with those from other areas that have been studied more extensively.

This volume comprises a glossary of early modern words used to describe same-sex relations and four parts, devoted to Traditions, Repression, Representations, and Revolution, with their own introductions. We have translated all of the texts. Merrick favors literal translation, which has the advantage of preserving the integrity of the original and the disadvantage of preserving convoluted syntax and archaic vocabulary as well. Ragan, by contrast, prefers less strict and more modern translation, which has the advantage of making the material more accessible to the contemporary reader and the disadvantage of sacrificing some historical specificity in language and meaning. We hope that we have found a middle way between these approaches and produced translations that are both accurate and readable. Bibliographical information about the texts is included in the notes. We have given the dates of first editions in brackets and cited the Loeb Classical Library (LCL) editions of classical works whenever possible. Words in Latin in the original, except for those commonly used in English, have been italicized. Terms that require explanation are defined within brackets the first time they are used, and page numbers for those definitions are provided in the index. Mythological, biblical, and historical figures are identified in notes. Past and present Parisian streets may be located in Jacques Hillairet, *Dictionnaire historique des rues de Paris*.[5] We have mentioned the most important articles and books in the notes to the four introductions, but we have not included a bibliography, because a comprehensive and current one is available through Merrick's website (http://www.uwm.edu/People/jmerrick/hbib.htm).

We have accumulated many debts in the course of collecting our material and completing this volume. We thank the helpful staffs of the institutions on both sides of the Atlantic that have shared their resources with us: the Archives Nationales, Bibliothèque Nationale, Bibliothèque de l'Arsenal, Archives Départementales du Nord, the Fordham, Marquette, Columbia, Harvard, and Yale University libraries, the University of Wisconsin-Milwaukee, University of Wisconsin-Madison, and University of Chicago libraries, the Newberry Library, New York Public Library, and Library of Congress. We also thank our own institutions, the University of Wisconsin-Milwaukee and Fordham University, for sabbaticals and research grants that allowed us to finish this project, if not exactly on schedule, at least sooner than we would have otherwise. Ragan was able to do much of the arduous work of initial translation in the postcard-perfect setting of Cassis, France, thanks to a fellowship from the Camargo Foundation. Gioia Stevens, Linda Jarkesy, and Benjamin Clark of Oxford University Press waited patiently for the manuscript and guided it expertly into print.

For locating documents, making suggestions, and offering assistance, we are indebted to Isabelle Aristide, Olivier Blanc, Pamela Cheek, Elizabeth Colwill, Suzanne Desan, David Devine, Louis Godbout, Lynn Hunt, Margaret Jacob, Penelope Johnson, Thomas Kaiser, Claude Lanette, Susan Lanser, Leonore Loft, Dorothy Medlin, Guy Poirier, Jeffrey Ravel, Eugene Rice, Mary Louise Roberts, Julius Ruff, Randolph Trumbach, Jack Undank, Gabrielle Verdier, and Elizabeth Wahl. Edwin Bezzina transformed an illegible seventeenth-century dossier into a comprehensible transcript. Jesse Lord Johnson prepared the index. Michael Sibalis, who has been involved in this project since the begin-

ning, has been generous with his photocopies, his knowledge, and his time, above and beyond the call of friendship.

As always, we thank our partners, Steven Atkinson and Dennis McEnnerney, respectively, for their patience and encouragement. They listened to our complaints when the work seemed unmanageable and reassured us that we were involved in a worthwhile enterprise when we had doubts ourselves. Last but not least, we thank our parents, Sally and Wayne Merrick and Bryant and Sandra Ragan, for supporting us in our personal and professional lives and taking pride in our relationships and our work.

J. M.

B. R.

GLOSSARY

This glossary includes definitions of words used repeatedly in the documents, collected from multiple editions of several dictionaries:

César Pierre Richelet, *French Dictionary* (1680)[1]
Antoine Furetière, *Universal Dictionary* (1690)[2]
Dictionary of the French Academy (1694)[3]
Universal French and Latin Dictionary (1704), known as the *Dictionary of Trévoux*[4]
Philibert Jacques LeRoux, *Comical, Satirical, Critical, Burlesque, Licentious, and Proverbial Dictionary* (1718)[5]

These definitions document conventional usage and linguistic changes over time. They also provide information about classical, biblical, and contemporary references and illustrate assumptions about men and women sexually involved with members of their own sex.[6]

Antiphysical (*antiphysique*) Used in the eighteenth century, not included in dictionaries until the 1771 edition of the *Dictionary of Trévoux*: "That which is against nature. Antiphysical love. See the epigrams of Rousseau."[7]

Bardash (*bardache*) Derived from an Italian word meaning boy or prostitute, used since the sixteenth century. According to the first editions of Richelet and Furetière, it meant "young boy who is shamefully misused" or "handsome boy who is misused by profligates." Both dictionaries illustrated its use by reporting that Julius Caesar (c.100–44 B.C.) was or was at least accused of having been the bardash of Nicomedes, king of Bithynia from 94 to 74 B.C. The first edition of LeRoux defined the bardash as "a young man or boy who is used as a succubus [a demon that has assumed female form in order to have sexual relations with a male human] by another and who allows sodomy to be committed on himself." He added, "These abominations are so common in France that women have complained about them openly, and I could name several individuals who keep bardashes, who are usually handsome boys, as people do with prostitutes." Trévoux, 1762, identified bardash as an "obscene term," and Trévoux, 1771, noted that "this term is banned among respectable people." Later editions of Richelet and the *Dictionary of the French Academy* concurred.

Bugger and buggery (*bougre* or *bougeron* and *bougrerie*) Derived from the Latin word

for Bulgarian, used with reference to both heresy and sodomy since the Middle Ages.[8] Furetière, 1701, defined bugger and explained its history in this way: "Sodomite, nonconformist in love. Some claim that this word comes from the Bulgarians, who were very attached to the love of boys and whom ancient writers called buggers and their country Buggry, for Bulgaria. Others because they used to burn those guilty of the crime of nonconformity as well as the heretics who were called buggers."[9] LeRoux suggested a man "who has young boys at his beck and call, with whom he commits sodomy" and warned, "In our language this word is very insolent and very objectionable, such that one rarely sees a respectable man pronounce it." Richelet, 1732, reported that *bugger* had become synonymous with *sodomite* in the past and that it was used loosely "at present" to mean "a scoundrel, one who has lost both honor and reputation, in short, a dissolute man." Trévoux, 1771, noted that this word, like *bardash,* was "banned among respectable people," and Richelet, 1789, omitted it.

Cuff (*manchette*) Suggested, perhaps, by gestures made in parks and streets to communicate sexual messages, used in the eighteenth century, most commonly in phrases like "men of the cuff," to identify males sexually attracted to and involved with other males, not included in dictionaries in this sense.

Ganymede (*ganymède*) Proper noun from Greek mythology, used in a generic sense since the sixteenth century, identified and defined in the first edition of Richelet as a "young shepherd whom Jupiter abducted and made into his minion" and a "young bardash." LeRoux, 1718, was more specific about the role: "Young boy who gives pleasure, who lets the sin of sodomy be committed on him." Trévoux, 1771, was less specific about the age: "In the style of antiphysical love, man who serves the pleasures of another."

Giton (*giton*) Proper noun from the *Satyricon* of Petronius (first century), used in a generic sense in the eighteenth century, not included in dictionaries. Applied to the younger, passive partner in sexual relations between males, it commonly implied promiscuity and prostitution.

Infamous (*infâme,* used as an adjective or as a noun) Dishonorable or disreputable, used in the eighteenth century in a more specific sense to identify males sexually attracted to and involved with other males. The first edition of Furetière noted that it was applied to "everything that is not within the general approbation of men" and added that "people use it particularly in speaking about some vices."

Lesbian (*lesbienne*) Proper noun derived from the name of the Greek island of Lesbos, home of the poet Sappho (b. c.650 B.C.), used infrequently in a generic sense as far back as the late sixteenth century, not included in dictionaries in this sense. According to the first edition of LeRoux, a variant (*lesbin*) of the even more uncommon masculine form of the word (*lesbien*) was synonymous with *bardash.*

Minion (*mignon*) Favorite, used since the reign of Henry III (1574–89) in a more specific sense to imply sexual relations as well as political influence. According to the first edition of Furetière, it suggested favoritism "in matters either of friendship or

of love. Most rulers have minions, favorites who control them." The 1727 edition added that the word, applied to Henry III's favorites, "implied something that is not very decent."

Nonconformist and **nonconformity** (*nonconformiste* and *nonconformité*) Derived from the English words applied to persons who did not conform to the beliefs and rites of the Anglican church, used since the late seventeenth century. The first edition of the *Dictionary of Trévoux* reported that "people say, in an obscene sense, that the Italians are nonconformists in love" and that "some, in jest, call the love of boys the sin of nonconformity." Later editions did not mention the conventional association of Italy and sodomy. The 1743 edition explained that people used "nonconformist" in order to avoid the word "sodomite," "which is extremely odious." The 1762 and 1771 editions indicated that nonconformity was synonymous with pederasty and antiphysical love.

Pederast and **pederasty** (*pédéraste* and *pédérastie*) Derived from the Greek word for the institutionalized educational and erotic relations between adult and adolescent males in ancient city-states, used infrequently since the late sixteenth century and commonly in the eighteenth century. The first edition of Richelet defined *pederast* as "sodomite" but did not include *pederasty,* which appeared for the first time in the 1701 edition of Furetière: "love of boys, the sin against nature." The *Dictionary of Trévoux,* 1752, noted that those guilty of this "crime against nature," a "heinous sin," were condemned "by the laws" to the stake and reported that the Humanist Marc Antoine Muret (1526–85) escaped execution (for his religious beliefs and sexual conduct) by fleeing to Italy with his "disciple and accomplice." The *Dictionary of the French Academy* added *pederasty* in 1765: "shameful passion, love between men." LeRoux finally added *pederast* in 1789 but misspelled the word (*pédareste*) and referred readers to *sodomist,* which is not even included in the book.

Philosophical (*philosophique*) Suggested by the relations of Greek philosophers with other males, used since the sixteenth century, most commonly to modify love or sin, not usually defined in dictionaries in this sense. Furetière, 1727, reported that the Jesuits, who were commonly accused of minimizing the seriousness of the "philosophical sin," declared that they detested it.

Socratic (*socratique*) Derived from the name of Socrates (469–399 B.C.), the famous Greek philosopher, used in a generic sense in the eighteenth century, most commonly to modify love or morals, not included in dictionaries in this sense.

Sodomite, sodomize, and **sodomy** (*sodomite* or *sodomiste, sodomiser,* and *sodomie*) Derived from the name of the city destroyed, according to the Book of Genesis, because of the sins of its inhabitants, used since the Middle Ages. The first edition of Richelet defined *sodomite* as a man "who commits the crime of sodomy" and *sodomy* as the "sin of the flesh against nature," an "execrable sin" that caused the destruction of Sodom, a sin "that every man who has a drop of good sense should abhor. Only rogues fit to be burned commit sodomies."[10] It noted that "the ancient Romans were somewhat sodomitical" and that the poet Ludovico Ariosto (1474–

1533) alleged that "secondary school teachers are prone to this horrible sin." It also reported that "sodomites are burned in France, but it is said, and it is perhaps a malicious thing to say, that in Italy they are treated somewhat more humanely." The first definitions in Furetière, in 1701, used the words "pederast" and "pederasty" and included supplementary information collected from various sources:

> Ménage calls it the sin against nature.[11] D'Assouci, condemned to the flames for sodomy, escaped, and, finding himself at Avignon, he exclaimed, "At last I am saved, because I am in papal territory."[12] La Chapelle.[13] In other words, sodomy is not a capital crime in Italy and under the rule of the Pope. The crime of sodomy is a privileged case [involving an offense that merits corporal punishment, which ecclesiastical judges cannot impose] with regard to ecclesiastics and therefore under the jurisdiction of the royal judge. Baillet and many others [Protestant writers] claimed that Della Casa, archbishop of Benevento, had written a poem in praise of sodomy as a divine work.[14] Ménage maintains that he had only praised the love of women.[15] Pope Sixtus IV, in response to a petition that was presented to him, allows the practice of sodomy during the three hottest months of the year.[16] Jurieu.[17] This petition to obtain permission to practice sodomy never existed, and I could be persuaded sooner of the truth than of the likelihood of such a proposition. Bayle.[18]

The *Dictionary of Trévoux,* from 1704 on, made the point that both divine and civil law condemned sodomites to be burned at the stake. The *Dictionary of the French Academy* defined sodomy for the first time, in 1740, as a "sin against nature" but abandoned the word "sin" in 1765: "crime of those who commit lewdness against nature." Richelet, 1759, omitted the phrase "fit to be burned," and Richelet, 1789, repeated only the first six words from the 1680 edition. Another dictionary published in the second half of the eighteenth century explained that this "crime against nature" consisted in "the use of a man as if he were a woman or of a woman as if she were a man."[19]

Tribade and **tribadism** (*tribade* and *tribaderie*) Derived from a Greek word meaning to rub, used since the sixteenth century. According to the first editions of Richelet and Furetière, it meant a woman "who couples with a person of her sex and who imitates a man" or an "immodest woman, in love with another of her sex. The Greeks made many references to these tribades." The first edition of LeRoux defined the tribade as "a type of hermaphrodite or a woman who hates relations with men but who takes her only pleasure in caressing women. See the *Treatise on Anatomy* of Dionis, in which he affirms that there are some women who have both sexes, that is to say that their clitoris, sticking out of the natural parts [vagina] with almost the same thickness as a virile member [penis] when they are enflamed by the fire of love, they can give themselves pleasure and also give it to other women."[20] The *Dictionary of Trévoux,* 1771, suggested "woman who has a passion for another woman" and added a "taste as inexplicable as the passion of one man for another." The *Dictionary of the French Academy,* 1765, identified the tribade as a "woman who misuses another woman" and warned, "One avoids this word."

I

Traditions

INTRODUCTION

Early modern French theologians, jurists, and doctors characterized sodomy as an offense against God, law, and nature. They commonly applied the word to a variety of non-procreative sexual acts including masturbation, bestiality, homosexual or heterosexual oral or anal intercourse, and vaginal penetration of one woman by another through use of an enlarged clitoris or phallic substitute. They evidently assumed that anyone could be induced or seduced into sexual misconduct with someone of the same sex, but, except in medical texts, they described this kind of misconduct largely as a male problem and added only cursory remarks about women.[1]

Like their medieval predecessors, early modern theologians took it for granted that several passages in the Old and New Testaments prohibited and condemned sexual relations between members of the same sex. Without asking the kinds of contextual and philological questions that modern commentators have raised about these passages, they routinely cited the story of the destruction of Sodom and Gomorrah (Genesis 19), Jewish law (Leviticus 18:22 and 20:13), and the letters attributed to Saint Paul (Romans 1:26–7, 1 Corinthians 6:9, and 1 Timothy 1:10). They believed that sexual deviance was a public, not private, matter and that royal authority, derived from God, should be used to enforce godly standards of conduct. Clergymen were reluctant, at the same time, to discuss "the sin against nature" in the confessional and the pulpit, because they did not want to arouse the curiosity of people who might have known nothing about it. Jean Lejeune, for instance, observed that "confessors are very reserved, and should be, about it; preachers dare not speak about this subject."[2]

Jurists discussed the subject with much more regularity but no less hostility. Because the French kingdom did not have a unified system of statutory law, magistrates generally followed customary law in the northern part of the country and Roman law in the southern part of the country. French kings, unlike some other early modern rulers, did not issue any edicts prescribing the death penalty for sodomy, so French jurists usually quoted the Old and New Testaments, Greek and Latin texts, the code of Justinian (Roman emperor, 527–65), customary law, and the *Institutes of Saint Louis* (Louis IX, French king, 1226–70). The *Institutes,* cited in the absence of any other royal pronouncements on the subject, condemned "buggers" to the flames in order to punish the offense and purify the realm. Some eighteenth-century commentators argued that the word referred to heretics and not sodomites, without suggesting, however, that the death penalty was an inappropriate punishment for sodomy. Most of them repeated the same list of cases adjudicated

1

by provincial courts, the Châtelet (the royal criminal court with jurisdiction over the capital), or the parlement of Paris (the royal appeals court with jurisdiction over a third of the country).

Because of phallocentric assumptions about sexuality, sexual relations between women seemed more puzzling than sexual relations between men at this time. More than a few writers asked themselves if people without penises could commit sodomy. In sections of anatomical treatises devoted to reproduction or hermaphrodites, doctors explained that some women had "abnormal" bodies that allowed them to usurp male prerogatives and play "unnatural" roles, without suggesting, of course, that it was permissible for them to do so.[3] The enlarged clitoris remained a fixture of medical and fictional discussions of tribadism throughout the early modern period.

A. RELIGION

1. JEAN BENEDICTI (d. c.1611), *Franciscan theologian, preacher, and administrator*

The Compendium of Sins and the Remedy for Them (1610)[4]

ON SINS AGAINST NATURE AND, FIRST, ON MOLLITUDE[5]

Those males or females who let themselves be defiled by sodomites give consent to and take part in the sin against nature. To understand this point, one must know that there are three types of mollitude. The first is a weakness and laxity that is opposed to the virtue of perseverance, as if someone were so indolent and so effeminate that he neglected what is necessary for his salvation. It is a type of sin of laziness. The second is that of which we have just spoken, which is voluntary pollution and happens while awake, through touch, imagination and delectation, speech or conversation with women or men, reading of obscene books, or any other means whatever. This is the third one, namely when someone is passive in the performance of this sin and fulfills the woman's function. So the gloss explains Saint Paul's word *molles* by saying pathics.[6] And it seems to me that they are those bardashes whose brothel king Josiah destroyed.[7] He demolished, the Scripture says, the houses of the effeminate, as our vernacular version calls them. The Hebrews call them *kedeshim;* the [unintelligible word] referred to them as *cinaedi,* that is to say cinaeduses.[8] Such was Ganymede, with whom Jupiter fell in love, if the poets tell the truth. Such was Julius Caesar, when still a boy, loved by king Nicomedes. And why do I cite the pagans? Those who pride themselves on bearing the name of Christian, do they not provide us with enough material, if we want to talk about it? I ask you, where is Audebert, young lad, one of the first pillars (I do not mean pillagers) of that fine Calvinist church?[9] Audebert's love, was it not preferred to Candide's?[10] Let Audebert come, he says, and let Candide withdraw. But what, she will be angry about it? She will hold her

tongue, he replies, contenting herself with a little kiss. And lest one think that I have made it up, the author of the words and the deed was also their historian, having written it down in his epigrams published by Robert Estienne more than thirty-five years ago.[11] And there are some who have known well enough how to reproach him for it, and I believe that Castellion, Hesshus, Baudouin, and Bolsec, in his legend [collection of stories], have not neglected the matter.[12] And since these courteous [Protestant] ministers come inspecting the life of [Catholic] clergy, I am sure that if we had the key to their shop in order to conduct an inspection of it, we would find some of their drugs as spoiled as those of others. But lest I burn myself out, let us return to our subject.

[discussion of masturbation]

ON SODOMY, THE SIN AGAINST NATURE

This sin is against the natural order because it is committed against the sexual order, a sin that is more grievous than having relations with one's sister, even with one's own mother. Now there is sodomy, and there is the sodomitical act, which are two different things. See the marginal note in Latin.* I hardly dare speak of this vile and horrible sin, and especially in our France. If I do, however, I will certainly say, with Lactantius, that this sin is so enormous that it cannot be mentioned because of its horror.[13] For, in the first place, such sodomites are compared to parricides and murderers. Secondly, they are infamous according to the laws. Thirdly, they should be punished with death and burned. The law of Moses orders that the active one as well as the passive one be put to death. Fourthly, according to ecclesiastical law, if they are lay, they should be excommunicated and expelled from the church, so that there is even a council that forbids giving them communion on the point of death.[14] If they are ecclesiastics, they should, according to the Lateran Council, be confined to a monastery, as to a perpetual prison, to do penance there.[15] But Pope Pius V recently issued an edict by which he deprives all ecclesiastics stained with this sin of every office, benefice, and clerical privilege, ordering that they be demoted and delivered into the hands of justice, to have them put to death according to the disposition of the secular laws.[16] From this extravagant [a type of papal text] one draws a conclusion, that if the clergyman who is accustomed to this sin is irregular [barred from fulfilling his functions because of his faults], he should be removed from his office and deprived of his benefice, which he cannot possess in good conscience. For this reason he should leave and renounce it. What, then, will the confessor do when such a person presents himself to him? He should refer him to the bishop, and if the penitent is not subject to the bishop, refer him to the Holy Father, the Pope, to obtain his dispensation. This is understood to apply in the case of someone who has indulged in this sin, which is condemned not only *in foro exteriori* [in the external court], that is to say through public judgment, but also *in foro interiori* [in the internal court], that is to say through the sacrament of confession, just as the same Pope Pius V, by word of mouth, interpreted it afterward. It is understood to be sodomy when it is practised through sodomitical copu-

*Sodomitical copulation is committed by a male by ejaculating semen inside the posterior pudenda. The sodomitical act is committed by polluting oneself with another person, and this is perhaps sodomy of women as much as it can also be of men.

lation and not only through the sodomitical act. This sin is so detestable that there are even some demons and wicked spirits who hold it in horror. For even though they sometimes keep carnal company with sorcerers and witches, still there are none who have ever committed the sin against nature. This is the mystical commentary of some Fathers on the passage from the Prophet [Ezekiel] that says, "I will deliver you into the hands of the spirits of the Philistines," that is to say of the devils, "who, even they, will be ashamed of your wicked life," that is to say of your sins against nature.[17]

Such shameless people fall from this miserable sin into others more terrible, such as apostasy, atheism, heresy, and finally, having reached the height of impiety, die damned. This is why the Apostle [Paul] calls them children of wrath and says that the philosophers were not pushed in the direction of damnation for that reason.[18]

On account of this sin, God made it rain lightning and burning fire on the cities of Sodom and Gomorrah, which were engulfed into hell in a moment. Moreover God often afflicts us with war, plague, famine, earthquake, inundations, and other calamities on account of this horrible sin. Among the reasons why God engulfed the world in that great cataclysm and deluge, Methodius martyr places the sin against nature, which is so abominable that even devils often killed and slayed those who practiced it.[19] And it is not inappropriate to note that it was demons who overthrew Sodom and Gomorrah along with their inhabitants, who, in addition to their prodigious lewdness, were worse than heretics, wanting, as much as it was possible for them, to abolish the human race by forsaking the natural usage of women. Some Fathers said that the divine Word postponed taking on human flesh for a longer time because it had been polluted by this foul sin. Let us add that all sodomites perished miserably the night that Jesus Christ was born in Bethlehem. And so it is one of the sins that cry out for vengeance before God. Philosophers who did not misuse natural law firmly hated this abomination, notwithstanding the pederasty that people would like to ascribe to Socrates, who was in truth a pederast, that is to say a lover not of children's bodies but of their minds, in order to instruct them in virtue, saying that he fulfilled the function of his mother, who, being a midwife, received babies from their mothers' wombs, and he received them to instruct them in virtue. All this is fully discussed by his disciple, Plato, in his dialogues.[20] Furthermore, this sin was firmly hated by the prophets as well as the apostles, the ancient and modern Fathers, to whom I refer the curious, contenting myself with having touched on it a bit, since it is preferable to say nothing rather than to speak too much about it. Not to mention the fact that I address this treatise of mine to our French nation, which is not as stained, at least as far as I know, as the Orientals, etc.

[discussion of bestiality]

2. JEAN EUDES (1601–80), *Oratorian preacher, founder of the Congregation of Jesus and Mary*

Admonitions to Missionary Confessors (1648)[21]

SIXTH COMMANDMENT: YOU WILL NOT BE LUSTFUL IN BODY OR IN THOUGHT

For Boys and Unmarried Men

Whether some other act with men or women or children, even more abominable than those above, did not take place, and of what status these men or women were.

Whether they have not touched other men and whether this was not the cause of making these men fall into pollution, and whether these were laymen or men consecrated to God.

Whether they have not allowed men or whether they have not encouraged them to commit filthy touching of their persons and whether pollution did not follow from it, and of what status these men were.

I speak of the sodomitical sin, about which the prudent confessor must question only males or females whom he observes, males or females, to be wholly surrendered to disgraceful passions, for this sin is committed not only between men but also between women, when they engage in dreadful lewdness in the manner of copulation, about which decency and discretion forbid discussion, about which Saint Paul nevertheless speaks in Romans 1.[22]

For Girls and Unmarried Women

Whether something lewd took place with other girls or women, along the lines of what has been said regarding boys and men, and whether it was they who taught the wrong to the others, and who incited them to do this.

3. JEAN LEJEUNE (1592–1672), *Oratorian preacher, known as the Blind Father after he lost his sight in 1635*

The Missionary of the Oratory or Sermons for Advent, Lent, and Religious Holidays of the Year (1662)[23]

ON THE EFFECTS OF GOD'S JUSTICE THROUGH THE LAW OF NATURE, IN THE DESTRUCTION OF SODOM AND GOMORRAH

"He who approaches God must believe that He is just."[24]

Yesterday we were considering the strictness of God's justice in the earthly paradise, in the punishment of the first man. Today we have to consider this same strictness in the law of nature. Holy Scripture offers us two quite remarkable examples of it. The first is the destruction of the whole world by the vengeful waters of the universal flood; the second is in the burning of Sodom and Gomorrah. We have discussed the first at great length above, when we spoke about unbelief. Today I have to discuss the second with you and to explain to you what the holy book tells us about it in the nineteenth chapter of Genesis, in order to give birth in our souls to the fear of God's judgments. This fear being a Christian virtue and a beginning of spiritual life, we should receive it from you, o holy and blessed Virgin! For you say in Ecclesiasticus, *"In me is all hope of life and virtue,"* because you produce it in the hearts of those who turn to you, as we do devoutly, in greeting you with the angel: *"Hail, Mary."*[25]

The angelic doctor [Aquinas], speaking about the merit of good works, teaches us a truth quite contrary to the sentiment, or to put it better, to the error of the greatest number of Christians. *"Speaking simply,"* says this saint, *"temporal goods do not fall under merit."*[26] Speaking simply and absolutely, earthly riches, bodily health, long life, and other worldly goods are too insignificant to be merited by the good works of Christians and to be their reward and recompense. We have seen the proofs of it above. I do not want to repeat myself unnecessarily, but it should not be inferred from it, *a contrario* [through opposition], and said: Worldly goods are not properly a subject and a matter of merit; thus they are not a subject and a matter of demerit. This inference is not valid. "Sin is a double-edged sword."[27] It is unworthy of eternal and temporal goods, the enjoyment of God, and the usage of creatures. You complain that God has taken away from you your husband, your child, and other creatures that you used to love. Have you never offended Him? Know that, even if you had only ever committed one mortal sin, if He took away from you all your friends, all your goods, your honor, your health, and your life, He would not wrong you. He would only do to you what you have rightly deserved for four reasons, without mentioning an infinite number of others that could be produced: because sin is a very unjust persecution against God; it is a monstrous ingratitude, a most criminal felony, an iniquitous and tyrannical oppression.

The most innocent and legitimate revenge that you could take on a weak man who attacks you unfairly is to take his sword from him and strip him of his arms. A deed of gift, although well worded and executed in good form, such that it is stipulated, accepted,

registered, and verified, can be revoked and annulled by the benefactor if the recipient commits an act of enormous ingratitude against him. The vassal who commits a felony or a rebellion against his ruler loses the domain he holds as a fief from him, and his goods are confiscated, without mentioning the other penalties that he deserves. A slave, finally, who is treated too unfairly and too strictly by his master can petition a judge and ask to be freed from this tyrannical domination and given to a more reasonable and more moderate master.

When you consent to mortal sin, you declare war on your God. You use your life, your health, and the other goods that He has given you to fight Him. You commit an act of unnatural ingratitude, an atrocious rebellion, against Him. You unfairly oppress His creations that serve you, by making them rebel against Him. You use bread, wine, gold, silver, and light to offend Him. Thus, if He deprives you of them in order to deliver them from this oppression, if He takes His goods away from you, if He revokes the gift that He had made of them to you, if He strips you of His arms, He does not do you any wrong. He makes use of the right of just defense. Thus, when the prophet Nahum affirms that God never takes revenge twice for the same crime and that He does not punish the same sin in both this world and the other—*"Oppression will not lift its hand twice,"* or, according to another version, *"God does not punish twice for the same cause"*—it should be understood to mean a sin that is effaced by a true, legitimate, and complete penance.[28] For there are some sinful souls that are so out of favor with God and of such a bad sort in His eyes that all the afflictions that befall them in this world are but foretastes, trials, preludes, and anticipations of what they will suffer in the other. Such were the inhabitants of Sodom and the other sinful cities. Here is what Moses says about them in the two-thousand-seventy-seventh year after the creation of the world.

The sins of these unfortunate cities having reached their limit, God wanted to punish them in an exemplary manner. For that purpose He sends two angels to Sodom. The righteous Lot, thinking that they were pilgrims, goes to meet them, invites them in, and, receiving them charitably into his home, welcomes them. The Sodomites, imagining that there were some people at his house who could serve as objects of and prey to their brutality, run there in a crowd. They beseige his house with the intention of forcing their way into it and satisfying their unbridled passion there. The good man goes into the street and says to them, "Wait! What are you thinking about, gentlemen? Don't you see that you're doing wrong? You're offending God. You're bringing His just vengeance down upon yourselves." "It hardly behooves you to remonstrate with us," they said to him. "You've only been in this city for two days, and you already want us to censure our actions. Withdraw from here; otherwise things will go badly for you." The angels, fearful that they might injure him, make him come back into the dwelling and strike those obstinate people blind, such that although they were still right next to Lot's house, they could never find its door. Then the angels said to Lot, "Think about taking all your household and your relatives away from here, for we are sent to this city by God to destroy it from top to bottom." He goes to find two young men who were to be his sons-in-law, or who already were such, according to the Greek text. "There's much news," he tells them. "We must get away from here immediately. The vengeance of heaven is going to overthrow this city." "Tell it to others! To others! Go tell your tales to children and not to men like us." The next day the angels urge Lot to leave, and, as he delayed, they take him, his wife, and his two daughters by the hand and draw them out of the city. And as soon as they were in a safe place, a great storm arises, the weather becomes overcast all at once in an extraordinary fashion, a rain of fire and burning sulphur falls from heaven,

which consumes Sodom, Gomorrah, Admah, Zeboiim, and all the surrounding places and reduces them to ashes. To benefit from this story and make ourselves wise at the expense of these unfortunate people, we must consider their sin in its propensities, its perpetration, and its punishments.

The prophet Ezekiel shows us the main propensities when he says: *"Behold, this was the injustice of Sodom: pride, abundance, plenty of food, its own and its daughters' comfort, and they did not help the poor."*[29] *Pride.* Ambition, vanity, desire for worldly glory. You want to be stylish, swagger, have valuable clothes, and claim more status than belongs to you. Your income cannot suffice for it. You sell true honor in order to have the means to keep up false honor. Being adjusted to the ways of the world, you wish to show off your luxury. You want your ostentation to be seen and admired by others. You loathe seclusion, you throw yourself into society, you frequent balls and dances, you lose the purity of either the body or the heart.

Pride. Presumption. You overestimate yourself and your strength. It seems to you that one might sooner pull your heart out of you than pull your assent to a bad action out of you. You throw yourself into events, you converse often or for a long time with persons of the opposite sex, you give your eyes and your other senses complete liberty, as if you were stronger than Samson, holier than David, wiser than Solomon.[30] The saying of the Holy Spirit is confirmed in you: "He who loves danger will perish in danger."[31] Saint Bonaventure says, "I am a bishop. I would not want to lie, believe me. I have seen the cedars of Lebanon, that is to say men of great piety, who have unfortunately fallen."[32] And again: "I do not speak of it by rote but from deplorable experience. I saw people fall, whose chastity I would not have questioned any more than that of Saint Jerome or Saint Ambrose."[33]

Pride. Pride, arrogance, and self-confidence. You have swollen your heart with pride. You have claimed for yourself the glory of your chastity and the honor of your past victories. You have not recognized that God alone was the cause of them and that you are but weakness and wretchedness on your own. You have despised the souls that had fallen, you have made fun of them, you have told stories and jokes about them. To humble your pride, God has let you succumb. He prefers to see you a brute rather than a demon. Pride makes you like demons and immodesty like beasts. For when Scripture wants to say that a virgin has lost her purity, it says that she has been humbled.

Abundance. The land of Sodom resembled an earthly paradise not only because of its luxury, excessive comfort, and great wealth but also because of its fertility and beauty, *"like the garden of the Lord."*[34] When you have everything you could wish for, you forget what you owe to others, you forget about God. You think that you do not need anyone. You do not turn to Him wholeheartedly; you only serve Him as a matter of form. You are so keen on leaving a great estate to your children. It means giving them the means and tools to do evil, to corrupt girls, to buy the honor of women, to have pompous clothes and outfits to please them, to lead a life wholly devoted to pleasure, which nourishes and increases the temptation of this vice.

Plenty of food. Intemperance, good care of the body, gluttony, feasts, stews, spices, wine that is not well watered down, never enduring hunger, filling oneself with meats, always eating well. It is throwing oil and sulphur on the fire instead of putting it out. *"Wine is an immoderate thing."*[35] *"The belly churning with food stimulates desire."*[36]

Its own and its daughters' comfort. Idleness and too much rest, uselessness of mind and body. *"They are corrupt and do abominable deeds."*[37] *"All alike have become debased; there is not one who does good."*[38] In doing nothing, one learns to do evil. One

has leisure to listen to temptations, and the spirit is open to receive them. *Its own and its daughters' comfort.* It specifically says, *and its daughters',* because when girls have nothing to do, they seek diversions, they leave the house to find some, they go to parties, they amuse themselves with inspiring love, and they often feel as much and more of it than they inspire.

They did not help the poor. Lack of charity. They were stingy and pitiless to the poor. Had they shown mercy to the poor, God would have shown it to them. He would have given them grace to repent, reform, abandon sin, do penance, and gain forgiveness.

The holy text of Genesis teaches me a sixth cause that inclined them to this sin. All those in the city were addicted to it, all of them, and even the little boys, *"from the young to the old, all the people without exception."*[39] Children, little boys, how had they learned it? From the example of their fathers, their mothers, the household servants, their companions. You put your children to bed in places where they can see or hear impurities. You put young boys and girls in the same bed. You are negligent about watching them when they play together to see if they do anything dirty. You send your girls to be schooled by men. You put lewd fancies into the minds of these poor youngsters through your immodest words and deeds. One need not be surprised if they take on the tint of this vice at such a young age and if they keep it for life, until the most advanced old age. *"A child started on his path will not leave it even in old age."*[40]

To the old. This shows the results that constitute the consummation of this vice. The first is habit. Old people were addicted to it because they were used to it. Nature, not habit, is all withered up in old people. On the contrary, habit becomes more strong, more violent, and more unruly as one advances in age. *"It acquires strength in going from the young child to the old man, who does not have the capacity to commit the crime, but has the desire to do so. The strength of the old man is weakened, but the mind is full of passion."*[41] It is a vice that makes everything it can sticky, that binds and holds its man. One forms a callous easily; one frees oneself of it with great difficulty. The other enemies of man may be kept at a distance or avoided. *"They can be put to flight or fled from."* One drives Satan away with holy water and signs of the cross. One can flee the world by withdrawing into the wilderness, but wherever one goes, one always takes one's body with one. Once initiated into pleasure and accustomed to impurity, the body always returns to its vomit, if one does not do great violence to oneself though austerities and mortifications, and if one does not gain efficacious grace from God through humble and fervent prayers, which one does only very rarely because one is very wretched without recognizing one's wretchedness.

One is struck blind like the Sodomites. *"Fire fell down, and they did not see the sun."*[42] Impurity is an infernal fire, similar to hell's fire, which burns without shining. It ravages all your possessions. It blinds the mind so strongly that you do not notice this loss. *"It is a fire burning until perdition."*[43] And as the Poet [Virgil] says, *"She feeds the wound with her life-blood and is wasted by a flame deep down within her."*[44] It consumes your possessions. You use them to corrupt women, to give them gifts, to maintain their luxury, to give balls, to prepare meals for them, to pay for the messages of your amours. You are blind to these losses, for since you have been possessed by this obsession, farewell to the shop, the lawsuits, and the care of the household. You let your business fall behind, your children are forgotten, and your servants do what they please. Your wife is vexed, stung with jealousy; she is enraged about your debauchery. You are no longer happy in wedlock; you are always quarreling. Your income decreases; your customers are lost. You are blind to this loss, because this vice spoils your body, it affects your health, it shortens your life, it afflicts

you with infamous, shameful, and contagious diseases that are never cured completely. It ruins your honor and reputation; you are the disgrace of your family, the butt of your neighbors' jokes, the laughingstock of the populace, the object of a thousand judgments, rash and correct alike, the subject of conversation and mockery in gatherings. They talk about nothing but your misconduct. They point you out and make fun of you. It makes you lose the grace of God, who, being purity itself, is the mortal enemy of this filth. God, seeing the sin of Adam, which tainted all later generations, the sin of Cain, who murdered his brother, did not regret having made man, but when He saw that men were addicted to the sin of the flesh, He said, *"I regret having made humans."*[45] It makes you lose your soul, your eternal salvation, and your place in paradise, for from this blindness of mind, one falls into impenitence and obstinance, into the hardening of the heart, in the outskirts of hell, on the brink of damnation.

The Sodomites, having been warned by the righteous Lot, rebuff and threaten him instead of turning it to their advantage. Having been struck blind by the angels, they persist in their wicked desire instead of being frightened and repenting. They search for the door in order to do evil. *"Their thoughts do not allow them to return to their God, for the spirit of harlotry is in them, and they do not recognize the Lord."*[46] *They do not recognize the Lord.* No, they do not know, they do not believe and do not fear the greatness of God, the strictness of His judgments, or the severity of His justice. Listen to what He did to the Sodomites, and you will tremble, if you have not lost your faith. He punished them through their persons, their relatives, and their friends, through their worldly possessions, their reputation, and their salvation.

First, through their persons. They are consumed by a rain of fire and burning sulphur, an appropriate reward, says Saint Chrysostom, a punishment that is in conformity with and correspondence to the quality of their crime.[47] They were addicted to the sin of the flesh; this passion is an ardor, an infernal fire. *"A flame devours her molten heart to its core."*[48] They are consumed by the fire. The fire of sulphur is malodorous, and the sin of impurity is foul and loathsome in the presence of God, the angels, and the saints. Saint Philip Neri recognized by smell those who were slaves to this vice.[49] The demon implants this sin in you to spite God and ruin you, but, what is more, he has a natural aversion and antipathy for it. When he has plunged you into this quagmire, he makes fun of you. Palladius, in his *Lausiac History,* chapter 29, says that the abbot Pachomius told him that Satan tempted him in the form of a girl he had seen in his youth.[50] He gave her a good slap in the face, as a result of which his hand became so malodorous that he could not stand the smell of it for the space of two years. The Sodomites are punished by a rain of fire. The nature of fire is to rise, and here it falls contrary to its nature. Rain is ordinarily fresh and wet; God makes this rain dry and burning. I say that it is God who makes it. Scripture expressly notes it— *"The Lord rained sulphur and fire from the Lord"*[51]—to signify that this rain came neither from some malignant influence of the stars nor from a natural cause, but rather that God Himself wished to put His hand to it and make use of His power for it, without relying on anyone, so much does He hold the sin in horror.

They are smitten through their relatives, their children, and their friends, whom they see perish by fire. Yes, their own children, yes, those still nursing, even the innocents, even those who were still at their mother's breast and who had no remedy to atone for their original sin. They are burned alive, their salvation is wrecked, they are deprived forever of entry into paradise in punishment for the sin of their fathers.

They are punished through their possessions, their houses, their inheritances, and their livestock. Their farms and the nearby villages are ravaged by the fire, with such exe-

cration for their impiety and impurity that the fire devoured and consumed the land upon which they walked and the assets of their inheritances. Yes, this land, which was previously so rich, so fertile, and so lovely that it seemed an earthly paradise, is now nothing but a heap of ash and dust. For Josephus and the other authors who have been there say that in the middle of this region there is a great hollow in the ground, about ten leagues wide, thirty-six leagues long, in which the nearby waters, having drained and collected, form a large lake that they call the Asphaltite or Dead Sea.[52] This lake continually emits stinking smoke, a vapor so fetid that the valleys and mountains for ten leagues around are burned and barren because of it, such that not only does this abominable lake not support any living thing, but also the adjacent lands have been so cursed by God that they support no plants, except for some trees loaded with apples, which, when picked and handled, are reduced to ash and dust.

From this it also follows that they are punished through their reputation, for this infamous and stinking lake is an eternal monument for posterity, which proclaims the abomination of their crime and the heavenly vengeance that justly destroyed them. But what is even more horrible is that after such a complete loss of everything worldly, they wreck the spiritual and the salvation of their souls. God catches them by surprise in a wicked state, in the very act. He does not give them a single minute of time to collect themselves and do penance: *"the sins of Sodom, which was overthrown in a moment."*[53] He warns those of the flood a hundred years before, then at the end of a hundred years, and then seven days before the event. Water falls little by little for forty days; He gives them time to repent, and indeed some do. *"He preached to the spirits in prison, who had not obeyed in the days of Noah."*[54] But the Sodomites pass from this rain of worldly fire and sulphur into the ponds of eternal fire and sulphur. They begin their hell in this world and are going to continue it in the next for all the centuries to come. *"Sodom and Gomorrah and the surrounding cities serve as an example by undergoing a punishment of eternal fire."*[55] Note that they are doubly punished, *by a double-edged sword,* punished in this world and the next, with worldly and eternal punishments.

Is it therefore in vain that God wished to inflict such an exemplary punishment on these wretched cities? Is it in vain that the Scripture tells its story? Is it in vain that God left a monument and memorial of the destruction of this land to all posterity? Saint Peter and Saint Thaddeus say that it is an example for all sinful souls.[56]

Does God make an exception for anyone? Do we think we can escape the same storm, having embarked on the same ship? Not to be their companions in punishment, being guilty of the same crimes? Are these words not an oracle of eternal truth? *"Unless you repent, you will all perish in the same way."*[57] What am I saying, "in the same way"? I am saying too little. *"If anyone will not welcome you or listen to your words, truly I tell you, it will be more tolerable for the land of Sodom and Gomorrah on the day of judgment than for that town."*[58] *"If the mighty deeds done in your midst had been done in Sodom, it would have remained to this day. It will be more tolerable for the land of Sodom than for you."*[59] All things carefully considered, we are guiltier than those cities were. Our sins, in God's scales, are more considerable, more numerous, and more punishable that theirs. *"As I live—the Lord God speaks—your sister Sodom and her daughters have not been as bad as you and your daughters. Behold, this was the injustice of Sodom, your sister: pride, abundance, plenty of food, its own and its daughters' comfort, and they did not help the poor."*[60] They were arrogant toward their fellow citizens; you are so toward your prelates. *Plenty of food.* They ate until they were stuffed, and you fill yourselves with wine and meat. *Abundance.* They wanted to live with an abundance of all things,

and you with excess and superfluity. *Comfort*. They lived in sloth, you in black and detestable actions. They did not give alms to the indigent; you take bread out of their hands, you rob widows and orphans. They were only under the law of nature, and you are under the law of grace. They had no efficacious sacraments, no Gospels, no Holy Scripture, and you have them. They had not been redeemed by the Son of God as you have been. They did not sin in sanctified flesh, and you soil your body, which was consecrated by the union and combination of the body of Jesus Christ in the eucharist.

You are a sinner like them, and more than them, says Saint Chrysostom, and the vengeance of heaven does not crush you like them because there are more good people among you who prevent it.[61] You take advantage of them and of the patience of God, who waits for you. For this, *it will be more tolerable for them,* but *"you are storing up wrath for yourself."*[62] For this, they will not be punished as severely as you. You are storing up a treasury of wrath against you. They are punished more strictly than those of the flood, because they did not learn from their example, as Lamech was punished more than Cain, Belshazzar more than Nebuchadnezzar.[63] You do not learn from their example, nor from the example of many others. You will therefore be punished more severely than they, and if they are punished in this world by fire and the destruction of all possessions, and from there they pass into eternal fire—*by undergoing a punishment of eternal fire*—I leave it to you to reflect on what you should expect in this world or in the next, or in both together. And do not imitate them, do not seek to live in the abundance and affluence of worldly goods; they are the accomplices and instruments of pleasure. *"Accomplices of pleasure,"* says Saint Augustine.[64] If you are rich, it will be a great accident if you are not proud, conceited, arrogant, ambitious, and presumptuous. You would not know how to be exempt from these faults without God's grace, and God's graces leave conceited souls to come to humble people, as the dews of heaven leave haughty mountains and descend into lowly valleys. *"They swim down from the arrogance of the hill into the humility of the valley,"* says Saint Augustine.[65] If you are rich, you eat well, you will have the means to engage in debauchery. You will not be obliged to work to earn your living, you will be lazy, idle, indolent, intemperate, and all these vices are steps and inclinations toward lust.

Do not imitate Lot's sons-in-law. When they were told about the justice of God and the destruction of their city, they took these threats for tales and jokes—*"they thought he was joking"*—but they were quite astonished when they saw them carried out.[66] When one speaks to you about judgment, hell, or God's justice, when one tells you that vengeful flames burn and will always burn blasphemous, vindictive, and lewd people, you think nothing of it. It seems to you that it is a child's game. Someday you will see its fulfillment, and then you will recognize and wonder at your unbelief, but it will be too late.

Do not even imitate Lot, for he put faith in the angels' words, but he did not make enough haste to carry them out. He delayed; he wasted time in packing his bags. It vexed him to let furniture that he could take away be lost, and in this way he delayed his departure. And if the angels had not taken him by the hand and pulled him out of his house as if by force, however righteous he was, he would have been enveloped in the ruins of his country because of his delay. Do not imitate him, when it is a matter of leaving a house, of leaving a position, a benefice, or a way of life that does not lead you to salvation. Do it immediately, do not delay a day, an hour, or a minute. Do not wait for your term to be completed, or your wages to be paid, or your lawsuit to be ended. If the preacher and your confessor, like two angels, do not tear you away from the event, you run the risk of being enveloped in eternal flames.

Do not imitate Lot's wife. Moved by curiosity, against the prohibition she had been given, she turned her head and eyes toward the fire of Sodom, and she was punished by death, for she died from it immediately. You do not dance at the ball, but you watch those who dance there. You lust after the girls or boys who dance gracefully, and you think you are innocent, as if Jesus Christ had not said, he who sees a woman and lusts after her commits adultery in his heart.[67] You do not gamble, but you watch those who do, and you say nothing to them when they take God's name in vain, as if Saint Paul had not said that not only those who commit the sin, but also those who acquiesce in it, deserve death.[68]

Do instead what the angels advised Lot to do: *"Flee for your life! Do not stop anywhere in the plain, but flee to the hills."*[69] Withdraw from the world, where there are so many risks, so many dangers and stumbling blocks. Save yourself on a mountain of perfection, in a cloister isolated from the world. If this is impossible, at least withdraw from worldly company, balls, dances, parties of boys and girls, and other amusements where there are so many opportunities to offend God. Remain secluded in your house, apply yourself to the care of your family, to some praiseworthy occupation that distracts you from temptations and opportunities to do evil. "Flee for your life": Save your soul, if you are wise. I ask God to give you the grace to do so. Amen.

4. CHRISTOPHE SAUVAGEON (c.1639–1710), *prior of Sennely-en-Sologne*

"The Manuscript of the Prior of Sennely" (begun in 1700)[70]

When one questions them about the sixth commandment, it is necessary to ask them if they have not been tempted by the sin of the flesh.[71]

Girls never acknowledge their acts of lewdness except on the deathbed, although they are much inclined to them.

It is also very rare that one acknowledges the sins of sodomy and bestiality except on the deathbed or during jubilees [years during which plenary indulgences were granted under certain conditions]. This is why it is necessary to question them about it, but it must be done with singular discretion, for fear of perhaps teaching them about sins that they have never known or, consequently, thought about committing. One may, in the questions one asks them, examine them in this way: "Have you not committed the sin of the flesh with girls or women? Have you not had the desire and the will to do so, and have you not made advances, pursuits, and declarations for that purpose? Have you not touched yourself indecently? Have you not spent your semen? While frolicking and clowning with your companions, have you not had wicked inclinations to commit the sin of the flesh with them?" And then speak to them about animals. These infamous and detestable crimes are all too common among them, and they have the misfortune almost never to acknowledge them until death or during jubilees.

B. LAW

1. JEAN PAPON (1505–90), *royal judge in the district court of Montbrison*

Collection of Notable Judgments of the Sovereign Courts of France (1563)[72]

On Abominable Lewdness

[discussion of bestiality]

Two women corrupting each other together without a male are punishable by death, and this offense is buggery and against nature. Law *Foedissimam*.[73] According to one of the readers of Accursius, the [Julian] code on adultery supports this interpretation and says that there are women so abominable that they follow other women, just as or more ardently than the man follows the woman.[74] And Françoise de l'Estage and Catherine de la Manière were accused of this. There were witnesses against them, but inasmuch as the witnesses were validly challenged, the women cannot be condemned to death on the basis of their testimony. And the depositions were taken as evidence only because of the gravity of the offense, and on this account said women were sentenced to torture by the seneschal [district official with judicial functions] of Landes and later released by a judgment.

[discussion of incest]

2. JEAN DURET (b. c.1540), *royal prosecutor in the presidial court of Moulins*

Treatise on Punishments and Fines in Criminal as well as Civil Matters (1573)[75]

Buggers

We have stated above the punishments appropriate for adultery and hope to deal succinctly below with concubinage, rape, incest, profligacy, and other related matters, when it seems more appropriate. Now seeing that the opportunity presents itself, let us see in a few words what punishment those who indulge in lewdness against nature must undergo. The common people call them buggers. Discussing this abominable sin, Moses commanded that a man who copulated with brute beasts, lay with another man as he might do with a woman, that both, having transgressed, be punished by death. In conformity with such holy commandments, when the man takes the place of the woman as if he hoped sometimes to beget (a thing loathsome to imagine), when Venus disguises herself,

when love is sought where it cannot be found, the imperial laws demand that the laws arm themselves and rise up to punish such monsters, infamous for all time, with death.[76] [discussion of bestiality] Here is a third type of this heinous sin that is practiced between women who are so abominable that they follow other women, just as or more ardently than the man follows the woman, corrupting each other together without males. In this case, if there are sufficient proofs, they do not escape from a lesser penalty than death.

3. CLAUDE LEBRUN DE LA ROCHETTE (1560–c.1630), *lawyer in the district and presidial courts of Lyon*

Civil and Criminal Proceedings (1618)[77]

SODOMY AND THE SIN AGAINST NATURE

If the singular scourges that the Sovereign Emperor of this great universe has at various times visited upon the earth for the punishment of this execrable crime did not make it obvious enough in everyone's eyes how abominable it is to His Divine Majesty, who attests that it cries out for vengeance before His throne, I would try to tell you something about it, gentle readers. But you hold it sufficiently in abhorrence, casting the eyes of your soul on the cataclysm or global flood and on the conflagration of the Sodomites, Gomorrheans, and their neighbors, which it caused. And considering that the most reliable group of the most speculative theological doctors affirms that for these iniquities God visits upon the earth plagues, wars, famines, and other calamities, with which His wrath, justly aroused against the brutality of men stricken by this crime, punishes the provinces that are infected by it. And in truth, it is rightly called the sin against nature, considering that other iniquities, such as fornication, adultery, rape are either in conformity with nature or derived from natural (albeit contrary to reason) instinct. But this one, trampling the laws of nature underfoot, going madly beyond its bounds, attacks it, confounds it, and violates it completely.

What pushes the unfortunate man (whom Eusebius, unable to find a name serious enough to dishonor him, calls parricidal and diabolical) to the performance of such disgusting and filthy vileness is nothing but the devil, who sees himself banished from heaven and sees that man, created for the glory of God, will possess it if he lives according to the rules that have been prescribed for him by the Eternal One.[78] To prevent his henchmen from going there and to destroy the propagation of humans as much as he can, and to hinder the generation that should someday fill the celestial ranks, the devil has found no better expedient than to put into the minds of those whom he already holds bound by other mortal vices the thought of giving themselves up to this damnable and impious practice, to which thought, if he could, he would draw the whole race of men in order to have soon extinguished it, using in this effort all the cleverness of his pernicious lies to incite them to it as much as he can.

The name of sodomy that was given to it was taken from the miraculous punishment of the Sodomites, when God sank the cities of Sodom, Gomorrah, Zeboiim, Zoar, and

Admah into the bowels of the earth for this execrable crime. We call it buggery in the manner of the Italians, who named those stricken by it *buzerroni,* which sounds like *buzo erroni.* And indeed, when someone is put to death in Italy, if people are asked for what reason the execution is taking place, their usual answer is, "that he mistook the *buzo,*" which means "hole" in their language.

This crime is committed in three completely different ways. Namely, either when a man corrupts and contaminates himself knowingly (and not when *he stains his night clothes and his belly* while dreaming) or when he commits sodomy with another man or with a woman *"contrary to the natural use"* or with brute beasts.[79]

[discussion of masturbation]

The second way is in fact that of the *buzerroni* of the Italians, when this wretched act is committed by a male with a male or by a male with a female contrary to the natural practice or by two women corrupting each other. This mad brutality is condemned by the Apostle [Paul] in the first chapter of the Epistle to the Romans, where he calls it shameful desire. *"For their women exchanged the natural use for that use that is contrary to nature, and in the same way also the men, giving up the natural use of woman, were consumed with desire for each other in turn, men doing shameful things with men and receiving in their own persons the due reward for their mistake."*[80] Lucian, though a wicked and wretched atheist, detested this crime as execrable.[81] In the notes to the eighth book of his history, Livy, the greatest of all the Roman historians, discussing the violence that Lucius Papirius wanted to commit against Gaius Pubilius, his debtor, and that Fabricius wanted to commit against one of the soldiers of Marius, marvelously exaggerates detestation of this vice, which cannot be imagined, which should always be punished by fire, a torture cruel enough for the expiation of such a detestable evil, so as to terrify offenders by this means. . . .[82]

[discussion of bestiality]

As for women who corrupt each other, whom the ancients called tribades, among whom are placed Sappho and Bassa (about whom Martial wrote, *"In that I never saw you, Bassa, intimate with men,"* etc.) and Philaenis, whom Tertullian calls *fricatrices,* there is no doubt that they commit this type of sodomy with each other. . . .[83] And this crime merits death, as Monsieur Bohier remarks in his *Decisions,* question 316, part 2.[84]

Certainly this crime, in its types described above, is so detestable that our laws have only dared to speak of it obliquely, without inquisitively explaining all its circumstances, judging emperors and jurisconsults to be responsible enough that they can impress upon the minds of judges how horrible it is and how severe its punishment should be. By the same token, let us see that the sacred decrees and pontifical law call sodomites children of wrath and enemies of salvation, of whom one ought to beware. . . .

And it must not be considered strange that the Apostle spoke so openly about it to the Romans, to whom he describes this vice clearly. For as one discusses vices more obliquely and speaks about them in more obscure words in the presence of young people who have never practiced them than before those whom one wants to turn away from such misdeeds, likewise the Apostle, who had spoken about it covertly everywhere else, in discussing it with the Romans, who were remarkably stained with it, exposes its turpitude to them without reservation, in order that, through remorse for this vice, their conscience, touched to the quick, might make them recognize the wretched state into which misfortune had plunged them.

The punishment for those who have carnal knowledge of female Jews, Turks, pagans, and other infidels should not be less than for those who commit sodomy, given the strange

hatred that such people have for the Christian religion and since they are regarded by us as beasts, not with regard to the use of reason but for being outside the path of salvation. . . .

[discussion of sexual relations with succubi and incubi]

4. ANTOINE BRUNEAU (1640–c.1720), *lawyer in the parlement of Paris*

Observations and Maxims on Criminal Matters (1715)[85]

ON SODOMY

Sodomy is a type of abominable lewdness, according to the laws cited by Jean Imbert, book 3, chapter 22, number 21.[86] Lactantius, *On the True Religion,* book 6, chapter 23, inveighs strongly against this vice. Sodomy, according to *Novella* 51, the law *Cum vir,* in the Julian code on adultery, is an abominable lewdness contrary to nature, which is committed by a male with another male or with an animal, and a person with a female *as with a brute beast.*[87] Julius Clarus, § sodomy, number 1; Mosnier, *under the word homicide, last number.*[88] There is no one, however poorly versed in sacred history, who does not know where the word sodomy comes from. It is the name of one of the two cities, which Genesis 19 speaks of, overthrown and reduced to ashes by fire from heaven because of the execrable vices, prostitution, and great lewdness of this city's inhabitants, who brought God's justice down on themselves. In France, it is also called *copulation with males* and the abominable sin against nature. The laws only speak of it with horror and with threats of terrible punishment. Law *Cum vir,* section 32 in the Julian code on adultery. Minors are not less guilty according to divine law. Leviticus 18 and 20:13; Exodus 22; Deuteronomy 17; Romans 1:27; 1 Corinthians 6:10; 1 Timothy 1:10. I stop there, *for these things are not to be spoken of.* The emperor did not want to call this crime by this name, in the *Institutes,* book 4, title 18, section 4 in the Julian law, being a crime that cannot be named. . . .[89]

The penalty for sodomy could not be strong enough to expiate a crime that makes nature blush, to put the active one and the passive one to death by fire that consumes them and have the ashes thrown to the wind. Law *Cum vir,* in the Julian code on adultery; Julius Clarus, § sodomy, number 1. I saw a memorable example of it in Paris, of two who were burned in the [place de] Grève [site of public executions] by judgment of the parlement. Nevertheless, it is not worth burning them alive, *lest he be led by slow death into despair of eternal salvation.* Julius Clarus, § sodomy, number 7. The sovereign courts can order a mitigation, but the regular judges are obliged to sentence the sodomite, according to the letter of the law, to be burned alive. Papon, book 22, title 7, cites several decrees that one has only to consult. The *Customs of Brittany,* article 633, punishes this crime by fire.[90]

[discussion of heterosexual anal intercourse]

From the moment that he is arrested and accused, a sodomite, being subsequently convicted, cannot make a valid will. He is proscribed and cannot make a will. A cleric

is deprived of his benefices, if he has any. *The cleric is deprived of the benefice by that very fact.* Andrea Alciati, *On the Meaning of Words,* chapter on violation, 101; Coras, chapter 73, page 302, etc.[91] A sixty-year-old sodomite was burned in the new market at six o'clock in the evening on Wednesday, 31 March 1677. See the constabulatory book of sieur de la Martinière, part 3, last chapter, section 4, folio 1007, sodomy.[92]

[discussion of sexual relations with animals and corpses] Women who corrupt each other are called *fricatrices* and *triballes.* It is a type of sodomy, on account of which they are punished. The canonists prescribe a gentler punishment for women than for men by condemning them to two years of penitence. Law *Foedissimam,* in the Julian code on adultery; Bohier, in his *Decisions,* question 316, part 2; Ivo of Chartres, book 9; *Decretals,* chapter 85, *from the penitential of Diodorus.*[93]

5. NICOLAS MEUSY (1734–72), *parish priest of Rupt in the Franche-Comté*

Code of Religion and Morals (1770)[94]

On Crimes against Nature*

French laws are absolutely silent about these dreadful crimes, which are mentioned only with fear and should be absolutely unknown.

Divine law punishes sodomy by death. *"If a man lies with a man as with a woman, both of them have committed an abomination. They shall be put to death; their blood is upon them."* Leviticus 20. *"You shall not have intercourse with a man as with a woman; it is an abomination."* Leviticus 18. God punished it in a terrible manner in the person of the Sodomites. Genesis 19. The law *Cum vir,* section 31 in the Julian code on adultery, is expressed in this way: *"We order the laws to rise up and justice to be armed with an avenging sword, so that the severest penalty may be visited upon those who are now, or will hereafter be, guilty of this infamous offense."* This law mandates the penalty of burning alive. See also *Novella* 77 and *Novella* 141 *(concerning those who commit the*

*Some question whether chapter 85 of the *Institutes of Saint Louis* of 1270 concerns sodomy. Here is the section: "About the Punishment of the Unbeliever and the Heretic. If someone is suspected of *bougrerie,* justice should arrest him and send him to the bishop, and if he is convicted, he should be burned and all his goods forfeited to the lord. And in this way a heretic should be handled, provided it is proved, and all his goods forfeited to the lord or ruler. And it is written in the Decretals [papal decrees], in the section 'On the Meaning of Words' in the chapter 'Concerning Particular Subjects.' And customary law is in agreement with it."[98] Some think that this passage concerns the Albigensian heretics, who had followed the same heresy as the Bulgars. Others think that it is about sodomites. It is certain that the word "b[uggers]" comes from Bulgars. The epitaph of Alix, countess of Bigorre, which is at Montargis, proves it clearly. It says there that she was the daughter of Guy de Montfort, who died for the faith while fighting against the buggers and Albigensians.[99] On this word, see Du Cange, page 180, *and the following;* the *Ordinances* of Laurières, volume 1, page 175.[100] For another etymology of this word, see the *Encyclopedia,* article "Guèbres."[101]

crime against nature).[95] Our jurisprudence is in conformity with this, whether the crime has been committed *between males* or *between females*. Papon reports several examples of it, among others that of Nicolas Dadon from Neuilly-Saint-Front, who had been rector of the University of Paris, who was hanged and burned with the trial records.[96] Book 22, title 7, numbers 2 and 3. The parlement of Toulouse, during its extraordinary session in Le Puy, pronounced a similar judgment on 17 September 1548. In 1584 an Italian was burned alive for the same crime in front of the Louvre [royal palace in Paris], as was a prothonotary from Montault in 1557. The same, book 23, book 10, number 6.

Judgment of 21 March 1720, which sentences two prisoners to make a public confession, have a hand cut off, and be burned alive in the Grève for violence committed by them against an abbé, also a prisoner.

An even more recent example of this detestable crime and its punishment is the judgment of Monday, 5 June 1750, and that of 5 July of the same year, which sentence the men named Deschauffours, Bruno Lenoir, and Jean Diot, sodomites, to be burned in the place de Grève.[97] Will these examples not be capable of stopping the most debauched men? Will they always affront the justice of heaven and earth with impunity?

[discussion of hermaphroditism]

6. DANIEL JOUSSE (1704–81), *royal judge in the district and presidial courts of Orléans, author of many books about the history and practice of French law*

Treatise on the Criminal Justice of France (1771)[102]

ON SODOMY

Sodomy is the most abominable of all the lewd acts and has been punished in all times with the severest penalty. It is this crime that was responsible for the destruction of the cities of Sodom and Gomorrah by fire. Genesis 19:24.

The penalty for this crime, according to divine law, in Leviticus 20:13, was death for the two guilty people.

For this crime the Romans had a particular law called the Scatinian law, which is mentioned in Juvenal, satire 2, line 44.[103] See also Cicero, book 8 of his *Epistles,* numbers 12 and 14, and *Philippics,* number 3, section 5; Valerius Maximus, book 6, chapter 1, number 7; Suetonius, chapter 8, on Domitian; Ausonius, epigram 88; Plutarch, in the life of Gaius Marcellus, number 1.[104] The fine was ten thousand sesterces, according to Quintilian, *On the Education of the Orator,* book 4, chapter 2.[105] But the Christian emperors established the death penalty for this crime. See the law *Cum vir,* section 31 in the Julian code on adultery.

In Athens this crime was also punished by death. See Aeschines, *Against Timarchus.*[106]

The same sentence applies in Italy. See Farinacius, question 148, numbers 5, 6, and 7, who adds that they even burn after death the bodies of those who are guilty of this

crime.[107] *Thus also* Julius Clarus, § sodomy, number 4; Menochius, *Of Uncertain Cases,* case 286, note I.[108]

In Germany those who are guilty of this crime are burned alive, along with their accomplices, according to Charles V's Constitution [criminal code] of the year 1532, in conformity in this regard with *Novella* 77 and *Novella* 141, both promulgated by the emperor Justinian.[109]

According to the old law of France, it was enough to castrate those who were convicted of sodomy. *Visigothic Code,* book 3, title 5.[110] And it is also the penalty discussed in Boutillier's *Rural Compendium,* book 2, title 40, page 870.[111] According to this author, a man who is proved to be a sodomite should lose his testicles for the first time and his genitals for the second time, and he should be burned alive for the third time. By the *Institutes of Saint Louis* from the year 1270, part 1, chapter 85, "If someone is suspected of *bougrerie,* justice should arrest him and send him to the bishop, and if it is proved, he should be burned." See also the *Customs of Brittany,* article 633, which states that they will be burned.

Nowadays the penalty for this crime is to sentence all those who are guilty of this crime, *both the active one and the passive one,* to be burned alive, and there are several examples of sentences of this kind. Sometimes the guilty are simply sentenced to death and then to be burned, which depends on the circumstances.

By a judgment of 13 December 1519, confirming a decision of the bailiff [district official with judicial functions] of Amiens, a man named Jean Moret, convicted of this crime, was sentenced to be burned alive. See Imbert, book 3, chapter 22, number 21.

Another judgment of the year 1557, reported by Chenu in his notes on Papon's *Judgments,* book 24, title 10, number 6, which sentences the prothonotary of Montault to the flames for this crime.[112]

Another judgment of 1 February 1584, reported by Papon, book 22, title 7, number 1, in the additions, by which Nicolas Dadon from Neuilly-Saint-Front, who had been rector of the University of Paris, was hanged and burned with the trial records for the crime of sodomy.

Another of the month of April 1584, reported by Chenu in his notes on Papon's *Judgments,* book 24, title 10, number 6, by which an Italian was burned alive in front of the Louvre for this same crime.

Another judgment of 28 November 1598, confirming a sentence of the bailiwick [district court] of Issoudun, by which a man named Ruffin Fortias, called Desrosières, convicted of the same crime, was sentenced to be hanged and his dead body burned, which was carried out the following 22 December.

By another judgment of 31 March 1677, a sixty-year-old individual guilty of this crime was sentenced to be burned in the new market in Paris, which was carried out the same day.

Another judgment of 26 August 1671, which sentences Antoine Bouquet to be burned alive with the trial records for this crime.

Another decision, handed down in last resort by the Châtelet of Paris on 24 May 1726, which sentences a man named Benjamin Deschauffours, for the same crime, to the flames, which was carried out.

Another judgment of 5 June 1750, in consequence of which the men named Bruno Lenoir and Jean Diot, guilty of this crime, were burned in the place de Grève the following day, Monday, 6 July.

Minors who are guilty of this crime are not punished less severely than others, at least if they are more than eighteen years old. *Thus* Julius Clarus, supplement, § sodomy, number 14. There is a law about it in several provinces in Italy. See Julius Clarus, ibid.

Ecclesiastics who are guilty of this crime are, like others, subject to the death penalty. Farinacius, question 148, number 28. There is a bull [papal pronouncement] of Pope Pius V about it for Italy.

[discussion of heterosexual anal intercourse]

It is permissible for an individual whom someone tries to assault sexually to kill the guilty party with impunity. *Thus* Farinacius, questions 148 and 149; Julius Clarus, supplement, § sodomy, number 15, where he gives examples of it. Plutarch, in his life of Gaius Marius, also tells how Gaius Lucius, the grandson of Marius, was killed by a young man named Trebonius, whom Lucius had tried to assault, even after having tried to use violence against Trebonius. Marius not only praised Trebonius's action but also judged him worthy of reward.[113] Cicero also praises this action in his speech *On Behalf of Milo*. . . .[114]

The attempt alone is punishable by death in the case of this crime because of its gravity, according to several authors. Others claim that it is necessary that it have been consummated and that otherwise it should be punished by a lesser penalty. See Farinacius, question 148, numbers 56–65. Which depends on the circumstances and the age, as well as the status, of the individuals involved. That is why a physical examination is usually ordered in these cases, especially for the crime of bestiality.

The weakness of age can sometimes make this crime excusable in someone who lets himself be corrupted, at least sparing him from the death penalty. See Farinacius, question 148, numbers 76 and 77; Julius Clarus, supplement, § sodomy, number 13.

And this excuse should apply all the more in favor of a person against whom violence was used to commit the crime, for he should not be punished in any way, provided, however, that this violence is proved. Farinacius, ibid., questions 79 and 80.

It is not necessary to have *eye* witnesses for the proof of this crime. It can also be proved by circumstantial evidence and sometimes by the declaration of the person who was assaulted, combined with other circumstances, and in general by the other proofs and evidence that are used in criminal cases. See Farinacius, question 148, numbers 66–75.

Finally, one last observation to be made about this type of crime, namely that it is not necessary, in order to punish it, that the facts of the crime be verified by experts, but only by the evidence, as it is done in the case of all crimes in which the facts of the crime are difficult to prove, because they do not leave any mark after them that can verify them. See Farinacius, question 2, number 24.

The crime of women who corrupt each other is regarded as a type of sodomy, *if they have sexual relations with each other after the example of the male and the female,* and it deserves capital punishment, according to the law *Foedissimam,* in the Julian code on adultery, and such is also the common view of the experts. *Thus* Julius Clarus, § fornication, number 29, where he reports several examples of similar sentences.[115] *Thus also* Farinacius, question 148, number 4. Sometimes, however, the penalty is less severe, according to the circumstances and nature of the crime. See Farinacius, ibid., number 41; Julius Clarus, ibid., number 29.

This penalty applies likewise according to our customs. See Papon's *Judgments,* book 22, title 7, number 3.

7. PIERRE FRANÇOIS MUYART DE VOUGLANS

(1713–81), *lawyer in the parlement of Paris, royal judge in the court that replaced the parlement from 1771 to 1774 and in the Grand Conseil [royal court that judged certain types of cases that otherwise would have been judged by the parlements], opponent of reforms in the system of crime and punishment*

The Criminal Laws of France in Their Natural Order (1780)[116]

ON SODOMY

This crime is otherwise known by the name of pederasty. It is also called against nature, because it tends to violate the rules prescribed by nature for reproduction.

Everyone knows that it derives its name from that infamous city from which divine justice believed it must exact a memorable vengeance by having it consumed by flames, so that not a single trace of it remained on earth.

Canon law considers this crime so serious that it ranks it above the incest that a father commits with his own daughter. Therefore we see that it pronounces against ecclesiastics who fall into this crime the severest penalties that the church can pronounce, such as those of excommunication and dismissal from sacred orders.

Roman laws did not show themselves less severe against those guilty of this crime. They all agree in decreeing the death penalty, in conformity with the law of Moses, and this penalty, which is that of fire, is stated, among others, by *Novella* 77 *(concerning those who commit the crime against nature)*.

The provisions of such a wise law were adopted by those of the realm. We have a capitulary of Charlemagne that orders its enforcement in the most exact manner, after having also deplored the public misfortunes that are the usual result of this crime.[117] It is also as a consequence of these pious laws, confirmed by the *Institutes of Saint Louis* of 1270, in which one finds a chapter specifically about this crime, that the established practice of punishing it by the penalty of burning, following the example of the punishment that divine justice made of it, was introduced into our jurisprudence. See the judgments reported by Papon, book 22, title 7, and book 23, title 10.

See also the judgments pronounced in the last instance against the men named Deschauffours, Bruno Lenoir, and Jean Diot.

[discussion of masturbation]

8. ANDRÉ JEAN BAPTISTE BOUCHER D'ARGIS

(1750–94), *lawyer, royal judge in the Châtelet, advocate of reforms in the system of crime and punishment*[118]

Universal and Reasoned Collection of Civil, Criminal, Canonical, and Benefice Jurisprudence (1784–85)[119]

SODOMY (1785)

It is the crime of the debauched against nature.

The Roman emperors established the death penalty against this crime. The Athenians had a similar law.

Farinacius and Julius Clarus teach us that not only are those who commit this crime punished by the death penalty, but also that their bodies are burned after their deaths.

According to the constitution of Charles V of the year 1532, those who are guilty of sodomy in Germany should be burned alive, along with their accomplices.

According to the old law of France, those who were convicted of sodomy should be castrated.

In his *Rural Compendium*, Boutillier says that sodomites should lose their testicles for the first time, their genitals for the second time, and be burned alive for the third time.

One reads in the *Institutes of Saint Louis* of 1270 that "if someone is suspected of *bougrerie*, justice should arrest him and send him to the bishop, and if it is proved, he should be burned."

The same penalty is established by article 633 of the new *Customs of Brittany*, which states that "all convicted of the crime of sodomy will be dragged on a hurdle and burned."

The current jurisprudence of the realm is similarly to sentence all those who are guilty of sodomy to the flames. Various judgments have pronounced this penalty. . . .[120]

Finally, by a judgment of 10 October 1783, Jacques François Pascal, convicted of the crime in question and of homicide, was sentenced to be thrown onto a burning pyre, after having been broken alive on the wheel.[121]

The crime of women who corrupt each other is considered to be a kind of sodomy.

Several jurists, and especially Julius Clarus and Prosper Farinacius, teach that it is permissible for an individual whom someone tries to assault sexually to kill the guilty party with impunity. Plutarch recounts that after Lucius, the grandson of Marius, had been killed by a young man named Trebonius, whom Lucius had tried to assault, Marius not only praised Trebonius but also judged him worthy of reward. Cicero also praises this action in his speech *On Behalf of Milo*.

9. BOUCHER D'ARGIS

Methodical Encyclopedia: Jurisprudence (1782–89)[122]

SODOMY OR PEDERASTY (1787)

Beneficent nature desired that the two sexes, swept away by a shared impulse, feel the irresistable need to come together, that this need be a pleasure and even the source of human reproduction. Can one imagine the madness of a contrary feeling? It exists, however, and it exists in different ways. It has perpetuated itself from age to age down to our time, and this idiotic and crude vice would inevitably bring about the annihilation of society as a whole, if it were possible that its contagion became widespread.

Sacred history tells us that heaven punished two cities completely given over to this shameful excess by a miraculous conflagration. Lacedaemon [Sparta] itself, who would believe it? Lacedaemon, one of the most famous cities of ancient Greece, the rival of Athens, the homeland of so many great men, was so contaminated with this crime that Lycurgus, its lawgiver, believed himself obliged to order that women walk around nude there, in order to bring men back to the natural feeling.[123] What a contrast with the law of Minos, who, hoping to prevent too many children from being born in Crete,* ordered separations of married couples in certain cases and allowed pederasty as a compensation for the privations that he imposed![124]

Among the Romans and among us, pederasty has always been ranked among the most serious crimes.

Crimes against nature are of several types. We make distinctions between pederasty or sodomy, masturbation, and bestiality.

Pederasty or sodomy is the crime of any man with a man, of any woman with a woman, and even of a man with a woman, when, through inconceivable debauchery, they do not make use of the usual paths of reproduction.

[discussion of bestiality and masturbation]

In this article we will deal only with pederasty. The law *Cum vir,* section 31 in the Julian code on adultery, declares that those who make themselves guilty of pederasty will be punished with the severest penalties. *"When a man couples like a woman, what can such a 'woman,' who offers herself to men, desire, when sex loses its significance, when the crime is one that it is of no advantage to know, when Venus assumes another form, when love is sought and not found? We order the laws to rise up and justice to be armed with the avenging sword, that the severest penalty may be visited upon those who are now or will hereafter be guilty of this infamous offense."*[125]

The commentator on this law rightly observes, *"That law deals with the foulest violation, and it is the foulest matter in this law, yet it is communicated through tasteful words, in which regard the emperor did well."*

The uncertainty that the Roman laws leave about the penalties suitable for this crime has been resolved by our jurisprudence.

*Aristotle, *Politics,* book 2, chapter 8; Bayle, *Works,* volume 3, page 221.[126]

One finds in Papon a judgment that he does not date, but which was carried out on a 1 February [1586], by which Nicolas Dadon from Neuilly-Saint-Front, who had been rector of the University of Paris not long before, was sentenced to be hanged and burned with the trial records for sodomy.

"Two women who corrupt each other without men," according to the same author, "are punishable by death, and this crime is buggery contrary to nature. . . ."

By a judgment of 7 June 1750, Bruno Lenoir and Jean Diot were sentenced to be burned for a crime of the same kind.

By a decree confirming a decision of the Châtelet of Paris, handed down by the *chambre des vacations* [magistrates who administered justice during recesses] of the parlement of Paris on 10 October 1783, Jacques François Pascal [was condemned to death]. . . .

We will not conclude this article without correcting a mistake into which we fell in drafting the article on pederasty that may be found in the *Universal Collection of Jurisprudence* published by Monsieur Guyot. In that article we dated the jurisprudence concerning the penalty for the crime against nature back to the time of the *Institutes of Saint Louis*. We were led to think so by the text of chapter 85 of these *Institutes*, which we had found in the penal code, but which is not faithfully transcribed there. Here it is as it is found in the collection of ordonnances from the Louvre and in the separate edition that Monsieur the abbé de Saint-Martin, counselor of the Châtelet, just published of it.[127] It is entitled "About the Punishment of the Unbeliever and the Heretic," and it is worded in this way. . . .

The text that we had read in the penal code used *bougrerie* instead of *bouguerie*. And although these two words have the same origin and the same meanings,** the first, however, having a more generally accepted meaning, left no room for any ambiguity, and we had believed that we should use it, without hesitating, for the crime against nature. But we are grateful to Monsieur the abbé de Saint-Martin for a more correct interpretation of the word *bouguerie* in the circumstances in which it was used by the legislator. We can do no better than to revise our view on the basis of his, which we are going to report, beginning with the translation that he has given of chapter 85 of the *Institutes*. . . .

In order to justify the translation of the word *bouguerie* as unbelief, Monsieur the abbé de Saint-Martin adds in a note, "*bouguerie* is in the text, and several understand this word to mean the crime against nature. If one pays attention to the title and to the rest of the chapter, it will be easy to convince oneself that it is not at all a question here of crimes other than unbelief and heresy. The title says 'to punish the unbeliever and the heretic,' and in the chapter it is said that he must be sent to the bishop. Now, it is customary to send unbelievers and heretics to the bishop in order to question them about their beliefs, something which, in those times of ignorance, could not have been entrusted to secular judges. It is not clear why one should have sent someone who had been accused of the crime against nature to the bishop. The judgment and sentencing of such a criminal belonged only to secular judges, etc."

We have found some evidence ourselves that supports the view of Monsieur the abbé de Saint-Martin. The fourth article of an ordinance of Saint Louis, issued in Paris in the month of April 1228, in favor of the churches and against the heretics in the province of Languedoc, states that the barons, the *baillis* of the king, and all his subjects will take

**Dom Carpentier, author of the supplement to Du Cange's glossary, refers one from the word *bouguerie* to *bulgari,* and here is what one reads there: *"Bulgars, heretics who are commonly called Albigensians. . . ."*

care to purge the territory of heretics, that they will look for them, and that, when they have found them, they will turn them over to the ecclesiastics to do with them what they must. . . .[128]

It also seems that not only heresy but even unbelief used to be punished with death. In 1588 the parlement of Paris sentenced a man named Guitel to be hanged for the crime of atheism.[129] In 1618 that of Toulouse sentenced an Italian who denied the existence of God to make a public confession, wearing nothing but a nightshirt, with a lighted stick of wood coated with wax in his hands, to be dragged on a hurdle, have his tongue cut out, and be burned alive.[130]

It follows from all these observations that the word *bouguerie,* used in chapter 85 of the *Institutes of Saint Louis,* should be translated instead as unbelief, that it ought not to be taken to mean the crime against nature.

C. MEDICINE

1. ANDRÉ DU LAURENS (1558–1609), *doctor to Henry IV*

Anatomical History of the Human Body (1599)[131]

On the Different Parts of the Womb

Finally, at the crest of the superior and anterior part of the vulva is seen a certain small part, which Falloppio, the first among the moderns, described elegantly.[132] Yet it had not been unknown to the ancients, for Avicenna called it *albatra,* that is to say the penis; Albacusius, *tentigo* [lecherousness]; Fallopius, *clitoris;* Colombus, the love and sweetness of Venus; and as for us, we call it woman's *mentula* [virile member] or penis.[133] This small part has two hollow ligaments that originate from the pubic bones, which are spongy inside and filled with a thick blackish blood and four small muscles. It also has at its tip something that resembles a *balanus* or acorn [or glans], which is covered by a very loose skin, as by a foreskin. It is different, nevertheless, from the virile member in that it does not have any duct for the excretion of semen. Its function (in my opinion) is to awaken the drowsy [sexual] faculty when it is rubbed by the man's penis during copulation. It grows so excessively in some women that it hangs out of the opening like a man's penis, and such women play with each other and are, for that reason, called tribades and fricatrices.

2. JACQUES DUVAL (c.1555–c.1615), *professor of medicine*

On Hermaphrodites, Women's Deliveries, and Care That Is Necessary to Restore Them to Health and Raise Their Children Well (1612)[134]

Without a significant defect, the length of the clitoris never reaches half the width of a finger. But in some, said clitoris is so big that there have been women in whom it exhibited the size and thickness of a virile member, erect and prepared for tillage, with which they abuse girls and women. But with the orgasm and venereal disturbance passing, it always remained of the same thickness or became very much smaller than it was before, for not being as fistular as the male member. This part is not perforated and does not shoot any spermatic matter. Those who have such a thick, long, and well supplied one are called *tribades* by Caelius Aurelianus, book 4, chapter 9; by Plautus, *subigatrices* [lascivious women]; by Arnobius, *fricatrices;* and by the French, *ribaudes* [lecherous women].[135]

[discussion of dildos]

But I leave that behind, inasmuch as I mean only to mention here what is excessively enlarged, in order to be of use to those *ribaudes,* always being part of the human body, of which Martial, discussing it in book 1, epigram 90, says

3. PIERRE DIONIS (d. 1718), *surgeon to Maria Theresa, wife of Louis XIV*

The Anatomy of Man (1690)[136]

LECTURE THAT DEALS WITH THE FEMALE PARTS DESIGNED FOR REPRODUCTION

We see in the internal part of the large opening, above the nymphae [labia minora of the vulva], a glandular body, round, long, and a bit thick at its extremity, which is called the clitoris. It is of no use to recount all the names that have been given to this part, which is said to be the main seat of pleasure during copulation. It is true that it is very sensitive, and there are women who are of such an amorous temperament that, by rubbing this part, they obtain pleasure that makes up for the lack of men. That is what makes some call it the scorn of men.

The clitoris is usually rather small. That is why it is almost never visible in dead women. It begins to appear in girls at the age of fourteen years or so and grows as they advance in age and according to whether they are more or less amorous. It swells and becomes hard in the ardor of coitus, which takes place by means of the blood and spirits with which it is filled during this act, in the same way that the man's penis does dur-

ing erection. That is why it is also called the woman's penis, because it resembles it in many things. There are women who have an extremely thick one and in whom it comes out of their labia. There are others who have one so long that it has the size of a man's penis, and these women can misuse it with other women.

4. SAMUEL ANDRÉ TISSOT (1728–97), *doctor*

Onanism, or Physical Dissertation on the Illnesses Caused by Masturbation (1760)[137]

CONSEQUENCES OF MASTURBATION BY WOMEN

Besides masturbation or manual pollution, there is another kind of pollution, which could be called "clitoral," whose origin dates back to the second Sappho—*Lesbians, whose love made me a byword*—and which is too common among the women of Rome at the time when all morals were lost there, more than once the subject of the epigrams and satires of that age.[138]

> Saufeia challenges the female slaves to a contest
> and her agility wins the prize,
> but she pays hommage to the rubbing of Medulina,
> so the palm remains with the mistress.[139]

Nature, in its sport, gives some women half a resemblance to men, which, poorly investigated, has led people to believe for many centuries in the chimera of hermaphrodites. The supernatural size of a part usually very small, and about which Monsieur Tronchin has produced a learned dissertation, brings about all the miracle, and the odious abuse of this part all the evil.[140] Glorying, perhaps, in this kind of resemblance, there have been some women who took possession of virile functions. Greece called them *tribades,* a name that was translated into French by that of *frotteuses* [rubbers]. This is a kind of monster that reappears often and that seduces the young [female] sex with even more facility because it has in its favor the argument of Juvenal's eunuchs,

> that there is no need of an abortive drug.[141]

If only we did not have to fear, with him, these consequences, which, unable to be concealed, reveal weaknesses, lead to crime, without its innocent accomplices even suspecting the danger. The danger, however, is no less than in other kinds of pollution; its consequences are equally frightful. All roads lead to exhaustion, languor, pain, death. This last kind deserves all the more attention because it is common today, and it would be easy to find more than one Saufeia and Medulina, who, like those Roman women, value nature's gifts so much that they believe that these gifts should make all arbitrary distinctions of birth disappear. A few years ago, a lady was seen at court who, so smitten

by a young girl, desired her so much that she conceived the strongest jealousy against a famous scholar who also found the young girl to his taste.

It is time to conclude this melancholy account. I am tired of portraying the turpitude and misery of humanity. I will not accumulate a larger number of facts here; those that remain will naturally find their place elsewhere. And I am moving on to an examination of the causes [of masturbation], after this general observation: It is that young people born with a weak constitution have much more harm to fear for the very same crimes than those who are born vigorous. None avoids the punishment; all do not experience with the same severity. Those especially who have cause to fear inheritance of paternal or maternal illnesses, who are threatened with gout, stones, consumption, scrofula, those who have attacks of asthma, coughing up blood, epileptic migraines, who have a predisposition to that kind of rickets I discussed above, all of these unfortunate people, I say, should be thoroughly convinced that every act of this kind of debauchery strikes deep at their constitution, every one hastens the appearance of the ills that they fear, will render the fits much more vexatious, and will throw them, in the flower of age, into the infirmities of the most languishing old age.

It is well known that a living person falls into infernal ways.[142]

5. J. D. T. DE BIENVILLE (dates unknown), *doctor*

Nymphomania, or Treatise on Uterine Fury (1771)[143]

On the Means of Healing in the First and Second Stages and the Relief that May Be Hoped for in the Third Stage

With regard to the third stage of the condition, it will be up to the parents or those entrusted with the education of the sick girl to carry out everything necessary to complete it fully. But I should show them the means to do so and demonstrate what experience, which has often filled me with shock and horror, has taught me only too surely. It is therefore necessary to investigate who the sick girl's most intimate and dearest acquaintances are. And without seeking to go into their morals or watching what the continuation of these intimacies might produce, with whatever sex these acquaintances might be, it is necessary to separate them on pretexts that can neither offend them nor cause the sick girl's mind to rebel, which it is advisable to spare because of its weakness, and that of the organs.

If this relationship exists with a servant, no matter how much prudence is attributed her, it is necessary to examine her and observe her conduct with the same strictness as one would with a prostitute who had given rise to the most vehement suspicions. The sick girl's gestures and glances when being attended by this servant should be observed with the greatest care.

Criminal familiarity between these unfortunate women and their young mistresses or young pupils is a more widespread contagion than is thought. Less is made of it when the danger is less evident, and the danger is great only when it is less perceptible. If after

all these observations, there does not appear to be any unusual relationship with anyone, it can be reasonably assumed that the sick girl's imagination is the source of her problems, and that a secret profligacy has brought them to the point of malignancy that requires the application of remedies. It will thus be necessary, if the sick girl persists in lying, not to lose sight of her for an instant, day or night, during which she should be given as a sleepmate a girl whose virtue and prudence are beyond reproach.

II

✦➤◄✦

Repression

INTRODUCTION

If not for the repression of sodomy, we would not know much about sodomites between the Renaissance and the Revolution. Magistrates had more men executed for this offense during the early modern period than during the Middle Ages, for the sake of retribution and deterrence, but they prosecuted the "crime against nature," like many other crimes, sporadically and selectively rather than systematically. Published sentences are much less informative than unpublished depositions and interrogations, but surviving criminal records are difficult to locate, especially in the departmental archives.[1] This part includes material about an unknown seventeenth-century provincial case whose outcome is not noted in the dossier and two well-known eighteenth-century Parisian cases that ended in the Place de Grève. Benjamin Deschauffours, burned at the stake in 1726, was charged with and convicted of not only abducting and selling boys but also murdering one of them. Bruno Lenoir and Jean Diot, burned at the stake in 1750, were arrested for nothing more than having sex in the street.[2] Their executions were no more representative of French jurisprudence at the time than the capital punishment of the Protestant Jean Calas in 1762 and the blasphemous chevalier de La Barre in 1766 or the last posthumous punishments of suicides in the 1770s. By the second half of the eighteenth century, magistrates were less likely to prosecute crimes traditionally defined in religious terms and also less likely to impose exemplary penalties that publicized those crimes.

The vast majority of sodomy cases were handled by the police without recourse to the judicial system. The police used undercover agents to observe and entrap men in the Luxembourg, Palais-Royal, and Tuileries gardens, where Parisians of all classes took walks and prostitutes and customers sought each other. They also conducted patrols in other areas frequented by what they called sodomites and then "infamous types" (without reference to Scripture) in the early and "pederasts" (without reference to morality) in the late eighteenth century. They collected information about and apprehended thousands of individuals, including members of the nobility and clergy, whom they usually released or at least treated with some deference, and large numbers of artisans and servants, who were much more likely to be punished. They sent many of the men they arrested to one of the Parisian prisons (Bastille, Châtelet, For-l'Evêque, Hôtel de la Force) or one of the medical establishments (Bicêtre for men, Salpetrière for women, and Charenton for the insane) or religious institutions (Saint-Lazare for men and Sainte-Pélagie for women) that served as penitentiaries. Prison sentences varied in length, depending on the circumstances of the offense and whether individuals had already been arrested for the same

reason, but prolonged imprisonment was the exception rather than the rule. Other men were simply expelled from Paris or specifically exiled to their places of birth. More concerned about preserving public order than punishing sexual sins by mid-century, the police knew that they could not eradicate sodomy, so they concentrated on trying to control sexual activity in public places and prevent the seduction and corruption of minors. They assumed that sexual relations between males usually involved victimization of younger by older males. Some men reported that they had been molested as schoolboys, but more often than not the younger males were adolescents rather than children, and some of the adolescents were obviously involved in prostitution.[3]

The police records in this part, selected from several different series of papers that survived the demolition of the Bastille, provide somewhat different types of documentation. Section 4 contains files on sodomites who were imprisoned by lettre de cachet (royal order), probably at the request of relatives or colleagues, and subsequently watched for signs of rehabilitation. Section 5 includes reports of entrapment that describe gestures made, words spoken, desires expressed, and acts committed by "infamous types" looking for sexual partners in public places. Section 8 comprises interrogations of "pederasts" who were usually just as intent on exculpating themselves as the police were on inculpating them. These documents provide sketchy information about men who did not frequent the gardens and selective information about men who did, but they have allowed historians to reconstruct some dimensions of the geography, sociology, and psychology of the sodomitical subculture as it evolved in the course of the eighteenth century.[4] They include facts about occupation, address, age, place of birth, and marital status, along with evidence about gendered characteristics, sexual tastes and roles, male prostitution, networks of sociability, and perhaps even an emerging sense of identity. They reveal little about women (Marie Dion, in section 5, document p, was not observed by the police but denounced by another woman) and more about workingmen than they do about notables, who often used intermediaries to locate sexual partners. These sources have their limitations, in both number and nature, but they tell us more than any other source about the real lives of real sodomites in early modern France.

1. Journal of a Bourgeois of Paris during the Reign of Francis I (1515–1536)[5]

In 1533 an Italian from the city of Alexandria was burned at Blois, where the king was, because he was a bugger and sodomite and had been brought to justice before for having counterfeited the signature of the chancellor of France, but the king pardoned him as a result of his friends' efforts.

1534. In this year and in the month of January, a merchant from Florence named Antoine Mellin was brought from Lyon before the parlement, appealing the death sentence of the lay justice of Lyon for having been found a bugger and having committed this sin unnaturally on a girl and on a young boy, which boy and girl brought suit against him for this reason. He had been condemned in Lyon to be burned alive, which sentence he appealed to the parlement. And said court handed him over to the lieutenant crimi-

nal [magistrate in charge of criminal cases] of the Châtelet of Paris to have him tried, which had been done badly in Lyon, and said girl and boy were sent for to be confronted with him, but in the end, by dint of money, he did not die for it.

2. MICHEL DE MONTAIGNE (1533–92), *essayist*

Journal of the Trip to Italy (1580)[6]

Vitry-le-Français. . . . a few days ago, at a place near there called Montier-en-Der, there had been a hanging for this reason. A few years ago seven or eight girls from around Chaumont-en-Bassigni plotted to dress themselves like males and continue their life in the world in that way. One among them came to this place, Vitry, under the name Marie, earning her living as a weaver, a well-disposed young man who made friends with everybody. At said Vitry he became engaged to a woman who is still alive, but because of some disagreement that arose between them, their agreement was not carried out. Later, having gone to said Montier-en-Der, still earning his living at said trade, he fell in love with a woman, whom he married and with whom he lived for four or five months, to her satisfaction, so they say. But having been recognized by someone from said Chaumont and the matter having been brought to justice, she was condemned to be hanged, which she said she would rather endure than go back to the condition of a girl, and was hanged for using illicit devices to make up for the deficiency of her sex.

3. Charges against Jean Verré (1651)[7]

9 February

The young lady Marie Pagnié, widow of the late Jacques Regnart, living like a bourgeois, linen worker of Cambrai, resident of the parish of Saint-Georges, 52 or 53 years old, after swearing an oath in the hands of the undersigned clerk of the archbishop's court of Cambrai, asked about certain questions put to her by the appointed proctor [lawyer presenting a case to an ecclesiastical court] of said court, said and deposed that master Jean Verré, priest, lately chaplain of said Saint-Georges, lived and kept a room at her house for a period of about two years, having left it at the time of the festival Saint-Remy [1 October] last year, during which time she saw that said Verré admitted to his said room, at different times and on different occasions, various men, both priests and laymen, who sometimes slept in his room, where there was but one bed. Not having seen or noticed any disorder, except that one time a certain Spanish soldier from Monsieur the governor's guard left the room at dusk or in the evening and came downstairs completely displeased, saying that said Verré was a badly disposed man and that he needed a woman

rather than a man, without having explained himself further. And having drawn some beer from the tavern for said soldier at the request of said Verré, he brought it to his said room, saying to said speaker that he would sleep there like he has done, and having asked him where he would sleep, he responded to said speaker that he would sleep on the floor, by which said speaker feeling scandalized and she expressed her resentment and dissatisfaction to said Verré. [In margin: The next day] asking him why he thus detained and had spent the night with such a person in his room. Upon which said Verré alleged excuses with which said speaker was hardly satisfied, everything heard, having signed after the reading.

Master Jean Martin, priest, chaplain of Sainte-Croix in Cambrai, 63 or so years old, introduced and examined like the preceding witness, after swearing the oath, *on the priest's word and by his sacred orders, with his hand on his heart,* said and deposed that he heard, about twelve or so years ago, from a certain soldier of the company of sieur captain de Pousque, now deceased, whose military nickname was My Faithful One, that various other soldiers told him that master Jean Verré, priest, formerly chaplain of Sainte-Croix and since of Saint-Georges in said Cambrai, that they, having gone to bed with said Verré, took them by the penis or virile member, and shook it and provoked pollution in them. Adding that being himself in bed with said Verré, Verré wanted to do likewise with him, with which the soldier did not want to comply, which he stated to Martin. Thus said My Faithful One told him that he was doing evil and something indecent and that it would be better if he purged himself with women or girls, and that the offense would not be so great, by which said speaker was greatly scandalized, and nevertheless by common report he understood that young men or lads called said Verré cock jerker, and said Verré was suspected of and caused scandal by such foul deeds.[8]

Michel le Jeune, mason, bourgeois of Cambrai, resident of the parish of Sainte-Elizabeth, 50 years old, sworn, heard, and examined like the preceding witness, said that several years ago now master Jean Verré caused scandal by and was suspected of the sodomitical sin and that when he was seen walking through the streets, people said, there is the priest who wants to play the Italian whore, which he heard in various places and taverns, and it happened again when he walked by the house of [illegible name], selling brandy-wine near the pottery cross, and other times heard it said in public, without being able to say by whom, when said Verré was seen going by, "There is the dear chaplain who wants to do it from behind." Antoine le Jeune, his brother, having told him that being one time in bed with said Verré, Verré wanted to attempt such a vile deed on him and that he was forced to get up and leave him, said also that a certain soldier of the company of said captain Pousque, known as My Faithful One, now deceased, recounted to him that said Verré also tried to make a similar attempt on his person and that he tried to win some soldiers in similar ways.

15 February

Before me, the undersigned apostolic notary and clerk of the archbishop's court of Cambrai, appeared personally master Martin de Bun, priest, pastor of Cauroict, 64 years old, after taking a solemn oath in my hands, *on the priest's word and by his sacred orders, with his hand on his heart*, said, attested, and affirmed as true that twelve or so years ago now, master Jean Verré, priest, not then having any position in said Cambrai, having recently left the office of chaplain that he held in the parish church of Sainte-Croix, lived

for nine months or so in a room in the house that said witness inhabited, on the rue des Blancs Linceuls, and rented from the woman from the beguinage [establishment for lay sisters leading a religious life], during which time he saw and noticed that various young men, soldiers and others, consorted and conversed familiarly with said Verré, coming to drink, visit, and spend time with him, whom said witness knew only by sight. Which young men, soldiers and others, de Bun having been chatting with them, asked him how he could endure such a priest in his house, for he was not worthy of being a priest because of the foul deeds that he wanted to do with young men, meaning that said Verré wanted to commit the sin of sodomy, of which said Verré was then, at that time, strongly suspected and scandalous. Yet said witness could not specify other circumstances or say more about it, having said that much.

17 February

Master Antoine Hustin, priest, living in Cambrai, 50 or so years old, witness and called by the appointed provost of the archbishop's court of Cambrai to testify about certain excesses of master Jean Verré, priest, formerly chaplain of the parish church of Saint-Georges in said Cambrai, after the oath taken solemnly by him in the hands of Monsieur the reverend official [judge of the bishop's court] of Cambrai, in the presence of his undersigned clerk, *by virtue of priesthood and by sacred orders,* said that about a month ago now went to make his confession to said Verré, as also one other time [in margin: before], not being able to indicate the time precisely, only that said Verré told him that he was then *indeed suspended* and prohibited from hearing confessions, but only in the church of said Saint-Georges and not anywhere else. Indeed the deponent states that he saw Monsieur Roucheuil, canon of Notre Dame, perhaps three weeks ago, make confession to said Verré in the privileged chapel, and adding to this firm deposition says that this Verré asked him not to tell others that he had heard his confession and that of said sieur Roucheuil.

Master David Sauvaige, priest, pastor of Estrinnel and ex-priest of Rumilly, 33 or so years old, sworn, heard, and examined like the preceding witness, said and deposed that Isaac Hustin's wife, not remembering more about her name, who was formerly his parishioner at said Rumilly, now living on the rue Saint-Jacques, at the bakery and house on the corner of the rue des Bellotes, just before the post, [in margin: said and stated to the speaker's sisters] that said Verré wanted to induce Arnould Hustin, his son-in-law, and also Augustin Dontricourt, then engaged and now married to a girl from Clarry and living in this town, on the rue des Juifs or des Lombards, to commit the sin of sodomy, not knowing about it otherwise than by the report of his sisters, to whom said Isaac Hustin's wife declared what is above, so that the deponent would stop frequenting this Verré.

Master François Lefort, priest, chaplain of Monsieur the captain de Prouville, 44 or so years old, sworn, heard, and examined like the preceding witness, said that he saw master Antoine Hustin, priest, make confession to master Jean Verré on the eighth of last January under the clocktower of the church of Notre Dame in said Cambrai, also said that Aubert, servant at the mill of Clicotteau, who told him that he likewise went to Verré to make his confession since the last [illegible word]. Moreover this deponent says that he heard, on the third or fourth of said month, from the man who presided at the [illegible word] of the prayer chapel of Notre Dame, that said Verré and Monsieur Wagon, canon of said church, having entered the sacristy of said chapel, and that he believed that this Wagon went to

confess to him. Asked further about the life, morals, and behavior of said Verré, answered that about six years ago now that he learned from Olivier Wynts, enseign bearer of the company of Don Alexandre de Robles, that said Verré was mocked by the soldiers when he passed through the gates, because he asked some of them to sleep with him. Moreover, said that he learned from Denis Rolland, then sergeant and now enseign bearer of sieur de Prouville's company, about six years ago that the abovementioned Verré took his shameful parts out of his pants to show Jacques Gressiers, then soldier of said sieur Prouville's same company, and now militia clerk of the village of Esclouber.

Hubert Laurent, linen worker by trade, bourgeois of Cambrai, living in the town of Lombardes, in the parish of the Magdelaine, about 28 to 29 years old, after taking the oath, questioned and examined like the preceding witness, said and deposed that last summer, while walking on the ramparts toward the Saint-Georges gate and the sieur governor's peacock meadow, he met master Jean Verré, priest, who took him to drink at the tavern of the Virgin Mary on the rue des Clefs, where, while they were drinking and drank four mugs of beer, said Verré took the deponent's hand and put in in his fly, making him touch his shameful parts, which this man did again, two or three times on the way, having left the tavern and going home. Having arrived at said Verré's house, this man did the same thing again, asking him if he was to marry and if he wanted to sleep with him, and as this Verré was not satisfied, he similarly wanted to touch dishonorably said deponent, who would not let him do so, withdrew and left said house. Moreover, states that another day, having gone to drink a few mugs of beer with Henry Lange and others he did not know at the tavern of the Black Lion, this Verré came up, who, after having seen the group, he took said Lange to his house, which Lange stated the next day to the deponent that he had slept with said Verré at his request and that he had touched him dishonorably without having spoken to him about the sin of buggery, but showed them a breviary, high breeches, and other odd things that this Lange said he took from said Verré at his request, asking if he wanted to go have something to drink and that said Verré would pay for everything, which he did. These men having gone again to said tavern of the Black Lion, where they had said Verré called, who paid six to seven florins. That when they had spent on drinks at said tavern . . . and after having stated that Antoine Briné, master linen worker, living on the rue des Stages in this town, said to him that said Verré tried to do the same thing with regard to him.

Antoine LeJeune, resident of the parish of Saint-Vrast, living near Sainte-Elizabeth, mason, 30 or so years old, sworn, heard and examined like the preceding witness, said and deposed that about ten to twelve years ago now, he met master Jean Verré, who took him to eat at his house, and after having eaten pestered him to sleep with him, which he did. And having gone to bed, this Verré said to him, "Let's feel each other's buttocks," and indeed he wanted to touch the deponent indecently, which he did not want to let him do, so he turned away from him and immediately got to his feet and left his house, said Verré not having done anything else to him.

23 February

Arnould Hustin, married layman, bourgeois of Cambrai, linen worker by trade, living on the rue de la porte Saint-Sepulchre, 24 to 25 years old, after the solemn oath taken in the hands of Monsieur the reverend official of Cambrai, in the presence of the undersigned clerk, said that he is well and personally acquainted with master Jean Verré, priest, for

the past two to three years, during which time the deponent met said Verré several times in taverns, or having come with said Verré and others, on different occasions he pestered and requested the deponent to come eat at his house, then sleep with him, caressing said deponent as if and neither more nor less than if it was a young man courting a girl, to which, however, said deponent did not want to listen, that is to say sleeping with him. Although Verré gave him supper at his said house and pestered and asked him to sleep with him, and that when said Verré was chaplain of Saint-Georges and lived at Marie Pagnié's home, but he did not want to sleep with said Verré, so he withdrew from him, never having been touched indecently by said Verré, nor said Verré by said deponent.

Augustin Dautricourt, native of Rumilly, married layman, now bourgeois of Cambrai, linen worker by trade, living on the rue aux Beuches, 23 or so years old, after swearing an oath like the preceding witness, said and deposed that he had known master Jean Verré for about two or three years, nevertheless without having consorted with or spoken to him, or even having been in his company except for one time, which was just after the siege of Cambrai, master Pierre Dautricourt, canon of Monsieur his uncle having come to Rumilly to see and observe the damage.[9] And as he, the speaker, gave his said uncle something to refresh him in the presence of two of his brothers and brothers-in-law at the tavern of said Rumilly, said Verré dropped in, accompanied by master David Sauvaige, pastor of said place, who drank a few mugs of beer together, then they returned to Cambrai, and said deponent, being sick then, stayed in said Rumilly, not having accompanied them from there. Moreover said deponent stated and states that last summer he had been requested by said Verré to go drink with him, that he always refused, on certain pretexts of hindrances, not wishing to accompany him because there was bad talk going around about him, nevertheless not remembering from whom he heard the talk, to the effect that he took young men to sleep with him, which the deponent considered indecent, especially since he, having lived with his said uncle the canon, his said uncle always had two beds made up, so that they would sleep separately, judging from that that it was not fitting that a young man sleep with a priest.

4. Documents from the Papers of Marc René de Voyer d'Argenson (1652–1721), Lieutenant General of Police of Paris, 1698–1715

a. Murat[10]

29 September 1698

I had Madame de Murat warned, as it pleased you to instruct me to do, but, while showing some willingness to reform her ways out of respect for the king's orders, she seemed resolved to continue holding the gatherings that take place at her home almost every night with much immorality and scandal. I would still like to hope that a bit of reflection will make her more circumspect and submissive. I have taken steps to keep informed about it, and I will have the honor of letting you know about it.

6 December 1699

I have the honor of sending you the memorandum that it pleased you to ask me for, concerning Madame de Murat. It is not easy to describe in detail all the disorder in her conduct without offending the rules of decency, and it pains the public to see a lady of this rank living in such shameful and open immorality.

24 February 1700

The crimes that are attributed to Madame de Murat are not of a kind that can be easily proved by means of making inquiries, since it is a matter of domestic wickedness and a monstrous attachment for persons of her own sex. However, I would like to know how she would respond to the following facts:

A portrait perforated by several thrusts of a knife because of the jealousy of a woman she loved and left a few months ago to attach herself to Madame de Nantiat, another woman of the worst immorality, known less for the fines levied against her for gambling than for the disorderliness of her morals. This woman, living with Murat, is the object of her continual adoration, even in front of the valets and several pawnbrokers.

The abominable curses uttered while gambling and the infamous conversations conducted while eating, which Monsieur the count de Roussillon, now estranged from Madame de Murat, had witnessed.

Lewd songs sung during the night and at all hours.

The insolence of pissing out the window after prolonged debauchery.

Her audacious conversation with Monsieur the curé of Saint-Côme, as far from modesty as from religion. . . .

I will add that Madame de Murat and her accomplices are so feared throughout the neighborhood that no one dares to risk their vengeance.

I can even have the honor of telling you that she is punctually informed about all the orders that you do me the honor of giving me, such that she is always forewarned about their execution before I can take any step to implement them.

20 April 1700

I have made the king's intentions known to Madame de Murat, and I made use in this notification of all the discretion that could lessen its bitterness. She has promised to yield to them and has given me her submission to them in writing. I have even gathered from her remarks that her plan is to withdraw to a remote province, at the home of one of her friends, and there to forget Paris altogether. . . .

1 December 1701

On the subject of Madame de Murat, who is mentioned in this memorandum, I would add that she has returned to Paris after a week's absence, that she has made up with Madame de Nantiat, and the horrors and abominations of their mutual affection rightly make all their neighbors shudder.

You have done me the honor of telling me that the intention of the king is that the former be put in prison if she persists in disobeying, but I beg you please to name her prison and to allow me to inform you that this woman, unworthy of her name and her birth, is connected with persons of the highest rank and that she is five months pregnant. I believe, therefore, that it would be more just and more appropriate to agree with her closest relatives about the site of her reclusion, to have her taken there with some discretion, and to use all the more circumspection because all her actions show well enough that she would not be displeased if her delivery was hastened.

4 December 1701

I take the liberty of sending you a letter I received this morning, regarding the abominable conduct of Mesdames de Murat and Nantiat, who offer the public further spectacles every day. The writing in this letter appears forced, and one may readily suspect that the reconciliation of these two women has provoked feelings of jealousy or vengeance in the heart of a third, who formerly reigned over that of Madame de Murat, but the blasphemies, obscenities, and drunkenness with which they are reproached are not less true because of it. I therefore hope that it will please the king to use his authority to expel them from Paris or even lock them up if nothing else can be done.

11 February 1702

Madame de Nantiat has finally left for her province. . . .

Madame de Murat continues to distinguish herself through her outbursts and the disorderliness of her morals. She knows that the king has been informed about it, but she reckons that no religious community will be found bold enough to take her in. Indeed, I do not think there is a single one, and I could not have a good opinion of those that would be willing to take the risk. What, then, could be done with respect to a woman of this character except to shut her up in a remote chateau, where a hundred écus will suffice for her subsistence and for that of the oldest female servant that can be chosen?

Because she is afraid that the horror of her life will bring this order down on her, she pretends to be pregnant and adds that since her husband does not complain about her conduct, the public is wrong not to approve of it. Her poor husband, however, only remains quiet in order not to expose himself to the rage of a woman who has considered killing him two or three times, and the least strict people can hardly stand the abominations that she turns into a kind of triumph.

30 April 1702

I have learned that Madame de Murat writes, from the chateau of Loches, not only to her family but to the individuals who were most implicated in her debauchery. It seems then that it would be no less advantageous than just to deprive her of this general freedom, most of her letters being fit only to maintain her in her misconduct and to perpetuate her dishonor. . . .

b. Neel and Guillaumie

30 August 1701

For a long time, I have known said Neel to be a libertine and sieur de la Guillaumie to be a profligate, but I did not think that their morals had reached the excess of corruption that I just discovered.

The whereabouts of some seventeen- or eighteen-year-old youths, whom people worried about, having obliged me to have the houses watched where I had been assured that they had been seen, this investigation convinced me that sieur Neel had seduced them, and that after having put them to the most criminal uses for his own account, he had sold them to sieur de la Guillaumie, his friend, and some other scoundrels who have engaged in this vile traffic for a long time. Among them was named sieur du Mas de Saint-Venois, brother of the magistrate in the parlement who has been talked about so much, and I will try to find out everything about this abominable cabal, which cannot be prosecuted too zealously.

I had sieurs Neel and de la Guillaumie arrested, but the third man escaped me. The two prisoners could not keep themselves from acknowledging their crime, and the youths were found according to the directions that they gave me. . . .

Neel has often been accused of theft, and several commissioners have received complaints about it. . . . But his thefts could not suffice for his subsistence, and his disorderly temper did not confine itself to just one vice. There is not one vice that has not become familiar to him, even impiety.

Sieur de la Guillaumie, although of a more tranquil spirit and a more austere temper, is of no less disorderly conduct, but as he seems to be attached to only one kind of debauchery, the public acknowledgment that he makes of it renders him all the more scandalous. You will remember, no doubt, that I had him imprisoned last year for having sung licentious songs under the windows of the collège [secondary school] of the Jesuit fathers, and if, at that time, I had investigated all his actions more closely, it would have been easy for me to convict him of the same crime of which he has declared himself guilty on this last occasion.

You know that there was no less difficulty in handing these three accused men over to the rules of ordinary procedures than in concealing their debauchery. Therefore, I think that said Neel deserves to be transferred to the Bastille and left to be forgotten there, and that it would be merciful to exile sieur du Mas de Saint-Venois to Tulle for a few years. With respect to sieur de la Guillaumie, Monsieur the first president of the parlement of Rouen, his brother-in-law, and his brother, magistrate in the parlement, ask as a favor that he be shut up by order of the king in the monastery of the Brothers of Charity at Charenton, and they promise themselves to leave him there for a very long time.

c. PETIT AND LEBEL[11]

Commissioner Bizotin to d'Argenson, undated [1702]

Martin and his wife, who have a small furnished room on the rue de Seine near the [establishment named the] Galley, just informed me that for a month they have rented the room to a young man named Petit, about 25 or 26 years old, with a handsome face, who day and night receives and brings in several youths with whom he not only revels [during Lent] in meat and other things, but he also prostitutes himself to all the youths who come to find him in bed until 3 o'clock in the afternoon, when he gets up and gets dressed. Then they go to the public gambling houses to look for others, whom they bring back to spend the night at his place. That last night, there were six of them there, and they ate a loin of veal and a leg of lamb. That having noticed that their bed was completely spoiled and having complained about it to Petit, he threatened to have them killed if they spoke to anyone about it. That he was supposed to leave his room tomorrow and go lodge nearby, above the Galley. That this young man is much discredited because of his dissipation and that wherever he has lived he has been thrown out on account of his debauchery. That they have not been able to learn anything else about his origins or his family, except that he was from the Beauce and that he brags about it. That he was friends with a young man who claims to have the honor of being one of your relations or relatives, but we have not been able to learn his name. Since this information regarding this infamous profligate seemed very important to me, I believed myself obliged to tell you about it, while awaiting your orders, which I will carry out promptly.

Bizotin to d'Argenson, 19 March 1702

To carry out your orders, I just had Petit de Boution arrested and taken to Monsieur Aulmont's.[12] He told us that he is a native of Chevreuse, a farmer's son, that he has been in Paris for four years. From what I saw of his papers, which I found locked up in a round trunk, it seems to me that he was formerly valet to Monsieur de Gadagne, and I found a sealed letter addressed to Monsieur the count de Tallard, lieutenant general of the king's armies.[13] All of these letters are full of remarks that justify, moreover, the abominable trade to which he has devoted himself for a long time, and yesterday he supped alone with a man of rank who is strongly suspected of this disorder. His papers have been put back into his trunk, locked with a key, and the key returned to his possession, and the trunk entrusted to the hands of Monsieur Aulmont. I believe that if you would be so good as to examine this man, you will learn some horrible things about his trade.

Bizotin to d'Argenson, 22 March 1702

Lebel is a good-looking lad, handsome, a former lackey, and who now passes himself off as a man of quality.

This man is utterly debauched, and [missing words] it is a place where every day one sees young lads enter with men of quality and even monks, who spend whole days

engaging there in great debauchery, and it is said that the sin of Sodom is committed there with the worst license.

It is to be noted that two memorandums against this man have already been submitted regarding this debauchery, and that he was expelled from the parish of Saint-Sulpice and from there went to live behind the Capuchin monastery, in a house well suited to this kind of debauchery. . . .

Memorandum signed by d'Argenson, 2 June 1702

People with whom Lebel has committed the sin of sodomy.

He is 24 years old and a native of Paris. His father is valet to Monsieur de Chanlot, secretary of the late Monsieur the Prince, and he studied at the Jesuit collège until the second form, after having been a choirboy at Saint-Sulpice for 3 years.[14] Duplessis, the famous sodomite, who lives around Saint-Etienne-des-Grecs and walks around the Luxembourg gardens every day in order to seduce young schoolboys there, is the first who debauched him, and it was in this same garden that he listened to his infamous propositions. He was only 10 years old then, and since that time Duplessis had almost every day at his place a gathering of youths whom he abused in turn.

Duplessis procured Lebel to Coutel, who lives at the Palais-Royal and who is not only a sodomite, but an ungodly character.

Astier belonged to the same group. All three of them go to the Luxembourg gardens and to the billiard rooms at the place de Saint-Michel almost every evening in order to play games with young children, lure them to the cabaret or to their room, and commit the worst abominations with them there.

Since they have no property and live only from this practice, they hand over the youths they have debauched to people who pay them well, and they share the price for them among themselves.

Abbé de Villefort, who was in the B[astille] and then expelled from Paris for similar infamies, also knew him and procured him to Monsieur de Ch . . . , discharged colonel, who gave him a gold louis and claimed afterward that he was his soldier, but his friends got him out of trouble. He knew several other people whose principal occupation is to corrupt the young and make open traffic of them. Here are their names:

Monsieur Leroux, who lives behind the Madeleine church, bragged about it in his presence. The former sends handsome lackeys to lords in the provinces when he is asked for them and arranges the terms of their employment here. Comtois, cafékeeper, who has his shop on the rue des Bons Enfants near the Palais-Royal. Monsieur de Sancerre, from Montpellier, who lives on the rue Dauphine across from the hôtel d'Anjou. Monsieur de la Guillaumie, abandoned to all kinds of debauchery and confined under the care of the Fathers of Charity at Charenton by order of the king and the request of his relatives. Baptiste, who worked for Monsieur de Vendôme and took advantage of his trust for a long time, to the extent of boasting that he supplied him with youths and that he had been well paid for it.[15] Monsieur the abbé de Capistron, who is said to be entrusted with the same responsibility.[16] Monsieur the abbé de Larris, formerly of the Sainte-Geneviève quarter, the latter has an agreeable face and prostitutes himself. Abbé Lecomte, who was thrown out of the Saint-Magloire seminary, is a native of Paris, and has applied himself for a long time to attracting schoolboys in order to corrupt them. Abbé Dumontier, usual companion of abbé Lecomte and involved in the same trade. Abbé Bruneau,

who has several relatives in the robe [magistracy]. Abbé Servien, and it is said that he has a special residence in the Saint-Paul quarter that he uses exclusively for this purpose.[17]

Monsieur the duke de L. . . , who in the month of August 1699, being accompanied by a person of rank he did not know, asked him to come dine with them, although he never had spoken to him, which invitation he did not accept.[18]

Also knows that the people involved in this abominable trade arrange to meet at Livry's café, at the place du Palais-Royal, but does not believe that Livry is involved in the practice.

Has heard it said that the last ambassador from Portugal was of this taste and that he had in his service a tall page named Louis, whom he later made his gentleman and who, after the departure of the ambassador, owned a very showy carriage.

It was said then that Monsieur the duke de Lesdiguières loved this page and that he gave him lots of money, and he remembers that people talked about a ring worth a hundred louis.

The son of Alvarez and abbé Bailly, son of president de Maison's mistress, usual companions.[19] Robert or Gobert, valet of the duke of Orléans's wardrobe.[20]

Suspects the young duke d'Estrées of having this propensity and knows that he wanted to have a tall, very handsome lackey whom he met in the Jacobin church leave his position in order to enter his service, which gave rise to talk about it that evening in the Tuileries gardens, as about something that was as ridiculous as possible.[21]

In the past Father Armant, from Paris, a capuchin friar, was involved in these abominations. That was before he was a monk, and now his behavior is exemplary. He lives in the Saint-Honoré convent, and he was known in society under the name of Ville-aux-Bois [City in the Woods]. His uncle is Monsieur Amoing, court recorder for the Grand Conseil, and he is about to be ordained as a priest.

The respondant offers to expose the most secret intrigues of this kind in Paris, especially concerning the regents and tutors who corrupt the innocence of the pupils in their care, and in return he only asks to be imprisoned in Saint-Lazare, on bread and water, while waiting to be judged worthy of becoming a monk at Joyenval, which is a monastery of the Premonstrant order, in keeping with the vow he has made about it. Monsieur the abbé de Chartres is abbot of this abbey, where he was about to be received when he was arrested and brought to this fortress.

Pontchartrain to d'Argenson, 21 June 1702

I read to His Majesty the interrogation to which you subjected Lebel. He would like you to examine in depth and in detail all the troubles and abominations that he began to tell you about, by promising to have him sent to Saint-Lazare as he wishes. Work on this matter without delay, then, without worrying at all about anyone he might name. You know better than anyone how important it is to know more about what concerns regents and teachers who corrupt their pupils.

d. CHABERT DE FAUXBONNE

Aulmont the younger to d'Argenson, 20 April 1704

Abominable priest. Gillain, being at 3 o'clock in the afternoon on Monday, 28 April, on the parapet of the quai Neuf on the side of the Grève and watching individuals who were playing ninepins under the quai, in the spot where charcoal is sold retail, an individual with short hair and dressed like a priest in a cassock and long coat approached Gillain on the parapet and began to talk to him about the game. Then this individual asked Gillain if he was from Paris, if he was married, and if he had any children. Upon which, having answered that he was Parisian, married for three years, and had one child, the priest said to him, "What, to have only one child in all that time? What do you do with it?" And flattering Gillain, asked him if he would like him to take him to his room, that he would buy him a drink, that they would drink together. To which Gillain answered him that he did not have the time. Then this priest left him, and the next day, the 29th, at the same time, at 3 o'clock in the afternoon, the priest returned and attacked Gillain, who was again on the quai Neuf with the coalmen, and the priest having asked him to go drink some good beer, Gillain took him to his room, where they drank a pint of beer that the priest bought for 18 deniers, and then the priest suggested to Gillain that they both get in his bed and that he b[ugger] him from behind and at the same time pulled his private parts out of his fly and wanted to put his hand on those of Gillain, who pushed him away and told him that he understood what he wanted from him, but that he did not have the time, that he needed to go sell some wood on the ships, but that he should come back some other day when he would have more time, and they parted after having finished their beer, and the priest promised to come see him tomorrow or later.

Chabert, priest from the diocese of Dié, on Thursday, 8 May, about 6 o'clock in the afternoon, approached Simmonet on the quai Neuf, saying hello to him. Monsieur Simonnet, who was surprised, answered him, "I do not know you." However, Simonnet, who wanted to know everything about this priest, accepted as the truth the reply made to him by this priest, who responded to him that he knew Simonnet and that he had seen him on the rue Montorgueil. Conversation having been started, this priest asked Simonnet where he lived, and he answered him that he lived on the rue aux Fèves. This priest said to him, "Let's go to your room." Simonnet agreed to it. They both went to Simonnet's room, which is Monsieur Aulmont's attic, where there was still nothing but a table. This priest said to Simonnet, "You fool around sometimes with your friends. Now, would you like us to fool around with each other?" And at the same time he pulled his private parts out of his fly. To which Simonnet, pretending not to understand what this priest was trying to say, he told him, "I don't know, Monsieur the abbé, what you mean." This priest answered, "What do you mean? Don't you fool around sometimes?" Simonnet answered him, "Oh! I understand you, Monsieur the abbé, but I don't have the time today. We'll see tomorrow." And said to this priest, "What's your name, Monsieur the abbé, and where do you live?" This priest told him that he lived on the rue du Sépulcre, at the invalid Delaunay's house, that his name was de Fauxbonne, and that he said mass at Saint-Eustache.

The next day, Simonnet being in his room, this priest came about 4 o'clock in the afternoon, and, having entered, he said again to Simonnet, "Well, how about today?" But Simonnet having claimed that a man in the neighboring room could see them, told the

abbé to come back at 6 o'clock. The abbé left and came back at 6 o'clock, but not find-ing anyone home, he went away.

He has made similar propositions to several people, who are Gillain, bootblack, whom he only knows under the name of Claude; a journeyman carpenter living on the rue du Sépulcre; Deslandes, a journeyman wigmaker, whom he has only complimented. He does not say mass at Saint-Eustache as he said, but he says it at the Charité. He does not have his priestly papers. He has only promissions at the bottom of his certificates, which are sealed. Among his sealed papers, there is a draft of a petition to the king against his bishop.

e. REGISTERS OF DISORDERLY CONDUCT COMPILED FROM D'ARGENSON'S PAPERS[22]

Jean Baptiste Lebel, sent to Saint-Lazare on 14 January 1703,
 sent to Saint-Lazare [by virtue of a lettre] de cachet issued
 by Monsieur de Pontchartrain. He is a native of Paris, 25 years old,
 and of very low birth.

His father was the steward of sieur de Chanlot, secretary of Monsieur the Prince. This young man, wicked since childhood, after having completed his studies in a collège in this city and having abandoned himself to the most infamous prostitution there, ran a school of abomination and sodomy at his place. He is convicted of all his debauchery by his own admission, but, after having been in the Bastille for nine months, he asked with the greatest earnestness to be transferred to this house to do a bit more voluntary penitence here. However his soul still seems restless, which gives reason for fearing that his conversion is still very much in doubt.

I have even learned that since he has been at Saint-Lazare, he has given new evidence of his vicious and corrupt inclination, in spite of the protestations and oaths, repeated so many times, that he had used to deceive me. It is therefore now no longer for the sake of mercy that he should be kept in this house, but for the sake of justice and penitence.

He is not mentioned in the register of 1705. Thus it seems that he has left this house.

Sieur Léon Benoist Le Féron, native of Paris, sent to Saint-Lazare
 on 26 July 1705. . . .

His criminal abominations have been the main cause of his detention, but what is even sadder is that there is a note of impatience and open stubbornness in all his remarks that does not promise any repentance. I therefore cannot stop myself from putting him in the category of those incorrigible sodomites who are equally incapable of virtue, religion, and probity. I would only like Monsieur de Massan, magistrate in the Grand Conseil, who has been put in charge of all his property, to have his board paid punctually to the house of Saint-Lazare, where he is surely much better off than anywhere else, until it pleases God to change Le Féron's heart and to tear out of it the infamous passions that possess him more than ever.

In 1708. Monsieur the lawyer of Monsieur de Massan has finally paid for his board, and if the public interest desires that a man such as this one remain hidden away, the honor of his own family requires it still more.

Nicolas Victor Alvares, provost [local ecclesiastical rank] of Marisy
in the diocese of Soissons, 39 years old, native of Paris,
sent to Saint-Lazare on 4 October 1708. . . .

Habitual sodomy and his unfortunate inclination for seducing people's children in order to plunge them into vice and corruption have brought about the royal order by virtue of which he was conveyed to this house. And his most customary pastime was to roam the public promenades to engage in conversation with the young schoolboys he encountered there. He even spent a large part of the summer now in the Tuileries, now in the Luxembourg gardens, where some people who were watching him overheard him making remarks that inspired righteous horror.

In 1708. He has been set free by order of the king and instructed to leave Paris. . . .

Jean Maurice Dury, gentleman, native of Paris, 39 years old,
sent to Saint-Lazare on 10 October 1708. . . .

He was the usual accomplice and confidant of the abominations of abbé Alvares. They roamed the promenades together to find youths whom they seduced and made serve their passion. He now seems to have very favorable inclinations, and he promises not to frequent any company that might arouse the slightest suspicion against him.

Pesquaires, monk sent to the chateau of Bicêtre on 1 May 1702.
He is 50 years old, native of Pavia, imprisoned. . . .

A scandalous sodomite, who had debauched a young child and loved him with a frenzy. Nevertheless, he could be sent back to his country and ordered to stay there under penalty of disobedience.

Antoine Pedre, sent to the chateau of Bicêtre on 3 May 1702.

He is 12 years old, native of Spain, imprisoned. . . .
 It is this young child whom the monk just mentioned above abused so scandalously. He was born with a lot of intelligence, and we are trying to make him forget vice. But it is not yet time to let him go on faith, and it is at least necessary to wait until the monk who corrupted him has returned to Italy. It is written in the margin, freedom.

Martin Petit, sent to the chateau of Bicêtre on 19 April 1704, imprisoned. . . .

He is 30 years old, native of Boution in Sorest.
 He came from the Bastille, and he is a very unworthy subject. Sodomy has been the main occupation of his youth, and when the prostitution of his person became unprof-

itable for him, he prostituted others and provided himself with some revenue from it. Sometimes he wants to be a Carthusian monk, sometimes he asks to be a soldier, and he would be well suited for it except for the wicked habit by which he is possessed.

In 1705. I even think that he could be given to a trustworthy officer, while forbidding the officer to let him come to Paris, where it is to be feared the sight of his former friends might make him return to his previous debauchery.

It is written in the margin of this register, in the hand of Monsieur the count de Pontchartrain, make him a soldier in the regiment of Noailles, 31 May 1706.

Jacques Chabert, sent to the chateau of Bicêtre on 10 July 1704, imprisoned. . . . He is 30 years old, native of Valence in Dauphiné.

He is an abominable priest who has dishonored his priesthood by a public profession of sodomy and who, for the sake of the hospital, may nonetheless be sent back to his province on the condition that he withdraw to a seminary that his bishop will select for him.

It is written in the margin, in the hand of Monseigneur the count de Pontchartrain, all right on these conditions and find out about his behavior from the bishop.

Simon Langlois, sent to the chateau of Bicêtre on 25 April 1706, imprisoned. . . .

He is 24 years old, native of Paris. He was taken to the Bastille for sodomy. He was the companion in debauchery of Emanuel Bertault, also a lackey, and they held gatherings in the taverns of the Saint-Antoine quarter, where they committed the worst abominations. At these gatherings, Langlois was nicknamed Monsieur the grand master and Bertault the mother of novices. The latter is in the Hospital by virtue of a royal order limited to one year, which should not expire until 25 April of next year. But it would be quite fair, it seems to me, that a rogue of this kind could be set free only on the condition that he take his place in the army, where he would be suited to serve well if his courage corresponds to his height.

It is written in the margin, have him enlist and confide in the one to whom he is given.

Emanuel Bertault, sent to the chateau of Bicêtre on 25 April 1706, imprisoned. . . .

He was taken to the Bastille for sodomy. He was the companion in debauchery of Simon Langlois, who is number 43 in the present register, but this man is a bit less guilty. His term should come to an end in the month of January, and he has pre-engaged himself to sieur Rancher, captain in the regiment of Anguin, to whom he could be handed over at any time, if the king approves it.

It is written in the margin, set him free, expel him from Paris.

Guy Benoist de Charosts, cleric from the diocese of Clermont, sent to the chateau of Bicêtre on 10 September 1706, imprisoned. . . .

He is 28 years old, native of Morin in Auvergne. His lettre de cachet should expire next September.

A sodomite who, having been exiled to his homeland and having returned from it without permission, was taken to the chateau, where he tried to corrupt a young child of fourteen years. Therefore I will suggest that you lengthen the term of his penitence rather than shorten it.

And since retained, by a second lettre de cachet dated 16 January 1707, until further instruction.

He is worse than ever, unsubmissive and incorrigible, violent, who has neither honor nor religion, who seeks to corrupt his fellows even in the middle of their penitence, and who glories in all of his vices.

In 1709. He is sick with scurvy, more impious and unsubmissive than ever.

He died in the year 1709.

Nicolas Dumontier, sent to the chateau of Bicêtre on 30 September 1706, imprisoned. . . .

He is 34 years old, native of Paris, canon of Bray.

He is the infamous ecclesiastic, so well known among the sodomites of Paris, and about whom the archbishop of Sens writes in such unflattering terms. However, with his father, who is one of our best hay merchants, offering to pay for his board at Saint-Lazare and asking with the greatest earnestness that his son be transferred there, I think that we can grant him this favor.

It is written in the margin of this register, take him to Saint-Lazare, where his father will pay his board.

Jacques Chabert, sent to the fortress of the Bastille on 17 September 1707, imprisoned. . . .

He is 38 years old, a native of Valence, priest from the diocese of Valence.

He is a sodomite and an infamous type who has been locked up in the hospital for the second time. He was in the Bastille for a long time, expelled from Paris, then brought back to the hospital, where, Monsieur de Pontchartrain did me the honor of telling me in his letter of 17 September, he cannot be detained too long. He appears very docile in the house, but people of this kind are usually only all the more dangerous and suspicious.

In 1709. It even seems that for a few months his mind is a bit disturbed and his indocility much more pronounced. Thus, although dangerously ill, he stated that he scorned religion and the sanctity of his status.

In 1710. He has been completely cured for a few months, but his mind is only more disturbed.

In 1711. He still has the same inclination for libertinism and impiety.

In 1712. His impiety is getting worse and worse, from which I conclude that he must remain in the hospital for the honor of religion.

This priest is in the hospital for the second time, and he is involved in a suit against his bishop. He is a fractious character.

In 1714. I have just been assured that he now seemed much more docile and that he asked to write to Monsieur his bishop to ask his pardon for his past misconduct. I even believe that Monsieur de Pontchartrain will decide that there can be no difficulty.

In 1715. He has not yet received any reply to his letter, and I think that the only thing more favorable that he can hope for is that Monsieur his bishop be consulted again about what concerns him.

It is written in the margin of this register, write to the bishop of Valence, and, following this note, it is written, liberty, exile to Valence, 10 September 1715.

François Couret, sent to the chateau of Bicêtre on 25 December 1707,
imprisoned. . . .

He is 66 years old, native of Tauny, diocese of Le Mans, a priest with a degree in theology from the University of Paris.

He is an infamous sodomite who corrupted young schoolboys and who, on the pretext of tutoring them, took advantage of their innocence in order to prostitute them to other rogues. He has been banished four or five times without having been able to bring himself to leave Paris. It is again at the recommendation of Monseigneur the cardinal de Noailles that he is still interred at the General Hospital, where he had previously been among the ecclesiastical pensioners.[23] No subject is more hateful or unfavorable as this one, too well known and despised in his diocese. He decided to go to Rome, from which he was expelled ignominiously some time after the last conclave. I therefore think that one can only let him be forgotten in the Hospital or banish him, at least after five or six months, on pain of being brought back to Bicêtre for the rest of his days in case of disobedience.

In 1709. He is sick at this time with an unbroken fever and is in danger of dying.

In 1710. His name is François Pourret. He died in the course of this year.

Louis Guillaume Regnault, sent to the chateau of Bicêtre on 29 May 1708,
imprisoned. . . .

He is 24 years old, native of Pont Sainte-Maxence.

He is one of those infamous sodomites who have the audacity to prostitute themselves in the Tuileries gardens. When he was arrested by order of the king, he was found with a young lad who was brought to me and agreed that this wretched man had debauched him.

He would much like to become a soldier, and he could be set free on this condition, by adding to it express prohibition of returning to Paris.

It is written in the margin, fine with a reliable captain who watches over him.

He left by order of the king, by lettre de cachet, on 6 July 1710.

Edouard Joseph, known as du Quesnoy, sent to the chateau of Bicêtre
on 5 January 1712. . . .

He is 47 years old, native of Bassé in Flanders, tonsured cleric.

One of the most infamous sodomites, who had corrupted young schoolboys on the pretext of teaching them Latin. The priest of Saint-Jacques de la Boucherie and some ecclesiastics of outstanding integrity, having been informed about his abominable trade,

appealed to the king's authority to shut him up in the Hospital, where I think it is appropriate to leave him for another year.

In 1715. He died in the chateau of Bicêtre on 23 June 1714.

Jean Josse Brard, sent to the chateau of Bicêtre on 13 September 1712, imprisoned. . . .

He is 22 years old, native of Rennes in Brittany.

One of the most infamous sodomites, who was caught in flagrante delicto [in the act] by a guard in the Tuileries gardens named Hulmet, who had been recommended for observation of women engaged in public prostitution and youths who sought to corrupt others. This man was noticed several times walking around by himself in the most secluded areas with an unknown young schoolboy who could not be identified and whose name he never wanted to reveal.

The order that keeps him in the Hospital is limited to two years, and I do not think that anything in it should be changed.

In 1715. The time specified by his lettre de cachet has expired, and the reports given to me about his docility and the good use he has made of his penitence lead me to suggest setting him free, while exiling him to Rennes, of which he is a native.

Here is the answer given by Monsieur de Pontchartrain: Exile him to Rennes, notify the intendant [royal provincial official] to watch him.

He was released on 24 April 1715 and at the same time exiled to Rennes.

Nicolas du Hamel, sent to the chateau of Bicêtre on 7 December 1712, imprisoned. . . .

He is 78 years old, native of Paris.

Innkeeper in the Saint-Jacques quarter who gathered some of the most infamous sodomites at his place, he had debauched a young lad who, after having acknowledged his crime, embraced the ecclesiastical life, in which he conducts himself with edification.

I believe nonetheless that this man, being quite old and seeming docile enough, could be released from Bicêtre, especially since the time specified by his lettre de cachet has expired and he himself suggests withdrawing to Normandy, close to his son, who, he says, has some property.

He has been set free by order of the king in the year 1715.

Pierre Bouticourt, sent to the chateau of Bicêtre on 29 November 1713. . . .

He is 36 years old, native of Paris, one of the most insolent and most dangerous sodomites, who applies himself especially to corrupting young schoolboys and young lackeys in order to procure and sell them for as much as he can. If he were not a native of Paris, he could be exiled to his place of birth, but since he is Parisian, it seems that his alleged repentance needs a longer trial.

Here is the answer given by Monseigneur the count de Pontchartrain on 10 September 1715: Freedom on 10 October 1715.

Charles Maurice du Bois, sent to the chateau of Bicêtre on 21 June 1714. . . .

He is 30 years old, native of Besfors in Haute-Alsace.

He is another sodomite and a corrupter of youths, whose birth and family are equally unknown, although he says he is a tonsured cleric from the diocese of Besançon. He was heard making the most obscene remarks to a young lad whom he had lured into one of the most out-of-the-way places in the Luxembourg gardens. He has been a prisoner several times, and the prisonkeeper of For-l'Evêque warrants that he had tried to corrupt a young child in the prison who was assigned to his service. I have even learned that his debauchery has become known at the Hospital, where they have yet new evidence of his abominable inclination, such that they were obliged to put him in a private room, where he is alone. I therefore do not dare recommend his release yet. The response of Monseigneur the count de Pontchartrain in this matter was that he should be freed and expelled, on 10 September 1715.

Sieur Jean François de la Guillaumie, sent to the hospital of Charenton on 27 September 1701. . . .

He is a native of Paris, more than 30 years old. His brother is a magistrate in the parlement and of noted wisdom, but this one has abandoned himself to the most infamous disorders, for it may be said that habitual sodomy constituted his only occupation and even his only concern. He was deprived of the management of his estate by judgment of the Châtelet and confined to this house once before, but all these remedies could not correct his heart or rectify his reason. His guardian is the secretary of Monsieur his brother, and he claims that his income amounts to more than ten thousand livres, but that is usual for persons of this sort, presuming much about their property, their innocence, and their wits. This one, however, remains in agreement about all his faults (which is rather rare), but he believes himself wholly corrected and almost faultless, which is not as certain as he claims. There is no subject in the houses of correction about whom it seems so difficult to me to take his side. For if it were necessary to treat him like a man who is in full possession of his reason, he would deserve the worst punishment, and he cannot be placed in the category of madmen without wronging his mind, which is certainly intact. He swears that he will never live in Paris and that he wants to serve the king in his armies, but men of this character are not less dangerous in war than in cities, and it is to be feared that if he is not recovered from his abominations, it will give him a chance to surrender himself to them more and more and to corrupt a multitude of youths. It seems then that he must still prove his conversion by a trial of a few months and that it would be imprudent to trust the assurances he will give of it.

In 1705, I still find myself in the same uncertainty with regard to him. . . .

He was set free in 1705.

Sieur Le Féron, 46 years old, native of Châteaudun, sent to the hospital of Charenton on 9 October 1712. . . .

He was previously confined in Saint-Lazare for his infamous life and abominable sodomy. As soon as he was freed, he returned to his previous abominations, such that, in the month

of August 1712, I was obliged to have recourse again to the authority of the king to have him confined in the Hospital, and Monsieur de Pontchartrain signed at that time an order by virtue of which he was taken there, but his family, informed about it, begged Monsieur de Pontchartrain to grant them an order to have him transferred from Bicêtre to this house, so that he would be fed and kept in a manner more appropriate to his birth. They nevertheless gained this favor only on the condition that his board there would be paid punctually and that he would not be kept at the king's expense. I have learned that his board has been very well paid for and that he seems tranquil enough, although he at first gave evidence of his criminal inclination, which has made it necessary to deny him any company. Therefore, I believe that we cannot free him without exposing him to the same scandal that led to his imprisonment twice before.

In 1714. I have learned today that he has been a bit calmer for the last five or six months, due to the lack of opportunity for misconduct, but that having found an opportunity a few days ago, he had again abandoned himself to the immorality of his corrupt inclination. I therefore believe that his penitence requires a longer test.

The response of Monseigneur the count de Pontchartrain in this matter was that he should be freed on 10 September 1715 and to watch him closely.

5. Documents from the Archives of the Bastille, 1706–50[24]

a. LANGLOIS AND BERTAULT

1 March 1706

Simon Langlois, lackey of Madame de Marsac, residing in Paris, imprisoned in the Bastille on 24 February 1706, freed on 21 April.

Emanuel Bertault, called La Brie, lackey of Monsieur Portail, residing in Paris, imprisoned in the Bastille on 24 February, freed on the 21st.

Accused of holding gatherings under the guise of a kind of order in which they received all the young lads who wanted to join it and took women's names, got married to each other. The places where they held these gatherings were ordinarily the taverns of the Cauldron on the rue Saint-Antoine and the Frank Burgundian on the rue Saint-Nicaise, where, after having drunk to excess, they committed the sin of sodomy. They performed certain ceremonies for the reception of the proselytes and had them take an oath of fidelity to the order.

12 March 1706

Interrogation by order of the king, conducted by us, Marc René de Voyer de Paulmy, chevalier, marquis d'Argenson, councillor of the king in his councils, maître des requêtes de son hôtel [a former magistrate in one of the royal sovereign courts who served as a deputy to the chancellor and member of the royal council], lieutenant general of police

of the city, provostship, and viscounty of Paris, with one Langlois, prisoner by order of His Majesty, in the chateau of the Bastille.

On Friday, 12 March 1706, in the afternoon in the hall of said chateau.

After the oath sworn by him to tell and answer the truth, asked about his name, age, religion, status, origin, and residence.

Said he was named Simon Langlois, 29 and a half years old, of the Catholic, Apostolic, and Roman faith, lackey of the widowed Dame de Marsac, in whose service he has been for almost fifteen years, native of this city, and that he was living on the rue Saint-Honoré when he was arrested by order of the king.

Submitted to him that by the penultimate entry of his previous interrogation, he admitted that being at the cabaret of the Frank Burgundian on the rue Saint-Nicaise, he had one Lebel kneel down. And asked to tell us if said Lebel, in this state, did not promise him, the respondant, to be faithful to his order and to follow its laws diligently.

Said that one Lebel, having kneeled, the respondant asked him if he didn't want to renew his vows and remain faithful to the order, to which said Lebel, who held a candle in his hand, having answered yes, those who were at the gathering, numbering ten or eleven, approached him and offered their hands to the candle he was holding and began to drink.

What the respondant meant by this renewal of vows.

Said that he meant that said Lebel would continue to belong to their order.

Of what number this order was composed.

Said that there was not a fixed number.

If since his last interrogation he did not remember the names of those who composed this order.

Said that he remembered them and that they are the men named La Brie, Alexandre, Desalois, Lebel, Desquais, Dudart, and Chevalier, named and described in his previous interrogation, and also the men named Garangé, lackey (the respondant does not know in whose service); Flamand, lackey of Monsieur S. de Gond-Dargentine, magistrate in the parlement; Gouvray, wigmaker; Lambert, lackey of Monsieur the marquis de la Carche; Babot, son of a wine merchant; a friend of said Deshayes who wears green livery; and another of Dudart's friends, and the respondant does not remember the names of these last two or of some others who were ordinarily brought by some of those named above.

If said Lebel having told the respondant that he indeed wanted to renew his vows and remain faithful to the society, he, the respondant, did not recite a model prayer over said Lebel, who remained on his knees throughout this time.

Said no.

If he did not make several signs of the cross with his hand over said Lebel and then have him kiss a diamond cross.

Said that he did not recite any prayer or orison and did not make any sign of the cross over said Lebel, that is is true that he had him kiss two clusters of fake diamonds in the shape of roses that were held together and were to be placed on the respondant's hat when he went to the ball.

Said no and that said Lebel, having sworn to the respondant and to the others that he wanted to be in their order, this respondant, who knew him to be given to sodomy, told him while laughing that he then needed to renew his vows.

How he, the respondant, knows said Lebel.

Said that he had known him for more than ten years and even knew his father and mother, who kept an inn on the rue des Fossés de Monsieur le Prince.

How he knows that said Lebel is given to sodomy.

Said that when said Lebel was arrested four years ago, the rumor circulated among people known by the respondant and by Lebel, that it was on account of the crime of sodomy, and, indeed, the respondant not having been informed about it from Lebel since his release from Saint-Lazare, said Lebel confirmed to him that it was for this reason that he had been arrested.

If said Lebel, since his release from Saint-Lazare, has not been to the gatherings that the respondant held.

Said that he was there three or four times.

If when he wanted to receive someone into this society, he does not perform the same ceremony that he had performed with regard to Lebel and give them a woman's name.

Said that he does not perform any ceremony except to put his hands on their shoulders in embracing them and having them kiss two diamond roses as if it was a cross, and he gave them women's names.

If he had not received several of them.

Said that he received another, named Dudart, and two or three others, whose names he does not remember now.

If he did not perform marriages among them.

Said that he does not perform any marriages, that it is true that on mid-Lent day last year, fifteen of them being assembled at the tavern of the Cauldron, several of the group put bouquets in the respondant's wig, saying that a marriage must be performed between him and one La Brie, nicknamed Madame de Saint-Antoine in their society, and immediately led this respondant (nicknamed Madame the General in this society) and said La Brie into a room next to the one where they were gathered, telling them that they had to go consummate the marriage in this bedroom, in which they shut them up. And they made noise at the door, saying that it was the charivari [noisy mock serenade for newlyweds].

If he, the respondant, or someone else in the group, did not perform some ceremony concerning this alleged marriage.

Said no.

If he, the respondant, and said La Brie were shut up in this room for long.

Said that they only stayed there for a moment, the door having been opened almost immediately.

If in this room they did not commit the infamous and abominable crime of sodomy.

Said, after repeating the oath, no and that there was not even any touching.

Represented to him that he is not telling us the truth and that we know for sure that infamous things happened between said La Brie and him.

Said again that he never committed the abominable crime with said La Brie nor with anyone else, that it is true that having gone one morning to see said La Brie, and who was in bed and had taken medicine, they touched each other.

If at these gatherings those who were there did not prostitute themselves to each other before or after having drunk together.

Said no, that it is only true that when they were at the table, they touched each other, but it did not seem like much because they passed their hands under the napkins.

If they did not have a gathering at the Cauldron about four months ago.

Said that they had one around that time.

If at that gathering they did not touch each other and he, the respondant, did not climb onto a tackle that was over the door of the room they were in.

Said that he does not know if anyone at all was touched at that gathering and that it is true that he climbed onto the tackle that is in the room.

If at that gathering there was not an individual dressed in a brown outfit trimmed with copper buttons and red facings, with light brown hair and an embroidered hat.

Said that this individual was at the gathering.

What is this individual's name and if it is not Lebel who brought him to that gathering.

Said that this individual is named Dolé, is a lackey, from what he sees without a job, and that it is not Lebel who brought him to that gathering because he was not in Paris then, having only arrived there from Rouen three months earlier.

How old said Dolé is and if he did not climb up on the tackle with the respondant.

Said that he seemed to be 18 or 19 years old and that he did not climb up on the tackle with the respondant, but it was one La Brie, a young lackey who was friends with said Deshayes.

If the respondant did not commit the abominable crime of sodomy with this young man on the tackle.

Said no and that they only touched each other.

If he knows one Champagne, who has lived at Monsieur Paparel's for a while.

Said that he knows that he is friends with Dudart and that he is one of those names he does not remember; that this Champagne only came twice to the gatherings that they held, to which he was brought by Dudart.

How old is this Champagne and if he is not one of those with whom he, the respondant, committed the abominable crime of sodomy.

Said no and he only touched him.

If he did not also commit this same crime with said La Brie, Lebel, Desalois, and others.

Said that he did not commit this crime with anyone and that he only touched them.

If he had not chosen said La Brie and one Alexandre to be the henchmen of his supposed generalship.

Said no.

If said Alexandre was not nicknamed Manon of the Luxembourg at these gatherings.

Said yes and that it was a name that he gave himself.

If this name, Manon of the Luxembourg, was not given by the respondant to said Alexandre because he went to the Luxembourg gardens in order to try to prostitute himself.

Said that it is not he, the respondant, who gave this name to said Alexandre and that he does not know the origin of this name.

If he, the respondant, did not commit the abominable crime with said Alexandre and does not know that said La Brie and Desalois committed the same crime with him.

Said that he did not commit this crime with anyone, that he had only touched said Alexandre once and does not know if anything happened between said La Brie, Desalois, and Alexandre.

If he does not know one Vaudeuil.

Said that he knows that he is Monsieur de Gaumont's lackey, who has only come to their gatherings twice, which Vaudeuil he only touched once.

If he, the respondant, said La Brie, and others of their society have not prostituted youths to their masters and others.

Said that he has no knowledge of it. States only that he had been told that Lebel and Dudart engaged in this infamous trade.

If he does not know that Lebel had a bedroom at the home of widow Dudart and he and Dudart, son of this widow, prostituted lads, among others this Champagne, to [illegible name].

Said that Lebel had a room at the widow Dudart's and that he saw said Champagne in this room several times but does not know what they did.

Reading of the questions and answers to the respondant completed, said that his answers contain the truth and persisted in them and signed.

15 March 1706

Interrogation by order of the king, conducted by us, Marc René de Voyer de Paulmy, chevalier, marquis d'Argenson. . . .

On Monday, fifteenth day of March 1706, in the afternoon in the hall of said chateau.

After the oath sworn by him to tell and answer the truth, asked about his name, age, religion, status, origin, and residence.

Said he was named Emanuel Bertault, nicknamed La Brie, 34 years old, of the Catholic, Apostolic, and Roman faith, lackey to Monsieur Portail, gentleman, native of Villier-sur-Marne, and that he was living at the home of said sieur Portail on the rue Saint-Antoine, in whose service he has been for eighteen years, when he was arrested by order of the king.

If he knows one Langlois, Alexandre, Lebel, Desalois, Desquets, Deshayes, and Dudart.

Said that he only knows Langlois, Alexandre, Desalois, and Deshayes but does not know said Lebel, Desquets, and Dudart, that said Langlois is Madame de Marsac's lackey, Alexandre, Madame de Villars's lackey, Desalois, the abbé de Verneuil's lackey, and said Deshayes, maître des requêtes Dangouges's lackey.

If he has not been at certain gatherings that were held with these individuals and others.

Said that he has, unfortunately for him, known said Langlois for two years, that he has been to nine or ten gatherings that were held at the cabarets of the Cauldron on the rue Saint-Antoine and the Frank Burgundian on the rue Saint-Nicaise.

Why he says that he knew said Langlois "unfortunately."

Said that it was because, not having ever been to any gathering, said Langlois urged him to come to those he organized.

Of how many people the gatherings were usually composed.

Said that they were sometimes composed of eight and sometimes ten or twelve youths, among whom were the abovementioned.

Asked to tell us the names of the others who were at these gatherings.

Said that there was one LaFrenaye, lackey of a provincial man whose name the respondant does not remember, one Fribourg, also a lackey, the respondant does not know of whom, two wigmakers unknown to him, but he believes they are known to Langlois.

Who organized these gatherings.

Said that he believes that it was Langlois, because a few days before these gatherings, he came by the respondant's residence and let him know to be at the Cauldron or the Frank Burgundian on the day he mentioned to him.

If at these gatherings said Langlois did not take the name of Madame the General.

Said yes.

If the respondant did not constitute with said Langlois and those abovementioned and others a kind of order, to which chevaliers came and in which he gave them women's names.

Said that he does not know anything about that.

If at these gatherings he did not take the name of Madame de Saint-Antoine, Alexandre that of Manon of the Luxembourg, and Deshayes that of the countess.

Said that it was true that they took these names, but without consequence, and only because they held a ball at which each dressed differently and they took names appropriate to their costumes. The respondant adds that they only held one ball, which was about two years ago, at the tavern of the Cauldron.

If he does not know that said Lebel was at these gatherings that took place at the Cauldron and the Frank Burgundian.

Said that he remembers having heard said Lebel named at these gatherings and even believes that he saw him there but is not completely sure about it.

If at these gatherings, said Lebel did not take the name of the countess, Desalois that of Manon, and one Saulnier, who is a sculptor, that of Margot.

Said that he only remembers that said Desalois took the name of Denise, that he does not know what name said Lebel took, and that with regard to said Saulnier, he was not at their gatherings and only came once with his wife and his son.

How old is Saulnier's son.

Said that he could be 12 or 13 years old.

If they, said Langlois and he, the respondant, did not lure this young child to their gatherings.

Says that said Saulnier's son had never come there except on the day that he came with his father and mother, with whom he went away.

If he does not know why said Langlois took the name of Madame the General.

Said no and that he does not even know on what occasion he took that name, because during the ball they held, he was dressed in Spanish style.

If they did not hold a gathering at the tavern of the Cauldron about a year ago, at which there were twelve or fifteen people.

Said otherwise that he can remember they held one around that time, at which there were twelve or fifteen people.

If after having drunk, they did not touch each other indecently.

Said that it is true that indecent things sometimes happened at these gatherings but did not believe that it could be of any consequence.

What were these indecent things that took place at these gatherings.

Said that it was putting your hands in other people's pants and saying silly things.

If in the month of December last, a gathering did not take place at the tavern of the Frank Burgundian.

Said yes.

If said Alexandre and he, the respondant, were not the confidants of said Langlois and if he did not nickname them henchmen of his generalship.

Said that said Alexandre and he were good friends of said Langlois, who sometimes told them that they were his henchmen or something to that effect.

If at this gathering that took place at the Frank Burgundian said Lebel was not there.

Said that he remembers that Lebel got there very late.

If said Langlois did not tell said Lebel that he needed to renew his vows and if, in order to accomplish it, said Langlois did not go to get a candle, which having been lit

and placed in said Lebel's hands, said Langlois did not have said Lebel repeat the words that follow: "You promise before God always to remain faithful to our society and to observe its laws and this secret strictly."

Said that he knows nothing about it because Lebel came late and that he, the respondant, had to go get his master. He went away and left them all in the tavern.

If said Langlois did not have him, the respondant, make a similar vow when he was admitted to this society.

Said no.

If he had seen this done to others in the same manner.

Said no.

If these gatherings were not composed of a fixed number.

Said no.

If one Babot, Beranger, and Flamand were not at these gatherings.

Said that he saw one Beranger, who is a lackey dressed in green but the respondant does not know of whom, once; said Babot, son of a wine merchant, twice; and said Flamand, who went there those last days before Lent dressed in costume because they had violins there.

If he did not know that said Lebel had been arrested before.

Said that someone told him that Lebel had been in Saint-Lazare, but he was not told the reason for which he had been there.

If he was not told at the same time that it was for the crime of sodomy and why, if he learned such things about him, he frequented him.

Said that he never knew the reason for which he had been arrested.

If it was not said Langlois who was the leader of the group and if in this capacity he did not receive those who wanted to join it.

Said that said Langlois made himself like the master of this group through his stubbornness and because he was feared, but that he, the respondant, did not see him receive anyone, everyone being welcome there for his money.

If they perform marriages among them.

Said no.

If he, the respondant, and said Langlois did not take each other as husband and wife at a gathering that took place on mid-Lent day of last year.

Said that it is true that they had a gathering on that day at the tavern of the Cauldron, at which said Langlois told the respondant that he had to marry him, to which the respondant paid no attention and only told said Langlois that he was making fun of him.

If those who were at the gathering did not lead him, the respondant, and said Langlois into a room next to the one they were in, saying that their marriage needed to be consummated.

Said that those who were at the gathering pushed him and said Langlois into a room that they all entered and which the respondant left immediately, telling said Langlois that they would be husband and wife together and does not remember that anyone at the gathering told him that the marriage needed to be consummated.

If he did not stay shut up in this room alone with said Langlois and if while they were there, those at the gathering did not come to the door to make noise, saying that it was the charivari.

Said that said Langlois stayed alone in the room, which always remained open, and that it is true that several of the group made noise but does not know why.

If in this room said Langlois and he, the respondant, did not commit the abominable crime of sodomy.

Said, after repeating the oath, no.

If infamous things did not take place between him, the respondant, and said Langlois. Said no.

If one morning when the respondant had taken medicine, said Langlois did not go to see him in his room, and they touched each other and did other infamous things.

Said no and that he has not taken medicine for more than twelve years and that it will be confirmed by his masters.

If at a gathering that they held about four months ago at the Cauldron, they did not touch each other and commit other infamies.

Said that he does not know that gatherings were held at the Cauldron at the time, he, the respondant, being in the country then and consequently could not know what happened there.

If he does not know one Dolé, a lackey, and if he did not go to these gatherings.

Said that he does not know him and that others unknown to him sometimes came.

If one day when they were gathered in a room at the tavern of the Cauldron, he did not see said Langlois climb onto a tackle with said Dolé.

Said that he remembers having seen said Langlois climb onto a tackle, upon which a lad named l'Eveillé, 20 to 22 years old, whom the respondant does not know, also climbed.

If he did not know that said Langlois committed the crime of sodomy with this young man on this tackle.

Said that this is not possible because they were both seen from all sides, that said Langlois only did some good roguish tricks on this tackle, and that with regard to said l'Eveillé, he only climbed up and down without stopping there.

If he, the respondant, was not nicknamed Madame de Saint-Antoine at these gatherings.

Said yes and that this name was given him by an individual named Piller, who is a shopkeeper's assistant on the rue Saint-Honoré.

If this named Piller did not also belong to said group.

Said no.

Reading of the questions and answers to the respondant completed, said that his answers contain the truth and persisted in them and signed and initialed each page with us.

b. VIEUXVILLE

11 July 1723

About nine o'clock in the evening, strolling in the Tuileries gardens, in the pathways where sod[omites] usually go, abbé de la Vieuxville, after having walked around me several times, approached me while speaking to me, telling me, "I see you here every evening. If you want to come with me under the yew trees, for there's no staying here because the moonlight is too bright and there are too many people around, I will f [uck] you, and I will give you two écus worth 15 livres. I know that you are of this taste because I see you here every

evening. So why are you having scruples about coming with me?" And at that moment taking his c[ock] out of his pants, telling me, "Look, I've got a nice one." And as he was making these infamous remarks to me, abbé Choiseul came up, who said to abbé de la Vieuxville, while approaching us, "Are you going to f[uck] this young man," speaking about me. "If so, you are very lucky, for I have been propositioning him to do it for more than ten years, and I do it every day, without his ever having been willing to agree to it." To which abbé de la Vieuxville said to him, "Go f[uck] off," and abbé de Choiseul told him, "I don't want to interrupt you, but I would like to have a word with him." And at that moment, abbé Choiseul, having led me away from abbé de la Vieuxville by a distance of two trees, turning toward me, untying his pants and showing me his c[ock], he tells me, "Grab it, then. It will soon be done, while nobody's around and you will go rejoin abbé de la Vieuxville," showing me some money to give me if I had been willing to consent to his infamous desires. Having said to him that I didn't want to do anything because it was too light, there were too many people around, and it wasn't safe enough in said garden, to which he said to me, "Tell me, then, where you want me to see you." I told him, "Wherever you want," and he told me, "Tuesday, when the opera lets out, be in the courtyard of the kitchens of the Palais-Royal, at the gate into the rue des Bons Enfants. The first to arrive should wait for the other." Then he left me, telling me, "Don't fail to show up. I want to f[uck] you, and I will give you what you want." And having left him, abbé de la Vieuxville rejoined me, telling me, "Don't fool around with that f[ucking] abbé Choiseul because if you were seen with him, you would soon be known, for he is the biggest b[ugger] in Paris. So come with me," he told me three or four times, while pulling me by the sleeve. "I won't f[uck] you, but we'll jerk each other's c[ock] off." I told him, "Enough, then, Monsieur the abbé. There's a frightful lot of people around here." To which he said to me, "Then tell me where you want me to see you. Don't you know a tavern that's convenient," to which I told him no. Holding his c[ock] out of his pants, and wanting by all means to grab mine, wherefore I left him, and he called me back, saying "Be here one of the last three days of the week. I'll come here all of those days, and I'll take you to a place where we'll be safe," and I left him.

c. UNNAMED

10 January 1724

Being under the Saint-Louis arcades about five weeks ago, I saw an individual, a lackey there, about 45 years old, of medium height, wearing a brown wig, dressed in yellow livery with blue facing on the sleeves, whom I know lives near the Saint-Michel gate, whom I saw looking for sex under the arcades with the first comer. And being under said arcades on the tenth of the present month of January, I was picked up by said individual, who had his c[ock] in his hand and asked me if I was h[ard], and getting close to me tried to put his hand in my pants. Having told him that we shouldn't expose ourselves in this spot, he asked me if I had a room, where we could go jerk off our c[ocks] or butt-fuck each other. He also told me that he had been involved in bardashery for more than twenty years and that he knew lots of lackeys with whom he fooled around very often, jerking off their c[ocks] or butt-fucking each other as they wanted, but that he was careful when he fooled around, which happened very often. And then led me into one of the rooms

of the Palais [de Justice, where the parlement met], where his master was, telling me that if I wanted to be under said arcades the following day at eight thirty, we would go to my room to fool around, which I accepted, and the following day, the eleventh of the present month, being at the rendezvous, said individual showed up there, and, in coming up to him, I said that I had come not to break my word, but that a matter had come up that prevented me from taking him to my room, and he said that we'd see each other another time, and I left him.

d. DUBOIS

20 April 1724

Robert Dubois, called Duhamel, native of Avranches, married man, 36 years old, unliveried lackey, in the service of dame Chambret, living on the rue de Sépulchre at the hôtel des Asturies.

Said day, the twentieth of the present month, having gone down under the Saint-Louis arcades to go to the bathroom, I found said Dubois, who was strolling there and took to watching me. And after having struck up a conversation together, he told me that he recognized me for having seen me last autumn under said arcades, that he had even made arrangements with me once to go fool around at Vaugirard, but that he had been unable to go there, upon which, having told him that I would reschedule the rendezvous whenever he wanted, after which he told me that he had had a good time under said arcades, that he had been there with sieur Tambonneau, that he had jerked off his c[ock] and had made him shoot, that he had kissed said sieur Tambonneau's c[ock], that he had never seen one finer and larger. He showed me the spot where one went up to fool around under said arcades. He also told me that he had been with an abbé, that the abbé had put it in his mouth and that he had felt it all the way at the back of his throat, that this abbé really liked to shoot in his mouth, that he liked to be f [ucked] more than f [ucking] because he had once caught a fever while f [ucking], that he believed that it was the clap and that he f [ucked] even though he knew very well that the disease that one catches from men was more difficult to cure than that one catches from women, but that if I wanted to have nothing to worry about, that the way was to withdraw from the a[ss] immediately after having shot, not to stay in there. And in order to alert sieur Simonnet, I sent this infamous type to wait for me on the quai de Conti, where, having gone to rejoin him, he told me that he was the lackey of a lady and lived in the Marais, and later he told me that one needed to look out for oneself. And having asked me to go to my room to fool around, while going there and passing in front of commissioner Parent's, said Duhamel was arrested by order of the king by sieur Simonnet and taken to the Petit Châtelet, past five o'clock in the evening.

[in margin:] Tamb[onneau] and the abbé deny knowledge of him. Freedom on 2 May 1724.

To Monseigneur, the lieutenant general of police,

Monseigneur, Mathurine Julienne Pomier, needlewoman, very humbly represents to your lordship that last Thursday, the twentieth of the present month of April, sieur Simonnet

had arrested between six and seven o'clock in the evening Robert du Bois, called Duhamel, husband of the petitioner, servant staying for six years in the service of Madame de Chambret, canoness, on the fantastical notion of an accusation of sodomy. The petitioner, who has been married to him for 22 years and had nine children with him, the lady in whose house he has stayed during that time, and the honest folks, male and female landlords of the petitioner and her husband, the prisoner, undersigned, will certify that this man has always conducted himself with all the integrity and respect possible, living a decent and moral life. With regard to herself, the petitioner hopes that you will be willing to give her back her husband, who even helped her for more than a year to cure her of a bad sickness in one arm. This tearful petitioner, this brokenhearted wife, this mistress alarmed by the loss of such a good servant, finally all the neighbors distressed by this disaster appeal to your lordship's justice to grant him freedom, and the petitioner and her husband will offer their wishes for your lordship's prosperity. 15 signatures.

13 April 1728

Being on the quai des Orfèvres about four o'clock in the afternoon, I was accosted by one Duhamel, Madame the canoness de Chambret's lackey, living on the rue de Taranne at the hôtel de Savoie, who was leaning over the parapet to watch some fishermen. And as one of the fishermen had caught three fish with one throw of the line, said to me, "Monsieur, there's a good throw," upon which we struck up a conversation. And he asked me who I was. I told him that I was from Provence, that I was here with a young nobleman from there, that we usually stayed in Lyon, and that we only came to Paris every year to spend two months. He told me that, as for him, he worked for a canoness with whom he has been for eight years, that he was perfectly fine there. Then he came to tell me that he had been in Brittany, where he had had a really good time, as much as in Rouen, that you could fool around freely there because there were no spies, whereas in Paris, there were spies to be feared, the spies of Simonnet. Having asked him who these spies were, he told me that they were people who pretended to be in on it and were not in on it, and who had you arrested. Then he told me that under the arcades that were there on the bank of the water, people held some fine parties. Having asked him how one got there, he told me that it was when the water was low, that he went down there sometimes to try to find someone who gave him pleasure. He also told me that he had once found himself with a capuchin friar, that they had shown each other their c[ocks] several times, that he had never seen such a fine one, and that he had really enjoyed him, that he had jerked him off three times and that he had made him shoot, that each time this capuchin shot, he wiped himself with a fine new calico handkerchief, that he had a dozen of them just for this, that the capuchin was so tall that he only had to bend his head down to kiss his c[ock], that a while ago he was also in a party of twelve men in which they had each put his c[ock] on a plate, jerking off their c[ock]s, to each other's envy, to see who would shoot first, that there was a destiny among them for that.

As he was talking to me in this way, he told me, "I renounce G[od] if I'm not h[ard]," words he said two times. During that whole conversation, he had his hand in his pants. Then I told him that I saw very well that I was dealing with a decent man and that I could confide in him. He answered me that I could do it with complete confidence, upon which, having asked him where he took part in his parties, if it was in taverns, he told me no, that I had only to come to his place, that he was free there, that I could sleep with him

in complete safety. Having told him that I could not leave until my master had gone to bed, which was around ten o'clock, ten-thirty in the evening, he told me that this was fine, that I could come there, and gave me his address and his name and even told me, if I wanted to go there right now, he would show me the spot and that we would fool around there. Having told him that I would like to go with him to see the house in order to return there in the evening, as we were going there, having noticed one of those who work for sieur Simonnet, he told me that he had an errand to do at present at the Palais and set about leaving me, walking at a very fast pace.

Note: He also told me that he knew archbishops, bishops, and priests who were in on it with all their might and in every way.

e. FIACRE

29 May 1724

Herculin Fiacre, married man, native of Paris, 50 years old, master shoemaker, residing in the Saint-Lazare quarter.

Being on the quai des Orfèvres, at eleven o'clock in the morning, I went down under the arcades. Said Fiacre followed me and set himself in front of me to do his business while showing me his a[ss] and his c[ock]. Then he came up to me and told me, "I think that I know you." I answered that it could be, and he even told me, "I think that we fooled around together on the boulevard near the Saint-Martin gate." I told him that I didn't go to that quarter to fool around. Said Fiacre told me, "I fooled around with some-one who looks like you. Oh, well, that won't keep us from fooling around together if you want, and you won't be sorry about it. I'm a shoemaker, and I can oblige you by giving you a few pairs of shoes." I told him that I would like to fool around but that I didn't want to fool around in that spot. Said Fiacre told me, "There's nothing to worry about. I come here fairly often to fool around. I'm not known and don't know anyone in this quarter, where we could go to fool around. I don't f[uck] in the a[ss], but I really like to grope a young man, and especially when he has a big c[ock], and I really like for someone to grope me and put his hands on my a[ss], jerk me off. It's my greatest pleas-ure. I also like to fuck a b[ugger]. Then he tried to put his hand in my pants to take hold of my c[ock]. And seeing that I didn't want to show it to him, he took his out of his pants and told me, "See how h[ard] I am. Let's see if you're as h[ard] as I." I told him, "Since you want us to fool around together, I've got my room right near here on the rue de la Bûcherie." He told me, "Let's go there. We'll jerk our c[ocks] off and grope each other." And going to my room and passing by the Petit Châtelet, said Fiacre was arrested by order of the king by sieur Simonnet at noon and put in said Petit Châtelet.

Said Herculin Fiacre was arrested by order of the king by sieur Simonnet for the same reason on 7 November of last year and released on the 16th of the same month, having promised his submission.

[in margin:] Freedom on 10 June 1724.

f. GUILLAY

1 June 1724

Verain Guillay, bachelor, 38 years old, native of Bony near Nevers, unliveried lackey liv-
ing on the rue des Bernardins at dame Martinot's.

 Being on the half-moon [in the fortifications] on 31 May about nine o'clock in the
evening, I found one Verain Guillay, who was holding his c[ock] in his hand and followed
me from the gate. After he had accosted me, he spoke some nonsense to me, told me that
we needed to wait until nightfall. Having sat down next to each other, he tried to put his
hands in my pants, asking several times if I was h[ard], telling me that he was up for any-
thing, that he put it in and that he had it put in him, that he didn't like women, that he had
done nothing but fool around with men since his youth, that this pleasure was in his blood.
He tried again to put his hand in my pants, begging me just to let him see my c[ock]. Hav-
ing prevented him from doing it, having told him that the spot was not suitable, he made a
rendezvous with me for today at seven o'clock in the evening at Notre Dame, to which he
would come, having told me that for the present he could not stay with me because the
horses were hitched to his mistress's carriage and he needed to follow it, imploring me not
to fail to be at Notre Dame this evening at seven o'clock, that he would not fail to be there.
He told me that he had served his mistress for 22 years, and having gone to said rendezvous
at seven o'clock, after having waited there until about eight o'clock, seeing that said Guil-
lay was not coming, I went away. And crossing the Petit Pont, I encountered said Guillay,
who asked me to forgive him if he had been just a quarter of an hour late and then said to
me, "Let's go to the tavern," and passing by the Petit Châtelet, said Guillay was arrested
by order of the king by sieur Simonnet about eight o'clock in the evening.

g. ROUETTE

1 July 1724

Sieur De Rouette, supervisor at the Mint, living at the Mint, married.

 Being in the Luxembourg gardens at eight o'clock in the evening, I met sieur Rou-
ette, who, after having taken several turns, entered one of the nurseries of said garden,
where he pretended to piss and turned toward me, showing me his c[ock]. I went away,
and said sieur Rouette followed me, having lost sight of me, walked around said nursery
to find me. Then, having caught sight of me, he came and passed close by me and made
a sign to me with his head to go talk to him. Since I did not go there, he came back to
me and asked me if I knew some spot where we could fool around in safety. I answered
him that I didn't know any. He told me that it was still too light, that I had only to stay
in said nursery until it was darker. I told him that I would instead come and go in the
vicinity. Having found sieur Simonnet, I alerted him about it. Said sieur Simonnet hav-
ing indicated to me the place to which I should lead him, sent me ahead to observe it.
As I was going there I met said sieur Rouette, who told me that he believed that there
were more hidden places on the other side. I told him that I was going to see; he told

me that he was going to wait for me and that I should hurry. Having come back, I went to find said sieur Rouette, who asked me if I had found some spot. I told him yes. He led me by the central pathway, where he told me, "There's no one here for the moment. We'll be better off in this pathway here. You'll be hidden in that hedge, and even if someone comes by, he'll believe that I'm alone, and you'll go behind the hedge." I told him that I didn't want to expose myself in the moonlight. He told me to go ahead. I went to the spot assigned by sieur Simonnet, to which said sieur Rouette followed me. He asked me if I was h[ard], then undid my pants in order to grab my c[ock]. I told him that I was not h[ard]. He took my hand to put it in his pants. I asked him what he came here for, if he wanted to put it in or have it put in. He told me, "Hurry up, then, and get h[ard], and then you can put it in me." Next he told me, "Grab my c[ock], then. Can't you find it? It's pretty big, though." And at the same time, he approached me and took hold of me with both hands, wanting to put his c[ock] between my thighs, and sieur Legrand, doorkeeper of the Carmelites, who was accompanying sieur Simonnet, having heard him make all of these infamous propositions, immediately arrested said sieur Rouette and took him to sieur LeGrand's residence, where said sieur Simonnet released him, out of consideration for his rank. And having promised to go to Monsieur d'Ombreval's hôtel at eleven o'clock in the morning on the second of the present month of July.[25]

He had his carriage that was waiting for him at the great gate of the Luxembourg gardens. He was arrested at ten o'clock in the evening.

h. LA TOUR

5 July 1724

Strolling in the Luxembourg gardens, on 5 June, around noon, I was accosted by a tall young man dressed in black, with a dark complexion, wearing a brown wig, with an abbé's cap on, who said to me, "For more than two weeks, I have wanted to talk to you, but I saw you talking to someone else. That is why I did not attack you." On 5 July, as I was sitting on the grass, and said abbé as well, he asked me if I was h[ard] and if I wanted to fool around with him, that I would not be displeased with it, that he was a man who could do me some good if I wanted to consent to let him do as he wanted. And at the same time, he tried to put his hand in my pants and said to me, "Let's take a walk." And while walking, he said to me, "Do you want to come to the Bois de Boulogne with me one of these days? We'll have a party. There'll be four or five of us. It's the most convenient spot in the world for fooling around." He told me that he had been there more than forty times and was f[ucked] in the a[ss] and jerked off his c[ock] there. He asked me if I knew some young man who wanted work as a servant, that he would find him a position, that it was to place him with a young man, but that this young man was not into buggery, but that he was here every day and that he fooled around with him. He came with me to the rue de la Calandre near the Palais de Justice, wanting to come to my room, where he wanted to pay for dinner, in order to f[uck] me in the a[ss]. He told me that one day he had met a young man dressed in light grey, with a vest of gold cloth, that they went into a grove, that he had f[ucked] him in the a[ss] twice, and while he f[ucked] him, said young man jerked off his c[ock].

6 July 1724

Strolling in the Luxembourg gardens, about 7 o'clock in the evening, I found said abbé de La Tour, who asked me how I was doing. We stayed at the Luxembourg until 9 in the evening. He asked me, "Do you want to meet tomorrow, 7 July, because I am glad to get to know you," and we arranged to meet at Notre Dame.

9 July 1724

Strolling in the Luxembourg gardens, said abbé was there with two youths. He took a few turns with them, and he left them as soon as he saw me and approached me. He told me, "You are not a man of your word," telling me, as we strolled, that he had come to our rendezvous at Notre Dame and that he had not found me there. He said to me, "There is a young lad just passing in front of you. I took him behind the Carthusian monastery and f [ucked] him in the a[ss] there, and I gave him a sixteen-sous coin." And he arranged to meet me on the following day at two o'clock in my room, to which he did not come.

16 July 1724

Strolling in the Luxembourg gardens around five o'clock in the evening, said abbé de La Tour was there with one of his friends, and he called to me and took me with him to walk toward the Capuchin Friars' at the Saint-Jacques gate. And we drank three or four bottles of wine, and before leaving the tavern, he made me promise him and the person who was with him to go to the Bois de Boulogne on Tuesday to have a party. On Tuesday we met at the Conférence gate with this individual, who works for the Jesuits as a valet. Said abbé de La Tour came there in a hackney coach with another lad whom he had already found at the Luxembourg gardens, who is the one he had taken behind the Carthusian monastery and had f [ucked] him in the a[ss]. In the afternoon, we were in the Bois de Boulogne, eating at the tavern that is at the entrance of the woods. Afterward, we strolled in the woods. Said abbé de La Tour f [ucked] said valet and then the other young man in front of me, and he told me "In an hour I want to f [uck] you, too." I told him that that would be for another time and that we would see each other more often. Then we went to Saint-Cloud. While returning from Saint-Cloud, he had his c[ock] jerked off by said young man, whom he had f [ucked] behind the Carthusian monastery. We came back to Paris. He told us that we should meet in the Luxembourg gardens next Sunday at the same time and that we would go for a walk in the direction of the Observatory. Said valet arranged to meet me on Wednesday, the seventeenth, at the Tower of Mechelen, at the Saint-Martin gate, at two o'clock sharp to have a drink there. I found him at that rendezvous. We ate there. Said valet wanted to f [uck] me in the a[ss] in spite of myself. I told him to come see me where I live, because I wasn't in the mood to have fun in the tavern. We left the tavern, and as we were going away, he said to me "It'll be on Sunday, then, that I f [uck] you in the a[ss]." I told him yes.

2 August 1724

Abbé de La Tour, tonsured student, 25 years old, native of Arles in Provence, studying in Paris, claiming to live at Madame Le Gendre's on the place des Victoires, and when

it was pointed out to him that he did not give his real residence, he told us that he lodged at the collège des Crassins. Being in the Luxembourg gardens on the second of August around eight o'clock in the evening, said abbé de La Tour entered said Luxembourg at nine o'clock and picked me up in the pathways where infamous types generally go and told me that I was not a lad of my word, that he had come twice to my place and that he never found me. He said to me, "Let's take a turn along the pathways, and we'll see if we will find someone with whom we can fool around." We didn't find anyone because the weather was bad. Said abbé de La Tour told me that he had made some nice acquaintances since he had seen me and that he had been f[ucked] well and jerked off his c[ock] well. And that he was not like me, that if I would wait for him tomorrow, the third of August, at my place with one of my friends, he would pay for dinner in my room, provided that the friend was a pretty lad, and that I and the lad I gave to him would be pleased. And while going home and passing by the gate of the rue d'Enfer, said abbé de La Tour was arrested by order of the king by sieur Simonnet at nine o'clock and taken to For-l'Evêque.

Said abbé de La Tour told me several times that if he was ever arrested, he would get out of prison, and after getting out, he would stab the one who had had him arrested with a knife. When he realized that he was lost, he told me, while leaving, "If I knew that you were not a pretty lad and that you were capable of doing me such a bad turn and if you told me, 'I need some money,' I would give it to you and them [those who arrested him], too, rather than causing me distress."

More than a year ago sieur Simonnet observed the behavior of said abbé de La Tour and had it observed, in the Luxembourg and Tuileries gardens as well as the Palais-Royal, where he has been seen looking for sex, and sieur La Jamers, while working for Simmonet, himself saw him. On 12 June 1723 he accosted one of sieur Simonnet's men, to whom he said that one should not trust everyone, that since he had lost an intimate friend he had had in his homeland, with whom he fooled around, he no longer trusted anyone. He resided then in a furnished room on the rue Fromenteau, which sieur Simonnet knew from someone by whom he had him followed.[26]

3 August 1724

I am sending you, Monsieur, several memorandums that regard the person of Monsieur the abbé de La Tour, whom I arrested yesterday evening while leaving the Luxembourg gardens. I beg you to give them to Monsieur d'Ombreval to read so that he pays attention to them. This matter is well worth the trouble because of its nature. He claims to be a man of rank. He has engaged in this vile trade for a long time. Simonnet.

17 August 1724

Pursuant to the king's order given to sieur Simonnet, officer of the company of Monsieur the lieutenant criminal of the Short Robe at the Châtelet of Paris, by Monsieur d'Ombreval, lieutenant general of police, I, Pierre de La Tour, respectfully and obediently submit to the king's orders not to frequent any public promenades and to return to Arles, my native city, under the penalties stated in the king's orders given to me by said sieur Simonnet. Signed Latour. Done by the lieutenant general of police in For-l'Evêque prison, 17 August 1724. Signed Latour.

Sieur Simonnet will set free abbé de La Tour and Claude Dolet, if they are not detained for any other reason than by order of the king or by my orders, while making them promise to return to their homelands. Written this 17 August 1724, signed d'Ombreval.

i. GALLIMARD

3 October 1724

François Gallimard, a lawyer in the parlement of Paris, native of Saint-Florentin in Burgundy, a married man not living with his wife, with whom he did not get along, living in Paris at dame Langlois's on the place Maubert, having a back door to the rue Perdue, at the sign of the King of the Plowmen.

Being at the half-moon on Saturday, 30 September, I was accosted by one Gallimard, claiming to be a lawyer in Burgundy near Sens, who began by telling me, four times, that a lot of whores came to said half-moon, but that they would not have his business because he did not like them, that he preferred to fool around with a friend, that there was nothing in it to worry about. He asked me where I lived and if I was alone. I told him where I lived and that I was alone. He said that I was very fortunate, that he wanted to get to know me, that we would reside together, and that he would pay half for the room, that we would live together like two brothers, that we would drink and we would eat together. Having left the half-moon to go to our own homes, he asked if I did not think it a bad idea for him to come see my room, and when we were in my said room, he said that we must live there together, all the while putting his hand in his pants and touching himself. Then we went downstairs, and he pretended to make water and jerked off his c[ock] in front of me. And in coming back toward me, said that he was really sorry to leave me, trying twice to put his hand in my pants, telling me that he was vexed that we had not flexed our wrists together, trying to get me to go back up to my room to perform his infamies. Since I did not want to go back up, he told me that he would wait for me the next day at his place at the King of the Plowmen on the place Maubert, at dame Langlois's, that we would have breakfast together there. Having gone there the next day, 1 October, we went to mass together and then ate together. He wanted to take me for a walk, telling me that we would come sleep together. He said that he had to leave the door of his room open when he had company because he had a landlady who watched him closely. And on 3 October, having been at said Gallimard's to see him, he told me again that he was a bachelor, that we must live together, that he would pay half for the room, that he was going to see a young lady, one of his friends, who was in the Châtelet, that if she was a whore, that it was not for him, since he had never liked women. And having gone to the Petit Châtelet, said Gallimard was arrested by order of the king by sieur Simonnet and put in said Petit Châtelet.

j. Saint-André Guidon

16 October 1724

Sieur marquis de Saint-André Guidon of the gendarmerie.

About six o'clock in the evening, two individuals were strolling in the central pathway in the Tuileries gardens. Said sieur marquis came and accosted them, asking them what time it was and striking up a conversation in this way, kissing the younger of said two individuals several times, asking the other one to let them stroll together, which he did in order to have the time to look for sieur Haymier and let him know about it. Said sieur marquis, having led said younger individual near the palisades, wanted to have him go in back in order to put it in him, making him touch his c[ock] several times, which he had out of his pants, and still kissing him tenderly. But said young man, not seeing anyone to have him arrested in the act, did not want to agree to his infamy, telling him on the contrary that he wanted to rejoin his friend and that if he wanted, they would go together to some place where they would fool around, since he seemed so glum about it, and having in actual fact rejoined him, said sieur marquis suggested that all three of them go to a tavern to eat a pullet and that he would please both of them. Upon which, the older of said two individuals having asked him if he usually put it in and if he allowed it to be put in him, he told him that as for allowing it to be put in him [the older of the two], the marquis was at his service, and that he had never had it put in him, but that he gladly put it in. And being sure that said sieur marquis was an infamous type, he agreed to go with him to said tavern, and all three setting out to leave through the Pont-Royal gate, sieur Haymier, who had been alerted about what was going on, had said sieur marquis arrested, who agreed about everything stated above, and, given his rank, Haymier released him after having taking down his name and address.

Said sieur marquis stated to the two individuals during the conversation that he knew several people of rank who liked these pleasures, and among others sieur count de Tressan.[27]

k. Crequi de Vaugicourt

17 October 1724

Sieur de Crequi de Vaugicourt, residing in the cloister of Saint-Germain de l'Auxerrois.

For the last few days, said sieur de Crequi has been noticed walking around alone in the evening in suspicious places, looking fixedly at those who passed by him there. Today, after having likewise strolled alone for a good hour and a half in those same places, having entered the central pathway, he found a young man whom he desired to sit down next to him on a bench. Whereafter having talked for a while about indifferent matters, he fell upon the subject of infamy, asked him if he was hard and put his hand in his pants, taking his hand and making him touch his c[ock], which he had out of his pants under his shirt. Then he wanted to take him toward the groves, telling him that he would put it in him and that said young man would also put it in him if he wanted to and that he especially liked it when the action was consummated inside him. Upon which,

sieur Haymier, passing in front of them with several of his men, having known by the signs made by said young man that said de Crequi was eagerly propositioning him, had him arrested on the bench where he was sitting, and said young man affirmed everything above.

1. Delestre

16 April 1730

Jean Delestre, native of Paris, 22 years old, working on the rue de la Roquette in the Saint-Antoine quarter at the home of sieur Mathieu, milliner.

Being on the half-moon at six-thirty in the evening, talking with a young man who had picked me up, said Delestre came up, who saw that I was speaking to this young man about a burial, who went behind the rubbish heap and accosted me. And at that very moment, I left the man I was with, and I stayed with him. And as we were going to take a walk, he asked me if I knew the young man who was on the parapet and just left me. Having told him no, after having talked a good deal about one thing or another, he asked if I was interested in women. I told him that sometimes I was and he responded to me that, as for him, a woman was a frightful thing to him, that he had never seen one up close in his life, that one time he had accompanied one of his friends to a brothel, and that he had approached a woman to touch her, and that he had only been able to have an erection on account of his friend rather than the woman, and he had relieved himself on his own. Having asked him why he hadn't given his virginity to that woman, he told me that it was an abbé who is dead who had had it, and who had debauched him in a col-lège. Then we came up to the parapet, where he pretended to piss and showed himself to me. And he told me that you needed to be careful when you wanted to fool around in this neighborhood because there were people who prevented it, but as for him, when he wanted to fool around, he went to the room of one of his friends, who is a master tiler who lives on the rue Saint-Louis in the Marais. And that when they slept together, he put it in him five times, the tiler likewise. Having asked him if this happened often, he responded that it happened five or six times per month, that he was one of the best han-dled men he had known, but that they denied each other nothing. As we left on the pre-tense of going to my room, he showed himself to me again at the corner of the place Royale, asking me if I would put as many thrusts in him as his friend did. From there we went to a place across from the hôtel de Soubise, where he believed he was coming to sleep with me in the room of one of my friends. But having pretended to go ask my friend, I came back to tell him that my friend wasn't there. Then we went to the Pinecone on the rue de la Juiverie, where we drank a bottle of wine and where I had run into some-one I knew, who, after having heard our conversation, said that he would lend us his room and joined us. Said Delestre told him that the third man would be the first to put it in him, since it was his room we were going to and it was therefore just that he have the reward because he was providing us with his room, with all the more reason because he, the third man, was more accommodating than I. He told me that one day he had been picked up by an abbé from Saint-Innocent but that he had never wanted him to put it in him because he was too blotchy and too filthy. "You can relieve yourself on your own."

And having left the tavern, said Delestre was arrested by order of the king and taken to the Petit Châtelet about nine o'clock in the evening.

[in margin:] I signed the order for his freedom on 22 April 1730

m. TASSAR

25 August 1735

Nicolas Tassar, married man, native of Paris, 58 years old, workman living near the Daughters of Charity on the boulevard de Bonne-Nouvelle.

Having walked down under the Saint-Louis arcades at three o'clock in the afternoon to go to the bathroom, said Tassard who came there to stand next to me undid his pants, showed both his frontside and his backside to me, and played with himself. Seeing that I didn't say anything to him, he got up, pulled up his pants, and went down to the edge of the water. Then, he came back and exposed himself again. He showed himself to me from the front and the back and started to play with himself again. I told him, "That's a fine game that you're playing there, for an old fellow like you." He told me, "I'm not so old that I'm not still very much in the mood. See what a state I'm in." While showing himself to me, he got up and, coming up right next to me, he played with himself until he shot his seed. Telling me to come closer and wanting to put his hand in my pants, I told him that I didn't want to expose myself in that place. We went up the stairs. When we were in the courtyard of the Palais, he told me, "I am going upstairs to the Sainte Chapelle to say an Ave Maria in order to ask the good God's forgiveness for what I just did." We went upstairs together and, having come downstairs together, we came as far as the rue de la Barillerie, where said Tassar was arrested for the third time by order of the king and taken to the Petit Châtelet.

[in margin:] Order for freedom signed, 31 August 1735

n. GIRARDOT

18 May 1737

Bernard Girardot, married man, 28 years old, native of Dijon, presently staying in Paris on the rue Saint-André-des-Arts at the home of sieur Ponsardin, merchant shoemaker.

Returning from above the sand at the end of the Pont Neuf, I found said Girardot, who was going there and who, while passing by me, looked at me fixedly, giving me the usual sign of infamous types, and then continued on his way until near the arch of the Pont Neuf, looking to see if I was coming. And since all of his signs obliged me to watch him, I went by him, turning my head the other way. He came up to me and struck up a conversation by telling me that if somebody walked barefoot under said arch, he would have pitted feet because the stones that composed its pavement were very sharp. While talking, we came up to the edge of the water at the end of the sand, where we saw a number of scamps, who were naked and bathing. He pointed them out to me, saying to me,

"See, they look quite young, and yet they are well formed, well developed, and well handled." We walked around the sand and went by on the side of the quai des Morfondus. Said Girardot, having seen a young man carrying water, exclaimed, "My God, look how pale and handsome he is. One can't resist it, and if I stayed here very long, I would commit more than a few mortal sins." And showing what was under his pants, he said, "You can see that I'm in the mood." I said to him, "So you like men." He answered that everyone had his weakness. I said to him, "So you're not married, because of this." Then, he said to me, "Go bathe, Monsieur." I told him that I didn't want to bathe. In touching the water, he told me, "I assure you that the water isn't cold." I told him that I absolutely didn't want to bathe. He said to me, "Are you worried about showing me what you're carrying?" I said no, but that I didn't want to. I came along the edge of the water, almost up to the Saint-Louis arcades. He tried to make me go in there to do some infamous things there. I told him that he smelled too bad. We walked up to the quai des Orfèvres. I leaned over the parapet; he came next to me. I left him and went away by way of the rue du Harlay, over the quai des Morfondus, and went down to the edge of the water. He followed me there and said to me, "Are you thinking about bathing." I told him no. He told me, "But I would like for you to bathe because I would be delighted to see you completely naked." I told him that I didn't want to bathe but that I was simply going to wash my feet. I washed my feet, and when he saw my hairy legs, he said to me, "Hey, you are hairy." And showing me his frontside, he said to me, "As for me, I am very pale and don't have hair anywhere on my body." He took off his shoes and sat down across from me to wash his feet, too, and taking his penis out of his pants, he said to me, "Look at the state I'm in. Water doesn't stop me, and in the past, when I bathed, I played with myself in the water." When we had finished washing our feet, he said to me, "Hey, now let's go elsewhere to do something else. Let's go to the Tuileries gardens. There are some places there where we can feel comfortable about fooling around." I told him that I didn't want to go to the Tuileries gardens. I went off in another direction; he followed me. I led him by the Petit Chatelet, where he was arrested by order of the king.

[in margin:] free[dom], 18 May 1737

o. ROLLAND

20 August 1737

Sieur Louis César Rolland, living in Paris on the rue de la Sourdière, at the sign of the Wooden Shoe, in the parish of Saint-Roch, has always been strongly suspected of being tainted with the crime of sodomy. He was even cited and appeared in court before Monsieur the lieutenant general of police on the occasion and at the time of the trial of Deschauffours.

The family of said sieur Rolland could allow itself to hope from such a sad event that he would reflect upon himself and that he would feel all of the horror of such a hateful vice. However he now lives, and has lived for a number of years, with a lackey in his employ named Remy, nicknamed Champagne, in such a scandalous manner that the family, tired of the frequent remonstrances that it endlessly but uselessly made to him to convince him to get rid of this lackey, finally finds itself under the cruel necessity of having recourse to the authority of the magistrate and begging him to have the goodness to

use it in order to prevent without delay the frightful consequences that such a scandal could have, by ordering the detention of said Champagne in order to send him subsequently to the islands [colonies to which convicts were deported] if the magistrate judges it appropriate.

The main reasons for the suspicion of criminal converse between master and valet are the familiarity with which they live together, keeping but one table; the insolent remarks of the valet, who daily speaks to his master with the worst indignity; the master's patience in hearing them in spite of the offense they cause to those who have often heard them; and finally, the bad affairs, which the master has the indulgence to get involved in, notwithstanding his bad luck, and most of the product of which is used to furnish not only the upkeep of the valet, who is often at least as well dressed as his master, but also his debauched pleasures, and especially drunkenness, to which he is much addicted.

It is not surprising that such conduct has brought down on said sieur Rolland the scorn of Mademoiselle his sister and that of Messieurs his younger brothers, who live together in Paris on the rue Popincourt in the Saint-Antoine quarter. Seeing the uselessness of their righteous remonstrances, they are all consequently determined to break off all relations with him and not to receive him in their home anymore. They have only taken this step belatedly and as a last resort. But notwithstanding this, said sieur Rolland came there on Monday, the 22nd of the month of July 1737, and found Mademoiselle his sister with Monsieur his brother.

Mademoiselle Rolland, seeing this contemptible brother arrive, went to meet him and very gently told him the reasons that she had for asking him to withdraw. He answered that her house would never be closed to him, and that he would come there as often as he wished, even in spite of her prohibitions, which he didn't care about. She tried to insist, always with the same gentleness, but anger took hold of him. He no longer controlled himself and uttered against her the most atrocious insults and slanders that deserve to be punished. Horrified by all the abominable things she had just heard, she shut herself in an apartment in her house with the one of her brothers who lives with her, but this madman increased his insults, which he uttered loudly enough that she heard most of them.

Since there is everything to fear from a madman of this sort, and, moreover, because his conduct, as has just been noted, cannot fail to have terrible consequences capable of making a family tremble and that will have an immense effect on it, Mademoiselle Rolland and Monsieur her brother beg Monsieur the lieutenant general of police to have the goodness to restore order to this situation and to protect them from the violence and outbursts of such a brother by taking them under his protection and by forbidding him not only to come to their house but even to approach it.

[in margin:] Look into the whole story and inform me.

27 August 1737

Monsieur, following your orders, I made inquiries about the facts set down in the present memorandum. I spoke to several people who know sieur Rolland very well and to whom he owes some money. They assured me that they had never noticed any evil converse with his lackey, who was in truth a drunkard, whom he supplied with his old clothes, that for the past month, this lackey has been on the verge of getting married to a cook on the same street, that he had become much more prudent. The people I spoke to assured

me that the marriage had taken place, or that he would marry her right away, and if sieur
Rolland has treated his family badly, he only deserves a severe reprimand.

p. DION

In the year seventeen hundred fifty, on the twenty-ninth of October, in the morning, at
the hôtel of and before us François Simon Chastelus, councillor of the king, investigator
and examiner to the Châtelet of Paris, appeared Geneviève Pommier, unmarried, 34 years
old, embroideress living at Arpageon, presently in Paris for the purpose explained below,
lodged at merchant founder sieur Flauchet's home on the rue Mazarine, who in execu-
tion of the king's orders addressed to us by Monsieur the lieutenant general of police,
after the oath sworn by her to tell the truth about the matter of which she had knowledge,
said that she knows la Maréchale because she had her arrested on 2 July 1746 on account
of some news sheets she was hawking at the time, for which reason she was kept in prison
until 1 October of the same year. That since her, the witness's, sisters had seized her
room in her absence, she had asked Monsieur de Marville to be transported there to put
her belongings in safety.[28] That sieurs Poussot and Davenel, in charge of her transfer,
came to take her several days later to For-l'Evêque. That la Maréchale was in the car-
riage and took her on her knees. That taking advantage of the absence of sieurs Poussot
and Davenel, who were seated above, la Maréchale seized the moment to tell her, the
witness, that if she would promise to love and come live with her, she would get her out
in less than two weeks, promised it with many fine words, and made her several gracious
offers that she, the witness, who did not really understand where such an engagement
could lead her, promised her everything she asked for in order to get out of prison, not
believing that there could be any worse place for her to stay. That la Maréchale acted
accordingly, and worked hard for her release and to remove all difficulties, offered to
take responsibility for her, the witness, in order to represent her whenever it was neces-
sary and in response to all the summons that might be issued to her in the course of pros-
ecution of the case that was brought against the authors of said news sheets. That since
this last meeting with said Maréchale, she did not really stay in prison more than 12 days,
during which said Maréchale wrote her letters full of tenderness and affection, sent her
food to eat, and anticipated all her needs.

That she remembers that the day that sieurs Poussot and Davenel came to let her out,
as she did not have any money to pay off the prison expenses and sieurs Pousset and
Davenel refused to lend her any, said Maréchale, who was at the door and who was wait-
ing for her, having been informed about it, slid a louis into her hand to pay off the prison
expenses. That released, she was handed over by said sieurs Poussot and Davenel into
the keeping of said Maréchale, who took responsibility for her. That arriving at her place
at 10 o'clock in the evening on said day, 1 October, there were no kinds of caresses, of
tender rebukes that said Maréchale did not make to her, reproaching her endlessly for not
loving her. That the cold assurances that she, the witness, gave her to the contrary did
not satisfy said Maréchale, whose excess of passions she did not yet know. Said
Maréchale, looking at her in a tender and affectionate manner, took her hand, which she
squeezed, and, stretching out in her armchair, did not feel well, repeating to her that it
was through an excess of love that she felt for her and that she would die if she was so
unhappy not to be loved by her. That in bed with her, she was surprised by what la

Maréchale said to her and wanted to teach her, telling her that if she knew the pleasure that two women could have together, she would abandon her Durot and that all men were of no use to her, wanting to reproach her for the passion she was known to have for the son of sieur Durot, police officer. That said Maréchale, continuing, told her that she was surprised that having been at the Salpetrière, she did not know what what was called "a good friend" was, the friendly favors that they gave each other, on which account and wanting to compensate for her lack of knowledge, she asked to kiss her, took her hand, which she placed, in spite of herself, on her private parts, asking her through brisk and violent movements to produce in her those raptures that love alone produces without revolting nature. That la Maréchale in this state, filled with pleasure and in the last moments of delight, overwhelmed her with the tenderest caresses, calling her her little husband and surrendering herself to the raptures of the detestable passion that devours her, adorned her words with all the sighs, transports, pretty terms, and oaths that passion excited in her. That having noticed, but too late, the labyrinth that she had thrown herself into, not knowing how to leave la Maréchale's home without risking going back to prison and, however, not being able to tolerate a woman who not only had nothing attractive about her, but whose excess of passions made her detest her even more. She reflected endlessly about the means of escaping from such shackles, especially given the tender reproaches and the ardor that said Maréchale exhibited toward her. All the kindnesses that she had shown her only served to increase the disgust she had conceived for this woman who demanded from her a thousand things against nature. That she would not finish if she could remember all the horrors that she had seen this abominable woman commit, who, at all hours of day and night, demanded of her favors like those she just told us about, to the point that it is true that since that time she retained in her right arm a numbness and a rheumatism that makes her repent, in the different seasons of the year, for having been the slave of that Messalina's pleasures.[29] Also and most often said Maréchale, whom nothing can satisfy, stimulated herself for four hours at a time in the middle of her room, on a mattress that she threw on the floor there or in her armchair, demanding of her, the witness, that at these moments she approach her and lavish kisses on her. That then said Maréchale, in this excess of passion, expressed herself to her, the witness, in the most lively and unrestrained terms, promising her that she would never lack anything and lavishing the tenderest names on her, and soon abandoning herself to passion and frenzy, bellowed, roared, cursed, blasphemed, and began trembling and moving convulsively, to the point that she would have been heard from four floors below. That, what is more, said Maréchale made her bondage all the more unbearable because she was only allowed to go out with her, she was not allowed to see anyone. La Maréchale followed her everywhere and made her always feel the effects of the most extreme jealousy, through the restraint and constraint in which she kept her. That finally weary and disgusted with living with such a vile woman and such a monstrous creature, whose temperament is invincible, and who would tear the arms off a dozen men a day, at the end of a month, she had one day found sieur Poussot, had confided in him about the torture she endured with said la Maréchale, and finally had begged him to take her back to For-l'Evêque.

6. The Case of Benjamin Deschauffours, 1726

EDMOND JEAN FRANÇOIS BARBIER (1689–1771), *lawyer*

Chronicle of the Regency and the Reign of Louis XV[30]

May 1726

The vice [of sodomy] has reigned for a long time in this country, and for a while it has been more in fashion here than ever. All of the young lords were madly devoted to it, much to the vexation of the women of the court. One Deschauffours was put in the Bastille about five or six months ago. He was an individual in Paris, a great b[ugger] by profession, a handsome and well-formed man. This man knew a lot of people among the high and low, for, in general, this is not the pastime of the petit bourgeois. His home was the common meeting place. Parties of debauchery took place there. He apparently provided lords with new subjects. This was finally uncovered; I do not know how. What is more, they had the list of all the participants in this debauchery, which amounted to more than two hundred persons of all ranks. It became a noteworthy affair. The king appointed Monsieur the lieutenant of police and a few magistrates of the Châtelet commissioners to pass judgment without appeal, and the royal prosecutor [in the Châtelet] Moreau was appointed as the commission's prosecutor. Horrible things were seen in the course of this trial, during which full proof was found. Several persons who were imprisoned were sent to the islands. It was even said that it would be hushed up, but the matter seemed too serious. Monsieur Hérault wanted, and made it clear that it was necessary, to make an example.[31] It not being possible to punish all those who were named because that would cause too much commotion. And furthermore, no more of that was needed to make this crime known and make it more common, most of the populace not even knowing what it is. Deschauffours was the guiltiest because it was he who held those secret parties. And with his trial over, he was taken last night from the Bastille to the Châtelet. Yesterday morning he was interrogated, on the stool on which accused prisoners sit, on account of the crime of sodomy, judged, and condemned to be burned alive. He was executed in the afternoon in the place de Grève, with the difference that he was first strangled. It had been a long time since anyone was executed for this crime, and this will restrain somewhat all those who are tainted with this crime against nature. As for the rest, there is no civil reparation to be made to anyone. He had a brother-in-law who is a provincial commissioner of war, who had even received king Stanislas when he passed through and entertained him, who [the brother-in-law] asked for him to be pardoned, but since this crime is becoming common and this man kept a house for it, they wanted to make an example of him.[32]

The oddest thing about this affair is that the night of the same day, the Jesuit collège caught fire, a sizeable fire that burned two floors. The lieutenant of police came there, and help arrived quickly. This gives wags an opportunity [to joke], for it either seems that heaven, not being happy that by the sentence of Deschauffours the accomplices' sentences were suspended, visited the fire upon the Jesuits because this crime is popularly attributed to this order, or to show that fire is the true punishment for this crime

and to justify the sentence. The joke did not fall flat. Everybody says that it was Deschauffours's ashes that sparked the fire at the Jesuits', where, they say, some ten thousand pounds of pewter dishware were melted.

They say that a painter named Nattier, who was in the Bastille with Deschauffours, cut his own throat.[33]

Monsieur the abbé de La Fare, bishop of Laon, belonged to this group.[34] He is locked up in the seminary. They say that the count de Tavannes, [who had been decorated with the] blue cord [of the Order of the Holy Spirit], has been exiled for the same reason.[35] With regard to abbé de Saint-Aignan, bishop of Beauvais, he is imprisoned in the Jesuit house for noviciates, and so it is clearly not for the same reason.[36] It is for debauchery with women.

7. The Case of Bruno Lenoir and Jean Diot, 1750

a. BARBIER[37]

July 1750

Today, Monday, 6 July, at five o'clock in the evening, they publicly burned in the place de Grève two workers, namely a journeyman joiner and a pork-butcher, 18 and 20 years old, whom the watch found in flagrante delicto in the evening, committing the crime of sodomy. There was apparently a bit of wine in play to push the impudence to this point. I have learned, from this event, that a man dressed in grey walks before the watch squad who notices what is going on in the streets, without looking suspicious, and who then summons the squad. That is how our two men were discovered. Since some time has passed between the execution and the judgment, it was believed that the penalty had been commuted because of the indecency of these types of examples, which teach many youths what they do not know, but it is said that it is because of a dispute between the lieutenant criminal of the Châtelet and the recorder over knowing who would attend this execution, especially as the recorder was no longer in the criminal [as opposed to civil] division. But Monsieur the chancellor decided that the recorder would go, although no longer being in the criminal division at the time of the execution. In short, the execution was performed to set an example, especially since it is said that this crime is becoming very common and that there are many people in Bicêtre for it. Since these two workers had no connections with people of rank, either at court or in the city, and they apparently did not implicate anyone, this example was made without any concern for the results.

The fire was composed of seven cartloads of wood, two hundred cartloads of sticks, and straw. The men were attached to two stakes and strangled first, although they were immediately suffocated by [the fumes from a shirt doused with] sulphur. The sentence was not announced by the public crier, evidently in order to spare people from hearing the name and description of the crime. The sentence for sieur Deschauffours for the crime of sodomy had been announced by the public crier in 1726.

b. Arrest, 4 January 1750[38]

In the year seventeen hundred fifty, on 4 January at eleven-thirty in the evening, before us, Jacques François Charpentier, councillor of the king, commissioner of the Châtelet of Paris, in our hôtel, appeared Jullien Danguisy, sergeant of the watch at the Saint-Jacques-l'Hôpital gate, who said that while going along the rue Montorgueil, he turned into the rue Saint-Sauveur and the rue Beaurepaire. He saw two individuals in an indecent position and behaving in a guilty manner, one of whom seemed to him to be drunk, so he arrested them as much for what he had seen of their indecency as for the statement that an individual passing by made to him, who said he had seen seen them committing crimes that propriety does not allow to be expressed in writing, so he brought them before us and signed our minutes.

Said by one of these individuals that he is named Brunot Lenoir, 20 or 25 years old, unmarried, shoemaker, living on the rue des Cordiers at the home of Lepitre, merchant shoemaker, where he works, that he does not know the other arrested individual at all, except that he had met him half an hour ago, that said individual asked him if he wanted to come with him, which he, the deponent having refused, said individual undid Lenoir's pants and committed indecencies on him and that the watch having come by, arrested them and brought them before us, and signed our minutes.

Said by the other individual that he is named Jean Adieu [Diot], that he is 40 years old, unmarried, servant to dame Marin, pork-butcher on the rue de la Fromagerie in the central marketplace, where he lives, that he does not know the other arrested individual at all, that having found him asleep on a doorstep, he had no other design than to do him a favor and was not in an indecent position as he has been reproached for and had not removed his pants when he was arrested and stated that he does not know how to write or sign his name in our minutes.

Said sieur Danguisy has persisted in his statement above made by him and says that he is all the more certain about what he states because one Giroux, his soldier, who walked twenty steps in front of the squad, is thoroughly acquainted with the facts, having waited in silence until the squad was close enough for it to be observed by Danguisy, deponent. And said Danguisy and Giroux signed in our minutes.

Upon which we, the commissioner, have given the deponents copies of their statements above, in consequence of which we have charged said Danguisy to take said Lenoir and Adieu prisoner to the Châtelet in accordance with the royal prosecutor's request, which he promised to do and signed in our minutes.

Charpentier

Having seen the report, I request, on behalf of the king, to be informed about the facts contained in it and, meanwhile, said Bruno Lenoir and Jean Adieu to be arrested and charged, done this 5 January 1750.

Moreau

c. Interrogation, 9 January 1750[39]

Bruno Lenoir, journeyman shoemaker, 21 years old, native of Douai in Flanders, in Paris for three years, living on the rue des Cordiers at the home of Lepy, master shoemaker, stated today, 9 January 1750, that on the 4th of the present month, he, the deponent, going along the rue Montorgueil at 9 o'clock in the evening, he was met there by an individual unknown to him and whom he has since learned to be named Jean Diot, a runner of errands, 40 years old, native of Sainte -Marguerite parish in the Saint-Antoine quarter, living at the home of sieur Mespece, seed-merchant, on the rue de la Fromagerie, on the third floor in the back, that said Jean Diot accosted him and proposed infamy to him, that he even asked him, the deponent, to put it in him from behind, that to this end Jean Diot undid his pants and that he, the deponent, put it in him from behind, without, however, being able to finish the business, given that they were surprised by the watch, who arrested them and who, after having taken them before a commissioner, took them to the Grand Châtelet prison, where they were turned over by the watch and charged by Monsieur Duveau by virtue of the decree that was issued against them.

Jean Diot denied the fact.

8. Patrols, Arrests, and Depositions, 1783–85

Pederasty patrol, 2 October 1783[40]

In the year 1783, on Thursday, 2 October, we, Charles Convers-Desormeaux, lawyer in the parlement, councillor of the king, commissioner to the Châtelet of Paris, for the execution of the orders addressed to us by Monsieur the lieutenant general of Paris, we went, accompanied by sieur Louis Henry Noël, councillor of the king, inspector of police, to the Champs-Elysées, the Cours la Reine, the Port aux Pierres [site where building stone was unloaded from barges], the marshes that exist behind the Coliseum [dining and dancing facility located off the Champs-Elysées], and other places where pederasts usually meet and retreat to indulge in pederasty. And, as a result of the patrols, observations, and searches undertaken up until midnight, said sieur Noël, by virtue of the king's orders of which he is the bearer, at nine o'clock in the evening, on the Champs-Elysées, among the chairs [available for rental] and under the shade of the trees, arrested two individuals found there in a suspicious manner. And having had them brought before us, one of them, in response to the questions addressed to him by us, told us, after the oath taken by him to tell the truth, that he was named Jean Pierre Messin, 25 years old, native of Paris, servant since 1 January 1782 of Monsieur the count François de Jaucourt, second colonel of the Condé regiment, at whose residence he lives, on the rue de Varenne at the hôtel de Jaucourt. Although dressed in a brown bourgeois outfit, he came to the Champs-Elysées to take a walk without any design, not ever having been found to be nor arrested on suspicion of being a pederast and, summoned to do so in keeping with the ordinance, refused to sign.

The other, in response to the questions addressed to him by us and after the oath taken by him to tell the truth, told us that he was named Louis Etienne Provendier, native of Paris, banker in that city, living there at the place du Chevalier du Guet, and that he was coming back from Chaillot, taking a walk, and never having been arrested for nor suspected of pederasty and, summoned to do so in keeping with the ordinance, refused to sign.

We then had said Messin and sieur Provendier released and enjoined them not to frequent suspicious places any more.

Then said sieur Noël arrested, at eleven o'clock in the evening on the quai de l'Ecole, at the place called the Canapé, two individuals seated next to each other in a suspicious manner and talking together. And having had them brought before us, one of them, in response to the questions addressed to him by us and after the oath taken by him to tell the truth, he told us that he was named Pierre Corby, an upholstery merchant, having a shop on the rue Mondétour and living on the rue Jean de l'Epine at the home of a wine merchant, that he does not know the individual next to whom he was seated and with whom he was talking, that he sat down on the parapet without any design, that he had never been arrested for nor suspected of pederasty and, summoned to do so in keeping with the ordinance, refused to sign.

The other, in response to the questions addressed to him by us, told us, after the oath taken by him to tell the truth, that he was named Louis Joseph Fontany, twenty-one years old, native of Nivelle near Brussels, journeyman shoemaker, living and working on the rue Sainte-Anne, at the residence of one Villemolle on the rue Cordonnier, master shoemaker, in the Marshal's house. That he did not know the individual with whom he was talking and next to whom he was seated, that he sat down without any design and that the other individual, having sat down near him, they had a conversation about the fine weather, that he had never been arrested for nor suspected of pederasty, and, summoned to do so in keeping with the ordinance, declared that he did not know how to write or sign.

We then had said Corby and Fontany released and enjoined them not to frequent suspicious places at unseasonable hours any more.

And then said patrol was continued until after midnight, without having found other suspicious persons. We went home and of everything above composed and drafted these minutes, which said Noël signed with us.

ARRESTS, 11 OCTOBER 1783

. . . sieur Noël . . . arrested at eight o'clock in the evening on the boulevard du Temple an individual whom he had observed for a long time walking around there in a very suspicious manner. . . . that he was named Charles Joseph Verbergh, 24 years old, native of Anguen in Hainault, journeyman shoemaker living on the rue aux Ours, at the home of his uncle Hubert Dianton, master shoemaker, that he had come to walk around alone because he could not work, having injured a finger. Showed it to us, told us that he had never indulged in pederasty nor been found with pederasts.

We had him released and enjoined him not to walk around in suspicious places and in suspicious manners any more.

By virtue of his orders, said sieur Noël also arrested, at ten o'clock in the evening on the boulevard de Richelieu, another individual dressed in the most obvious outfit of pederasts and whom sieur Noël told us he knew. One Baudry, called the female Seeker of Wit

among pederasts, had been arrested by him for pederasty on 1 January 1782, transfered to Bicêtre on the tenth of that month, and released from that place after a few months of detention at the request of his parents. . . . that he was named Henry Baudry, twenty-one-years-old, native of Paris, journeyman cabinetmaker, living in Paris on the rue Notre Dame with his father and mother, acknowledged that he had already been arrested as a pederast. . . .

This fact and given that he had already been punished for pederasty, that he had been arrested in a very suspicious place and dressed in the most suspicious manner, said Baudry was handed back over to sieur Noël, who took charge of him, by virtue of orders, to take him to the prison of the Hôtel de la Force. . . .

ARRESTS, 25 APRIL 1784[41]

. . . sieur Noël . . . arrested at ten o'clock in the evening at the [establishment called the] Pendulum, at the end of rue de Ménilmontant, two individuals known to be pederasts under the names of François, nicknamed the Pretty Seamstress, the other under the name of Richard, nicknamed Beauregard [Good Looks], and brought them before us in order to have the report about their arrest drawn up and proceed with their interrogation.

Having had one of the arrested individuals brought before us, we proceeded with his interrogation, as follows.

First asked about his name, nickname, age, birthplace, status, and address.

Answered after the oath taken by him to tell the truth, that he is named François Blaise, nicknamed the Pretty Seamstress, 28 years old, native of Versailles, tailor, living in Paris on the rue des Poulies, number 3.

Asked how long he had been addicted to the crime of pederasty.

Answered that having come to Paris about fourteen years ago, he was drawn into that vice by some young people he met.

Asked with what persons of this kind he has relations.

Answered that he knows one Beaufils, called Holy Chapel, one Beauregard, arrested with him.

Asked how long he has known and consorted with said Beauregard and where he met him.

Answered that he has known him for two months and met him through one of his friends, who brought him to the residence of a sister of Beauregard, who was there.

Asked with what intention this friend took him to said Beauregard's sister's place and what her name is and whether it was to meet said Beauregard or his said sister.

Answered that he went upstairs in passing by like everybody to the residence of this prostitute, also named Beauregard, who lived then on the rue Mercier and lives now at the corner of the boulevard and the rue de Bonne Nouvelle.

Asked with what intention he returns to her place and if it is to get to know her or her brother better.

Answered that it is in order to entertain himself, that, however, he has never had anything to do with her.

Asked if he was not informed, in going to this prostitute's place, that parties of men take place there.

Answered no and that he does not know about it.

Asked if he knows one Dubreuil, chorister of the parish of Saint-Germain-l'Auxerrois.

Answered that he knew him and that he died in the Hôtel-Dieu at the beginning of last winter, that he was not at all connected with him but that for the last two years he did not consort with him anymore and that it is by chance that he encountered him at the Hôtel-Dieu, where said Dubreuil was sick.

Asked if he knows abbé Viennet and has not been to his home.

Answered no.

Asked if he knows one Beaupré and what kind of relation he has with him.

Answered that he does not know him.

Asked what he does to earn his living.

Answered that he works in his capacity as tailor.

Asked why, with disregard for the prohibitions that were issued to him, he continues to go frequently in the evening to the Tuileries, the Palais-Royal, and other suspicious places.

Answered that he does not go there anymore, since he has been forbidden to do so.

Asked what was the purpose of his walk with said Beauregard today.

Answered that it was to go dancing and that said Beauregard's sister was with them.

Asked if he has never prostituted himself to men.

Answered that he has had that misfortune, but that he reformed himself of it three or four years ago and that if he currently consorts with people suspected of this vice it is in order to get work in his capacity as tailor.

Having had him searched, there is found in his pockets a letter, written on a piece of decorated paper, to go on the twentieth of this month, signed Bruriot without an address.

Showed him said letter, asked him to recognize it and to tell us by whom it is sent to him.

Answered that it is not to him, that it is to Dumar, hosier under the Passage du quai de Gesvres from whom he, the respondant, took it and that it was written to him by a woman whom he must have known, according to him, the respondant.

Asked if he has never been in prison or arrested.

Answered no.

The present interrogation having been read to him, said that his answers contain the truth, persisted in them, and signed.

This done, said Blaise was turned over to said sieur Noël who took charge of him, by virtue of said orders, to take him to his destination, and also took charge of said letter, and signed.

Having then had the other arrested individual brought before us, we proceeded with his interrogation, as follows.

First asked about his name, nickname, age, birthplace, status, and address.

Answered after the oath taken by him to tell the truth, that he is named Charles Thiriot, called Beauregard and nicknamed Richard, 22 years old, native of Joinville, women's hairdresser, former servant, living in Paris at the Hôtel de la Grenade on the rue de Cléry.

Asked how long he had been addicted to the crime of pederasty.

Answered that he has been addicted to it for three years.

Asked who the people are with whom he has been involved in parties of this kind of debauchery and where he attended them.

Answered that he does not remember the names of the people and that it is in his room, with one Lambert, a clothing merchant in Bordeaux.

Asked if he has not also fooled around with one Potin, former French guard, with one Dussy, dancer.

Answered that he does not know said Potin, that he knows said Dussy but has not fooled around with him.

Asked how long he has known the individual with whom he was arrested and what his name is.

Answered that he has known him for two months and that he is named François.

Asked where and how he met him.

Answered that he met him through his, the respondant's, sister, who is kept but he does not know by whom, at whose place he, the respondant, met said François.

Asked if he has often been to said François's place.

Answered that he has been there two or three times.

Asked if said François has often been to his, the respondant's, place.

Answered that he has also been there two or three times.

Asked what parties they have had together.

Answered that they never had any.

Asked if he knew that said François was addicted to that vice.

Answered that said Dussy had told him so.

We then had said Thiriot searched, on whom nothing suspicious is found.

Asked if he has never been in prison or arrested.

Answered no.

The present interrogation having been read to him, said that his answers contain the truth, persisted in them, and signed.

This done, said Thiriot was turned over to said sieur Noël who took charge of him, by virtue of said orders, to take him to his destination, and signed.

PEDERASTY PATROL, 17 JULY 1784[42]

. . . sieur Desurbois . . . arrested at ten o'clock in the most suspicious spot in the [marshy land on the northern edge of the city called the] Coalpit an individual—dressed in the showiest ribbons on his shoes, a wide tie, golden earrings, a large frock-coat in the levite style, a very large round cloth hat, and a ring with no stone in it on his finger—known to prowl and pick up men in the Tuileries, in the Palais-Royal, and to be friends with famous pederasts and observed to prowl in this place for a long time. Having had this individual appear before us, in response to the questions addressed to him by us and after the oath taken by him to tell the truth, he told us that he is named Philippe Rouveau, 22 years old, native of Paris, valet to Monsieur the count de Beauharnais, officer of the guards, that he lives on the rue Notre Dame des Victoires, and, summoned to do so in accordance with the ordinance, stated that he does not wish to sign and moreover answered us with the greatest insolence.[43] In his pockets are found a thick pair of stockings made of wool from Bicêtre, a strip of gray cloth with some gauze on both ends forming a kind of tie with a delivery note signed by a female servant, Devision, without an address and which said Rouveau said was intended for a servant whose name he does not know, living on the rue Montmartre, and two white handkerchiefs and some very worn gloves and a candy box of blond wood with gold pricking. This done, said Rouveau was turned over to said sieur Desurbois who took charge of him, by virtue of said order, to take him to his destination.

Said sieur Desurbois also arrested at the same place and time two individuals observed prowling in a suspicious manner, and having had them brought before us, in response to the questions addressed to them and after the oath taken by each of them to tell the truth, they told us they are named, that is the one arrested prowling with another who ran away at the approach of said sieur Desurbois and could not be arrested, Charles Quillet, 40 years old, native of Paris, unemployed companion cabinetmaker, living on the rue Saint-Sebastien, in the house of sieur Billiot, master painter, that he was coming from the faubourg Saint-Antoine and returning home and was alone and, summoned to do so in keeping with the ordinance, stated that he did not know how to write or sign.

The other, Jean Pavoyeau, 26 years old, native of Tours, journeyman gauzemaker working for sieur Cordier, on the rue de Charenton, on his way back to his place in the faubourg Saint-Antoine at the Adam pavilion and, summoned in keeping with the ordinance, stated that he does not know how to write or sign.

This done, said Quillet and Pavoyeau were released, and we enjoined them not to prowl in suspicious places anymore.

And at midnight, said sieur Desurbois arrested on the boulevard between the rues Montmartre and de Richelieu, behind the garden of the hôtel de Montmorency, three individuals observed prowling separately there and then coming together, two of them known as prowlers, which three individuals resisted at the time of their arrest, such that it was only with difficulty that they were brought to the guardpost, where, having had them brought before us, after the oath taken by each of them to tell the truth, in response to the questions addressed to them by us, they told that they are named Philippe Augustin Coqueley, 32 years old, native of Masclaveu in the diocese of Amiens, stocking worker, living on the rue Notre Dame de Nazareth at the home of Prevost, stocking maker, knows the other two only from having drunk once with them, and that this done, it is they who accosted him, and, summoned to do so in keeping with the ordinance, stated that he does not know how to write or sign.

Another is named François Fournery, 30 years old, native of Montmorin in the diocese of Clermont, cook in the house of Dame Perducat, with whom he lives on the rue de Grétry, and is walking on the boulevard and, summoned to do so in keeping with the ordinance, stated that he knows but does not want to sign.

And the other is named Ambroise Mariel Dumaine, 20 years old, native of Pechiviers, servant of said dame Perducat with whom he lives on the rue de Grétry. Summoned to do so in keeping with the ordinance, stated that he does not know how to write or sign.

This done, said Coquelay, Fournery, and Dumaine were released, and we enjoined them not to prowl in suspicious places at improper hours anymore.

We then continued said patrol until about two o'clock in the morning and we have done and drafted the present report of everything, which said sieur Desurbois has signed with us.

DEPOSITION, 11 AUGUST 1784

In the year 1784, on Wednesday, 11 August, at one o'clock in the afternoon, was brought before us, Charles Convers-Desormeaux, lawyer in the parlement, councillor of the king, commissioner to the Châtelet of Paris, in our hotel, Paul Regnault, servant looking for a

position, lodged in Paris on the rue Bergère at the home of sieur de Plancy. He told us that yesterday noon, being at the domestic employment bureau on the rue Montmartre, which he frequented for a month after he arrived in Paris, he met another unemployed servant there named Toutin, who asked him if he wanted to pay for a bottle of wine. They went together to an inn where they dined, and he, the deponent, paid the bill. That under the pretext of making him acquainted with Paris and helping him find a job, said Toutin urged him to go for a walk. That they were on the boulevard where the shows are, then in a café near said boulevard, and stayed there until about two o'clock in the evening, said Toutin continually preventing him from leaving. That in the end, said Toutin told him that they will be asleep in the house where he, the deponent, lodges, and urged him to come sleep with him in his room, on the rue Saint-Sauveur. That he, the deponent, went there, that said Toutin bolted and locked the door and put the key in his pocket, then, having undressed, pushed him, the deponent, and threw him down on the bed, where he prepared to commit the crime of pederasty on him and to touch him indecently. That he, the deponent, resisting it, said Toutin begged him to let him do it, said that it was his pleasure, that he would give him a gold watch, a blue levite that he had in said room, and a pair of silver buckles. That he, the deponent, refused all of this, and said Toutin persisted in trying to enjoy him from behind as one enjoys a woman from the front. He, the deponent, grabbed his stomach and hit him several times. That said Toutin defended himself and that they hit each other several times. That said Toutin, seeming to calm himself, told him, the deponent, that he would leave him alone, that he could go to sleep without fearing anything, and that he hoped that in the morning, he, the deponent, would be more docile. But he still refused continually to open the door and let him, the deponent, leave, who in this way found himself obliged to sleep with said Toutin, under the promise that the latter reiterated to him that he would leave him alone until morning. That at eleven o'clock in the evening, he, the deponent, seeing that said Toutin was asleep, took the key to the door from the pocket of his coat, then, having promptly put on his pants, his stockings, shoes, and frock-coat and hat, opened the door of said room and got away with so much haste that he left in that bedroom his watch in a gold case, a twist of black silk, his undershirt of white cotton cloth, a simple tie, a black roll of garter material like another one that he still has, and a walking stick with a cracked gold handle, [illegible], and spent the rest of the night in the street. That having returned to the employment bureau, he told sieur de Gonnevalle, the director, what had happened to him, that several servants who were there said they know said Toutin to be subject to such things and wholly given over to the debauchery of pederasty. That he, the deponent, having returned with someone else to the house where said Toutin lodges, to recover his watch and other belongings, said Toutin was not there, for which reason he came to make the present statement to us, of which statement he requested a copy, which we gave him, and, summoned to do so in keeping with the ordinance, stated that he does not know how to write or sign.

And also brought before us Alexandre Thomassin, unemployed servant, living in Paris on the rue de Menars, number 9, who told us that seven or eight days ago one Toutin, denounced in the deposition above, leaving his quarters on the rue Neuve d'Artois, asked him, the deponent, to bring his trunk to the furnished home where he presently lodges on the rue Saint-Sauveur, at the home of Tallion, who rented rooms at number 32. That he, the deponent, took it and that, being in said room with said Toutin, this Toutin wanted to enjoy him and consummate the crime of pederasty on him, which he, the deponent, did not allow. That defending himself and preventing by force said Toutin from clos-

ing the door and getting away, of which statement he requested a copy, which we gave him, and signed.

[at bottom of page:] Regnault lodges with Cheradaine, servant of Monsieur de Plancy.

Thomassin, rue de Menars, number 9, with Perin, coachman of Monsieur Richard, American.

PEDERASTY PATROL, 11 OCTOBER 1784

. . . sieur Desurbois . . . arrested at eight o'clock in the Coalpit an individual who, after having prowled in said place, accosted two of said sieur Desurbois's observers, began a conversation with them, and propositioned them to fool around, saying that he would rather fool around with two than just one, then strolled and crossed said marsh with them, and took them behind a wall, a place that he told them was suitable, where he was arrested while continuing to proposition them.

Said sieur Desurbois also arrested after eight o'clock walking in said place called the Coalpit two other individuals observed prowling on the boulevard and then entering said place called the Coalpit, where after having prowled together, they parted in order to try their luck separately.

And finally said sieur Desurbois arrested in the same place at eight-thirty another individual observed prowling for a long time in a suspicious manner. And having brought the said four individuals before us, in response to the questions addressed to them by us and after the oath taken by them to tell the truth:

The first told us that he is named Pierre Louis Henry, 44 years old, native of Vraigne in the diocese of Amiens, laundryman living in Paris on the rue de Bercy at the corner of the rue du Charbonnier in the faubourg Saint-Antoine at the home of sieur Vrinoul, wine merchant, that he is married without any children, that the propositions are nothing, and that he did not do anything but accost two individuals. And that it might have been to have a drink or to walk around as for anything else. That if he told them, "Let's fool around," it could mean to drink a bottle of wine as well as fooling around. That he saw his wife again this morning, and then that it is true that he was addicted to pederasty while a soldier, but that for the fourteen years he has been married, he no longer had that taste. That, however, he said to the two men that he accosted that he is ready to fool around or such with them, and that it is the result of a glass of wine he drank, and, summoned to do so in keeping with the ordinance, stated that he did not know how to write or sign.

Another man known as a famous pederast, much noted for picking up men every evening in suspicious walks, especially in the Tuileries, participating in parties, prostituting himself, debauching young people, procuring them, having committed various extortions and supports himself only through this trade, using the name of the marquise de Chenil [dog kennel], which was given to him for having been surprised in flagrante delicto at the dog kennel at Versailles, where he lived most of the time, having left Bicêtre on the past 2 September, where he had been taken by an officer of the prévôté [de l'Hôtel, court with jurisdiction over the royal household], told us that he is named Antoine Marie Massy, called Verneuil or the marquise du Chenil, 22 years old, native of Versailles, hairdresser living on the rue de Lancry at the home of sieur Lanove, contractor, that it is false that he is addicted to pederasty, that he was only taken to Bicêtre at the request of his parents, whom he had disobeyed, that he goes to the Tuileries and the

Palais-Royal but only to walk around, and, summoned to do so in keeping with the ordinance, stated that he knows how but does not want to sign.

Having had him searched, nothing suspicious was found.

The other individual seen with said Massy and arrested at the same time, and also known and noted as a pederast, picking up men in the royal gardens, participating in parties, and prostituting himself, told us that he is named Louis Delorme, called Louison, 21 years old, native of Bray-sur-Seine, unemployed servant, living on the rue des Prêcheurs with his sister, flower worker, that he has been fooling around with men for two years or so, that it was one Fabre, dragoon of the Dauphin Regiment that debauched him in a chateau near Damme Marie where he, Delorme, was in service. That he knows said Massy, who picked him up at Versailles in the park, the first week of last May, and took him to sleep with him, that they masturbated each other. That, since then, they have slept together on several occasions and likewise masturbated each other. That he knows that said Massy is called the marquise du Chenil. That he also knows that said Massy and one Paris, servant at a home on the rue d'Anjou in the Marais, indulge in pederasty together.

Having had him searched, there was found in his pockets an address of one Barré, hairdresser known as a famous pederast, debaucher, and procurer, which address said Delorme told us had been given to him by said Massy and Paris, who had taken him up to said Barré's door, telling him that Barré would do him some good, but that he did not find him home.

And the last arrested individual told us that he is named Jacques Chevauché, 30 years old, native of Dijon, clockmaker, living in Paris on the rue Saint-Martin at the home of sieur Demortot, apothecary, that he was going from his home to the home of one La Hoile, tinsmith, his brother-in-law, living on the rue Saint-Antoine, at the corner of the rue Traversière, and, summoned to do so in keeping with the ordinance, stated that he did not know how to write or sign.

This done, said Chevauché was released, and we enjoined him not to prowl suspicious places any more, and said Henry, Massy, and Delorme were turned over to said sieur Desurbois, who took charge of them, by virtue of the orders that he carried, to take them to their destination.

We then continued said patrol until midnight, and of everything above we composed and drafted the present minutes, which sieur Desurbois signed with us.

PEDERASTY PATROL, 11 DECEMBER 1784

... sieur Desurbois ... arrested at seven-thirty in the evening on the quai des Augustins an individual observed prowling for a long time on said quay as well as on the quai des Orfèvres, having accosted an observer with whom he took two turns on both said quays, while talking about pederasty and telling him that he liked youths but that he did not like married people.

And an instant afterward, said sieur Desurbois arrested another individual observed prowling for at least half an hour in the place called La Fourissière and finally committing there the horror that people addicted to this vice call eating the world, with an individual who got away and could not be arrested.

And having had the first of said individuals brought before us, in response to the questions addressed to him by us and after the oath taken by him to tell the truth, he told

us that his name is Pierre Barthe, 43 years old, native of Gaillac in the diocese of Albi, master tailor in Paris, living there on the rue de Sorbonne, with the carriage entrance next to Monsieur Delpeche, that he left his home at five-thirty in the evening, went to services at Saint-Sulpice through the entrance on the rue du Grand Sentier, that he returned by the quai des Orfèvres to buy a fowl on the quai de La Vallée, that he was accosted by an individual on the quai des Orfèvres who spoke to him about the debauchery of men, that he listened to these statements simply out of curiosity, but that he, the deponent, is not addicted to this vice and has never indulged in it, that he has a wife with whom he lives and a fifteen-year-old son. Having had him searched, there was nothing suspicious found on him.

We then had the other arrested individual brought forth. In response to the questions addressed to him by us and after the oath taken by him to tell the truth, he told us that his name is Benoist Liber, 34 years old, native of Mâcon, unemployed apprentice butcher, in Paris for two months, not doing anything there, lodged there on the rue Jean de l'Epine at the home of one LaForest, that he went down to the spot where he was arrested in order to relieve himself and did not speak to anyone there, and did not do anything there. That since he has been in Paris, he has not yet taken any steps to find a job, having always eaten up his money. Having had him searched, there was nothing suspicious found on him, and he added that he did not prowl the quays, and did not go as far as La Fourissière.

This done, said Barthe was released, and we enjoined him not to prowl at night and in suspicious places, and with respect to said Liber, who seemed moreover very suspicious to us, he was turned over to said sieur Desurbois, who took charge of him by virtue of said orders to take him to his destination.

We then continued said patrol and, in response to the tip that said sieur Desurbois received that said Liber was living from trade in pederasty with another individual with whom he lived in a furnished room and as suspicious as said Liber, we went to the rue Jean de l'Epine to a boarding house kept by one Tezenas, the same house as that of said LaForest, innkeeper, where we found in the shop of said LaForest an individual suspected of being said Liber's comrade, which individual sieur Desurbois arrested by virtue of said orders that he carries. And having had him brought before us, he told us that he is named Joseph Merillat, 24 years old, native of Mâcon, without an occupation, came to Paris two months ago with said Liber, apprentice butcher, in order for him, the deponent, to seek a position as a servant. That he has lived in the crime of pederasty with said Liber for the past three years, but more especially since they came together to Paris, where they sleep together. That said Liber has consummated this crime on him, the deponent, once, but that said Liber's greatest passion is to have it put in his mouth, which he, the deponent has done to him several times, and the last time this morning before getting up. That he, the deponent, was debauched into this crime six years ago by an old man named Duperey, whom he was told was a Jesuit, and that he also fooled around several times about a year later with an apprentice cafe-keeper whose name he does not know, all this in Mâcon. That it is said Liber who helps him live in Paris and who has paid his expenses since Mâcon. That he brought him to Paris to the [French or Italian] Comedy and Nicolet's.[44] That he has still not taken any steps to find a job, said Liber intending to buy the investment in the inn for the two of them from said LaForest. Having him searched, there was nothing suspicious found on him. This done, said Merillat was turned over to said sieur Desurbois, who took charge of him by virtue of said orders to take him to his destination.

We then continued said patrol until half past midnight and of everything composed and drafted the present minutes, which said sieur Desurbois signed with us.

ARRESTS, 22 FEBRUARY 1785[45]

. . . sieur Desurbois . . . arrested an ecclesiastic brought by the guard for having tried to seduce into the crime of pederasty a journeyman mason at whose home he presented himself in order to sleep with him, to which end he offered to give him twelve livres, and brought him before us and brought said mason to make his statement to us, and said sieur Desurbois signed.

And also appeared before us Gabriel Guinedon, journeyman mason, living in Paris on the rue des Cannettes, near Saint-Sulpice, who stated to us that this evening at 8:30 or thereabouts, in coming home, he met, on said rue des Cannettes, the arrested ecclesiastic, who accosted him and said to him, "My friend, would you be willing to lodge me tonight? I will give you twelve francs." That he, the deponent, said to him that for that price he would find a better inn than his room. That said abbé answered, "What does it matter to you, as long as you earn my money rather than someone else?" That he, the deponent, having returned to his house, said abbé entered a moment later and went upstairs. That, seeing it, he, the deponent, made a sign to one of his neighbors to come upstairs behind them. That being on the landing where he, the deponent, lives, and said abbé having reached that place, asked him, the deponent, if he liked women, to which he, the deponent, answered yes, that he then asked if he liked men, that he, the deponent, answered, "I do not hate them. Why would you want me to hate them? They've never done me harm." That then said abbé said, "Well, kiss me, then," presented himself to kiss him, the deponent, and put his hand on his [private] parts on top of his breeches, while saying to him, "Do you like to f [uck] in the ass?" That he, the deponent, pushed him vigorously with a punch and a kick that made him fall on the staircase. That he got up and said, "My friend, don't hit me, I'm going to give you twelve francs." That he, the deponent, said to him, "I don't want anything to do with your money," and went down the stairs to hold him back and have him arrested. That said abbé removed his frock coat and threw it on the stairs, and, having seen one of his neighbors on the stairs, he began to cry, "A thief! They're killing me." That he, the deponent, nevertheless followed him with the help of the neighbor to whom he had made a sign, while going upstairs, to follow them. That since he saw him held back by said neighbor, and that he, the deponent, had gone down to send someone to find the guard, said abbé asked if he could not find some place to get away. That he was arrested, and that he, the deponent, came to make the present statement to us, of which he requests a copy, which we gave him, and, summoned to do so in keeping with the ordinance, stated that he does not know how to write or sign.

Having had the arrested individual brought forth, we proceeded with his interrogation, as follows.

Asked about name, nickname, age, birthplace, status, and residence.

Answered, after the oath taken by him to tell the truth, that he is named Maximilien LeClerc de Piervalle, 30 years old, native of Montmartre, priest of the diocese of Paris, not being assigned to any parish, saying mass at the Oratory on the rue Saint-Honoré, and living on the rue du Sépulchre on the alley between the cleaning shop and the stationary store.

Asked how long he has been addicted to pederasty and by whom he was debauched.

Answered that he has been addicted to it for about ten years, that he developed this taste at the seminaries and collèges, that his passion is to kiss men, to suck their [private] part, to masturbate them, and to have himself masturbated, and to have his part sucked, but that he does not have the inclination to consummate the crime from behind, and that he only indulged in those amusements at home or in alleys.

Asked with whom he indulged in this debauchery.

Answered that he cannot specify the people well, because they never told him their names or their addresses, except for a tall young man at whose residence he was, in a house opposite the Café Dauphin on the new boulevards near the rue de Vaugirard, which individual sells boxes and candy and occupies the store that is opposite said Café Dauphin, wears earrings, and told him, the deponent, that he had consummated this crime with a Polish nobleman, that he, the respondant, did not pay this young man anything but paid others twelve and twenty-four sous.

Asked if he does not go to indulge in this vice on the promenades and in the public gardens.

Answered no, that he has been accused of it by, among others, sieur Mercier, painter living on the rue Saint-Victor across from Saint-Nicolas, at whose home he had boarded, but that he does not go there [promenades and gardens], however.

Having read him said Guinedon's statement and asked him to respond,

Said that the truth is that about six weeks ago having met this mason, he, the deponent, asked him if he wanted to jerk him off. That he, having answered yes, he went up to the mason's residence, where this mason told him that before [he did it], he had to give him some money. That he, the respondent, did not have any at the time. He suggested that he come to his room and that he would give him some, which he accepted, but that he, the respondent, having taken the rue de [illegible], lost sight of him, and that this evening, having found him on the rue des Cannettes, he, the respondent, asked him if he wanted him, the respondent, to go up to his place. That the other having agreed, he went up to said mason's room, whose name he does not know, on the fifth floor. That being there, he, the respondent, kisses him, and suggests that he jerk him off. That said mason asked him for some money before doing it. That he, the respondent, offered him ten sous, which was all the money he had, and put them on his table. That not being pleased with it, he grabbed him by the collar and told him that he would not leave unless he gave him his frock coat, then, having opened the door, after he, the respondent, had given him his brown frock coat, told him that he could go away safely. That he, the deponent, left and, being on the stairs, met another individual, a friend of the mason, who kicked him, the respondent, in the thigh, which made him fall on the stairs, which made him yell, "The Guard!" and "Murder." That said mason was advised by a person to put his frock coat and his, the respondent's, hat on the stairs and to say that it was he, the respondent, who had put them there, and that this mason, having called the guard, had him, the respondent, arrested.

Asked if he had not already received reproaches from his superiors for his morals.

Answered that Monsieur the archbishop of Paris addressed some to him three years ago, that his creditors had presented the archbishop with memorandums about some debts he accumulated as well as his morals, without going into other details.

Asked if he has never been in prison.

Answered no.

Having had him searched, there was nothing suspicious found on him.

The present interrogation read to him, said his answers contained the truth, persisted in them, and signed.

And having had said Guinedon brought before us, after said abbé Leclerc maintained against him the facts contained in his interrogation and that concern him, we took from said Guinedon the oath to tell the truth about said facts and called on him to respond to them. And said Guinedon agreed that indeed said abbé came to his home about a month ago, although he did not know him, and only suggested to him to let him enter his home and did not make him any other proposition. And that today, he did not receive the ten sous mentioned by said abbé, who did not even enter his room, and that he did not leave his frock coat as he claimed but that it is on the stairs, in fleeing, that he removed and threw his frock coat, and, summoned to do so in keeping with the ordinance, stated that he does not know how to write or sign.

This done, said sieur Le Clerc de Pervalle was turned over to said sieur Desurbois, and said Guinedon, given that he seems to have tried to extort money from said sieur Le Clerc, was likewise turned over to sieur Desurbois, who took charge of both of them, by virtue of said orders that he carries, to take them to their destination, and signed.

Arrests, 22 June 1785[46]

. . . sieur Desurbois . . . arrested at the exit of the Tuileries two individuals, one of them observed there prowling in suspicious places and accosting several individuals. The other also observed there prowling in the most suspicious manner and picking up, among others, an individual with whom he was overheard talking about pederasty, with another party about going to fool around, who brought them before us in order to have the report about their arrest drafted and signed.

Having had the first of the arrested individuals brought forth, dressed in a suspicious outfit, having a very wide tie, earrings, a round hat, and having a cane in his hand with a sword inside, in response to the questions addressed to him by us and after the oath taken by him to tell the truth, he told us that he was named Claude, count de Beauharnais, 28 years old, native of La Rochelle, officer in the regiment of the French Guards, living in Paris on the rue Notre Dame des Victoires, that he went to the Tuileries at the end of the terrace by the water to see the illumination of the Hôtel de Montmorency on the quay, that then he crossed the garden and left it by the courtyard of the riding school, but neither accosted nor talked to anyone and he is not at all addicted to pederasty, and signed.

Having had the other arrested individual brought forth, in response to the questions addressed to him by us and after the oath taken by him to tell the truth, he told us that he is named Jean Gouldhorn, 37 years old, native of Embden in Prussia, valet in the service of Monsieur de Fitz Hemberg, Englishman, lodged on the rue du Colombier at the hôtel du Parc Royal, that he went to take a walk in the Tuileries gardens under the trees, that a man who passed in front of him several times accosted him and suggested going with him, saying that he had two pretty girls, but they did not speak about the debauchery of men and he is not addicted to it. He indeed offered three écus of six livres when he was arrested in order to be let go, because if he went back too late he would lose his job. Having had him searched, nothing suspicious was found on him, and he signed.

This done, said Monsieur the count de Beauharnais and said Gouldhorn were released, and we enjoined them not to go to the Tuileries and other suspicious places in the evening anymore, and said sieur Desurbois signed.

9. Methodical Encyclopedia: Police and Municipalities (1789–91)[47]

INSPECTOR (1791)

Arrests of pederasts were very common under Monsieur Lenoir and at that time gave a lot of work and profit to the one who was responsible for it. There was much disrespect and abuse. It [the rate of arrests] has lessened, and these gentlemen [*ces messieurs, sodomites*] devote themselves freely to their taste. . . .

PEDERASTY (1791)

It is the same thing as sodomy.

We would not enter into any discussion of this vice if the police had not involved themselves in preventing its spread in society. It can be seen under the word "inspector" that there was formerly in Paris a unit of police specifically charged with the task of knowing and arresting pederasts, whose number is generally quite large in the capital.

The police used to divide them into two groups: those who surrender themselves to this kind of prostitution and those who support it through their taste for this monstrous depravity.

The investigations of the police were primarily directed against the first group. The names of the youths who composed it were all, or almost all, written down in the inspector's registers. The names of those whose pleasures they served were also noted.

The conduct of the police was quite prudent in this regard and of a nature to prevent the publicizing of the scandal. Those who were known as pederasts of the first or second group were not bothered as long as their debauchery was kept secret, but when it happened that members of one or the other looked for sex in public, then they were arrested and taken before a commissioner. Since the youths who prostituted themselves to this disorder were, as they still are in general, only hairdressers, wigmakers, grooms, unemployed servants, they were usually sent to Bicêtre for one, two, three, or six months, as the lieutenant of police decided based on the inspector's or commissioner's report. As for those with whom they were found, their names were taken down, and sometimes they were subjected to extortion. . . .

10. JACQUES PEUCHET (1760–1827), *Parisian police official in 1789–90*

Memoirs Extracted from the Archives of Police of Paris (1838)[48]

It was under Monsieur Hérault and by him that the sentence was handed down against Deschauffours, accused and convicted of the crime of sodomy. Deschauffours was condemned on appeal to the Tournelle [criminal chamber of the parlement] to be burned alive in the place de Grève.

I should point out here that at the time when this judgment was issued, the police knew of more than twenty thousand individuals who offered examples of the vice for which Deschauffours mounted the pyre. They wanted a public punishment. It fell not on the most criminal but on the least protected of the guilty. That is the common practice, and it is for this reason that the populace can flatter itself for being more virtuous than the great. The executioner worked at making it so. In the long run, pederasty can only be a vice of great lords.

III

‑►‑◄‑

Representations

INTRODUCTION

While theologians, jurists, and doctors condemned sodomy and police pursued sodomites, contemporaries discussed and debated the subject of same-sex relations in other contexts and for other purposes. Diarists, moralists, and satirists recorded gossip, composed reflections, and published polemics that not only documented rumors about particular individuals but also constituted commentary on French society as a whole. They commonly associated sodomy with religious deviance, foreign (especially Italian) influences, and political disorder. They used the theme of sexual irregularity to defame Catholics and Protestants, clergy and nobility, ministers and monarchs. Protestants charged popes, cardinals, bishops, priests, monks, and Jesuits with sodomy, and Catholics returned the compliment in their attacks on Calvinist leaders.[1] Dissatisfied with the efforts of Henry III (1551–89, king from 1574) to end the religious conflicts that had disrupted the country for decades, Protestants and Catholics in turn denounced him, with all the rhetorical resources available to them, as a heretic, devil, monster, tyrant, and sodomite surrounded by effeminate male favorites.[2] Pamphleteers recycled this combination of religious, political, and sexual themes in their attacks on the Italian-born cardinal Jules Mazarin (1602–61), prime minister during the civil war known as the Fronde (1648–53).[3] Sodomy played a large role in reports about the corruption of the court in less turbulent times as well, as indicated by the sources from the reigns of Louis XIV (1643–1715) and Louis XV (1715–74) included in Section A.[4]

That section also includes two substantial and influential discussions of and excerpts from several pornographic texts about sexual relations between women, who are not well represented in the types of materials used in the first two parts of this collection.[5] Religious and legal sources generally state that the strictures against sodomites apply to tribades as well, but they devote much more attention to the former than to the latter. Police records contain abundant information about female prostitutes but almost nothing about women sexually interested in other women, who evidently did not make a nuisance of themselves in parks and streets. The stories of Brantôme's ladies, Chorier's Tullie, d'Argens's Thérèse, Pidansat de Mairobert's Sappho, and Mirabeau's Laure, on the other hand, show how contemporaries combined gossip about actual women with stereotypes about sexual deviance and expressed concerns about sexual disorder through stories about fictional women.

95

The sources in Section A document continuity and change in assumptions about and attitudes toward both female and male same-sex relations. They identify sexual deviance with gender inversion (passivity and effeminacy in men, activity and masculinity in women), invoke and rework classical and Biblical references, and associate "unnatural" habits with exotic "others."[6] They describe informal and formal initiations and organizations, against the background of the development of the sodomitical subculture in Paris. "Tribadism has always been in vogue among women, like pederasty among men," one source acknowledged in 1784, "but these vices had never been flaunted with as much scandal and ostentation as today."[7] The perceived increase in the incidence and visibility of male and female deviance stimulated more extensive and vigorous commentary about the subject in the second half of the eighteenth century, as did ongoing debates involving advocates and opponents of Enlightenment.

The philosophes challenged their contemporaries to repudiate errors based on Scripture and mistakes based on custom and to formulate more reliable standards of human conduct by using the faculty of reason to investigate nature. The concept of nature, however, turned out to be more problematic than they generally expected or acknowledged. All of them indignantly rejected the argument that government was obligated to punish crimes traditionally defined in religious terms, and most of them offered naturalistic explanations for the practice of sodomy, but few of them completely rejected the argument that the "crime against nature" was unnatural.[8] Many of them admitted personal aversion to same-sex relations and rephrased the conventional objections in more modern language. Like Montesquieu and Voltaire, the aspiring philosophe Jean Paul Marat left no doubt about his feelings about "that disgraceful love that nature rejects" in the essay he submitted for the competition announced by the academy of Châlons-sur-Marne in 1778 on the subject of the reform of the system of crimes and punishments.[9] Like Montesquieu and Voltaire, again, Brissot and Bernardi (who won the prize) cited utilitarian considerations in their essays submitted for the same competition. The materialists Diderot, Naigeon, and Sade, by contrast, expressed more relativistic and radical views about nature and sexuality.

A. GOSSIP AND SATIRE

1. HENRI ESTIENNE (c.1531–98), *printer, Humanist,*
Protestant, satirist

Apologia for Herodotus (1566)[10]

On the Sin of Sodomy and the Sin against Nature in Our Time

And if there were nothing to be taken into consideration other than sodomy, such as we see it in our day, could one not with good reason call our century the paragon of wickedness, even loathsome and execrable wickedness? I admit that the pagans (at least most of them) were addicted to this vice, but is it possible that such a vice has ever been considered a virtue among those who have called themselves Christians? Certainly not. But in our time not only have people considered it a virtue, but people have gone so far as to write its praises and then have them printed to be read by everyone. For this should not be kept secret, that the Florentine Giovanni della Casa, archbishop of Benevento, composed a book in Italian verse in which he praises in a thousand ways this sin, which true Christians cannot even think about without horror, and among other things he calls it a divine work. This book was printed in Venice by a certain Trojan Nanus, according to the testimony of some, which they put down in writing.[11] Now the author of this most abominable book is the very person to whom I dedicated some of my Latin verses while I was in Venice, but I protest that I made this mistake before knowing him to be such and that, after having been informed about it, the mistake was already irreparable. But to return to the subject of such an infamous sin, is it not a great shame that those who, before setting foot in Italy, abhorred even the remarks that were made about it, after having lived there, not only take pleasure in the words but go as far as actions and profess it among themselves, like something that they learned in a good school? For as for those who through bad habit have retained only Italian ways of speaking, which, though marked with such wickedness, are used there ordinarily and customarily, they indeed have some semblance of an excuse, but what can the others allege? Now I do not want to say, however, that all those who find themselves stained with this sin learned it either in Italy or Turkey, for our master Maillard certainly professed it and he, after all, had never been there, but he who, as a doctor of the Sorbonne, had so many poor folks burned unjustly and without cause every day was he whom the agents of justice could have had burned with good reason, not as a Lutheran (as they called [Protestants] then) or overly obstinate evangelical, but as a sodomitical bugger.[12]

But I would be very wrong if, being on this subject, I forgot Peter Louis or rather Alois (for his name was Pietro Aloisio in the Italian language), son of Pope Paul, the third of that name.[13] This Louis, duke of Parma and Piacenza, so as not to deviate from the papal line from which he descended, was so addicted to this horrible and loathsome sin, indeed so carried away with the passion for it, that he not only forgot completely about God's judgment, he not only forgot about the esteem in which he ought to hold his

honor (at least with regard to those who naturally have no great scruples about aban-
doning themselves to such wickedness), he not only forgot that he was a man, but he also
forgot about the risk of death (which even animals dread), which confronted him daily.
For not contenting himself with having acted out his infamous desires upon a great num-
ber of persons of various ranks, in the end he turned his attention to a young bishop named
Cosimo Cherio, occupying the bishopric of Fano, and, unable to achieve his objective in
another way, he had him seized by his men.[14] After which act it was not long before he
received the reward owed to such monsters, and since he had led an infamous life, so an
epitaph was made for him so infamous that it demanded readers who had taken some pre-
caution for fear of feeling squeamish.

[discussion of bestiality]

I have just told the story of a marvelously strange crime, but I am going to tell the
story of another that is even more so (yet not as vile) that also happened in our time,
about thirty years ago. It is about a girl from Fontaines, which is between Blois and
Romorantin, who, having disguised herself as a man, worked for about seven years as a
stable hand at an inn in the suburbs of Foye, then married a girl from the area, with whom
she lived for about two years, working in the vineyards. After which time, the wicked-
ness she employed to fake a husband's function having been exposed, she was arrested
and, having confessed, was burned alive there. This is how our century can boast that, in
addition to the wickednesses of the preceding ones, it has some that are characteristic of
and pecular to it. For this story has nothing in common with that of certain vile women
who were called tribades in the olden days.

2. PIERRE DE L'ESTOILE (1546–1611), *official in the royal chancery*

Memoirs and Journals[15]

July 1576

The name of minions began, at this time, to make the rounds through the mouths of the
people, to whom they were very odious, as much for their ways of acting, which were
silly and haughty, as for their effeminate and immodest makeup and attire, but especially
for the immense gifts and bounties that the king gave them, which the people thought
were the cause of their ruination. Yet the truth was that such bounties, unable to remain
in the minions' savings for a single moment, were passed on to the people as fast as water
is by a conduit.

These fine minions wore their hair longish, curled, and recurled through artifice, rais-
ing their little velvet caps on top, as whores from the brothel do, and the ruffs of their
linen shirts starched and half a foot long, so that to see their heads above their ruffs, it
looked like it was the head of Saint John on a platter.[16] The rest of their apparel was
designed in the same way. Their activities were gambling, blaspheming, playing bowls,
dancing, tumbling, brawling, lechering, and following the king everywhere and in all soci-

eties, doing and saying nothing but to please him, caring little, in effect, about God and virtue, contenting themselves with being in the good graces of their master, whom they feared and honored more than God. . . .

April 1583

On Holy Thursday, 7 April, around nine o'clock in the evening, the procession of the penitents, in which was the king with all his minions, went all night through the streets and to the churches, with great magnificence of candles and excellent music, with bag-pipes.[17] And there were some (even some minions, according to what people said) who scourged themselves in this procession, whose poor backs were seen to be all red from the blows they gave themselves.

About which the following stanza was circulated:

Minions, who carry the royal blood of France [the king]
Tractably on their rumps [as a horse carries a rider],
Don't beat only your back,
But also your Q [*cul,* ass] that committed the offense. . . .

Several other such lampoons, mockeries, and slanders about this new scourging and penitence of the king and his minions were composed and spread, among which those that follow (although they deserve, for the most part, to be burned with their authors) were nevertheless known at court and in Paris, sure signs of a great storm ready to befall a state.

I
You who have humbled yourself
To serve God with a human heart,
New penitents, don't forget
To have your scourge [or penis] always in hand.

II
They are paired off, two by two,
In a devout enough manner,
But I find them wicked
When they go single file [or copulate from behind].

III
They are discreet and quite wise
To cover their faces in this way,
For one would see, among the good ones,
The buggers and buggerers.

IV
The flagellants are clad with cloth
Just like their church,
But the truth will be such

That their leader will be seen in a smock [worn by criminals on the way
 to execution].

V

The king became a penitent
Because he has no children,
But hear why that is:
It's because he hardly tries [or gets hard].

VI

There he is, now and then almost a priest,
But so much vice surrounds him
That I believe he'll change his state
And that he'll lose his crown.

VII

You want people everywhere to believe
That your life is devout?
Beware the wrath of God,
Who punishes the wicked soul.

VIII

He has chosen Our Lady
For the patron of his vows,
But he prefers, on my soul,
A young lad with blond hair.

IX

You should not marvel that the great king of the Gauls
Has adopted his minions as his sons.
There's a good reason for it, since they have carried this father
On their backs and shoulders [during sexual relations], as Aeneas did his.[18]

X

They are like Judas
And want to do as the Jews did,
For their company and crew
Is only intended to overthrow Jesus Christ,
And these foolish hypocrites seek them
In plain daylight with lanterns [or rascals].

XI

The female penitents have only
Opened their c[unts],
But they say that this male penitent [the king]
Commits the sin against nature.

XII [IN MARGIN: VILE]

If the f[uckers], f[ucked] in the buttocks,
Don't want to be f[ucked] any more,

But very well scourged [or aroused] and beaten [or banged],
Do you see any deceit in it?

XIII

They are sorry, it is said,
About their incestuous lewdness.
Let's couple them with the repentant prostitutes
Who, as whores, made their c[unts] available.

. .

Stanzas composed by Jan Sibiloth*

XV [VILE]

What! Isn't it a great shame
That such a fine kingdom is ruined,
Shedding, on the pretext of friendship,
Royal blood in s[hit].

XVI [VILE]

You seem a fool and a dolt,
In spite of God, to your lay brothers.
They will make you a wretch and a rogue.
These are your trodden [or screwed] penitents.

February 1586

The first day of February, Master Jean Dadon, a learned man renowned in the University of Paris, recently regent and at the time teacher at the collège du Cardinal Lemoine, not long before rector of said university, was hanged by judgment of the court in the Grève, and his body was then burned and reduced to ashes, for having committed sodomy with a child in his service. He defiled him so much that the child, feeling quite ill from it, was forced by the pain to complain about it to his friends and relatives, who pursued the matter so earnestly that it was not possible for said Dadon to escape such an ignominious death, although he had many friends and much support, even on the side of the League, to which he belonged and which did for him what it could, considering him a good enough man (although he was a bugger) because he belonged to the League.

January 1602

Toward the end of this month, the two Carmelite friars accused of sodomy, having been sent back before the official, from whom they had received a judgment of absolution, were set free and returned to their Carmelite monastery, where, out of curiosity, I went to see them and spoke at length with father Camus.[19] And if innocence could be proved by words, there would be no more saintly and innocent men in the world than these. He

From the realm of all Sodoms the Lord picks out Lot for himself [sibi Loth].

told me that they had been examined completely naked at the Châtelet and that, by the grace of God, their virginity had been revealed and recognized, which one would not have judged from the physiognomy of the handsome father. And likewise La Noue, surgeon, who examined the children, does not say so, as one of my friends, to whom La Noue (who is nevertheless neither a heretic nor a Huguenot, but a bigoted Catholic) related it in particular, assured me. Camus complained strongly to me about the lieutenant criminal and told me (which was not true) that he had treated him as badly as he could have, was very pleased with president de Villiers, to whom he had had their trial records shown, and told me that as soon as he had seen them he had the judgment handed down by the official.[20]

The honor of religion, which they wanted to defend, and the respect they had for the outward garb that they wear, more than for that of innocence, saved their honor and lives, according to the report of the least passionate. For the people of Paris themselves considered them so guilty of the deed that many of them still cannot be persuaded that they were not punished secretly as they deserved, and the people believe that the friars were thrown into the water in a sack.

February 1602

On Saturday, the ninth of this month, a binder of church books (which he went out looking for in the villages) named Charles Auvré and, by a nickname that people had given him, Monbagage, was burned in the place Maubert in Paris, as the abominable sodomite that he was, tied to a stake, on which he was strangled after having felt the fire. They wanted to make the people believe that he was a Huguenot and that the Carmelite friar who had been given to him to console him had converted him, which was false. For he even boasted about having left his wife in Reims on this occasion, which was nevertheless not true, but he alleged it to conceal his vileness, her relatives having taken her back because she had complained to them that he wanted to have relations with her as he since did with children.

March 1611

Wednesday the sixteenth, when I was in Adrian Perrier's [book]shop, commissioner Langlois arrived and forbid him to distribute or in the future sell to anyone of any rank the book by a Jesuit named Sanchez, *On Marriage*, printed in a folio edition, or even to own or have it in his shop.[21] The decree (which he showed me) used these words: "the book for being abominable and the reading of it wicked and dangerous." It was nevertheless sold publicly in Paris and everywhere, printed and reprinted with the name and identity of the author, whom people considered learned, though not a bugger, because he was a Jesuit. But the last part is commonly the worst, as one discovers toward the end and in the second part of his book, where he discusses the fine art of sodomy thoroughly but in such a vile and abominable manner that this paper on which I am writing blushes from it, and, what is more, he writes like a man about whom it seems to be the case that he had much practiced the craft.

Plutarch says that there was a law that ordered that if one rooster had mounted another rooster (even in the absence of chickens), it would be burned alive, this act being like a

forewarning and sign of misfortune, so much did those poor pagans hold such a horrible crime in abomination and horror, the likes of which does not occur among brute beasts.[22]

And yet, in the last century (the sewer of all the preceding ones), we see it practiced and taught by the Jesuits themselves, who seem to want to incline the French to it, as to parricide, the French who are today enough and overmuch inclined to this abomination and vileness on their own.

3. PIERRE DE BOURDEILLES, SEIGNEUR DE BRANTÔME (c.1540–1614), *aristocratic author of observations about contemporary men and women published half a century after his death*

Collection of Ladies' Lives[23]

ON LADIES WHO MAKE LOVE AND CUCKOLD THEIR HUSBANDS

So I will ask yet this question, which has never been looked into or, perhaps, thought of by anyone, and then no more, namely, whether two ladies in love with each other, as has been seen and is often seen today, sleeping together and doing what is called *donna con donna* [woman with woman], imitating the learned Sappho of Lesbos, can commit adultery and between them cuckold their husbands.

Undoubtedly, if one wants to believe Martial, in his first book, epigram 90, they commit adultery. He there presents and speaks to a woman named Bassa, a tribade, attacking her vehemently for the fact that people never saw men enter her home, so that she was regarded as a second Lucretia.[24] But she came to be exposed because people saw many beautiful women and girls routinely coming there, and it was found that she herself served them and played the role of man and adulterer and coupled with them. And Martial uses these words: *to unite twin cunts*. And exclaiming later, he states this enigma and leaves it to be imagined and guessed in this Latin line:

There, where there is no man, yet there is adultery.

I knew a courtesan in Rome, old and sly if there ever was one, who was named Isabella de Luna, a Spaniard, who took such a liking to a courtesan named Pandora, at the time one of the beauties of all Rome, who came to be married to a butler of cardinal d'Armagnac without, however, giving up her first trade.[25] But this Isabella kept her and usually slept with her, and, as licentious and unrestrained as she was in her speech, I often heard her say that Isabella turned Pandora more of a whore and made her give her husband horns [cuckold] more than all the pimps she'd ever had. I don't know in what sense she meant this, if it is not the case that she based what she said on this epigram of Martial.

It is said that Sappho of Lesbos was a very good mistress in this art. Indeed, they say she invented it, and that the ladies of Lesbos have imitated her in this since and continued down to today. As Lucian says, such women are women of Lesbos, who will not

tolerate men, but approach other women as men themselves do.[26] And such women, who like this practice and will not tolerate men, but devote themselves to women, as men themselves do, are called tribades, a Greek word derived, as I have learned from Greeks, from *tribo, tribein,* which is the same as saying *fricare, freyer,* or *friquer* [to rub], or to rub each other. So tribades are call *fricatrices,* in French fricatrices, or those who perform the fricarelle in the art of *donne con donne* [women with women], as it has still been found today.

Juvenal also speaks about these women when he says, "*she pays homage to the rubbing of Grissas,*" speaking of such a tribade, who adored and loved the fricarelle of one Grissas.[27]

That good fellow Lucian makes a chapter out of it and says, as it were, that the women come to couple together like men, coupling with lewd, secret, and monstrous instruments fashioned in a sterile form. And this name, which is rarely heard applied to these fricarelles, appears freely throughout his work, and it must be that the female sex are Philenises, who performed the activity in certain mannish loves.[28] Yet he adds that it is much better that a woman be addicted to a libidinous liking for playing the male than it is for a man to become effeminate, so little does he show himself courageous and noble. According to this, then, the woman who imitates the man in this way may have the reputation of being more valorous and courageous than another woman, as I have known some to be, as much for the body as for the soul.

In another place Lucian presents two ladies chatting about this love, and one asks the other if so-and-so had been in love with her and if she had slept with her and what she had done to her.[29] The other answered her freely, "First, she kissed me as men do, not only in joining her lips, but also in opening her mouth (this means like a female pigeon, with the tongue in the mouth), and, although she had no virile member and was like the rest of us, even so she said that she had a manly heart, love, and everything else. And then I embraced her like a man, and she did the same to me, kissed me and *allantait* (I don't understand this word well) [panted], and it seemed to me that she got pleasure beyond measure out of it. And she coupled in a certain way that was much more pleasant than with a man." That is what Lucian says.

Now, from what I've heard said, there are many such ladies and Lesbians in several locations and regions, in France, Italy, Spain, Turkey, Greece, and other places. And where women are kept in seclusion and do not have complete freedom, there this practice continues strongly. For such women, burning in their bodies, surely must, as they say, make use of this remedy to cool off a bit or else they burn all over.

Turkish women go to the baths more for this lechery than for anything else and are very addicted to it. Even courtesans, who have men at their disposal at all hours, yet have recourse to these fricarelles, seek each other out and love each other, as I have heard it said by some in Italy and Spain. In our France such women are common enough, and yet it is said, nevertheless, that it has not been for long that they have dabbled in it, indeed that the fashion for it was brought from Italy by a lady of rank whom I will not name.

I heard it told by the late Monsieur de Clermont-Tallart the younger, who died at La Rochelle, who, as a young boy, having the honor to be the companion of Monsieur d'Anjou, later our king Henry III, in his study and studying with him customarily, whose tutor was Monsieur de Gournay, that one day, being in Toulouse, studying with his master in his cabinet and being seated in a corner by himself, he saw, through a little crack (inasmuch as the cabinets and rooms were made of wood and had been built quickly and in haste thanks to cardinal d'Armagnac, archbishop of the place, to receive and accommodate the king and

all his court better) in another cabinet, two very tall women, with their clothes all tucked up and their drawers down, lie one on top of the other, kiss each other in the manner of pigeons, rub themselves, caress each other, in a word move their hips vigorously, copulate, and imitate men.[30] And their sport lasted almost a full hour. They were so overheated and tired that they were left so red and sweaty from it that, even though it was exceedingly cold, they were worn out and were obliged to rest for as long. And he said that he saw this game played on several other days, in the same way, as long as the court was there. And he never again had the convenience of seeing this sport, inasmuch as the room facilitated it on this occasion and on the other occasions he could not see.

He told me even more about it than I dare to write about it and named the ladies. I do not know if it is true, but he swore it to me and vouched for it a hundred times with sincere oaths. And, in fact, this is quite probable, for these two ladies have in fact always had the reputation of making and prolonging love in this way and spending their time so.

I have known several others who have discussed such loves, among whom I have heard talk in society about one who is quite fully addicted to this and who loved many ladies, honored and served them more than men do, and made love to them as a man does to his mistress, and so she took them with her, maintained them in bed and board, and gave them what they wanted. Her husband felt very comfortable and quite pleased about it, like many other husbands I have seen, who were quite content that their wives were involved in these affairs rather than those with men (not imagining their wives to be so foolish or whorish). But I believe they are quite mistaken, for, from what I have heard, this little practice is but an apprenticeship leading to the big one with men. For, after they have warmed up and sent each other into heat, their warmth not decreasing on account of this, they must bathe in cool running water, which refreshes much better than still water. Thus I have it from reliable surgeons, and considering that, if anyone wants to dress and cure a wound well, he must not waste time medicating and cleaning around it or along the edge but must probe it to the bottom and apply a syringe and bandage to it well before that.

How many of these women of Lesbos have I seen who, for all their fricarelles and rubbings together do not forsake recourse to men! Even Sappho, who was their mistress, did she not take to loving her good friend Phaon, on whose account she died?[31] For in the end, as I have heard several ladies report, nothing matters but men. And whatever they do with other women, it is only practice for the real thing with men, and these fricarelles only serve them for lack of men.[32] If they find men conveniently and without scandal, they would duly leave their companions to join them and fall upon their necks.

In my time I have known two lovely and respectable gentlewomen from a good family, both of them cousins, who, having slept together in the same bed for the space of three years, became so accustomed to this fricarelle that, after having supposed that the pleasure was rather modest and incomplete by comparison with that with men, they set themselves to trying it with them and turned into very good whores from it. They confessed afterward to their lovers that nothing had corrupted them so much and incited them to it but this fricarelle, detesting it for having been the only cause of their corruption. And for all that, when they ran into each other, or with others, they always made some snack of this fricarelle and thereby always increased their appetite for the other with men. And this is what a respectable woman I knew once said, who was asked by her servant one day if she did not practice this fricarelle with her companion, with whom she usually slept. "Oh, no," she said in laughing, "I like men too much," but she nevertheless did it with both.

I know a respectacle nobleman who, desiring one day to seek a very respectable gentlewoman at court in marriage, asked the advice of a female relative of hers about it. She told him frankly that he would be wasting his time, inasmuch (she told me) as such and such a lady (whom she named to me and about whom I knew some news) would never allow her to marry. I understood the hitch quickly, because I knew very well that she kept this gentlewoman in bed and board for her pleasure and kept her for herself like a treasure. The nobleman thanked his cousin for this good advice, not without attacking her, in laughing, for speaking thus in this matter on her own behalf as well as for the other woman, for she got some little strokes out of it now and then on the sly, which she, however, denied to me.

This story reminds me of some who have their own whores in this way, whom they love so much that they would not share them for all the wealth in the world, even with a prince, a great noble, even with a colleague or a friend, so jealous are they of them, like a leper of his little keg, and yet he offers it to anyone who wants to drink from it.[33] But this lady wanted to keep this gentlewoman entirely for herself, without sharing her with others. Nevertheless the gentlewoman cuckolded her on the sly with some of her companions.

They say that weasels are driven by this love and are pleased to conjoin themselves, females with females, and live together, so that women loving each other with this type of love were formerly represented in hieroglyphic signs by weasels. I have heard talk about a lady who dabbled in this love and always kept some and and took pleasure in watching these little beasts couple in this way.

Here is another point: it is that these feminine loves are handled in two ways, some through fricarelle and, as this poet says, through *uniting twin cunts*. This way does not cause any harm, some say, unlike when one makes use of instruments made of [missing word], but which people have chosen to call dildos.

I have heard it said that a great ruler, having suspicions about two ladies of his court who made use of them, had them watched so well that he surprised them, so that one was found possessed of and fitted with a large one between her legs, neatly fastened with little bands around her body, so that it seemed to be a natural member. She was so surprised that she did not have a chance to remove it, so that the ruler compelled her to show him how the two of them did it.

They say that several women have died from it, from engendering abcesses in their wombs caused by unnatural motions and rubbing. I am well acquainted with some of this number, to whom serious harm was done, for they were very beautiful and respectable ladies and gentlewomen, for whom it would have been much better if they had kept company with some respectable gentlemen, who for all that would not make them die, but live and revive, as I hope to relate elsewhere. And furthermore, it is said that, for the cure of such illness, as I have heard it said by some surgeons, there is nothing more proper than to have them well cleaned inside there by men's natural members, which are better than the suppositories that doctors and surgeons use, along with waters prepared for that purpose. And nevertheless there are some women, in spite of the misfortunes that they often see follow from them, for whom it is necessary that they have these imitated devices.

I have heard a story told, being then at court, that the Queen Mother having ordered an inspection one day of the rooms and chests of all those who were housed in the Louvre, without excepting ladies and girls, to see if there were any hidden weapons, and especially pistols, during our troubles [civil wars], there was one who was found by the captain of the guards in possession in her chest not of pistols but of four large, neatly made dildos, which gave everyone a good laugh and caused her a good deal of astonishment.[34]

I knew the gentlewoman. I believe she is still alive, but she never looked well. Such instruments, in the end, are very dangerous.

I will tell yet this story about two ladies of the court who loved each other so much and were so ardent about their business that wherever they were, they could not keep or refrain from at least making some sign of toying or kissing, which discredited them very much and gave men much to think about. One of them was a widow, and the other was married. And when the married one, on a day of great sumptuousness, was very well adorned and dressed in a gown of silver linen, since their mistress had gone to vespers, they went into her cabinet and began to perform their fricarelle so roughly and so violently on her close stool [toilet chair] that it broke under them. And the married lady, who was the one underneath, fell backward in her lovely silver linen gown, flat down in the filth from the chamber pot, so that she spoiled and soiled herself so much that she did not know what to do but wipe herself off, as best she could, tuck up her skirt, and go with great haste to change her gown in her room, not, however, without having been noticed and indeed smelled along the way, so much did she stink, about which some who knew the story laughed a lot. Even their mistress, who relieved herself as they did, knew it, laughed herself silly over it. So this ardor must surely have swayed them excessively, that they did not wait for a suitable place and time without discrediting themselves. Even so people pardon girls and widows for liking these frivolous and empty pleasures, preferring to devote themselves to them and relieving their passions in this way rather than consorting with men and getting pregnant and dishonoring themselves or aborting their offspring, as some have done and do. And they think that in this way they do not offend God so much and are not such whores as with men, since there is a big difference between throwing water in a vessel and just watering around it and on the edge. I leave it to them. I am neither their judge nor their husband. They might consider it wicked, but I have seen none who were not quite glad that their wives were smitten with their companions and who wished that they would never commit adultery except in this manner. For, in truth, this coupling is very different from that with men, and, no matter what Martial says, they are not cuckolded on this account. The word of a foolish poet is not like the text of the Gospels. It follows, as Lucian says, that it is much more seemly for a woman to be manly or a genuine Amazon, or to be lascivious in this way, than for a man to be feminine, like a Sardanapalus or Heliogabalus or many others like them.[35] For the more she is like a man, the braver she is. And I rely on the outcome of the debate about all of this.

Monsieur Du Guast and I were reading a little book in Italian one day that is entitled *On Beauty,* written in dialogue form by Angelo Firenzuola, a Florentine, and came across a passage where he says that some women who were created by Jupiter in the beginning were made with this nature, that some started to love men and the others the beauty of each another.[36] But some in a pure and holy way, as of this type there is found in our time, as the author says, the most excellent Margaret of Austria, who loved the beautiful Laodamia Fortenguerra, and the others lewdly and wantonly, like Sappho of Lesbos and, in our time, the celebrated Venetian courtesan Cecilia in Rome.[37] And these by nature hate to marry and flee familiarity with men as much as they can.

On that score Monsieur Du Guast criticized the author, saying that it was false that this fair Margaret loved that fair lady with a pure and holy love, for since she had attached herself to her rather than to others who might have been as beautiful and virtuous as she, it was to be presumed that it was in order to make use of her for her pleasure, no more or less than others. And to conceal her lewdness she said and proclaimed that she loved her in a holy way, as we see several like her do, who disguise their loves with such words.

That is what Monsieur Du Guast said about it, and whoever wants to discuss it further can do as he pleases.

This lovely Margaret was the most beautiful princess of her time in Christendom. Now beauties love each other with whatever type of love they like, but with the lewd kind more than the other. She was married three times, having married, first, king Charles VIII, second, John, son of the king of Aragon, and, third, the duke of Savoy, known as the Handsome, so that, in his time, they were called the best-looking pair and finest couple in the world.[38] But the princess did not enjoy this union for long, for he died very young and at the height of his beauty. She grieved exceedingly for him and therefore never married again.

She had built the lovely church that is near Bourg-en-Bresse, one of the most beautiful and magnificent edifices in Christendom. She was the aunt of the emperor Charles and aided her nephew greatly, for she wanted to pacify everything, as she and the Queen Regent did in the treaty of Cambrai, where they both saw each other and met there, where, I have heard from old men and women what a fine sight it was to see those two great princesses.[39]

Cornelius Agrippa composed a little treatise on the virtue of women and all in praise of this Margaret.[40] The book is a fine one about it, which could not be otherwise given the fine subject and the author, who was a most illustrious personage.

I have heard talk about a great lady, a princess, who loved one among the maids in her service above all and more than the others, about which people were surprised, because there were others who surpassed this maid in everything. But in the end it was found and disclosed that she was a hermaphrodite, who gave the princess recreation without any inconvenience or scandal. It was something else indeed than among those tribades: the pleasure penetrated a bit better.

I have heard a great lady named who is also a hermaphrodite and who has such a virile member, but very small. She is nevertheless more like a woman, for I have seen her looking quite lovely. I have heard of some great doctors who have seen a good number of such and especially very lewd ones.

There at last is what I will say on the subject of this chapter, which I could have lengthened a thousand times more than I did. . . .

4. The Mazarinade (1651)[41]

Muse who pinches and makes us laugh,
Come to me, I pray, and breathe into me
The spirit that inspired Catullus
When he tackled Mamurra.[42]
Just like Catullus I have a grudge
Against the tyrant called Julius,
But my Julius is not Caesar.
He is a whim of chance
Who was born a boy and became a whore,

Who was born for nothing but farce,
For cards and for dice,
For all disorderly pleasures,
And for the ruin of the kingdom,
Unless some master Jean Guillaume [public executioner]
Delivers us from him in the end.

. .

Instead of the cardinal virtues
You have only the animal ones,
The vain pride of a buffoon,
And you are nothing but a loose stallion,
An old bugger involved with a bardash,
And above all a scoundrel.

.

Do you remember Alcalá well,
When, ganymede or valet,
The love of a certain female fruitseller
Earned you many blows of stirrup leather,
When cardinal Colonna
Abused you with words,
And with fleet feet like a rogue
You escaped to Barcelona?[43]
From Barcelona you left for
Your country, where you did your business
So well that you became the whore
Of another bugger with a red biretta.[44]

. .

Poor rat formerly seen
In a little chamois dublet,
When, secretary to Sacchetti,
A worthy job for a wretch,
You served the most dissolute
In the ministry of sins.[45]

.

Constable with a rod [or penis] of Sodom,
Exploiting the kingdom left and right,
Buggering bugger, buggered bugger,
And bugger in the highest degree,
Bugger this way and bugger that way [with both sexes],
Bugger in large and small size,
Bugger sodomizing the state,
And bugger of the highest carat,
Investing the world in the stern,
That is to say, screwing in the rump,
Bugger of goats, bugger of boys,
Bugger in all ways,

Bugger directly descended
From Onan, the notorious masturbator,
Doctor of buggery in both kinds,
Swindler as well as sorcerer,
Man to women and woman to men. . . .

5. NICOLAS CHORIER (1609–92), *lawyer and historian*

The Academy of Women (1680)[46]

OCTAVIE: So, Tullie, here we are sleeping together in the same bed. You've been looking for such an opportunity for a long time, and your husband Oronte's absence has made it happen according to your desire.

TULLIE: I can't say how happy I am about it. Suffice it to say that I have been burning with love for you and that the intensity of that passion has caused me many sleepless nights. My annoyance at not being able to enjoy as I wanted the object that I've cherished more than myself has been intolerable.

OCTAVIE: But, my cousin, I think that if you cherished me then, you don't love me less now.

TULLIE: Yes, my heart, I love you, or rather, I languish and die for love of you. And I can even assure you that my passion equals that of Pamphile [Octavie's fiance].

OCTAVIE: What do you mean by that, my cousin? For I can't imagine what the friendship you have for me and the love Pamphile might have for me have to do with each other.

TULLIE: I'll explain it to you. But first you have to banish completely all that embarrassment and childish prudishness that could interfere with the pleasure of our conversation.

OCTAVIE: Didn't I sufficiently shed all my timidity when you wished to have me completely naked in this bed and I obeyed you? Isn't it enough that I got into bed with you in the same way as if it were with Pamphile and that I've promised you that you'll find as much docility in me as in a novice?

TULLIE: I hope so. So then, for the first proof of your obedience, give me a kiss, but a real kiss from the heart.

OCTAVIE: I'll give you not only one, but a thousand if you want.

TULLIE: Ye gods, what a divine mouth you have! How bright your eyes are! And how the shape of your face resembles the beauty of Venus!

OCTAVIE: But you're throwing off the covers! I can't imagine what I'd have to fear if you weren't Tullie. Here I am, completely naked in your arms. What more do you want?

TULLIE: Ye gods, if you'd give me the power to play the actual role of Pamphile here! But alas, I see that your authority is limited because I don't notice any change in my constitution.

OCTAVIE: Why, Tullie, will Pamphile seize my two tits like that? Will he make his kisses as frequent as yours? And will he bite my lips, my neck, and my breast as you do?

TULLIE: All of those things, my dear heart, are but preludes to love. They are little attacks that precede a greater combat, and all of these caresses are but trifles if you compare them to the supreme pleasure.

OCTAVIE: Oh, pull back, Tullie, you're putting your hand too low. Oh, oh, you're pinching my buttocks. Why are you tickling that part so hard . . . that you're staring at so fixedly?

TULLIE: I'm contemplating, my love, with keen pleasure the field of Venus. I admire its beauty. It's tight, it's narrow, it's strewn with roses, and its charms would be strong enough to bring the gods down to earth.

OCTAVIE: I think that you're crazy, Tullie, for kissing me, looking at me up and down in this way. I don't see anything anywhere on my body that surpasses the beauty of yours, and you only have to stop and look at yourself to satisfy your curiosity.

TULLIE: It would not be modesty in me, but rather foolishness, if I denied that I'm endowed with some beauty. I'm still only nineteen years old, and, being the mother of only one child, I can't have lost all of the allurements that were formerly found in my person. That's why, Octavie, if you can take some sort of pleasure in me, act freely. I'm not against it.

OCTAVIE: Me neither. I'll give you whatever you want, but I know that you can't take any satisfaction in a girl like me, and I can't imagine any pleasure you could give me, either, being of the same sex as I am. It's not that when I look at your face I can't imagine seeing a garden planted with lilies and roses. Allow me to use these expressions.

TULLIE: You're the one, rascal, who has a garden in which Pamphile will pluck the flowers and taste fruit more delicious than the meat of the gods.

OCTAVIE: I don't have any garden that you don't also have, as abundant in fruits as mine. What do you mean by this garden, anyway? Where is it planted? What are its fruits?

TULLIE: That smile betrays your naughtiness. What you're pretending not to know, you know better than I.

OCTAVIE: Maybe you call by that name this part whose entrance you're closing with your right hand, that you're tickling with your fingers, that you're pinching and stimulating by scratching it.

TULLIE: Yes, that's it, you've guessed right. But, silly girl that you are, don't you know what it's good for, and are you in the dark about how to use it?

OCTAVIE: If I had learned about it outside of marriage, I'd be indecent and unworthy of your affection. But do me the favor of teaching me about it. Let's get back into bed, for sitting down, completely naked as we are, we might catch cold.

TULLIE: That's fine with me, but pay attention. The garden that I was telling you about is that part that's located below the abdomen, in the middle of a small mountain, covered with kinky hair. This down's a sure sign that a girl is in her maturity and that the flower of her virginity's ready for picking. There are several names for that place in the body. The folly of lovers has led them sometimes to call it a "vessel," "field," "band," and so forth, but the most common term is "cunt." Admire, Octavie, the location of this part (so take these sheets off you; you're too afraid of catching cold). Don't imagine that

it has been placed between the thighs as some mark of shame that it carries in itself, as our sanctimonious friends think, but only to make its usage more accessible and pleasurable. This little hill that you see adorned with this downy moss is called the mound of Venus. It's a mountain, Octavie, that those who are fortunate enough to climb prefer to Parnassus, to Olympus, and to all the most famous mountains of Antiquity.[47]

OCTAVIE: Oh, your conversation's delightful, and I would gladly surrender to you the enjoyment of all parts of my body, which you seem to desire so much, in order to taste in exchange the sweetness of your conversation!

TULLIE: Kiss me, then, my dearest, and soothe by your kisses the intensity of the love that I feel for you. Don't refuse my eyes and my hands the pleasures that you can grant them. It won't wrong either Pamphile or you. But alas, how useless my efforts are! How vain they are! And how miserable I am for not being able to put out the fire that consumes me!

OCTAVIE: I make you the mistress of my body, and I grant you the enjoyment of the part that you're tickling, if that can contribute to your satisfaction. Your will can serve you as a rule in all your investigations.

TULLIE: You make me, then, the mistress of the path that leads to the supreme good. Oh, I see its door, but alas, I can't make use of the power that you give me. I don't have any key to open it, no hammer to strike, nor any other instrument that might help me enter it. Oh, Octavie, let me make an attempt.

OCTAVIE: Oh God, what game do you want to play in stretching out like this on me? What, mouth to mouth, breast to breast, stomach to stomach! Tell me what your intention is in this sport. Should I hug you like you're squeezing me?

TULLIE: Yes, my little heart, grant me this favor and don't refuse my caresses, for they can only give you pleasure. Open your thighs and raise them on mine. That's well done. You were as quick to obey me as I was prompt to order you.

OCTAVIE: Oh, Tullie, oh, how you're squeezing me. Oh, gods, what shaking! You've got me all on fire. You're killing me with these movements. At least put out those torches, because I'm ashamed for the light to witness my passivity. Do you think, Tullie, that I'd put up with this from anyone else but you?

TULLIE: My dear Octavie, my love, kiss me deeply and take mine in. Oh, oh, oh, I can't bear it any longer; I'm coming! Oh, oh, oh, I'm dying of pleasure!

OCTAVIE: Get off, Tullie, you're crushing me with the weight of your body. What, you've nothing to say? Have you lost your tongue?

TULLIE: Oh, it's done, my goddess. I've been your husband, and you've performed the office of wife. I swear to you that I've never felt pleasure sweeter than that which I've tasted in your embraces.

OCTAVIE: Oh, may it please the gods that I had a husband as loveable as you! That you had a wife who would cherish you, that she would love you, and that Oh God, I'm all wet. Where did it come from? I didn't notice it. Is it you, Tullie, who drenched me in this way? How did this happen?

TULLIE: Yes, it is I, my little heart, who did you this good turn. But how did you feel about this sport?

OCTAVIE: To tell you the truth, the pleasure that I shared with you wasn't that great. I only felt a few flurries, and a few sparks of the fire with which you were burn-

ing heated up my part. But please tell me if other women feel such a love for their own sex, or is this sickness unique to you?

TULLIE: All women, my dear child, burn with the same fire, and one would have to be as cold as marble and as hard as porphyry to remain insensitive to the sight of what's most loveable. For what is there more pleasing than a young pretty girl, tender, pale, and clean, as you are?

OCTAVIE: Oh, my cousin, I'm beginning to feel a little tickling and a certain itching in that place that's giving me a lot of satisfaction, but I think that it isn't anything if this pleasure's compared to what we receive from men when they sleep with us.

TULLIE: You're right, my little wife, and you'll experience it tomorrow night with complete satisfaction, but much greater than if you received it from a man other than Pamphile.

OCTAVIE: And why is that, my cousin? Don't all men do it in the same way?

TULLIE: No, poor innocent girl, that's not it, but it's because pleasure outside of marriage is always accompanied by dread and fear and often followed by misfortune. Apart from pregnancy, childbirth and a thousand other inconveniences that are the fruits that are born from our secret intimacies expose us to odd accidents. But in the pleasures of matrimony, by contrast, there is a bold and serene satisfaction that isn't found in others. Moreover marriage is a veil that hides and covers the faults in our behavior, since we can amuse ourselves without fear or risk once we are dressed in it. Thus there are some pleasures for virgins as well as for those not in a state of celibacy. They can find by themselves a taste of the pleasures that others enjoy, but pleasures much more pure because discord and jealousy almost never disturb them. Don't be surprised, then, that a girl entertains love for another. As for me, I burn with this passion, and I would happily choose your kisses over those of Oronte [her husband], although I cherish him dearly. My darling, you shouldn't think me less upright for it. This disposition isn't unique to me. French, Italian, and Spanish women cherish each other like this, and often, if modesty and shame don't restrain them, they give each other public signs of this passion when they see each other.

OCTAVIE: Oh, I'm delighted, my cousin, by your conversation. I'd prefer my situation to those we'd think happiest if I were as knowledgeable as you.

TULLIE: So, my goddess, my love, my Venus, you're no less a virgin than you were. I didn't want to do anything that could have robbed you of that pretty flower that's reserved for Pamphile. He'll still find the door of the garden locked, and he'll have a secret obligation to me for it.

OCTAVIE: I think that Pamphile shouldn't be too obligated to you for it, because if you didn't open it, it was due more to lack of strength than to lack of inclination.

TULLIE: I can see that you don't know what a dildo is. The women of Miletus made leather ones, eight inches long and proportionately thick.[48] Aristophanes said that in his time almost all women used them.[49] Today they're much used among Italian and Spanish women, and this instrument is one of the valuable articles in the boudoir of all the women of Asia.

OCTAVIE: I can't imagine what it is, nor what it could be useful for.

TULLIE: You'll learn in time. But let's talk about something else. . . .

TULLIE: I'll satisfy your curiosity about what you're asking me. All men, Octavie,

are subject to the same passions and are made in the same way and with the same members. They call "love" this lust or rather this sharp desire that drives them to unite with the object they cherish, but they think more about their pleasure in this union than that of the beloved. They love to distraction all parts of our body that inflame their passions more and stimulate them most to the ejaculation of that liquid that we call semen. This liquid is used in man's reproduction when it is shed in the part that nature destined for that purpose, and it's in its shedding that men find true bliss. But it's a strange thing, Octavie, that this discharge is no sooner done than they typically scorn our caresses, our kisses, and our hugs, and what enraptured them in the extreme before no longer has the least charm for them.

As for the semen that's cooked in the loins of man and of woman, the wisest people maintain that it shouldn't be used entirely for reproduction. And they say that it's the same with the seeds of trees and other plants. Isn't part of the wheat destined for the use of animals and the other part for the farmer, so that part's changed into our substance and the other part's lost? As for other plants, whose seeds aren't used by man and which no pleasure drives us to pick, nature gives part of it to the earth and doesn't care if the other part's lost. It's the same, said Socrates and Plato, for man's semen. It's foolish to think that nature's intention is that it all be used for reproduction. Indeed, Octavie, when we are pregnant and our pregnancy is well advanced, nobody denies that our husbands have a right to our body. Now it's absurd to maintain that their semen's then used in forming a man because he's already formed, and it's impossible, even when they fill our wombs with it, that another one be formed. And one would have to be crazy to wish for one. Another reason that confirms what I'm saying is that there are many girls who fall into dangerous illnesses of which they can only be cured by remedies that provoke the expulsion of the semen that was stagnating in their loins. All of these reasons have some appearance of truth because they're drawn from nature's intention, and that's what has led men to seek in their sex and in ours the means to satisfy their lubricity, such that what was in the beginning only the immoderation of a few delicate men finally became in certain provinces the vice of a whole people. If they took women in marriage, it wasn't at all for love but only in order to have children by them. And as soon as the women were pregnant, they regarded them as slaves, locked them up in the most secret parts of the home, and had no more relations with them.

Our sex was not sought out anymore in many other places. It was held in opprobrium by all the kings of Asia, and all the peoples there, basing their manners on the conduct of their princes, burned like them with an infamous love. Philip of Macedonia loved Pausanias, by whom he was assassinated for not having avenged him for the violence that the king's favorite Attalus did him by subjecting him at a banquet to the sensuality of his servants.[50] The king Nicomedes took this pleasure with Julius Caesar. Augustus was not spared from this whim.[51] Nero married Tigillinus, and Sporus married Nero.[52] While Trajan subjugated the whole Orient, he had with him a seraglio of young boys, the handsomest that could be found, with whom he spent whole nights.[53] Plautinus's rival served as Hadrian's wife and was happier than this empress, for the love that the emperor had for him was so violent that he mourned him greatly after his death and even consecrated temples to him, placing him in the ranks of the gods.[54] You see that masculine weddings were in fashion like the other kind. Heliogabalus took his pleasure in all parts of the body; bottom, mouth, ears were delectable cunts for him, and this lavish disorderliness made him known as a monster in men's eyes. Don't think that this inclination was confined to kings. Philosophers, whose serious solemn morals should serve as an example for the rest of men,

succumbed to this folly. Alcibiades and Phaedo were favorites of Socrates, and when these two disciples wanted to learn something from their master, it was necessary for them to sleep with him. It's in bed that he taught them the finest points of his morality and politics, and they never learned more than when he gave them lessons between two sheets, from which comes the proverb: *to love with Socratic faith.* Plato, that divine man, could not be a moment without his Alexis, his Pledios, or his Agathon. Xenophon spent his time with Callias and Antolicus. Aristotle had his Herminas, Pindar his Amaricon, Epicurus his Pirocles, Aristippus his Entichides, and so forth.[55]

Lycurgus, that great legislator who lived several centuries before Socrates, said that a citizen could be neither good nor useful to the republic if he didn't have a friend with whom he slept. He ordered that virgins appear completely naked at the theaters on the days of performances so that the sight of their nudity would blunt (so to speak) the tip of the love that the young conceived for them, and so that this would make the love they had for each other more ardent, for one isn't moved by objects that are often seen. What should I say about the poets? Anacreon burned for Bathyllus.[56] All the witticisms of Plautus deal only with this topic, and all the phrases that fill his works show us that he was strongly addicted to it.[57] Virgil, that master of poetry, who was called the *artexius,* that is to say "virgin," because of the purity of his writings, loved Alexander, whom Pollio gave him as a gift, and offered him much praise in his verses under the name of Alexis.[58] Ovid felt the same passion; nevertheless he prefered the love of the female sex to that of youths because he wanted delight to be shared by one and the other and the pleasure of coming to be equally tasted by both.[59]

Asia was the first seat of this evil, then Africa, whence this plague spread throughout all of Greece, and from Greece into the neighboring provinces of Europe. Orpheus first put this pleasure into practice in Thrace after the death of Eurydice, his wife.[60] His crime didn't go unpunished, for the women tore him apart during the mysteries of Bacchus and scattered all the pieces of his body in the fields. They say that the Celts made fun of those who did not want to taste this pleasure; they didn't have any esteem for them. And they were for the most part so addicted to it that moral purity was an obstacle to having a position. So true is it, Octavie, that the wise man shouldn't attach himself slavishly only to his maxims. So good, even necessary, is it that he let himself be carried away by the tide of the populace.

OCTAVIE: Ye gods, what wit! Continue. I'm delighted by your knowledge and eloquence.

TULLIE: Under the name Celts, I don't include only the French who are beyond the Alps but all the nations of the West, like the Italians and Spaniards. These last two are the most addicted to it. Most French people have an aversion to it and even have those who are convicted of abandoning themselves to it burned. They believe that iron [in the form of chains] isn't capable of avenging the offense that has been committed against chastity. The Italians aren't as harsh and say that the French don't have a good taste for pleasure, since they scorn it in what has the sharpest flavor. They are, however, currently beginning to be a bit more susceptible to it. As for me, Octavie, I don't see that men, on this score, were as wrong as is imagined. And I confess that as long as beauty, which is the source of love, is our lot, we still give reason to seek elsewhere a pleasure more complete than that which they have with us.

OCTAVIE: I don't understand what you mean.

TULLIE: You'll understand it presently. Who will deny, Octavie, that we others,

Italian and Spanish women, have wider cunts than all other European women? This assumed to be true, won't you agree that a cock that wants, in the fray, to be pressed and sucked until the last drop, feels no pleasure when it enters so easily and wanders here and there? Now, it doesn't happen in the same way in our behinds. Its entrance is very small, and once the member is in there, it not only fills that part, but it even breaks it and makes it fit its size, its largeness or its smallness, which can't be done in the womb, for once it's opened, there's no technique, there's no posture or movement that can shrink the width of the mouth by an inch, or prevent it from swallowing up a poor cock all at once. And it's for that reason that it happens that men ride us in the behind in order to satisfy their lascivious appetite better. By contrast, the women of the North are not exposed to these foul deeds because they are much narrower than we are. It seems that the cold tightens this part in them, so small is it usually, which means that their husbands, finding complete pleasure there, do not amuse themselves by seeking it elsewhere. There, Octavie, is what you wanted to learn from me.

OCTAVIE: You forgot to tell me if you approved of this conjunction or if you were horrified by it as am I.

TULLIE: I'd be wrong to approve of it. If the earth said nothing, the thundering voice of heaven condemns it. I'll even tell you this about the ancients before stopping. Lucian has these two Venuses dispute ingeniously; he doesn't condemn either one of them, and it's even difficult to say to which he attaches a preference.[61] Achilles Tatius does not talk about it with any less obscurity in his *Clitophon*.[62] The Latin writers seem to have been of the same sentiment, but what's more surprising is that no legislator prohibited it. They approved of all ways to take pleasure, except for having oneself sucked. With good reason they wanted the mouth to be an inviolable place for the cock, which it could never enter. This dissoluteness, nevertheless, still occurs today in many places in Italy.

I'll act in good faith, not in that Socratic faith, and I'll tell you that this vice should be severely punished, for the notions that men have to join themselves to us are so natural to them that it's a clear theft that they commit against us when they abandon themselves to their counterparts. As soon as the blood begins to heat up in a young man's veins, without consulting anyone but himself he knows naturally that he can only put out his fire in a woman's heart. This same nature makes the same impression in a girl's heart, and however coarse she may be, she'll be agitated by as intense a desire for a man's member, even if she's never seen one, as he'll have for a woman's part, even if it's unknown to him. Since they're made for each other, all their thoughts tend only toward joining together. Such is the progress of decent love. It's not the same in the conjunction of the other love. It's not nature that inspires it but rather the corruption of morality. If the behind had been destined for this use, it would have been more conveniently formed. Man's member would have been able to enter and leave it without much work and danger, which we don't see, since young girls, who are easily deflowered, cannot endure attacks in the behind without feeling sharp pains that are often followed by illnesses that all the industry of Asclepius cannot cure.[63]

The reasons that these debauched men cite to justify their dissoluteness do not convince me, although they draw them from the nature of things, from the examples of the ancients, and from the morals of even the wisest men. For can anyone think, however weak his powers of reasoning may be, that the voluntary loss of semen can be committed without some crime? Isn't it true, Octavie, that he who abandons himself to this infamous pleasure kills a man, since he would have been able to form one? It's adultery, it's

murder, and he strangles (so to speak) by this dirty voluptuousness a child who isn't born yet. Isn't it taking life to refuse it when one can give it? When nature works to form semen in our loins, its end is reproduction and not just the fulfillment of our sensuality, which is only the secondary motive through which nature tries to attract us to the obligation, by which men and women would be repelled, because of the pain of childbirth, if the pleasure wasn't the payment for it. But, someone will say, what should the man do when the wife's pregnant? Isn't the semen that he shoots into her womb while riding her lost? No, it's a mistake to think so. She can be known as before. It's just necessary to be careful that she not be put in a position that could disturb the child. Doctors maintain that a new fruit can be formed, that the first will leave at term and the second a few days later, and that's what they call an "extra-birth." Why not entrust to the power and the skill of nature this material with which it forms its masterpiece? Here I answer those who, in order to defend their disorderliness, make use of the comparison with wheat and other plants, of which one part is consumed by animals and the other produces grain. I answer, I say that wheat isn't really a semen, but a complete fruit that contains in itself its semen, by means of which it is reborn.

The cow and the lamb are exemplary animals of their kind. Who can prevent us from eating them because they contain within them a vital semen that propagates their species? Nature isn't wronged at all in this way. One doesn't go against its plan, and the most critical philosophers have never condemned the use humans made of wheat and other fruits.

OCTAVIE: In truth, Tullie, you speak like an oracle. But allow me to say that the reasons you use to demolish the arguments that you set forth still don't seem strong enough to me. For it's certain that if love is born of resemblance, it's more complete between two boys than between a man and a girl. If it's true, as everyone says, that what's agreeable is preferable to that which is useful, we should not be at all surprised if men scorn our embraces to seek a pleasure that they find more complete with their counterparts. Moreover these customs, sanctioned by long usage and confirmed by the example of the greatest men, seem to justify the practice of this pleasure.

TULLIE: You must learn, Octavie, that there's no custom that can allow the corruption of morals on account of its age. Thefts, murders, and poisonings are crimes that are as old as the world, yet who is there who will praise and tolerate them? We've seen entire families extinguished by sickness and great provinces ravaged by the plague; who'll dare deny that it's a great evil on account of its origin, which is as old as the world? That's why, as a crime's age does not take away its ugliness and deformity, likewise the praises of great men can't make them legitimate. Besides, you shouldn't believe that this evil's so widespread that nobody can be protected from it. No, there are countless men who aren't addicted to it, and the number of those who are free from this stain is much larger than that of the others. Finally, Octavie, so as not to be mistaken in the judgments you make, you should judge things in and of themselves, never through practice.

6. LOUIS FRANÇOIS DE BOUCHET, MARQUIS DE SOURCHES (1639–1716)

Memoirs of the Reign of Louis XIV[64]

June 1682

The beginning of the month of June was marked by the exile of a large number of eminent individuals accused of ultramontane debauchery.[65] The king did not expel them from court all at once, but he first exiled Monsieur the prince de La Roche-sur-Yon, whom he sent to Chantilly to be with Monsieur the prince, his uncle; Monsieur the prince de Turenne and Monsieur the marquis de Créquy, who received orders to go to Strasbourg to join the royal infantry regiment of which he was the colonel.[66] Several days later the king exiled Monsieur the chevalier de Sainte-Maure, one of the six lords whom His Majesty had attached to the Dauphin to follow him everywhere; Monsieur the chevalier de Mailly, who had been raised with the Dauphin since infancy; Monsieur de La Caillemotte, son of Monsieur de Ruvigny, deputy general of the Huguenots; Monsieur de Mimeure, who had been maintained as a page in the Dauphin's chambers and was still in his service with a pension of 1000 écus; and Monsieur the chevalier de Tilladet, first cousin of Monsieur de Louvois, who had been colonel of the dragoons and brigadier general.[67] The last of these hoped for several days to be reconciled, but in the end he had to leave like the others. Finally the king expelled Monsieur the count de Roucy and Monsieur the vidame de Laon, children of Monsieur the count de Roye, of the house of La Rochefoucauld, a Huguenot, but one of the most courageous, respectable, and admirable lords in the kingdom.[68] Monsieur the duke de La Rochefoucauld used all his influence with the king to spare his relative, whom he loved very much, such a mortal affliction, but the king was inflexible on his account.[69] He granted, however, in response to the urgent entreaties of Monsieur le Grand that Monsieur the count de Brionne, his older son, should not be exiled like the others, although he was accused of the same thing. But Monsieur le Grand could not save Monsieur the count de Marsan, his brother, who, though he was not expelled from court, was nonetheless utterly lost in the king's mind.[70] A large number of other courtiers were accused. Monsieur the count de Vermandois, admiral of France, who was still only fourteen or fifteen years old, was much involved in this debauchery, and the king having questioned him with all the authority of a father and a king, he had not been able to hold out against him and had confessed everything, so that the king had known through him all those who had had something to do with it, which was the cause of their disgrace.[71] A large number of others were accused, but by the tenth of June none had been expelled but those I have named.

7. France Become Italian with the Other Disorders of the Court[72]

The pliancy of all the ladies had rendered their charms so contemptible to the young men that one hardly knew at court what it was to look at them anymore. Debauchery reigned there more than any other place in the world, and although the king had several times expressed an inconceivable horror for these types of pleasures, it was only in this that he could not make himself obeyed. Wine and that which I dare not name were so much in vogue that people hardly took account anymore of those who sought to pass their time more pleasantly. And whatever inclination they had to live according to the order of nature, since the number of those who lived in disorder was larger, the example of the latter perverted the former so much that they did not remain long in the same sentiments.

Not only were most of the men of rank of this character, but there were even princes, which annoyed the king exceedingly. They hid themselves, however, as much as they could in order not to displease him, and this obliged them to stay up all night, in hopes that darkness would be favorable to them. But the king (who was informed of everything) knew that one day after he had gone to bed they came to Paris, where they engaged in such debauchery that there were many who returned from it drunk in their coaches. And since this took place in a tavern (for they took no more precaution than that to conceal their disorders), he used that as a reason to read the riot act about it to a young prince whom he cared about, who had been there. He told him that, if he was unlucky enough to be addicted to wine, he should at least get drunk at home and not in a place like that, which was in every way so unbecoming for a person of his birth.

The rest of the cabal did not suffer the same reproaches, because there was not one of them who was so closely connected to the king, but, in exchange, he showed them such great contempt that they were quite mortified. And, in truth, they went for a while without daring to do anything except in secret, but as their character did not allow them to restrain themselves for long, they soon returned from it to their inclination, which led them to do things with more fanfare.

In order not to attract the king's wrath, however, they judged it appropriate to take an oath, and to have it taken by all those who joined their confraternity, to renounce all women, for they accused one among them of having revealed their mysteries to a lady with whom he was on good terms, and they believed that it was in this way that the king learned everything they were doing. They even resolved not to admit this man into their company anymore, but, having presented himself to be admitted and having sworn not to see that lady anymore, they forgave him this time, on the condition that if he did it again, there would be no more mercy. This was the first rule of their confraternity, for, most of them having said that their order was soon going to become as large as that of Saint Francis, it was necessary to establish sound rules for it that they would be obliged to abide by. The others approved this resolution, and then it was only a question of selecting the one who would work on this formulary. Opinions were divided on this score, and as they well understood that it amounted to proclaiming the one to whom they gave this task head of the order, everyone solicited votes and engaged in rivalry for such a fine job. Manicamp, the duke de Gramont, and the chevalier de Tilladet were those who made the most noise in the chapter and who claimed this honor for themselves, each to the exclusion of the others.[73] Manicamp, because he had more experience than anyone in the business. The duke de Gramont, because he was a duke and peer and because he didn't lack proof of performance, either.

As far as the chevalier de Tilladet is concerned, he based his claims on the fact that, being a chevalier of Malta, it was such an essential qualification to be completely debauched that, whatever advantage the others might have, since they did not have this one, it was certain that he surpassed them by far in the practice of virtue.

Since all three of them had influence in the chapter, it was difficult to reach agreement on the choice, and someone having expressed the view that they should subject each other to reproaches, so that they might choose, after this, the one who was the most accomplished, everyone approved this method. And the chevalier de Tilladet, taking the floor at the same time, said that he was delighted that they had proceeded in this way and that it was going to get him what he wanted, that Manicamp might have competed with him in the past and that he would not have found it strange, because the word was that he had good qualities, but that now that his strength was weakened, it was a mistake to want to put him in office, unless they declared that what they did with him would be of no consequence for the future, that, indeed, he no longer had anything worthwhile but his tongue and that all the other parts of his body were dead in him.

Manicamp could not bear that he be put on trial in this way in such fine company, and, fearing that after this no one would want to have anything to do with him anymore, he said that he was not yet so infirm that he had not rendered some service to marshal d'Estrée's wife, his [Tilladet's] sister, that she had been pleased enough with it not to seek company elsewhere, that those who knew her knew very well, furthermore, that she was not satisfied with so little, and that since she had not complained, it was a sign that he was worth more than people said.[74]

There were some who wanted to say that this reasoning was not convincing and that a woman who had taken a husband aged eighty-five or -six years was not a party capable of passing judgment about it, but those who knew her temperament silenced them and maintained that she knew more about it than anyone.

The chevalier de Tilladet was a bit flustered by this reply. Nevertheless he said many more things to support his claim and, among others, that he had done something with Manicamp and that he had not demonstrated that great vigor of which he made such a show. People were obliged to take him at his word about it, and there arose a murmur in the company that made Manicamp sense that his business would not go well. When this murmur died down, the chevalier de Tilladet took the floor again and said that as for the duke de Gramont, there was an original sin that debarred him from his claims, that he loved his wife too much and that, since this was incompatible with the matter under consideration, he had no other objections to make against him.[75]

The duke de Gramont, who did not expect this insult, did not hesitate for a moment about the reply he had to make, and as he knew that there is nothing like telling the truth, he acknowledged in good faith that this had been so in the past, but that it was no longer so. The reason that he gave for it was that he had been mistaken about her temperament, that he had attributed the favors that he had obtained from her before his marriage to the penchant she had for him but that those she had given since to his valet having made him recognize that it was impossible to be answerable for a woman, it had so fully destroyed his liking for her that it had replaced it with contempt. That it was on this account that he had renounced the love of the fair sex, which had formerly had his devotion and which might still be if one could have any confidence in it. That, although he was the son of a father and the junior of a brother who both had great talents for obtaining the highest ranks in the order, he was, however, less indebted for his merit to what he had inherited

from them than to his spite.[76] That God made use of all things to bring about perfection, that thus, far from grumbling against providence for the causes of vexation that it sent him, he acknowledged every day that he was much indebted to it.

The chevalier de Tilladet had no reply to this, and everyone believed that the humility of the duke de Gramont, combined with such great sincerity, inspired reflection about the advantages that he had over the others, either in the charms of his person or the rank he possessed. Indeed, he was about to obtain, by acclamation, what they had assembled for, if the count de Tallard had not ventured to say that the order was going to become too famous to have just one grand master, that all three were worthy of this office, and that, after the example of the order of Saint-Lazare, in which several grand priors had recently been established, they could not fail to choose all three.[77]

Every one of them, who intended in his turn to reach this rank, approved this view, but, as they reflected on the fact that it is at the beginning of any institution that sense is especially needed, they resolved to choose a fourth, because the other three were not suspected of ever being able to start a new heresy. The choice fell on the marquis de Biran, who had more sense than bulk, but whose excessive youth would have excluded him from this honor if not for the need they had of him.[78] Now that the election was completed, they entreated all four of them to work on the rules of the order, whose principal objective consisted in banishing women from their company. In order to devote themselves to such a holy business, the four left not only the court but also the city of Paris, where they feared they might encounter some distraction, and, having shut themselves up in a country house, they arranged a rendezvous with the others two days later, promising them that it would not take them more to be inspired. Indeed, everyone having gone to meet them at the end of this time, they found that they had drafted these rules in writing, of which here are the articles:

I

That henceforth they would no longer welcome into the order persons who had not been inspected by the grand masters to see that all parts of their bodies were healthy, so they could endure the austerities.

II

That they would take a vow of obedience and chastity with regard to women and that, if anyone violated it, he would be expelled from the company without being able to rejoin it on any pretense whatsoever.

III

That everyone would be admitted equally into the order, without distinction of rank, which would not in the least exempt one from complying with the rigors of the novitiate, which would last until the beard appeared on the chin.

IV

That if any of the brothers married, he would be obliged to state that it was only for the sake of his business or because his parents made him do it or because he needed to leave an heir. That he would take an oath at the same time never to love his wife, to sleep with

her only until he had an heir by her, and furthermore that he would ask permission to do it, which could be granted him only for one day of the week.

V

That the brothers would be divided into four classes, so that each grand prior would have as many of them as the others, and that as for those who presented themselves to join the order, the four grand priors would take them in turn, so that jealousy could not upset their harmony.

VI

That they would tell each other everything that had happened in private, so that when there was an office to be vacated, it would be granted only on the basis of merit, which would be recognized in this way.

VII

That as for outsiders, it would not be allowed to reveal the mysteries to them and that whoever did so would be deprived of them himself for a week and even longer, if the grand master to whom he answered judged it appropriate.

VIII

That nevertheless one could be open with those one had some hope of attracting to the order, but that it must be done with so much discretion that one was sure of success before taking this step.

IX

That those who brought brothers to the convent would enjoy the same prerogatives for two days that the grand masters enjoyed, with the understanding, however, that they let the grand masters go before them and would content themselves with having what had been removed from their table.

It is in this way that the rules of the order were drafted, and, having been read in everyone's presence, they were widely approved, with the exception of some who thought that they should apply some moderation with regard to women, a crime that they did not want to be handled with the greatest severity, but for which they hoped that one might be pardoned, after, however, having asked for forgiveness before the whole chapter and fulfilled some type of penitence. But the grand masters were all so zealous that those who had voiced this opinion believed they were going to be expelled at once. And, if they had not expressed great repentance, their mistake would never have been forgiven.

They celebrated in this country house with much rejoicing for having reached the end of a great undertaking so easily, and, after many things had happened that it is well not to talk about, they agreed that the chevaliers would wear a cross between the shirt and the jerkin, on which there would be embossed a man trampling a woman underfoot, after the example of the cross of the order of Saint Michael, on which that saint is seen trampling the demon underfoot.

After they had completed these holy mysteries, everyone went back to Paris, and, someone not having kept the secret, a rumor soon spread about everything that had happened in this country house, so that some, moved by their inclinations, and others, by the novelty of the event, hastened to join the order.

A prince, whose name I am not allowed to reveal, having had this desire, was presented to the chapter by the marquis de Biran, and, having asked to be exempted from the ceremonies, they answered him that this was not possible and that he must set an example for the others. All they did for him was that they allowed him to choose which of the grand masters pleased him the most, and he chose the one who had presented him, which much annoyed the others, who saw that he was handsome, young, and well built.

This favor was followed by yet another that was granted him, namely that he could choose from all the brothers the one who was the most pleasing to him, about which, however, most of them started to grumble, saying that if the rules were broken so quickly, everything would soon be perverted. But they were answered that these rules, however strict they must be, could be bent somewhat in the case of a person of such an exalted rank, that, although they had said that the rules would be the same for everyone, it was the case that they had not believed that a prince of such high rank would present himself, that, as in Malta, princes of sovereign families were naturally named chevaliers of the great cross. It was surely right that they likewise have some privilege in their order. Otherwise they would not join it, which would not bring the order any great honor.

They were not on their guard to resist such good arguments, and, everyone having mollified his anger, they complimented the prince on the honor that redounded to the order from having a person of his birth, and there was not one of them who did not offer to give him all manner of satisfaction. He showed himself very civil to everybody and promised that they would shortly see that he would not be the least zealous of the chevaliers. Indeed, he had no sooner revealed the mysteries to his friends than every one made it his business to join the order, so that it was soon filled with all sorts of respectable people.

But, as excessive zeal is harmful in all things, the king was soon informed about what was going on and that they had even seduced another prince, whom he cared about even more than the one about whom I have just spoken. The king, who had a mortal hatred for these types of debaucheries, wished the worst for all those who were accused of them, but they, who did not believe that they could be convicted of them, presented themselves before him as before, until, having inquired more specifically about the matter, he banished some of them to cities far from court, had one of the princes whipped in his presence, sent the other to Chantilly, and, in short, expressed such great aversion for all those who had been involved that no one dared to speak up for them.

The chevalier de Tilladet, who was a first cousin of the marquis de Louvois, used the good favor of this minister to obtain his pardon and protested to him so much that he was innocent that Louvois went to speak to His Majesty about it right away. But the king, who did not believe anything easily, did not wish to rely on what Louvois told him and delayed responding to him until he was more fully informed about it. To that end, he had the young prince who had been whipped called and, having ordered him in the presence of the marquis de Louvois to tell him the truth, the marquis de Louvois was so annoyed to hear that the chevalier de Tilladet had lied to him that he left at once to tell him all that fury and spite were capable of inspiring in him.

There was only the duke de Gramont to whom the king said nothing, as if he had not been one of the number, which gave rise to grumbling on the part of the relatives of

the exiles, who were vexed to see him remaining in Paris while the others went off to the depths of the provinces. But the king, aware of their discontent, said that they should not be surprised about it, that the duke de Gramont had long ago become so contemptible in his eyes that anything he might do was a matter of indifference to him, so that it would be showing him too much honor to feel some resentment toward him. The court was too malicious to conceal a reply like this one from the duke, and, instead of priding himself, as before, on having been overlooked, he had so much cause to feel distressed about it that anyone other than he would have died of grief from it.

The cabal was dispelled in this way, but, whatever power the king had, it was impossible for him to uproot from the minds of the young men the seeds of debauchery that were too firmly rooted there to be so quickly extinguished. The ladies, however, rejoiced greatly about what had just happened, and, some of the crosses of these chevaliers having fallen into their hands, they judged them worthy of burning, although this was small vengeance for them. After this, they thought that the young men would be obliged to come back to them, but they threw themselves into wine, so that every day nothing was heard but talk about these excesses.

8. FRANÇOIS HÉBERT (1651–1728), *curé of Versailles, 1686–1704*

Memoirs[79]

But what is more dreadful and which even grieves me very much to write is that disorder having no limits, the crimes that are the most abominable and most contrary to nature and to the welfare of society, these crimes, I say, punished in the past by fire from heaven and worthy, according to the laws, of being repressed and punished by burning, had become common. People talked about these kinds of execrable engagements between libertines by profession as if they were talking about gallantry between a man and a woman. They knew about this shocking profligacy as they knew about the most public affairs. People only made a secret of it to the extent that they had some fear that it might reach the ears of the king, who was known to have an extreme abhorrence for this sin. I was sometimes obliged, in order to stop its spread and put an end to some rank disorders of this type, to make use of His Majesty's name to intimidate the guilty.

It is true, because everything must be said, that I would have wished very much that the king had acted firmly to oppose those detestable vices. I had, in these circumstances, a very long conversation with Madame de Maintenon, who was thoroughly informed about what was going on in this regard.[80] I pointed out to her as strongly as it was possible for me the obligation that I believed she was under to speak to the king and to lead him effectively to use all his authority to prevent such terrible corruption. She told me she had done so more than once.

"But Madame," I replied, "has the king not been noticeably touched by your arguments, and can His Majesty not see that such crimes are capable of drawing down upon his realm all manner of misfortunes and the vengeance of God, who never leaves them unpunished?"

"I have told him so," this lady answered me, "and one day when I was urging him to set these things right, he answered me, 'So I must begin with my brother?'"[81]

She added that it was the consideration that he had for that prince that stopped him. But I did not hesitate to point out to her, as I was obliged to by my ministry, that before God this motive should not prevent the king from quickly putting an end to such a frightful disorder and that he should correct it in his own brother as in all other subjects. I even added that His Majesty, by speaking firmly to him, would by this example make the guilty tremble and that, in the end, not to oppose it was to burden his conscience with it.

Such was the conversation that I had at that time with this lady. The problem did not stop. A prince of the house of Lorraine still kept this prince [the king's brother] under the same obligations, and both of them died, in the end, in the most tragic manner in the world, one of apoplexy that deprived him of the means of receiving the sacraments and the other absolutely refusing them through notorious impiety, which he had professed throughout his life.[82]

9. LOUIS DE ROUVROY, *duke de Saint-Simon (1675–1755)*

Memoirs[83]

At the same time, Monsieur, who had won the battle of Cassel with much valor, and who had always shown such natural valor at all the sieges in which he was involved, otherwise had only the bad qualities of women.[84] With more manners than sense and no learning, although with an extensive and accurate knowledge of families, origins, and marriages, he was capable of nothing. No one else was so indolent in body and mind, more weak, more timid, more deceived, more ruled or more scorned by his favorites, and very often bullied by them, a busybody incapable of keeping any secret, suspicious, distrustful, spreading rumors at his court to sow discord, in order to be in the know, often to have fun as well, and repeating things about some to others. With so many faults, lacking all virtues, an abominable taste that his gifts and the fortunes he bestowed on those to whom he had taken a fancy had made public with the greatest scandal and which had no limits either in number or in time. Those men owed him everything, often treated him with great insolence, and also often gave him vexing work to stop horrible tiffs and jealousies. And all these folk, having their supporters, made this little court quite stormy, without counting the quarrels of that troop of women settled at Monsieur's court, most of them very nasty and almost all of them worse than nasty, whom Monsieur made fun of and entered into all of these troubles.

The chevalier de Lorraine and Châtillon made a large fortune there by their looks, with which Monsieur was infatuated more than with others.[85] The latter, who had not a crust of bread, neither sense nor wit, lifted himself up and enriched himself there. The former took it in stride like a descendant of the Guises who blushed at nothing, as long as he succeeded and led Monsieur around by force all his life, was loaded with money and benefices, did for his family what he liked, always remained publicly the master in Monsieur's household. And as he had, along with the arrogance of the Guises, their skill and spirit, he knew

how to interpose himself between the king and Monsieur and have himself treated well, if not to say feared, by both of them, and to enjoy a regard, a distinction, and an influence almost as pronounced on the king's part as on Monsieur's.[86] So he was very touched, less by his loss than by that of this tool he had managed to make such ample use of for his benefit. Besides the benefices that Monsieur had given him, the spending money that he obtained, as much as he wanted, from him, the gratuities he levied and took with authority on all the financial dealings that took place on Monsieur's property, he had from him a pension of ten thousand écus and the finest lodgings in the Palais-Royal and at Saint-Cloud.[87] As for the lodgings, he kept them at the request of Monsieur the duke de Chartres, but he did not wish to accept the continuance of the pension, out of greatness of character, as through such greatness it had been offered to him. . . .[88]

Monsieur was a short, potbellied man mounted on stilts, so high were his shoes, always adorned like a woman, covered with rings, bracelets, and jewels all over, with a long wig all exposed in front, black and powdered, and ribbons everywhere he could put them, full of all kinds of perfumes, and, in every regard, cleanliness itself. He was accused of imperceptibly wearing rouge. His nose very long, his mouth and his eyes fine, his face full but very long. All his portraits look like him. I was annoyed, on seeing him, that he made one remember that he was the son of Louis XIII and that his portraits looked like those of that great prince, whom, valor aside, he was so completely unlike.

10. ELISABETH CHARLOTTE, DUCHESS D'ORLÉANS
(1652–1722), *Monsieur's second wife*

Letter to countess Amalie Elisabeth, 13 December 1701[89]

What they say about king William is only too true, but all heroes were also that way, especially Hercules, Theseus, Alexander, Caesar.[90] All of them were that way and had their favorites. Those who have this vice and believe in the Holy Scripture imagine that it was only a sin when there were still few people in the world and what they did could be injurious to the human race, in that it prevented more humans from coming into being. But since the world has been fully populated, they regard this only as an amusement, but they keep it secret as much as they can so as not to make the common people angry by it. But among persons of rank, they talk openly about it, regard it as a witticism, and know very well how to say that our Lord God hasn't punished anyone for it since Sodom and Gomorrah. You'll find me knowledgeable on this subject. I've heard it talked about many times since I've been in France.

11. PIERRE FRANÇOIS GODARD DE BEAUCHAMPS
(1689–1761), *novelist and playwright*

The History of King Apprius (1728)[91]

[sodomites:]

The customs of the inhabitants are most unusual. They are divided into two tribes equally obedient to their ruler: the Ugobers [buggers] and the Chedabars [bardashes].

The Ugobers are enemies of display and ostentation. Their outfits are clean but simple, their houses modest, their food frugal. They have a wise countenance, a decorous bearing, and a respectable way of talking. They run from, or at least they attempt to make others believe that they run from, excess and disorder. They pride themselves on science and even philosophy. They give lessons in these subjects and strive, not in public but in private, to inspire their students with them. They are as mysterious about their morality as their worship. An inviolable secrecy conceals them from the eyes and scrutiny of all those who have not been initiated into them themselves. Great zealots for their religion, they carefully seek and diligently cultivate means of gaining proselytes for it, and, strict observers of their principles, they uphold its practices scrupulously. They are, furthermore, so gentle, so humane that their gentleness has become proverbial and that it is commonly said, *un bon bougre* [a good fellow].

It is not the same with the Chedabars. Indeed it must be said that they are like the slaves of the Ugobers. They would be the most contemptible, most uncivil of all men, if their masters were not good enough to mitigate their servitude. A stupid pride blinds them to the disgrace of their condition. Because they are free in appearance, they do not feel the weight of their chains. Their cowardly complaisance renders them insensible to the repugnance of humiliation. They are flattered; they are caressed. Their mercenary souls congratulate themselves on it. Madmen who do not realize that they are the playthings of those whose happiness they think they produce, they pride themselves on beauty, but this beauty is soft, effeminate, and ephemeral. Lost in immoderate luxury, they sigh only for ornaments and apparel. They are recognized by the richness of their outfits and even more by their manner of handling themselves. Their glances are calculated; their gait is affected. There is nothing natural about them. They are the first who let their hair grow long, who curled and powdered it. They started the use of pastes, oils, and perfumes. Their speech resembles their manners. They have a language of their own, full of affectation. They call each other Réfers [brothers], Gnotis [gitons], and Manégides [ganymedes]. These strange names are the names they use among friends. They have among them a chivalric order whose origins and privileges are unknown. They all consider it such a great honor to bear its title that only the wretched ones do not have it. It is called the order of Thalactemne [the cuff]. The slavery of the Chedabars sometimes comes to an end. There are some of them who gain admission to the ranks of the Ugobers. Then they forget the lowliness of their previous condition, and the slave takes on the sentiments of the master. . . .

[tribades:]

A fantastical, undefinable, incomprehensible people, loving pleasure to excess, they seek it where it does not exist. They have such an erroneous idea of things that they always

mistake the shadow for the body. They speak of feelings, pleasures, ecstasies, but all of this is only jargon in which nothing is understood. They pride themselves on nicety, but this is only a ridiculous, superficial, imaginary refinement, either a natural antipathy or a fear of being deceived. They have no relations with their neighbors. They are self-sufficient, or at least they think that they are self-sufficient. Loving the impossible, they are passionately fond of imaginary objects. Their madness goes as far as wanting to give existence to nothingness. They resemble the Danaidae.[92] They resemble Tantalus.[93]

12. Anecdotes to be Used in the Secret History of the Ebugors (1733)[94]

ON THE CAUSES OF THE WAR BETWEEN THE CYTHERANS AND THE EBUGORS [BUGGERS][95]

For a long time the Cytherans and Ebugors eyed each other warily. The former, accustomed to ruling the whole world, could not watch with indifference the rapid progress that their neighbors were making every day. The latter, for their part, thought about ways of weakening a power to which they themselves feared succumbing. Each day some of them deserted and thereby rendered the enemy side more formidable. Few Cytherans abandoned their colors to place themselves under the standards of the Ebugors. . . .

With such dispositions, it was not possible for peace to last between the two peoples. On one side and the other they tried to do each other all possible harm. Insulting speeches, satirical writings, stinging jokes, none of this was spared. . . .

MANIFESTO OF THE EBUGORS AGAINST THE CYTHERANS

No one is unaware of what a great degree of power the Cytherans have attained. This ambitious nation has always been persuaded that men were created to be its slaves. We see it expand through new conquests every day. It seems that it aspires to universal monarchy. But it is less to its courage than to the weakness of its adversaries that it is indebted for its success. For the Cytherans only have to show themselves to win the victory. Just one of their glances suffices to overwhelm the enemy, who, after his defeat, sees himself condemned to shameful slavery. The loss of his liberty is not the only affliction he has to endure. He must also suffer the whims of these imperious tyrants, carry out their most unjust orders without delay, even respectfully kiss the shackles under the weight of which they crush you. It is only after having sacrificed the better part of their possessions that the captives can break their chains, or when the delicacy of their complexion or the infirmities of old age make them incapable of bearing the tasks to which they are sentenced. In spite of such harsh treatment, no one tries to escape from this frightful tyranny. The love that we have for our fellows obliges us to take up arms in their favor. It is for us to help the unfortunate ones who have only sighs and tears for food, whom cares and worries keep from

enjoying the comforts of sleep, whose weak and prostrate bodies are a sure sign of the harshness practiced toward them. One would have to be crazy not to be touched at the sight of such a spectacle. Can people fail to approve our conduct when they know the praiseworthy motives that move us to declare war? It is in our interest, as for our glory, to destroy a nation that seeks to subjugate men only to make them miserable. . . .

Manifesto of the Cytherans in Response to That of the Ebugors

It is with the greatest surprise that the queen of Cythera has seen the impressive but untruthful manifesto of the Ebugors, her enemies. Obligated from time immemorial to pay tribute, which the whole world makes a pleasure of paying, they alone refuse the Cytherans the homage that they owe them. . . .

These unfortunates, whom their sacrilegious fury blinds, overthrow the order established for all time. They consume between them and at a complete loss the fruits that we should dispose of and that we know how to make the most of, both for their utility and our own. They devour each other through a sham friendship that tends to nothing less than the complete destruction of the human race. Every new recruit by which they augment their number is a new theft they make from society and an attack on the most ancient customs.

We have the greatest interest in opposing such dangerous innovations. . . .

The Manners of the Ebugors

The Ebugors or Modosistes [sodomites] are a very ancient people. They used to constitute the body of a nation. Modose [Sodom] was the capital of their states. An Egan [angel] (such is the name given to certain ambassadors) passing through that city one day was kindly welcomed by the leading inhabitants. Although they did not know about the authority with which this young lord had been invested, everyone came to offer him hospitality because he had such a pleasant face. He accepted that of a bourgeois named Tol [Lot]. The others, jealous of this choice, came to insult the traveler at his host's house. The Egan left abruptly and went off to go express his complaints to the king, his master. The latter, to avenge his ambassador, had red shells fired at the city of Modose and reduced it to ashes. Since that time the Ebugors have scattered through all parts of the world. The descendants of this unfortunate people, after having wandered for a long time, reached Séthane [Athens], where they maintained themselves honorably for a rather substantial period of time. In that country they made several proselytes; among them is counted the famous Ascrote [Socrates]. More misfortunes obliged them to move on to Elitia [Italy]. In that country they were given such great privileges that they forgot their previous disgraces. They were even seen to reach the most eminent offices.

The number of Modosistes increasing every day, they resolved to send colonies into some of the neighboring states. They attempted to establish themselves in the kingdom of the Valges [Gauls]. Thirosiren [Henry III] received them with favor, but after this king's death, they were not much esteemed. In order to secure a favorable settlement

among the Valgois [Gauls], they worked to get the highest nobility on their side, and they succeeded.

Now we must make known the manners of a people who make such a splash in the world today. The Ebugors are naturally witty, enemies of prejudices, and of a very sociable disposition. Relations with them are dangerous. They make you a thousand protestations of friendship in your presence, while they do you very bad turns behind your back. They are bold soldiers. The fear of gunfire has never stopped them. Is it necessary to penetrate a position? They do not take a good look to see if the breach is practicable. They lacerate, they tear to pieces all that resists their fury. The cries of the wounded are not capable of moving them, but after the engagement they become much more accommodating. Whatever anyone says about it, their service is not gracious, and I am persuaded that people enter this body through vanity rather than taste.

They had at their head Kulisber [Butt-breaker]. This general had served his first campaigns among the Caginiens [Ignatians, i.e., Jesuits]. After having passed successively through all the subaltern positions, he reached the highest military rank. His merit alone raised him to this sublime office. He was a man zealous for his nation and ready to sacrifice everything for it. Active, daring, full of fire, he did not like to fight in the open country. He got out of trouble much better in the narrowest gorge. His valor being then tightened, he hardened himself against the obstacles and impetuously broke down the strongest barriers.

GENERAL KULISBER MAKES A FEINT

The proud Kulisber wore a helmet decorated with a magnificent plume. He held an enormous spear, whose sight alone inspired horror. The horse he proudly mounted gnawed its bit and seemed to live only for battles. But what deserved the most attention was his shield. The workmanship on it was marvelous. There was Jupiter, who, in the form of an eagle, abducted the young Ganymede. Apollo appeared there inconsolable for the death of his dear Hyacinth.[96] The beautiful Narcissus sought in vain to satisfy through himself the passion of which he was the object.[97] The fond Nisus came to offer his life to the Rutulians to save that of his dear Euryalus.[98] Alexander laid the pride of the crown down at the feet of Hephaistion, and the impetuous Alcibiades listened with docility to the lessons of the virtuous Socrates.[99] But the craftsman wanted to outdo himself in representing the apotheosis of the celebrated Fouruchuda [Deschauffours], who received in his lifetime the honors granted to Roman emperors only after their deaths. . . .*

*Fouruchuda, famous inhabitant of Spira [Paris], who out of zeal for the defense of a very large army of Ebugors, having been taken prisoner in battle, was condemned and then thrown into the flames by order and sentence of the leading supporters of the Cytherans.

THE EBUGORS RAISE THE SIEGE AND MAKE
A TREATY WITH THE CYTHERANS

Articles of the Treaty of Peace between the Ebugors and the Cytherans

The Ebugors will not extend their dominion further, because of the disadvantages that would result from it for the general welfare. They will be allowed to live according to their laws and customs, but they will not disparage, as they have done until now, the rule of the Cytherans. On the contrary, the two peoples will work together to maintain peace and will have for each other the respect that they owe each other.

13. JEAN-BAPTISTE DE BOYER D'ARGENS (1704–71),
novelist and philosophe

Thérèse the Philosophe (1748)[100]

I had supper with my new mentor, who artfully explored what my way of thinking was and the line of conduct that I had followed up until then.

Her open-heartedness toward me excited my own. I babbled more than I meant to. She was at first alarmed to learn that I had never had a lover, but she was reassured once she was convinced, by the answers that she shrewdly extracted from me, that I knew the value of love's delights and that I had turned them to good account. Bois-Laurier kissed me, caressed me; she did everything she could to induce me to sleep with her. I thanked her, and I went back to my place, my mind quite preoccupied with the good fortune that awaited me.

Parisian women are lively and obliging. The very next morning, my thoughtful neighbor came and offered to fix my hair, serve as my maid, and get me dressed. But the mourning period for my mother prevented me from accepting her offers, and I kept my little nightcap on. The inquisitive Bois-Laurier made a thousand naughty remarks to me and examined all my charms with her eyes and hand while giving me a slip that she wanted to put on me herself.

"But, hussy," she said to me on second thought, "I believe that you're putting on your slip without having washed your pussy. So where's your bidet?"

"To tell the truth, I don't know what you're talking about with your 'bidet.'"

"What!" she said, "no bidet? Take good care not to boast of having lacked a piece of furniture that is as necessary for a proper girl as her own slip. For today I'll gladly loan you mine, but tomorrow, without delaying any more, think about the purchase of a bidet."

Bois-Laurier's was then brought. She planted me on it, and in spite of everything I could say and do, this overly obliging woman, while laughing like a madwoman, herself washed thoroughly what she called my "pussy." Lavender water was not spared on it. How little I suspected the entertainment that was being prepared for it and the motive behind this careful washing. . . .

After this fine story [of an incident in Bois-Laurier's life], which prepared us to laugh wholeheartedly, Bois-Laurier continued more or less in these terms:

"I am not talking to you about the taste of those monsters who only have a taste for antiphysical pleasure, either as active or as passive partners. Italy now produces fewer of them than France. Don't we know that a likeable, rich lord, infatuated with this frenzy, could only finish the job of consummating his marriage with a charming wife on their wedding night with the help of his valet, whose master ordered him, in the thick of the action, to enter him from the back in the same way that he was doing to his wife in the front?

"I note, however, that Messieurs the antiphysicals make fun of our insults and defend their taste vigorously by maintaining that their antagonists only conduct themselves according to the very same principles as themselves. 'We all seek pleasure,' say these heretics, 'in the path where we think we find it. It's taste that guides our adversaries as well as us. Now, you'll agree that we're not the masters of having this or that taste. But people say that when tastes are criminal, when they offend nature, they must be repudi-ated. Not at all: in matters of pleasure, why not follow one's taste? No one's guilty as a result. Besides, it's false that the antiphysical is against nature, because it's that same nature that gives us the inclination for this pleasure. But still, people say, one cannot procreate one's own kind. What pitiful reasoning! Where are the men, of one taste or the other, who take carnal pleasure with the purpose of producing children?'

"Finally," Bois-Laurier continued, "Messieurs the antiphysicals give a thousand good reasons to make people believe that they are not to be pitied or censured. However that may be, I detest them, and I must tell you a rather funny trick that I played once in my life on one of those execrable enemies of our sex.

"I was warned that he was supposed to come see me, and although I'm naturally a terrible farter, I took the additional precaution of stuffing my stomach with a large quan-tity of turnips, in order to be in a better state to receive him according to my plan. He was an animal that I only tolerated out of deference to my mother. Every time he came to the house, he busied himself for two hours in examining my buttocks, opening them, closing them again, putting his finger in the hole where he'd have gladly tried to put something else if I hadn't expressed myself clearly about the matter. In a word, I detested him. He arrives at nine o'clock in the evening. He has me lie down on my stomach on the edge of a bed. Then, after having carefully raised my skirts and my slip, he goes, in keeping with his laudable habit, to arm himself with a candle with the intention of com-ing to examine the object of his worship. That's where I was waiting for him. He puts one knee on the floor, bringing the light and his nose closer, and I let him have, at close range, a juicy wind that I was holding back with difficulty for two hours. The prisoner, in escaping, made a furious noise and put out the candle. The inquisitive man threw him-self forward, no doubt making a devilish grimace. The candle, fallen from his hands, is relighted. I take advantage of the disorder and make my escape, bursting out laughing, to a neighboring room, where I lock myself in and from which neither prayers nor threats could drag me, until my snubbed man had cleared out of the house."

Here Madame Bois-Laurier was obliged to stop her narrative because of the exces-sive laughter this last escapade provoked in me. Keeping me company, she also laughed wholeheartedly, and I think that we wouldn't have stopped so soon if not for the arrival of two gentlemen of her acquaintance who were announced to us. She had time only to tell me that this interruption annoyed her very much because so far she had only told me about the wicked part of her story, which could only give me a very bad opinion of her,

but that she hoped to tell me about the good part soon and to let me know with what eagerness she had seized the first opportunity that presented itself to withdraw from the type of abominable life in which Lefort [her procuress] had involved her.

I should, indeed, be fair to Bois-Laurier. With the exception of my experience with Monsieur R. . . [a financier who had attempted to rape Thérèse], which she was never willing to agree to having been involved in, there was nothing incorrect about her conduct during the time that I knew her. Five or six friends composed her circle. She saw no women but me and hated them. Our conversations were proper in public, [but] nothing so libertine as those we had in private since our exchange of confidences. The men whom she saw were all sensible people. We played little games; then we ate supper at her place almost every evening. Only B. . . , her so-called uncle the financier, was admitted for conversation in private.

I said that two gentlemen has been announced to us. They entered. We played quadrille [a card game]; we ate supper merrily. Bois-Laurier, who was in excellent humor and who was perhaps quite content not to leave me alone, given over to reflections about my experience in the morning, led me to her bed. I had to sleep with her. One howls with the wolves. We said, and we did, all kinds of nonsense. . . .

After some other remarks by Bois-Laurier, who sought to provide me with lessons fit to teach me to recognize the different dispositions of men, we went to bed, and, once we were in bed, our follies took the place of reasoning.

14. CHARLES THÉVENEAU DE MORANDE (1748–1803),
journalist and pamphleteer

The Armored Gazeteer or Scandalous Anecdotes about the Court of France (1771)[101]

POLITICAL NEWS

People swear that the chancellor doesn't treat women in a way to keep them for long, having been caught with some Jesuits with whom he's accused of having scandalous relationships.[102] The lieutenant general of police of Paris reproached him to his face for having had dealings [or sex] with five members of this society in three days (1). . . .[103]

APOCRYPHAL NEWS

The king's confessor having been disgraced for having been caught playing around with some pages, a competition has been opened for this position, which will be granted to the one of our prelates who will exert the least pressure in cases of conscience.[104] Monsieur the archbishop of Rouen has been proposed, but since he's been involved in scandalous relations with one of his grand vicars for a long time, he was rejected (2). . . .[105]

NEW INVENTIONS

A coach has been invented recently that is entered only in the rear, which wits call coach in the Villette style. . . .[106]

ENIGMATIC NEWS

In Paris there's a little marquis, one inch less than five feet tall, who strolls in the suspect spots in the Tuileries gardens every evening but who, in return, appears in public with prostitutes, who speaks ill of everyone but does not get angry if others speak ill of him, even to his face, who has killed people he'd never seen (3) but lets live those who wanted to beat him up. This marquis is mocked wherever he goes, but yet he's on visiting terms with everyone. If you ask why, it's because he has an income of fifty thousand écus, good food, a lot of impudence, and a bit of wit (4). . . .

The marquis de Ville[tte], tired of plucking his beard to look younger, has just taken on the role of the old man, which exempts him from that trouble in the future (5).

People claim that cardinal de Bern[is], our ambassador to Rome, has been naturalized as a Roman by cardinals Pallavicini and Acciaiuoli, who treated him like a choirboy at a nocturnal assembly of the sacred college [of cardinals] (6).[107]

The marquis de Marig[nan] having had a statue of Ganymede that cost him ten thousand écus brought from Rome, people claim that he was caught in meditation at the feet of this statue by the marquise, his wife, who came running devoutly with a goblet to receive the incense that was going to be spilled (7).

Mademoiselle Clairon very often has Madame the duchesse de Vil[leroy] and Madame the duchesse de Beau. . . for supper, as well as the First President's wife and Madame de Port[ail], who are good enough to allow Mademoiselle d'Oligny and Mademoiselle Dervieux, as well as several other amphibious princesses, whose company is useful to them, to join them.[108] Monsieur the duke d'Aumont, who lives between Mademoiselle Clairon and the marquis de Villette, has petitioned the parlement to have them both turned out. As this worthy lord has always been afraid of fire, he fears that if one or the other of these banquets is burned up, he will be endangered by the conflagration (8). . . .[109]

Fréron, accused by Monsieur de Voltaire of having confessed a shameful sin in his presence (9), has revenged himself by reproaching his antagonist for having slept under the same roof with the marquis de Villette and his so-called secretary.[110]

The ambassador of a republic located on the Adriatic Sea [Venice], having been found unconscious in the arms of an unknown man in the Luxembourg gardens, was taken back to his residence by two Swiss guards, who would have given him accommodations [in prison] if he hadn't identified himself upon coming out of his swoon. The guards, having deposited this minister in the hands of the secretary of the embassy, asked him for a quittance [documentation of discharge of obligation] and refused the money that was offered them to keep quiet about this swoon (10).

Monsieur the count de Noail[les] having taken scandalous liberties with one of his lackeys, this rustic knocked Monseigneur over with a slap that kept his Lordship in bed for a week (11). . . .

If the general of the Jesuits had two hostages as handsome as and more accommodating than Lot's angels to send to Paris, he's sure to reenter France through that door, which would be just fine, although it's a back door (12).

When people asked the marquis de Villet[te] a while ago why he'd taken a mistress (13), he justified himself by saying that she had two sphincters (14). . . .

The abbé Grizel, who used to give advice to Saint Billard for money and absolution to his female devotees for sweets, was accused by the sacristan of his parish of hugging the little children whom he confesses for their penitence (15).[111]

The sect of the Guebers (16) has gone into mourning for three months for the champion of the order who just died in a large mansion on the rue de Charenton, where he had free quarters for thirty years (17).[112]

The son of a grocer from Lille, in Flanders, who turned into a baron after he entered military service and became a colonel, by dint of complaisance for a great nobleman, just bought the rank of brigadier general (18), which makes him well informed about prostitutes of the first rank (19). . . .

The papal nuncio just received from the sacred college a gift of twelve pages, who would be fit to perform the cardinal's most difficult service. The sovereign pontiff added two black eunuchs to look after their behavior and prevent French noblemen from invading the privileges of the court of Rome (20).

They've just counted all the Guebers that are known in Paris. Their multiplication is as unbelievable as it is frightening. If the sudden multiplication of monks who invaded the realm of the Christian world hadn't prepared the way for the wonders of the procreation of neuter beings, one wouldn't believe in the possibility of their existence. A con-

troversialist claims that the Jesuits sent missionaries around the world to strengthen their proselytes and make new converts. A civic crown has been promised to each woman who receives the abjuration of a member of this sect. The crown is especially recommended to likeable women, who should overcome their aversion for being useful to humanity (21).

(1) The Chancellor having reproached Monsieur de Sartine for not fulfilling the duties of his office, because he didn't know who was putting notes under the king's napkin, this magistrate told him, "Monseigneur, to show you that I'm doing my business, I knew that you had dined with two disguised Jesuits two days ago, that the same two Jesuits were at your place yesterday in the morning, and that a third who has not shown up there yet was there today." The Chancellor fell silent and begged the lieutenant of police to hold his tongue.

(2) The anecdotes about the pages, the grand vicar . . . are known by everybody. If the author's mistaken, it's along with the public.

(3) The marquis de Sabran, whom the one-inch-less-than-five-foot marquis said he'd killed, had actually died from pneumonia on the same day, but they'd never seen each other.

(4) The one-inch-less-than-five-foot marquis has written panegyrics about Henry and Charles, was accommodated in the Abbey [prison of the abbey of Saint-Germain-des-Près] for a month, was judged in the last resort by Madame Bontems when he was arrested in the Tuileries gardens in an indecent state, was locked up for two years for not having killed Monsieur the count de Sabran and having said it. The same man lost two of his lackeys, who left his house to enter Bicêtre. He has refused to duel, etc. If his name were not an insult one could say it to him, but we'll keep quiet out of consideration for the readers.[113]

(5) It's a metamorphosis from Alcibiades to Socrates.

(6) Unfortunate prelate! What did you go to Rome for?

(7) The statue exists, and the marquis is very attached to it, but the sacrifice wasn't consummated on marble.

(8) The duke's fear is quite justified. The two mansions would be seriously in danger if we lived in the age of miracles.

(9) In a little booklet called *God*, in which some anecdotes about Fréron are found. Voltaire reproaches him for having acted and endured [played the active and passive roles] in the same session.[114]

(10) This minister is as big, as dark, as rich as he who pays the debts of his special friends.

(11) Monseigneur the count is such a pious man that he turned the other cheek, in keeping with the maxim of the saints, but his lackey didn't have the courage to strike such a good master twice.

(12) The general of the Jesuits will do well to hasten to send his hostages before respectable folk are put back in place.

(13) There's no one in the world but V[illette] impudent enough to respond in this way.

(14) Anatomical term enigmatic for everyone except people in the business and unbelievers.

(15) Monsieur de Voltaire said in an epistle to Monsieur the marshal de Richelieu,

I do not wear the hairshirt
Of saint Grizel or saint Billard.[115]

(16) When he was young, the Gueber who just died killed a man because the man maintained that all Guebers were cowards. The Gueber could not control his feelings and wanted to prove the contrary.

(17) The incident of the killed man involved the chev[alier] G . . . , officer of the black-robed musketeers.

(18) We have seen in the Political News that this rank is bought.

(19) People maintain that the baron Delb. . . and Monsieur du Chang. . . are the very same person; however Monsieur Delb. . . is a baron, and Monsieur du Change's father was a grocer.

(20) Monsieur the archbishop of Dam[ascus], papal nuncio, uses Italian pages because he finds them more docile than those from any other country.[116]

(21) If the list of all the Guebers that are in Paris was printed, with their stories, people swear that this book would be twice as long as the *Encyclopedia*.

15. MATHIEU FRANÇOIS PIDANSAT DE MAIROBERT
(1727–79), *journalist and pamphleteer*

The English Spy or Secret Correspondence between Milord All'Eye and Milord All'Ear[17]

LETTER 9

Paris, 28 December 1778

I'm from the village of Villiers-le-Bel. My father's a farmer who lives well enough by working, he, his wife, and his children. As for me, country chores always disgusted me. While they were in the fields, they left me at home to take care of the housekeeping, and I often did it very badly, which often got me scolded and mistreated. My character inclines me solely to coquetry. From my childhood I took a lively pleasure in looking at myself in streams, in fountains, in a bucket of water. When I went to see Monsieur the curé, I couldn't leave the mirror. For my part, I was also very clean. I washed my face often, I scrubbed my hands, I fixed my hair and bonnet as best I could. I was delighted when I heard it said by someone around me, "She's pretty; she'll be charming." I spent the whole day longing for Sunday because on that day I was given a white smock, a brown jacket (1) that fit my figure well and brought out the whiteness of my skin, new shoes, a little lace on my bonnet. When I could wear Mamma's gold cross, her ring, her silver buckles, I was satisfied. What's more, complete idleness, walking, running, dancing. Thus I reached my fifteenth year. I was a tall girl, and all my faults had grown with age. New ones soon developed. I became remarkably lascivious. Without knowing why or what I was doing or what I wanted, I stripped as soon as I was alone. I beheld myself with satisfaction, I looked over all the parts of my body, I caressed my throat, my buttocks, my belly. I played with the black hair that already shadowed the sanctuary of love (2). I tickled its mouth lightly, but I didn't dare to put anything into it. It seemed so narrow, so small to me that I was afraid of hurting myself. However I felt a devouring fire in that part of my body. I rubbed myself with pleasure against hard objects, against a little sister whom I had and who, too young to work, stayed with me. One day my mother, back from the fields early, caught me in this activity. She flew into a rage, she treated me like

the worst of wretches, she told me that I was a bad lot who would never be good for any-thing, a profligate who would dishonor my family, a prostitute who should be sent to la Gourdan's convent.[118] These epithets, whose meaning I didn't understand, seemed hurt-ful to me only because they were accompanied by curses and blows so violent that I resolved to leave the paternal home and run away.

Madame Gourdan, as a matter of fact, had a country house at Villiers-le-Bel back then

[Gourdan brought Sappho back to Paris and entrusted her to a woman who reported,] "You've found a treasure in this child. She's a virgin, on my honor, even if she's not vir-ginal, but she has a diabolical clitoris. She'll be more appropriate for women than for men (3). Our renowned tribades should pay you her weight in gold for this purchase."

Madame Gourdan, having verified the fact, wrote at once to Madame de Furiel, whom you all undoubtedly know, at least by reputation, to inform her about her find (4).[119] The latter sent for me with the same speed and had me taken to her hideaway.

The chambermaid who had mysteriously come in a coach to get me first showed me into a sort of cottage, so that I thought I'd gone back to the village. We crossed another courtyard where, although there was a gate for wagons, stables, sheds, I also saw barns, a dairy, chickens, turkeys, pigeons, which agreed well enough with my guess. I was finally disabused when a little door had been opened and I saw a splendid garden shaped like an oval, surrounded by very tall poplars that deprived all the neighbors of any sight of it. In the middle was a pavilion, also oval, topped by a large statue, which I later learned was that of the goddess Vesta.[120] One climbed up to the pavilion by nine steps that sur-rounded it on all sides. I first found a vestibule lighted by four candelabra. On both sides were basins in which naiads [water nymphs] supplied water from their breasts at will. On the left was a billiard room and on the right a bathing room where I was stopped. I was told that I wouldn't see the mistress of the place until I'd undergone the preparations nec-essary for appearing in her presence. To this end, they began by bathing me. They took measurements for the first clothes that I should have. During supper my guide talked to me solely about the lady whom I was going to belong to, about her charms, her graces, her generosity, about the happiness I'd enjoy with her, the absolute devotion that I owed her. I was so astonished, so dizzied by the novel objects that struck me on all sides that I didn't sleep all night.

The next day they took me to Madame de Furiel's dentist, who inspected my mouth, put my teeth in order, cleaned them, gave me a wash in order to make my breath fresh and sweet. On my return, they placed me in the bath again. After having wiped me down lightly, they did my toenails and fingernails. They removed corns, calluses, and callosi-ties. They depilated me in places where inconveniently located hairs might make the skin feel less smooth. They combed my mane (I already had a splendid one) so that the overly arranged locks wouldn't cause painful tangles during embraces, like the folded rose petals that made the Sybarites shriek (5).[121] The gardener's two young daughters, used to this duty, cleaned my orifices, ears, anus, vulva. They kneaded all my joints voluptuously in the manner of Germain (6) to make them more supple. With my body prepared in this way, they poured great streams of oils on it. Then they dressed me in the way that's usual for all women. They fixed my hair in a very loose chignon, with curls waving on my shoulders and my breast, some flowers in my hair. Then they put a smock made in the style of the tribades on me, that is to say open in front and in back from the belt down but crossed and closed with cords. They circled my bosom with a flexible and light corset. My intimate (7) and the petticoat of my dress cut like the smock granted the same facil-

ity. They finished by fitting me with a polonaise [a type of overdress] of rose colored satin in which I was ready to be painted. Given my fixed character, you can imagine what my joy must have been, what rapture when I saw myself like this. I was embellished by three quarters. I didn't recognize myself. I hadn't yet experienced so much pleasure, for I didn't know the nature of that which Madame de Furiel was going to give me. Moreover, although lightly dressed and in the month of March, when it's still cold, I didn't feel any chill. I thought I was in springtime. I was swimming in a gentle draft kept up all the time by heat pipes that extended throughout the rooms.

When Madame de Furiel had arrived, I was led to her through a corridor that connected the area where I was with a boudoir where I found her reclining casually on a large sofa. I saw a woman thirty to thirty-two years old, with swarthy skin, a lot of color in her face, lovely eyes, very black eyelashes, a splendid throat, plump, and presenting something mannish in her whole person. As soon as I was announced, she threw passionate glances my way and exclaimed, "But they didn't tell me enough about her; she's heavenly." Then, softening her voice, "Come closer, my child, come sit next to me. Well, how are you doing here? Are you enjoying yourself here? This house, this garden, this furniture, these jewels, all this will be for you. These women will be your servants, and me, I want to be your mother. In exchange for so many things, attentions, and love, I ask you only to love me a little. So, tell me, do you feel inclined? Come kiss me." Without saying a word and filled with gratitude, I throw myself on her neck and embrace her. "Oh! But, little fool, that's not how you do it. See those doves that peck at each other lovingly?" Meanwhile she makes me raise my eyes toward the arch of the niche where we were, decorated with a sculpted garland of flowers in which were indeed suspended this lascivious couple, symbol of tribadism. "Let's follow such a charming example." And meanwhile she darts her tongue into my mouth. I feel an unknown sensation that leads me to do the same to her. Soon she slips her hand to my breast and exclaims anew, "What pretty tits, how firm they are! They're like marble. It's easy to see that no man has defiled them with his vile touch." Meanwhile she tickles the ends lightly and wants me to return the pleasure that I receive. Then, with her left hand untying my ribbons, my cords in the back, "And this pretty little ass, has it been whipped often? I bet it hasn't been done like I do it!"

Then she gives me some light slaps at the bottom of the buttocks, near the center of pleasure, which serve to inflame my lust. The she turns me over on my back and, opening the way in front, she falls into admiration for the third time. "Ah, the magnificent clitoris! Sappho didn't have a finer one. You'll be my Sappho."

From then on it was a convulsive fury on both sides that I couldn't describe. After an hour of struggle, of pleasure inflaming my desires without satisfying them, Madame de Furiel, who wanted to save me for the night, rang the bell. Two chambermaids came to wash us, perfume us, and we supped delightfully.

During the meal, she informed me that this hideaway, which belonged to her, had in a way become sacred through her usage, that it had been converted into a temple to Vesta, considered the foundress of the anandrine (8) sect or tribades, as they are commonly called.

"A tribade," she told me, "is a young virgin who, not having had any relations with men and convinced of the excellence of her sex, finds in it true pleasure, pure pleasure, dedicates herself wholly to it, and renounces the other sex, as perfidious as it is seductive. Or it is a woman of any age who, having fulfilled the wish of nature and country for the propagation of the human race, gets over her mistake, detests, abjures crude pleasures, and devotes herself to training pupils for the goddess.

"Furthermore, not just anyone who wants to is admitted into our society. There are, as in all societies, trials for the postulants. Those for the women, which I can't reveal to you (9), are in particular very arduous, and there's hardly one out of ten who doesn't succumb. As for the girls, it's the mothers who judge them in the intimacy of their relations, who attach them to themselves and who answer for them. You already seem worthy to me to be initiated into our mysteries. I hope that this night will confirm the good opinion that I've formed of you and that we'll lead an innocent and voluptuous life together for a long time.

"You won't lack anything. I'm going to have dresses, finery, hats made for you, buy you diamonds, jewels. You'll have only one privation here, that is that no men are seen. They can't come in here. I don't use them for anything, even for the garden. It's sturdy women that I've trained for this cultivation and even for the pruning of trees. You'll only go out with me. I'll show you the beauties of Paris one after another. I'll take you frequently to the theatre in my box seats, to balls, to strolling places.

"I want to shape your education, which, making you more pleasant, will save you from the boredom of being often alone. I'll have you taught to read, write, dance, sing. I have mistresses for all these subjects at my disposal. I have them for other subjects as your tastes or your talents develop."

Such was more or less Madame de Furiel's conversation, which preceded our going to bed and which was not interrupted on my part except by thank-yous, embraces, caresses that enchanted her and led up to others more intimate.

The night was difficult but so ravishing for me that tired, worn out, exhausted, I wanted more in the morning. The wiser Madame de Furiel, who was saving me for the big day of my initiation, stopped first. She had a broth brought to me and, before leaving me, directed that the greatest care be taken of me. She sent me her seamstress, dressmaker, wardrobe dealer in turn, and it didn't take me long to be supplied with all that I needed to make my debut in the world with a splash. Thus clothed with the embellishments that luxury and skill could add to my charms, I was taken to the opera by my protectress, who received endless compliments from her colleagues.

As for the men, I heard that they were saying in the corridors when I went by to leave, "Madame de Furiel has fresh meat. This is something new indeed. Too bad that it falls into such bad hands!" She pretended to talk to me, so I wouldn't hear these comments, and swept me away to her coach very quickly.

The time of my initiation into the mysteries of the anandrine sect had been fixed for the next day, and I was indeed admitted into it with all its honors.

This extraordinary ceremony was too striking for me not to have remembered its least details, and it's surely the most curious episode in my story.

In the center of the temple is an oval salon, an allegorical figure that is seen frequently around here. It rises the whole height of the building and is lit only by upper windows that form the arch and extend around the statue looking down on the outside and which I have already spoken to you about. At the time of assemblies, a small statue, also representing Vesta, of the size of an ordinary woman, is detached from it and descends majestically, with its feet posed on a globe, into the midst of the assembly, as if to preside over it. At a certain distance the iron rod that supports it is disconnected. It remains thus suspended in the air (10) without having this marvel, which they're used to, frighten anyone.

Around the goddess's sanctuary extends a narrow corridor in which, during the assembly, stroll two tribades who keep watch over all the doors and avenues. The only entrance

is through the middle, where there's a double door. On the opposite side there's a piece of black marble on which verses that I'll soon give you an account of are engraved in gold letters. At each of the extremities of the oval is a type of small altar that serves as a stove, which the guards light and keep going from the outside. On the altar on the right upon entering is the bust of Sappho, as the most ancient and most famous of the tribades. The altar on the left, vacant until then, was supposed to receive the bust of Mademoiselle d'Eon, the most illustrious maiden among the moderns, the most worthy to figure in the anandrine sect, but it wasn't completed yet, and they were waiting for it to emerge from the sensual Houdon's chisel.[122] Around the room and at intervals were placed on as many shafts the busts of the beautiful Greek maidens celebrated by Sappho. On the bases are read the names of Telesilla, Amithona, Cidno, Megarra, Pirene, Andromeda, Cirine, etc. In the middle rises a bed in the shape of a basket with two bolsters, on which the president and her pupil rest. Around the salon, cushions in the Turkish style equipped with pillows, on which each couple composed of a mother and a novice, or, in mystic terms, the incubus and the succubus, sit facing each other and with their legs intertwined. The walls are covered by superlatively fashioned sculpture in which the chisel outlined in a hundred places with unique precision the various secret parts of the woman, such as they are described in *The Picture of Conjugal Love,* in Monsieur Buffon's *Natural History,* and by the most skillful naturalists.[123] There you have an exact description of the sanctuary, in which I believe I haven't left anything out. Now here's the description of my admission.

All the tribades in place and in their ceremonial outfits, that's to say the mothers with a dressing gown the color of fire and a blue belt, the novices in a white dressing gown with a pink colored belt, what's more the tunic or smock and the petticoats split and covered up. They came to let us know, Madame de Furiel and me, that they were ready to receive us. This is the duty of one of the tribade guards. Madame de Furiel was already in her costume; I, on the other hand, was very decked out and in the most worldly outfit.

Upon entering I saw the sacred fire, consisting of a vivid and fragant flame shooting out of a golden stove, always ready to die out and always rekindled by the crushed aromatics continually thrown into it by the couple responsible for this job, which is extremely wearisome because of the constant attention it requires. Having reached the feet of the president, who was Mademoiselle Raucourt (11), Madame de Furiel said, "Lovely president and you, dear companions, here's a postulant. She seems to me to have all the necessary qualities. She's never been with a man, she's marvelously well shaped, and in the tests that I've made of her, I've seen that she's full of fervor and zeal. I ask that she be admitted among us under the name of Sappho."

After these words, we withdrew to let them deliberate. At the end of several minutes, one of the two guards came to inform me that I had been admitted to the trial by acclamation. She undressed me, left me completely naked, gave me a pair of slippers or flat shoes, wrapped me in a simple peignoir, and brought me back like that into the assembly, where the president having descended from the basket with her pupil, they stretched me out and removed the peignoir from me. This state, in the midst of so many witnesses, seemed unbearable to me, and I wriggled in every way to avoid their looks, which is the object of this practice, so that no charm escapes inspection. Besides, says one of our amiable poets (12),

The embarrassment of appearing nude
Constitutes the charm of nudity.

It's now the moment to tell you what those verses are that I promised to tell you about and that you're no doubt awaiting with impatience. They contain a detailed enumeration of all the charms that make up a perfectly beautiful woman, and these charms are counted up to the number thirty therein. They don't, furthermore, state the name of their author, who surely wasn't a member of the female sex, at least not a tribade. None but a cold philosopher is capable of analyzing beauty in this way. What's more, these verses, very original in their genre, have not escaped my mind. Here they are (13). . . .

It's in keeping with this catalogue of comparison that they proceed with the inspection, but because there hasn't been a woman since Helen who combined these thirty elements of beauty, they've agreed that it would suffice to have more than half of them, that is to say at least sixteen. Each couple joins the discussion in turn and gives its vote in the ear of the president, who counts them and announces the result. All were in my favor, and after having received the accolades, one after another, with a Florentine kiss, I was taken back and given novice's clothes, in which I reappeared with Madame de Furiel. Then, throwing myself at the president's feet, I took between her hands the oath to renounce relations with men and not to reveal anything about the mysteries of the assembly. Then she divided a gold ring in two halves, on each of which Madame de Furiel and I wrote our names with a bodkin. She rejoined the two parts as a sign of the union that should reign between my teacher and me and put this ring on the ring finger of my left hand. After this ceremony, we took our place on the cushion that was meant for us, in order to listen to the speech on the occasion of donning the outfit that the president, following custom, was to address to me. I omit this speech, too long to be read to you here, but I've kept a copy of it (14) and will share it with those who want to acquaint themselves with this unique piece of eloquence.

After the speech, the goddess went back up and vanished. The guards, the thurifers (15) were withdrawn from their posts. They let the fire go out and went on to the banquet in the vestibule. However, the outsiders could not come in there to serve, and the table utensils, platters, wines, etc., were passed through revolving doors from which the novices took them and served the meal. With dessert they drank the most exquisite wines, especially Greek wines. They sang the most cheerful and voluptuous songs, most of them drawn from Sappho's opuscules. Finally, when all the tribades were in the mood and couldn't restrain themselves any longer, they restaffed the posts, rekindled the fire, and returned to the sanctuary to celebrate its great mysteries, offer libations to the goddess, that is to say that a veritable orgy then began. . . .

Here, milord, I interrupt the narrative of the historian and stretch a veil across the disgusting pictures that she presented to us. I let your imagination run free, which will surely paint them for you with a more delicate and voluptuous brush. I'll only add that in this academy of lewdness there's an endowed prize, for they're needed everywhere, that this prize is a gold medal on which is represented on one side the goddess Vesta with all her attributes, and on the other are engraved the effigies and names of the two heroines who, in this general struggle, kept up the amorous attacks for the longest time, and that it was Madame de Furiel and Sappho who won the prize. . . .

(1) Country term in France that amounts to short gown.

(2) You think rightly, milord, that this is not the word employed by Mademoiselle Sappho, but I thought I should substitute this image for the language of debauchery that she used, and I'll do likewise with regard to many other excessively crude phrases.

(3) Madame Gourdan is versatile. She supplies girls to men and men to women. It seems from this that she also supplies succubi to tribades. That's what they call the passive ones in amorous combats between women.

(4) Mademoiselle Sappho had kept a copy of this note, and you will perhaps be pleased, milord, to have an example of Madame Gourdan's style:

Madame,

I have found for you a tidbit fit for a king, or rather a queen, if there were one who had your depraved taste, for I can't describe a passion too contrary to my interests in other terms, but I know your generosity, which makes me overlook the severity that I should show toward you. I inform you that I have the finest clitoris in France at your service, moreover a genuine virgin of fifteen years at the most. Give her a try. I leave it to you and am persuaded that you'll not know how to thank me enough for it. Furthermore, as you won't have damaged her much, send her back to me if she doesn't suit you, and it'll still be an excellent maidenhead for the best gourmets.

I am with respect, etc.

I learned since that Madame Furiel had sent Madame Gourdan a roll of 25 louis as a deposit and then the remainder of the delivery fixed at 100 livres in total.

(5) This manner of expressing herself, milord, undoubtedly won't seem very natural to you on the part of Mademoiselle Sappho, but you'll see in what follows that she'd received an extensive education around Madame Furiel, that she'd read lots of novels in particular, and that if she'd spoiled her heart around her, she'd trained her mind well there.

(6) Charlatan in vogue here for a while and who claimed to cure his patients by kneading their limbs.

(7) Petticoat made of two muslins, called intimate because it clings right to the body.

(8) Mademoiselle Sappho couldn't explain the etymology of this word to me, which I think comes from Greek and which means anti-man in French.

(9) Mademoiselle Sappho told us that she later learned what this type of test consists of and told us about it. They lock the postulant up in a boudoir where there's a statue of Priapus in all his vigor. One sees several groups of couplings of men and women in the room, presenting the most varied and most lewd positions. The walls, painted with frescos, show nothing but images of the same sort, virile members everywhere. Analogous books, portfolios, prints are on a table. At the base of the statue is a stove, whose fire and flames are kept up only by materials so light and combustible that, as soon as the postulant has a minute of distraction, she runs the risk of letting the fire go out, without being able to relight it, so that when they come to get her, they see if she's experienced any strong feeling that indicates an inclination for fornication still in her, which she must renounce. These tests, moreover, last three days in a row for three hours.

(10) There is great likelihood, milord, that this statue and globe are hollow and filled with air that is lighter than the atmosphere of the salon, so that they are in perfect equilibrium. That is how skilled physicists present for this narrative explained this prodigy, which smacks very much of novels. They even cite the work of a Dominican father, Joseph Gallen, former professor of philosophy and theology at the University of Avignon, who published *The Art of Navigating through the Air* in 1755, based on the principles of physics and geometry.[124]

(11) Famous actress of the Comédie Française.[125]

(12) Cardinal de Bernis, in his *Four Seasons* or *Four Times of Day*.[126]

(13) I believe, milord, that these verses are imitated or paraphrased from a Latin poet named Jan de Nevizan, who lived in the 15th century and composed a poem entitled *The Forest of Marriage*. Here is the original excerpt, which you will undoubtedly be pleased to compare. . . .[127]

(14) I didn't neglect to ask Mademoiselle Sappho for this text, in order to see if it was worth send-
 ing to you, but she could never find it. To compensate me for it she got me another speech
 delivered under the same circumstances and by the same author for Mademoiselle Aurora, a
 new acquisition made by Madame de Furiel this year.

(15) Word taken from the sacred liturgy. The choirboys who carry the incense are called so.

[More than a year later Sappho, who thought herself "the happiest of women," was seduced
and raped by a pretty young hairdresser who, thanks to his average height and ruddy com-
plexion, successfully disguised himself as a delivery girl for Mademoiselle Bertin.[128] His
frequent visits made her sexual relations with Madame de Furiel seem "insipid and tire-
some" by comparison. When Madame de Furiel found out what was going on, Sappho
defended herself by declaring that "you know, from your own experience, that one can-
not escape one's inclination." Expelled from "this modern Sodom," Sappho became a
prostitute.]

APOLOGY FOR THE ANANDRINE SECT OR EXHORTATION TO A YOUNG TRIBADE BY MADEMOISELLE DE RAUCOURT, DELIVERED ON 28 MARCH 1773

"Women, welcome me to your bosom; I'm worthy of you."
—These words are drawn from the *Second Letter to Women* by Mademoiselle d'Eon.[129]

Thus exclaimed recently she whose bust you see exposed for the first time to your hom-
age. This maiden, the pride of her sex, the glory of the century, and, through the combi-
nation of her various talents, perhaps the most illustrious who ever has lived, who ever
will live, the most worthy, especially, to appear here, to occupy a position of preemi-
nence that I owe only to the indulgence of the assembly. That touching effusion, that
swift transport, that seething ardor, those impetuous outbursts that led Mademoiselle
d'Eon back toward her sex are all the more honorable for her because, disguised as a man
from the cradle, regarded as a man, educated as a man, having lived constantly with men,
she contracted their tastes, manners, habits. She conquered, so to speak, all their talents,
all their skills, all their virtues, without staining herself with any of their vices. Invested
with their corruption, she always preserved the purity of her origin. In the collège, at ban-
quets, at the most licentious parties, at court, in the middle of battlefields, and, some-
times, obliged to share her bed with the opposite sex, she resisted so many dangerous
temptations and, until she could have a female companion, found within herself pleasure
preferable to that whose strong attraction goaded her incessantly. Thanks be given to you
for it, o august goddess who presides over our mysteries! And you, my dear child, to
whom this exhortation is primarily addressed, may you profit from such a great exam-
ple! Having escaped the seductions of men since your tender youth, enjoy the happiness
of finding yourself joined to the bosom of those like you, a happiness that Mademoiselle
d'Eon, controlled by circumstances, has yearned for so long in vain.

 The anandrine sect, furthermore, isn't like so many others that are founded only on
ignorance, blindness, and credulity. The more one studies its history and progress, the more

one's respect for, interest in, and attachment to it increases. So, then, I'll first show you its excellence, since one practices badly what one doesn't know well. The letter kills, and the spirit vivifies. I want to increase your zeal by enlightening it, by teaching you the importance and extent of your duties. Finally, the reward at the end of the race is usually what animates and sustains the athlete along the way. I offer you one not, like so many others, fit to satisfy only pride, avarice, vanity, but to fill your heart completely: it's pleasure. I'll describe to you those that we enjoy. Such is the natural division of this speech into parts.

O Vesta, tutelary divinity of this place, fill me with your sacred fire. Make my words go engrave themselves in strokes of fire in the heart of the novice whom it's a matter of initiating into your cult. May she exclaim, with as much sincerity and ardor as Mademoiselle d'Eon, "Women, welcome me to your bosom; I'm worthy of you!"

FIRST PART

The excellence of an establishment is determined especially by its origin, its purpose, its resources, its results.

The origin of the anandrine sect is as old as the world. One can't doubt its nobility, since a goddess was its founder, and what a goddess! The most chaste, whose symbol is the element that purifies all the others. However opposed this sect is to men, the authors of the laws, they've never dared to proscribe it. Even the wisest, strictest of legislators sanctioned it. In Lacedaemon Lycurgus had established a school of tribadism where young girls appeared naked, and in those public games they learned tender and amorous dances, postures, advances, embraces. Men bold enough to look in there were punished with death. This art is found reduced to a system and described energetically in the poetry of Sappho, whose name alone awakens the idea of what was most amiable and enchanting in Greece. In Rome the anandrine sect received, in the person of the vestal virgins, almost divine honors. If we believe travelers on this score, it spread to the most distant lands, and the Chinese are the most celebrated tribades in the world. Finally, this sect has lasted without a break until our time. No country in which it's not tolerated, no religion in which it doesn't exist, except the Jewish and Muslim ones. Among the Hebrews, celibacy was odious, and women stricken with barrenness were dishonored. But this nation, completely worldly and crude, had no objective but to increase and multiply, and the Jews became such a vile people that God was obliged to renounce them. As for the Muslim religion, one can still regard the seraglios that it encourages as a mitigated form of tribadism.

It is true that the objective of this institution among the Turks is less to spread the cult of our goddess than to stimulate the brutality of the master of so many beautiful slaves locked up together for his pleasure. They say that the current Grand Turk, when he wants to proceed with the creation of an heir to the empire, has all his wives assembled in a large salon in the seraglio destined for this use and called the room of turns for that reason.[130] Its walls are frescoed, and all the life-size female figures depict the most lascivious positions, postures, couplings, and groupings. The sultanesses take all their clothes off, mingle, intertwine, under the eyes of the jaded despot copy and vary these models, which they surpass through their agility. When, with his imagination well aroused by this spectacle, he feels his sluggish ardor rekindled, he enters the bed of the favorite prepared to receive him and performs wonders.

In China, the old mandarins make use of the same help but in a different manner. At the husband's orders, the actresses are coupled in hammocks there. Then, slackly suspended, they sway and toss without having to bother to move, and the lewd man, with

ardent eyes, misses nothing of these libidinous scenes until he goes into action himself. Tribadism in this sense was introduced even among the cursed Jews. What would Solomon have done with his three thousand concubines without this practice? And, according to the secret anecdotes of some of the more trustworthy rabbis, the prophet king, the holy king David, made use of the young Sunamites that he put in his bed only to revive his prolific heat by having them tribadize over his body.

But it must be acknowledged, this usage, this mixture of male activities profaned such a fine institution. It's in Greece, in Rome, in France, in all Catholic countries that its objective was grasped on a large scale and in its true spirit. In the schools for girls established by Lycurgus, the vow of virginity was not permanent, but they purified their hearts early on there, and, living solely among themselves until they married, they acquired a delicacy of feeling there that they still longed for even in the arms of their husbands. And, having fulfilled the role that called them to motherhood, they always returned to their first practices.

Nothing so fine, nothing so great as the establishment of the vestal virgins in Rome. This priesthood showed itself in the most august state there. Protection of the Palladium, depository and maintenance of the sacred fire, symbol of the preservation of the empire, what splendid functions![131] What a dazzling destiny! Our monasteries of women in modern Europe, descendants of the society of the vestal virgins, are its priesthood perpetuated but, unfortunately, offer only a weak likeness of it because of the mixture of punctilious exercises and childish formulas. On the other hand, the virgins are not subjected to the servile work of maintaining a physical fire there. Their truly sublime role is to raise their pure hands incessantly to Heaven to bring down its blessings on the country. If their fervor is extinguished by a criminal passion for a man, the proofs of which are the all too tangible results of obvious deflowering, they're not punished by death but endure more dreadful canonical penalties, given their refinement and duration. How, then, has this institution sustained itself despite the perils that surround it? Through these simple, easy, effective, attractive means.

Is a young novice tormented by a libidinous itching in her vulva? She has within her own makeup the means to satisfy it right away. Nature leads her to it automatically, as with all the other parts of the body to which she makes her move her fingers in order, through beneficial scratching, to suppress or suspend their itching. When, through this frequent practice, the inflamed and enlarged channels need more solid and ample relief, she finds it in almost everything that surrounds her, in the tools of her work, in the implements in her room, those of her wardrobe, on her walks, and even in foodstuffs.

Through lucky confidence, does she soon dare to tell a comrade as innocent as herself about her discoveries? They both enlighten, assist each other. They become attached to each other, they become necessary to each other, they can't do without each other anymore. They're no longer but one soul and one body. Then the ascetic life seems to them preferable to all the vanities of the time. Hairshirts, those instruments of penitence, are converted into instruments of pleasure. Days of collective and public discipline, so frightening for worldly people who fixate only on the name, become, through these multiplied couplings, orgies as delightful as ours. For flagellation is a powerful vehicle of lewdness, and it's undoubtedly from the convents that this practice spread to the schools of courtesans, who teach it to their pupils as a triumphant means ready to revive exhausted old men and libertines for pleasure.

No matter what, sweet art of tribadism, your results are such that the little nun leaves possessions, friends, relatives, father, mother for you, that she renounces the richest prop-

erties, the most pressing enjoyments, which are the most innate in the heart of man, the much vaunted pleasures of matrimony, and that she finds supreme felicity in you. Oh, but your charms are great, your attractions are strong, since you dispel the boredom of the cloister, make solitude delightful, transform this odious prison into the palace of Circe and Armide.[132]

And that's enough, my dear daughter, to acquaint you with the excellence of the anandrine sect. I don't want to tax your attention too much. It's time to teach you its duties, the most essential purpose of this speech.

SECOND PART

No human institution that doesn't have as its purpose either utility or pleasure, that doesn't procure benefits and provide enjoyments. There are some that combine the two, and that's the height of perfection. Such is, undoubtedly, the anandrine sect, considered from the sublime point of view under which I presented it to you in the foundation of the society of the vestal virgins and the religious societies of women that followed it and are honored today in our rite.

It must be acknowledged, my dear daughter, our society that we're talking about at this time does not have that degree of worth. It has, for its primary and single objective, only pleasure, but to secure it, there are steps, methods, obligations, or, to say it all in a word, duties to fulfill. Some are directed to the preservation of the society, for, without it, the results would be lacking. Others are directed to maintain its harmony, for in discord and disorder one has no pleasure or little pleasure. The last are directed to extend or propagate it, for nothing's well done without this taste, this fervor, this zeal, which, like the always active element whose image you have before your eyes, spreads and consumes all that surrounds it.

Let's take up and work out these three truths in order to inculcate them well into your memory and your heart.

Homage, in the first place, to the founder of our cult, Vesta, whose statue, always present at our assemblies and suspended over our heads, is the guarantee of her everlasting protection, her vengeance always ready to break out against dishonesty and infidelity. Let's invoke her often, not through vain prayers but through sacrifices and libations. No intemperateness of speech, wisdom, reticence with regard to what goes on in our assemblies, discretion, complete silence about the mysteries of the goddess so as not to arouse jealousy and envy, absolute submission to its laws, which will be explained to you either by the person in my position in the assemblies or by the mother to whose care you are entrusted and who is responsible for guiding you in private life. But above all else energetic and open war, perpetual war on the enemies of our cult, on that fickle, deceptive, and perfidious sex leagued against us, working incessantly to destroy our institution either in the open or secretly, and whose efforts and tricks can be repulsed only by the most intrepid bravery, by the most tireless vigilance.

What's more, it's not enough that a structure be built on solid and lasting foundations, that it be kept away from destructive elements and protected from dangers that can threaten it. It's necessary, in addition, that it offer the eye fine proportions, a sense of harmony, a whole, the great merit of masterpieces of architecture. It's the same with our moral structure. Tranquility, unity, concord, peace should constitute its principal support, its praise in the eyes of outsiders. May they see nothing in us but sisters, or rather may they admire in us a large family in which there is no hierarchy other than that established by nature itself for its preservation and necessary to its administration.

Benevolence toward all unfortunates should be one of our distinctive characteristics, a virtue flowing from our gentle and sociable manners, from our essentially loving heart. But it's with respect to our sisters, our pupils, that it should be deployed. Complete community of property, so no one distinguishes the poor from the rich. May the latter, on the contrary, take pleasure in making the former forget that she was ever impoverished. When she is brought forth into society, may she be noticed because of the sparkle of her clothes, the elegance of her adornment, the abundance of her diamonds and jewels, the beauty of her horses, the quickness of her carriage. May those who see her recognize her and exclaim, "It's a pupil of the anandrine sect. There's what it means to make sacrifices to Vesta!" It's thus that you'll attract others, that you'll plant in the heart of others like you, who will admire you, the desire to enjoy your fate by imitating you.

This expansive zeal for the propagation of the cult of the goddess should consume a genuine tribade most of all. If it were possible, she would like all her sex to share the same happiness she has. At least such is the case for all those I see here and a quick listing of whom will contribute more to your edification, my dear daughter, than all I might add about this subject.

You see, first, two philosophical women of rank (1), breaking away from the glamor and honors of the court, from the more enchanting charms of the advanced sciences that they cultivate with such taste and success, to come to our assemblies to imitate the simplicity of the dove, that bird so dear to Venus, so ardent in its combats.

Next to them is the wife of a magistrate if not celebrated, at least famous for several years (2), but who, disdaining to associate herself with her husband's renown, breaking away from conjugal caresses, from the delights of motherhood, has risen above all fear of public opinion in order to devote herself with more reflection and without interruption to the cult of our society and its work.

Her neighbor is an adorable marquise (3), rivalling her in enthusiasm for the anandrine sect, facing all prejudices, overstepping in the radiant outbursts of her nymphomania what those not devoted to our cult call all proprieties, all public decency, all modesty, like the master of the gods even sometimes undergoing the most humble metamorphoses to win proselytes for the goddess (4).

She whose forehead is wreathed with a double crown of myrtle and laurel is the modern Melpomene (5), the pride of the French Theatre, who, for almost three lustrums [periods of five years] since she withdrew from there, has left a void there not yet filled and perhaps irreparable.[133] Today, responsible for the education of the son of a sovereign (6), she sees the grownups of that court at her feet. Too well informed through long experience, through cruel illnesses about the danger of relations with men, she disdains both their homage and sighs. On the pretext of training her pupil, she divides her time between Germany and this capital. She comes to take a break from her important tasks in our bosom with renewed fervor.

We possess, in addition, her worthy rival, the Melpomene of the lyric stage, a great actress (7). She was also a delightful singer. She captivated us with the strains of her enchanting voice. A playful and mischievous spirit, she sprinkles puns, witticisms, sarcasms with as much ease as grace. Surrounded by the most seductive people from the capital and the court, she succumbed in turn. Today she's a lost sheep returned to the fold of the goddess. In the maturity of age, she seeks to make us forget the disorders of her youth.

Shall I overlook you, illustrious foreigner (8), and would the friendship that unites us prevent me from doing you justice, from announcing how you've preferred the sweeter

and keener affections of your sex to the charity, the love of a prince, brother of a great king (9)? You rejected his august embraces for my embraces.

You won't be forgotten, immature novice (10), who, profiting from the great examples that were presented to you, walked with giant steps down the road and deserved, before the usual age, to climb the first step.

I believe I may, without arrogance, cite myself after so many others, and wouldn't it be insulting to the selection made by the assembly if, named by it to preside over it, I confessed myself without talent and aptitude? You know the sacrifice I've just recently made (11) in order to surrender myself completely to the inclination that has always dominated me and that I take pride in.

Such are, my dear daughter, the great models that you have to imitate. You'll be even more encouraged to do it when I've described for you the pleasures that are enjoyed in our society.

THIRD PART

Due to the unfortunate condition of the human race, our pleasures are ordinarily ephemeral and deceptive. They're at least futile, vain, and brief. One pursues them, one secures them with difficulty, one enjoys them with anxiety, and they most often bring about disastrous consequences after them. From these characteristics you recognize above all those that one enjoys in the union of the two sexes. It's not the same with pleasures between women. They're genuine, pure, lasting, and without remorse. It can't be denied that a violent inclination drags one sex toward the other. It's even necessary for the reproduction of the two, for without this fatal instinct, what woman could surrender herself with sang-froid to that pleasure that begins with pain, blood, and carnage, that is quickly followed by the worries, disgust, drawbacks of a pregnancy of nine months, that finally ends with a laborious childbirth, the sufferings of which are the measure of and point of comparison for those whose excess cannot be reckoned or expressed, that keeps you in danger of death for six weeks and is sometimes followed, during a long life, by cruel and incurable ailments. Can this be called enjoyment? Is this genuine pleasure? In intimacy between women, on the contrary, all is enjoyment, without frightening and difficult preliminaries. Each day, each hour, each minute, this attachment is renewed without drawbacks. It's waves of love that follow each other like those of the sea without ever drying up, or, if it's necessary to stop in this delightful activity, because everything has an end and the body finally stops responding to the effusions of two souls so closely united, they part with regret, they look for each other again, they find each other again, they begin again with new ardor, far from being weakened, excited by inactivity.

Pleasures between women are not only genuine but also pure and unadulterated. Independent of the physical ailments preceding, accompanying, and following the pleasures of that kind between man and woman, on account of which one might rightly refuse to call them genuine, there are ailments that I call moral because they especially affect the soul, which disturb and poison these enjoyments. I'm not talking about those continual struggles imposed on a young girl by our customs in concealing, dissimulating her passion, in rejecting the caresses of an amiable man whom she would provoke, irritate, into whose arms she would throw herself if she yielded to the impulses of her heart. I assume that she has succumbed, which happens only too frequently. There she is in rapture, in ecstasy. Doesn't she have to escape from it, use artifice in order to avoid the very object of nature, conception? If she forgets herself for a second, it's too late. She carries within

her bosom the mark of her mistake, an accuser who confounds her. What cares, what worries, what torments if she wants to conceal this fatal mystery, and Heaven save her from being forced to have recourse to the most dreadful of crimes in order to avoid dishonor!

I know that these disadvantages are abolished in matrimony, but it entails others. The most considerable and inevitable is aversion to the husband. The facility, the repetition of the enjoyment of the most enchanting object satiates the man in the long run, all the more so when he's the husband, that is to say attached by an indissoluble bond and when pleasure's a duty for him. That's what was confessed by one of our most vaunted wits (12), who thought he was only bantering like a fop and spoke like a philosopher. Owner of a wife in the springtime of age, combining all charms, graces, talents, virtues, when he was reproached for deserting her for prostitutes, he replied, "Nothing more true, but she's my wife."

Without doubt there are consolers and consolations for such an Ariadne.[134] Furtive and forbidden pleasures are only more attractive for being so. Still it's necessary that the husband not be one of those eunuchs in the middle of the seraglio, doing nothing there and harming whoever wants to do something (13), that jealousy's not involved in it. Otherwise it's hell. This passion can also exist between tribades. It's even inseparable from love, but what a difference, since among us jealousy only serves to stimulate love and almost always turns to the advantage of enjoyment! Yes, it's this feeling that gives our pleasures a stability, a duration that those of men are not capable of.

Indeed, imagine the woman most cherished and best pampered by her husband, or rather by her lover. With every caress she receives from him, she must fear that it might be the last; at least it's a step toward it. Kisses discolor her face; touching blemishes her throat. Her stomach loses its elasticity from pregnancies. Secret charms are ruined by childbirth. Through what resource does beauty thus deteriorated call back the man who flees it? I'm mistaken, he's still attached to her. He hasn't stopped loving her; his heart still burns for her. But nature resists. It's in the languor, the coldness, the numbness. All the homage he can offer to his lover is not to be unfaithful to her, not to seek to recover his faculties elsewhere. Cruel state for both of them! Distressing prospect for a woman's self-esteem, which, alone, if I didn't know the whims, the falsity, the betrayals, the atrocities of men, would make me renounce relations with them forever.

None of these contradictions between feelings and faculties among tribades. Soul and body go hand in hand. One doesn't jump to one side, while the other goes in another direction. Enjoyment always follows desire. Whence, no doubt, without going into it more, the cause of our constancy. Always receiving and giving pleasure, why change? For one must acknowledge it and be fair: inconstancy arises from the constitution, from the very essence of the virile individual. He is often required to leave. The diversity of objects is an infinite resource for him. He doubles, triples, quadruples, multiplies his strength tenfold. He does with ten women what it would be impossible for him to do with one. However, he weakens imperceptibly. Age consumes and wears him out. It's not the same way with the tribade, in whom nymphomania increases with age. It's a frenzy. She changes then from succubus to incubus, that is to say from passive to active. She moves up to the rank of mother and trains a pupil in her turn. This selection deserves a lot of attention. If it's done, if she's found the object that suits her, that other half of herself, with whom she soon unites herself through attraction, she does not abandon her. She watches over her with a gentle and anxious jealousy that is caused by the fear of losing a unique and precious possession and that has more in common with maternal tenderness than with

that unbridled passion of men. And this feeling in a tribade, far from distancing her pupil from her, attaches her to her more and more and makes their love imperturbable. But pleasures continued in this way are still without any remorse, and that's the height of happiness. How would we have it? The pleasure of tribadism is inspired in us by nature. It's not an offense against the laws. It's the safeguard of the virtue of maidens and widows. It heightens our charms. It maintains them, preserves them, prolongs their duration. It's the consolation of our old age. Finally, it sows roses without thorns equally in the beginning, the middle, and the end of our course of life. What other pleasure can be likened to that?

Make haste, my dear daughter, to enjoy it. May you, after having received it for a long time, a long time, also pass it on and always repeat with the same relish, "Women, welcome me to your bosom; I'm worthy of you."

(1) Madame the duchess d'Urbsrez and Madame the marquise de Terracenès.[135]

(2) Monsieur de Furiel was attorney general for the entire duration of the Maupeou parlement, and you can remember how much he made himself talked about.

(3) Madame the marquise de Téchul.[136]

(4) Madame de Téchul has been known to disguise herself sometimes as a chambermaid, a hairdresser, a cook to reach the objects of her passion.

(5) Mademoiselle Clairon.

(6) A minor German ruler, a margrave.[137]

(7) Mademoiselle Arnould.[138]

(8) Mademoiselle Souck, a German.[139]

(9) Mademoiselle Souck was maintained by a brother of the king of Prussia.

(10) Mademoiselle Julie, young tribade trained by Mademoiselle Arnould and Mademoiselle Raucourt.

(11) Mademoiselle Raucourt just left Monsieur the marquis de Bièvre, not without having fleeced him a good deal. He had guaranteed her a life annuity of twelve thousand livres, which made this punning lord call her the ungrateful Amaranth (*à ma rente* [for my annuity]).[140]

(12) Monsieur de Monville.

(13) "He's a eunuch in the middle of a seraglio, who does nothing there and harms whoever wants to do something." Everyone knows Piron's epigram that ends this way.[141]

16. HONORÉ GABRIEL RIQUETTI, COUNT DE MIRABEAU
(1749–91), *pamphleteer and Revolutionary statesman*

The Raised Curtain, or Laure's Education (1785)[142]

[The young heroine has been frolicking around with her adoptive father, with whom she
has been sexually involved, and the siblings Vernol and Rose.]

Rose had already taken hold of my papa's cock, which she had been staring at for a
long time. Meanwhile Vernol was holding me closely, and his hand had taken posses-
sion of my cunt, when my papa stopped us.

"Wait, my children, I attach one condition to my compliance; it is fair that I be paid
for it. If Vernol puts it in Laure, I want to imitate that courtier, who, having his wife sleep
with a page whom she loved, did to that page's ass the same thing he was doing to the
lady's cunt. While Vernol fucks Laure, his ass must be similarly at my disposition."

At that moment I was convinced that Vernol's charms had inspired desires in him
as they had aroused mine. I was enchanted by the idea. I therefore became freer to yield
to my desires, and this thought released me from shackles that had, until then, caused me
some discomfort. I animated our games with raptures of joy; I tried, for my part, to add
to them everything that could make them more charming. I took hold of Vernol, I tore
off his robe, I presented his ass, I separated his charming cheeks, his cock drove into my
womb.

"No, Vernol, don't think about putting it in me on this condition."

Rose, who had seen that my papa had likewise put it in me [in the ass], exclaimed
that there was no cause for hesitation and swore that she would take it instead.

"What," said Vernol, "what then would be the obstacle that could stop me? For a
long time I have been tortured. What wouldn't I do, lovely Laure, to enjoy you and die
in your arms?"

"In that case," said my papa, "Rose will also join the party."

In a moment the table was removed and the basin covered again. A thick cushion
filled its expanse and was wrapped in puce-colored satin, so suitable for heightening the
whiteness [of skin]. That nook was the true sanctuary of pleasure. We were immediately
freed of everything that was foreign to us, and we climbed onto this altar with only the
ornaments of nature, such as were necessary to offer our vows to the divinity that we
were going to worship and for the sacrifices that we were going to make to it. The mir-
rors reflected our various charms from all sides. I admired those of Vernol. This hand-
some youth took me in his arms, he covered me with kisses and caresses, he got hard
with all of his might. I held his cock; my papa handled his buttocks with one hand, and,
with the other, the tits or cunt of Rose, who was caressing all three of us. Finally yield-
ing to our amorous fury, Vernol turned me over, spread my thighs, kissed my mound,
my cunt, put his tongue in it, sucked my clitoris, lay on me and made his cock enter me
all the way to the hilt. My papa put himself on him at once. Rose was on her knees, lean-
ing on her elbows, her cunt turned toward me. She opened Vernol's buttocks, moistened
the entry, and guided my papa's cock along the route she had prepared for him. While
they proceeded, she tickled both of their balls. I grabbed her cunt, I put my finger in it,
I jerked her off. Soon my hand was completely moist. Her rapture, which materialized

first, excited us greatly. Vernol followed soon after her. My papa noticed it; he hastened his business, which was pleasing to me. I redoubled my efforts, and we fell almost immediately into the same ecstasy. Our three united persons, so to speak, no longer constituted but one, which Rose covered with her kisses.

Having come back to our senses, our caresses replaced our raptures and filled the time that pleasure left us to traverse. They soon brought us back to a state in which we could feel it in ourselves. Vernol admitted that he had never felt anything comparable. . . .

[Later, while talking with her father, Laure thinks to herself:]

I still wanted to shed some light on a suspicion that our frolics in the country had raised in me, and I wished it to be verified to prevent any return to the regrets that I had felt, but I did not have occasion to draw this benefit from the request that I made of him.

"Dear papa, I would like to ask you a question which I beg you to answer without reserve."

"What then, my little Laure, could I have any reserve with you and give you an unworthy example after having tried myself to make you always sincere? Speak, the truth will never be disguised in my mouth."

"When we were in the country for the first time with Rose and Vernol, after having heard you state the condition under which you would lend yourself to my folly, I was persuaded that the sight of that handsome youth's charms had given birth to your desires, as he had excited mine, and that, in order to enjoy them, you had agreed to yield to his in demanding this duty from him. Are my thoughts well founded?"

"Oh, you are wrong, my dear child! I had some desires, it is true; you saw the sure signs of them. Well, who wouldn't have had them? But the charms and attractions spread all over your person were the primary cause of them; the scene added to them, but Vernol had nothing to do with them. I even admit to you that the taste of many men for their sex seems more than bizarre to me, although it's spread throughout all the nations of the world. Besides violating the laws of nature, it seems foolish to me, at least unless there's a complete dearth of women; then necessity is the first of laws. That's what happens in boarding houses, in collèges, on ships, in countries where women are shut up. And what's unfortunate, this taste, once tried, is preferred. I don't see that which women have for their own sex in the same light. It doesn't seem extraordinary to me. It even follows more from their essence; everything leads them to it, although it doesn't fulfill general purposes [procreation]. But at least it doesn't usually distract them from their inclination for men. Indeed, the almost complete constraint under which they find themselves, the enclosure in which they are held, the prisons in which they are shut up in almost every nation gives them the illusory idea of happiness and pleasure in the arms of another woman who pleases them. No risks to run, no jealousy to endure on the part of men, no slander to experience. A reliable discretion, more beauty, charms, freshness, and delicacy. So many reasons, dear child, to lead them to a tender passion vis-a-vis a woman! It isn't the same with regard to men. Nothing leads them to it. In general they don't lack women. The path they seek is no less sown with risks than that which they flee in women. Finally, it seems to me contrary to everything, and you should remember that that is the only time that I acted in this way with Vernol. If this affected taste seems more bizarre to me in men, don't think I see it the same way in women. A poorly endowed man in a wide path is obliged to look for the narrow path to scatter, afterward, the beneficial dew in the field that he should fertilize. But there's more: there are women who can only be loved by this means, and for them the entrance into the path is almost always free of thorns.

B. ENLIGHTENMENT

I. CHARLES DE SECONDAT, *baron de Montesquieu* (1689–1755)

The Spirit of the Laws (1748)[143]

On the Crime against Nature

God forbid that I wish to diminish the horror that people have for a crime that religion, morality, and politics condemn in turn. It would be necessary to outlaw it if it did nothing but give to one sex the weaknesses of the other and lead to a disreputable old age through a shameful youth. What I will say about it will leave it all its stigma and will only bear upon the tyranny that can misuse the very horror that one should have for it.

Since the nature of this crime is to be hidden, it has often happened that lawgivers have punished it on the testimony of a child. That was to open a very wide door to slander. "Justinian," says Procopius, "promulgated a law against this crime. He had those who were guilty of it pursued, not only since the law, but before. The testimony of one witness, sometimes a child, sometimes a slave, sufficed, especially against the rich or those who belonged to the faction of the Greens."[144]

It is strange that among us three crimes—magic, heresy, and the crime against nature, of which it could be proved, in the first case, that it does not exist; in the second, that it is susceptible to a great number of distinctions, interpretations, limitations; and in the third, that it is very often hidden—have been punished, all three of them, by the penalty of burning.

I would even say that the crime against nature will never make great progress in a society, if people are not otherwise led to it by some custom, as among the Greeks, where young people performed all their exercises in the nude; as among us, where domestic education is out of fashion; as among the Asians, where some individuals have a large number of wives whom they despise, while the others cannot have any. Let nothing lead to this crime, let it be proscribed, like all transgressions against morals, through strict maintenance of order, and one will immediately see nature either defend her rights or recover them. Gentle, lovable, generous, and, in showering us with pleasures, she leads us, through the children in whom we are, so to speak, born again, to satisfactions greater than those pleasures themselves.

2. Encyclopedia or Reasoned Dictionary of the Sciences, Arts, and Crafts (1765)[145]

a. ANTOINE GASPARD BOUCHER D'ARGIS (1708–91), JURIST

SODOMY is the crime of those who commit lewdness against the order of nature itself. This crime derived its name from the city of Sodom, which was destroyed by fire from heaven because of this abominable disorder, which was common there.

Divine justice pronounced the penalty of death against those who soil themselves with [this] crime. *They will be put to death,* Leviticus 20.

The same penalty is pronounced by the antiheretic. *So that they not be made dissolute.*

The law *Cum vir* in the [Julian] code on adultery requires that those who are convicted of this crime be burned alive.

This penalty was adopted in our jurisprudence. There has been another example of it in the execution of the sentence of 5 June 1750 against two individuals who were burned alive in the place de Grève.

Women, minors are punished like other guilty people.

Some authors, such as Menochius, however, claim that the penalty should be mitigated for minors, especially if the minor is under the age of puberty.

Ecclesiastics, monks, given the example of chastity, of which they have taken a specific vow, should be judged with the greatest severity when they are guilty of this crime. The least suspicion suffices to have them removed from every function or job that has something to do with the education of the young. See Du Perray.

Under the term "sodomy" is included that kind of lasciviousness that the canonists call *mollitude* and the Romans *masturbation,* which is the crime that one commits upon oneself. When it is detected (which is quite rare outwardly), it is punished by service in the galleys or banishment, depending on whether the offense is more or less great.

Those who teach the young to commit such lewdness are also punished with the same penalty. In addition, they are subjected to exposure in the pillory with a sign bearing these words, "Corrupter of the young." See *Novellae* 77 and 141; Du Perray, *On Canonical Pleas,* chapter 8; Menochius, *Of Uncertain Cases,* case 329, note 5; M[uyart] de Vouglans, in his *Institutes of Criminal Law,* page 510.[146]

b. UNSIGNED

TRIBADE, woman who has a passion for another woman. Type of odd depravity as inexplicable as that which inflames a man for another man.

3. FRANÇOIS MARIE AROUET DE VOLTAIRE (1694–1778)

Philosophical Dictionary (1764)[147]

SOCRATIC LOVE

If the love that has been called Socratic and Platonic were only a decent sentiment, we must applaud it; if it was debauchery, we must blush for Greece on its account.

How has it happened that a vice that would destroy the human race if it were widespread, that an infamous offense against nature, is nevertheless so natural? It seems to be the ultimate stage of deliberate corruption, and yet it is the common lot of those who have not yet had time to be corrupted. It has entered wholly fresh hearts, which have not yet known ambition or fraud or thirst for riches. It is blind youth that, through a badly distinguished instinct, throws itself into this disorder, as well as into onanism [masturbation] (1), on leaving childhood.

The inclination of the two sexes for each other declares itself early on, but no matter what has been said about female Africans and the women of southern Asia, this inclination is generally much stronger in man than in woman. It is a law that nature has established for all animals; it is always the male that assaults the female.

Young males of our species, raised together, feeling this force that nature begins to deploy in them, and not finding the natural object of their instinct, fall back on what resembles it. A young boy, because of the freshness of his complexion, the brightness of his color, and the softness of his eyes, often resembles a pretty girl for two or three years. If he is loved, it is because nature is mistaken. One pays homage to the female sex by becoming attached to that which has its beauties, and when age has made this resemblance vanish, the misapprehension stops.

> . . . to pluck the first flowers
> and brief springtime of life.[148]

It is not unknown that this misapprehension of nature is much more common in mild climates than in the ice of the north, because the blood is more inflamed and the opportunity is more frequent there. So what appears to be nothing more than a weakness in the young Alcibiades is a disgusting abomination in a Dutch sailor and a Muscovite sutler [vendor who follows armies and sells supplies to soldiers].

I cannot endure that people claim that the Greeks sanctioned this license (2). They cite the legislator Solon, because he said, in two sorry verses,

> You will love a handsome boy
> As long as he has no beard on his chin (3).[149]

But, in good faith, was Solon a legislator when he composed these two ridiculous verses? He was young then, and when the profligate had become wise, he did not include such an infamy among the laws of his republic. Will Théodore Béza be accused of hav-

ing preached pederasty in his church because, in his youth, he composed verses for the young Candide and said:

I'm for him; I'm for her.

It must be said that, having celebrated shameful loves in his youth, in his maturity he had the ambition to be the leader of a party, to preach reformation, to make a name for himself. *This is the man, and that is the boy.*

People misuse the text of Plutarch, who, in his babblings in the *Dialogue on Love,* has an interlocutor say that women are not "worthy of true love" (4), but another inter-locutor supports the women's side as he should.[150] People have taken the objection for the conclusion.

It is certain, as much as the study of antiquity can be certain, that Socratic love was not an infamous love. It is the word "love" that has misled. What were called a young man's lovers were exactly what the *menins* of our princes are among us, what honorary pages were, youngsters associated with the education of a child of rank, sharing the same studies, the same military exercises, a warlike and holy institution that was abused, like noctural entertainments and orgies.

The band of lovers founded by Laius was an invincible band of young warriors bound by oath to give their lives for each other, and that is the finest that ancient discipline ever had.[151]

Sextus Empiricus and others said in vain that this vice was recommended by the laws of Persia.[152] Let them cite the text of the law. Let them produce the code of the Persians. And if this abomination were found there, I would not believe it. I would say that it is not true, for the reason that it is impossible. No, it is not in human nature to make a law that contradicts and offends nature, a law that would destroy the human race if it were followed to the letter. But I will show you the ancient law of the Persians, written in the *Avesta.* It is said, in article or door nine, that "there is no greater sin."[153] It is in vain that a modern writer tried to vindicate Sextus Empiricus and pederasty. The laws of Zoroaster, which he was not familiar with, constitute irreproachable testimony that this vice was never recommended by the Persians.[154] It is as if one said that it is recommended by the Turks. They commit it boldly, but the laws punish it.

How many people have mistaken the shameful practices tolerated in a country for the laws of the country! Sextus Empiricus, who questioned everything, should surely have questioned this jurisprudence. If he had lived in our time and seen two or three young Jesuits abuse a few schoolboys, would he have had the right to say that this game was permitted them by the constitutions of Ignatius Loyola?[155]

I may be allowed to mention here the Socratic love of the reverend father Polycarp, shod [as opposed to shoeless] Carmelite of the little town of Gex, who, in 1771, taught religion and Latin to a dozen young schoolboys. He was their confessor and master at the same time, and he gave himself a new position in relation to all of them. One could hardly have more spiritual and temporal chores. Everything was discovered. He withdrew to Switzerland, a country very far from Greece.

These amusements have been quite common between preceptors and schoolboys (5). Monks responsible for raising the young have always indulged in pederasty somewhat. It is the necessary consequence of the celibacy to which these poor folk are condemned.

Turkish and Persian lords, according to what we are told, have their children raised by eunuchs: a strange alternative for a pedagogue, to be castrated or a sodomite.

The love of boys was so common in Rome that they did not venture to punish this turpitude, in which almost everyone was blindly involved. Octavius Augustus, that debauched and cowardly murderer who dared to exile Ovid, thought it just fine that Virgil celebrated Alexis. Horace, his other favorite, composed little odes for Ligurinus. Horace, who praised Augustus for having reformed morality, offered the reader a boy and a girl alike in his satires (6). But the ancient Scatinian law, which forbade pederasty, still existed. The emperor Philip put it back in force and expelled from Rome the little boys who practiced the trade [prostitution].[156] If there were witty and licentious schoolboys like Petronius, Rome had professors like Quintilian. See what precautions he takes in the chapter of the *Preceptor* to preserve the purity of earliest youth: *"Not only the crime but also the suspicion of infamy is to be avoided."*[157] In the end I do not believe there has ever been any civilized nation that has made laws (7) against morality.*

(1) See the articles Onan, Onanism.

(2) In a lampoon filled with errors of all kinds and with the crudest criticism, a modern writer named Larcher, a secondary school tutor, dares to cite who knows what book, in which Socrates is called *sanctus pederastes*, Socrates the holy b[ugger].[158] He has not been followed in these horrors by abbé Foucher, but this abbé, no less crude, was still grossly mistaken about Zoroaster and the ancient Persians.[159] He has been vigorously rebuked for it by a man learned in oriental languages.

(3) Translation of Amyot, grand almoner of France.[160]

(4) See the article Woman.

(5) See the article Petronius.

(6) *If a female slave or boy is at hand. . . .*[161]

(7) Messieurs the nonconformists should be sentenced to present a child of their own making to the police every year. The ex-Jesuit Desfontaines was on the point of being burned in the place de Grève for having abused some young Savoyards who swept his chimney; some protectors saved him.[162] A victim was needed; Deschauffours was burned in his place. That is all well and good. *There is a limit in things.*[163] Punishments should be proportioned to offenses. What would Caesar, Alcibiades, Nicomedes, king of Bythnia, Henry III, king of France, and so many other kings have said?

When they burned Deschauffours, they based themselves on the *Institutes of Saint Louis,* rendered into modern French in the fifteenth century. "If someone is suspected of b[ougrerie], he should be sent to the bishop, and if he is convicted, he should be burned and all his goods forfeited to the lord." Saint Louis does not say what should be done to the lord, if the lord is suspected and if he is convicted. It must be noted that by the word "b[ugger]" Saint Louis meant heretics, who were not known by any other name then. Ambiguity got Deschauffours, a gentleman from Lorraine, burned in Paris. Despréaux had good reason to compose a satire against ambiguity; it has caused much more harm than is believed.[164]

*[note by Marie Jean Antoine Nicolas de Caritat, marquis de Condorcet (1743–94), in the Kehl edition of Voltaire's works, published in 1784–90]

We will be permitted to offer some reflections here about an odious and disgusting subject that is unfortunately part of the history of opinions and morals.

This turpitude goes back to the first ages of civilization. Greek history, Roman history leave no doubt about it. It was common among those peoples before they had formed an orderly society guided by written laws.

That is enough to explain why these laws seemed to treat it with too much indulgence. One does not propose to a free people strict laws against an action, whatever it might be, that has become common among them. For a long time several of the Germanic tribes had written laws that allowed compensation for murder.

Solon, then, contented himself with forbidding this turpitude between citizens and slaves. The Athenians could appreciate the political motives for this prohibition and comply with it. It was, moreover, against slaves alone, and to prevent them from corrupting free youngsters, that this law was made. And the fathers of families, whatever their manners were, had no interest in opposing it.

The strictness of women's morals in Greece, the custom of public baths, the passion for games in which men appeared naked, preserved this turpitude of manners despite the progress of society and morality. Lycurgus, by allowing women more liberty and through several others of his institutes, succeeded in making this vice less common in Sparta than in the other cities of Greece.

When the morals of a people become less rustic, when it is familiar with the arts, the luxury of wealth, if it keeps its vices, it at least tries to hide them. By attaching shame to liaisons between free persons, by making marriage indissoluble, by pursuing concubinage with censures, Christian morality had made adultery common. As every type of pleasure was equally a sin, it was surely necessary to favor that whose consequences could not be public. And through a strange reversal, genuine crimes were seen to become more common, more tolerated, and less shameful in public opinion than simple weakness. When the inhabitants of the [former] West[ern Roman empire] began to civilize themselves, they conceived of hiding adultery under the veil of what is called gallantry. Men openly confessed a love that it was agreed that women would not share. Male lovers did not dare to ask for anything, and it was after ten years, at the most, of pure love, combats, victories won in jousts, etc., that a chevalier could hope to find a moment of weakness in his lady.[165] Enough evidence from this time is left for us to show us what the morals were that this kind of hypocrisy concealed. It was more or less the same with the Greeks when they became refined. Intimate liaisons between men had nothing shameful about them any more. Youngsters bound themselves to each other with oaths, but they were those to live and die for the country. One became attached to a young man leaving childhood in order to shape him, instruct him, guide him. The passion that was mingled with these friendships was a type of love, but a pure love. It was only under this veil, with which public decency concealed vices, that they were tolerated by public opinion.

Finally, just as we have often heard chivalric gallantry praised among modern people as an institution fit to lift the soul, inspire courage, this love that united the citizens with each other was praised among the Greeks.

Plato says that the Thebans did a useful thing by prescribing it, because they needed to refine their manners, stimulate more activity in their souls, their minds, numbed by the nature of their climate and soil. One sees that it is a matter only of pure friendship here. It is thus that, when a Christian prince had a tournament announced, at which everyone was supposed to appear with the colors of his lady, he had the laudable intention of arousing rivalry among the chevaliers and refining their manners. It was not adultery, but only gallantry, that he wanted to encourage in his domain. In Athens, according to Plato, they should limit themselves to toleration. In monarchical states it was useful to prevent these liaisons between men, but in republics they were an obstacle to the lasting establishment of tyranny. A tyrant, in sacrificing a citizen, could not know what avengers he was going to arm against himself. He was always exposed to seeing these associations that love formed between men degenerate into conspiracies.

However, despite these notions so distant from our views and morals, this vice was considered, among the Greeks, as a shameful debauchery every time it showed itself openly and without the excuse of friendship or political liaisons. When Philip saw, on the battlefield of Chaeronea, all the soldiers who composed the Sacred Band, the Theban band of friends, killed in the ranks in which they had fought, he exclaimed, "I will never believe that such brave folk could have done or endured anything shameful."[166] This remark by a man tainted himself with this infamy is certain proof of the general opinion of the Greeks.

In Rome this view was even stronger. Several Greek heroes, regarded as virtuous men, were looked upon as having surrendered themselves to this vice, and among the Romans it was not seen to be attributed to any of those whose virtues have been praised to us. It appears only that among those two nations it did not have the idea of crime or even that of dishonor associated with it, unless those excesses were committed that make even the taste for women a degrading passion. This vice is very rare among us, and it would be almost unknown here if not for the shortcomings of public education.

Montesquieu claims that it is common among some Muslim nations, because of the "facility" of having women; we think that it should read "difficulty" instead.

4. VOLTAIRE

The Reward of Justice and Humanity (1777)[167]

ON SODOMY

The emperors Constantine II and Constans, his brother, were the first who decreed the dealth penalty for this turpitude, which dishonors human nature (*Code,* book 9, title 9).[168] *Novella* 141 of Justinian is the first imperial rescript in which the word sodomy was used. This term was not known until long after the Greek and Latin translations of the Jewish books. The turpitude it refers to was previously specified by the word *paedicatio,* drawn from Greek.[169]

The emperor Justinian, in his *Novella,* does not decree any penalty. He limits himself to inspiring the horror that such an infamy deserves. One must not believe that this vice, become too common in the city of Fabricius, the Catos, and the Scipios, was not curbed by laws.[170] It was by the Scatinian law, which expelled the guilty from Rome and made them pay a fine, but this law was soon forgotten, especially when Caesar, conquerer of corrupt Rome, placed this debauchery on the dictator's throne and when Hadrian divinized it.

Constantine II and Constans, as co-consuls, were then the first who took up arms against this vice too honored by Caesar. Their law *Cum vir* does not specify the penalty, but it says that justice must arm itself with the sword: *We order justice to be armed with an avenging sword;* and that extreme punishments are necessary: *severest penalties.* It appears that they were always more severe against the corrupters of children than against the children themselves, and they should have been.

When these offenses, as secret as adultery and as difficult to prove, are brought to the courts, which they scandalize, when these courts are obliged to take cognizance of them, should they not carefully distinguish between the grown man and the innocent age that is between childhood and youth?

This vice unworthy of man is not known in our hard climate. There was no law in France for its pursuit and punishment. People thought they found one in the *Institutes of Saint Louis. . . .* The word *bulgarie,* which only means heresy, was taken for the sin against nature, and it was on this text that they based themselves in burning alive the few unfortunates convicted of this filth, more fit to be buried in the darkness of oblivion than to be lit up by the flames of stakes before the eyes of the multitude.[171]

The wretched ex-Jesuit, as infamous because of his writings against so many decent folk as because of the public crime of having corrupted even chimney sweeps in Paris, was only sentenced, however, to secret fustigation in the beggars' prison of Bicêtre. It has already been pointed out that penalties are often arbitrary and that they should not be so, that it is the law, and not man, that should punish.

The penalty imposed on this man was sufficient, but it could not be as useful as we would like because, not being public, it was not exemplary.*

*[note by Condorcet in the Kehl edition]

Sodomy, when there is no violence, cannot fall within the competence of the criminal laws. It does not violate the rights of any other man. It has only an indirect influence on the good order of society,

like drunkenness, love of gambling. It is a vile, disgusting vice, whose true punishment is scorn. The penalty of burning is atrocious. The English law that exposes the guilty to all the insults of the rabble, and especially of the women, who sometimes torment them to the point of death, is at once cruel, indecent, and ridiculous. Furthermore, it must not be forgotten to note that it is to superstition that one owes the barbarous practice of punishment by burning.

5. DENIS DIDEROT (1713–84)

D'Alembert's Dream (1769)[172]

SEQUEL TO THE CONVERSATION

[discussion of masturbation]

BORDEU[173]: Listen, Mademoiselle, I don't let myself be impressed by words, and I explain myself all the more freely because I am candid and because the purity of my morals does not leave me open to attack from any side. I'll ask you, then, of two actions equally confined to pleasure that can only give pleasure without utility, but one of which gives it only to the one who performs it and the other shares it with a fellow being, male or female—for the sex, and even the usage of the sex, doesn't matter—which would common sense pronounce in favor of?

MADEMOISELLE DE L'ESPINASSE[174]: Such questions are too lofty for me.

BORDEU: Ah, after having been a man for four minutes, now you're putting on your cap and petticoats again. Fine, well, you must be treated as such. That's that. No one says a word about Madame du Barry anymore. You see, everything works out. They thought the court was going to be disrupted. The master acted like a sensible man. *He won all the votes.*[175] He has kept the woman who pleases him and the minister who's useful to him. But you're not listening to me. What are you thinking about?

MADEMOISELLE DE L'ESPINASSE: I'm thinking about those combinations that all seem contrary to nature to me.

BORDEU: Everything that is cannot be either against nature or outside nature. I don't except even chastity and voluntary continence, which would be the first of crimes against nature, if one could sin against nature, and the first of crimes against the social laws of a state in which one weighed actions in a scale other than that of fanaticism and prejudice.

[discussion of bestiality]

6. DIDEROT

Fragments That Slipped Out of a Philosophe's Portfolio (1772)[176]

ON THE ANTIPHYSICAL TASTE OF THE AMERICANS

But physical weakness, far from leading to this type of depravation, keeps it at a distance. I believe that its cause must be sought in the warmth of the climate, in scorn for a weak sex, in the insipidity of pleasure in the arms of a wife exhausted by hardships, in the inconstancy of taste, in the oddness that, in everything, pushes people toward less common enjoyments, in a search for pleasure easier to understand than decent to explain, perhaps in a resemblance of organs that created more proportion between one American man and another than between an American man and an American woman, a disproportion that would encourage both the aversion of American men for their wives and the taste of American women for European men. Besides, these hunts, which sometimes separated a man from his wife for months at a time, did they not tend to bring men together? The rest is nothing more than the result of a universal and violent passion that tramples under foot, even in civilized countries, honor, virtue, decency, probity, laws of blood, patriotic feeling, because nature, which has organized everything for the preservation of the species, has not much looked after the preservation of individuals, without taking into account that there are actions to which civilized peoples have with reason attached moral ideas that are completely foreign to savages.

7. JACQUES PIERRE BRISSOT DE WARVILLE (1754–93)

Theory of Criminal Laws (1781)[177]

SODOMY

The Persians have seraglios of boys; the bonzes [monks] in the Indies do not see women, but they know how to compensate themselves for them. It has been noted that in all warm countries, men were strongly inclined to all illicit conjunctions, that the climate makes them tolerated even in the most rigorous religions. I do not discuss whether this crime is against nature. I do not discuss whether great men have committed it, whether it has even been permitted in certain circumstances.* It harms the population; it should therefore be

*Johannes Lydius, in his *Analects*, claims that Sixtus IV granted permission to sodomize.[178] While doubting this assertion, it is nonetheless problematic that he had a b[rothel] constructed, if one believes what Agrippa says about it. *"But in recent times Pope Sixtus erected a celebrated brothel in Rome."* Works of Agrippa, 1: 135.[179]

prohibited. But it is not by death that it should be punished, for the remedy would be worse than the problem. That is to harm the propagation of men doubly. All crimes against morals should be punished by public opinion. It is with the seal of ignominy that those who attack morals, public modesty should be marked. In France prostitutes are punished by parading them on a donkey, with their faces turned toward the tail. The guilty person is ridiculed in this state by the people. Impose the same punishment on all sodomites, without exceptions for rank, individuals. Since this crime is more common among the great, among opulent people (for the artisan limits himself to his wife), it is through public opinion that they should be branded, because they are more subject to it than others. Above all, no monetary penalties. The sodomites would not pay fewer boys for their pleasures, but they would cost them more. It is a mistake in politics to deprive the state needlessly of subjects who could be useful to it. A sodomite can make amends for his crime. One should not be so eager to find the unfortunate men who commit this crime. The large number of criminals makes the frequency of punishments necessary, and this frequency diminishes the horror that the people have for this crime. They are becoming familiar with its image.**

**The crime against nature is not punished severely in France at present. Imprisonment is the usual penalty for those who are convicted of this crime, which religion, morality, politics condemn in every country, which worn-out sensuousness calls to its aid in warm climates. Montesquieu. See the continuation.

Constantine II and Constans, being co-consuls, were the first who took up arms against the vice of sodomy. Their law, *Cum vir,* does not specify the penalty, but it says that justice should arm itself with the sword and that extreme punishments are necessary when these offenses, as secret as adultery and as difficult to prove, are brought to the courts, which they scandalize. When these tribunals are obliged to take cognizance of them, should they not carefully distinguish between the grown man and the innocent age that is between childhood and youth?

This vice unworthy of man is not known in our hard climate. There was no law in France for its pursuit and its punishment. People thought they found one in the *Institutes of Saint Louis,* by virtue of an article that sentenced heretics or *bulgares* to the flames. They burned persons afflicted with pediculosis [infestation of the body with lice].

Justinian, more wisely, did not decree any penalty against them. *Reward of Justice,* p. 77.

8. JOSEPH ELZÉAR DOMINIQUE DE BERNARDI DE VALERNES (1751–1834), *lawyer in the parlement of Aix*

The Means of Mitigating the Severity of the Penal Laws in France without Jeopardizing Public Safety (1781)[180]

ON CRIMES AGAINST NATURE

We will not follow any other rule [than that expounded in the preceding section, on incest] with regard to the crime against nature. "God forbid," I will say, with Monsieur de Montesquieu, "that I wish to diminish the horror that people have for a crime that religion, morality, and politics condemn in turn. It would be necessary to outlaw it if it did nothing but give to one sex the weaknesses of the other and lead to a disreputable old age through a shameful youth."

Plato sentences those guilty of this crime only to disgrace and to deprivation of all the benefits of society, and he requires that the crime be known and public.[181] But in the system of Plato's *Republic,* where every citizen had an occupation, where employment and wealth were distributed appropriately, such a crime should have been very rare. It is the large cities that are usually the stage for it, those opulent cities filled with lazy citizens, whom debauchery, and this satiety that is born of too much usage of pleasure, moves incessantly to seek new ways to stimulate dulled senses.

Let marriages be facilitated, let the inhabitants of the provinces be prevented from going to bury themselves, along with morals, in huge capitals, let exorbitant wealth not be amassed in the hands of lazy and unmarried men, and one will soon see nature recover its rights. Without these precautions, one would attempt to restore morals by strict penalties in vain. These penalties will fail through their very severity, and they will only serve to prove that punishments cannot replace morals. The practice of the crime will imperceptibly lessen the shame, and such a degree of depravity will be reached that the guilty will hardly be exposed to any mockery, if they do not, indeed, take pride in their infamous deeds.*

*Augustus decreed the death penalty for the crime against nature, but it was necessary, for this penalty to be inflicted, that it be accompanied by violence. The Christian emperors demanded that it be punished by death, even if it was not accompanied by any aggravating circumstance. Charlemagne decreed the penalty of burning for this crime in a capitulary of the year 780. In it he paints a very emphatic picture of the ills that debauchery causes in society. It is noticeable that this vice is beginning to make progress in northern countries, which proves that it is not a vice caused by climate and that if it has been more common until now in southern countries, this had its cause in legislation.

9. LOUIS SÉBASTIEN MERCIER (1740–1814)

The Tableau of Paris (1782)[182]

UNTITLED

There are vices about which censure should remain silent, because it would risk unmasking them without correcting them. What will morality do against these deplorable vices and turpitudes destined to die in darkness? How will the accomplices of these abominable secrets come back to virtues they are incapable of? It is a generation that leaves no more hope. Stricken with gangrene, it should fall off, rot, and disappear, and even indignation can turn into pity when one thinks of the depravity into which these beings, so basely corrupted, plunge themselves.

Strictness against these monstrous errors is a dangerous and most often useless remedy. It is disadvantageous to attack that which cannot be destroyed, and when it is a matter of correction of morals, one must succeed and not make vain attempts.

The magistrate who keeps a secret register of the violaters of the laws of nature may take fright at their number. He should check guilty morals that go as far as scandalous conduct, but, apart from that, what circumspection! The pursuit would become as odious as the crime. What effrontery in these new vices! They did not have names among us a hundred years ago. Today the details of this debauchery enter into our conversations. Old men put aside the gravity of their character to talk about this criminal license. The holiness of morals is offended by remarks all the more dangerous because people joke almost publicly about these incredible turpitudes.

Where does this new scandal that has exploded among us come from? Who has offended public decency in this way? Who has handed over to derision the holy sadness of virtue, which moans about these infamies that degrade women, makes them a separate class whose desires and strange furies one describes? Is that where the progress of civilization and the arts should lead?

What degradation! This kind of corruption was a phenomenon even for some libertine spirits, and, in its excesses, it has not shocked our century as much as it should have.

One should lament, let these shameful vices, which punish those who surrender themselves to them, melt and disappear before the sweet, decent, and virtuous passions that, through their eternal charm, should regain their amiable dominion. That is Montesquieu's notion, and he had pondered it carefully, when he published it in a book as serious as *The Spirit of the Laws*.

10. JACQUES ANDRÉ NAIGEON (1738–1810)

Methodical Encyclopedia:
Ancient and Modern Philosophy (1791)[183]

ACADEMICIANS, PHILOSOPHY OF THE

To judge Arcesilaus with reference to the vice imputed to him, let us transport ourselves
to the most glorious times of Greece and Athens, where this kind of debauchery was only
too common, without one's seeing, from the history of these brilliant centuries, that those
who surrendered themselves to it with more or less openness and effrontery were, on
account of that, either less respected or respectable when they had all the qualities that
make a good man, a great captain, an eloquent orator, a profound philosopher, and a use-
ful citizen.[184] Let us not pass on this strange turpitude an absolute judgment based on
certain notions of modesty, decency, and indecency that we have today and which, by
their nature and as a result of an infinity of causes that are always active, are in flux like
many other notions. Let us reserve odious names for vices and crimes genuinely harm-
ful to society and which, in destroying the springs and connections of the different parts
that compose it, sooner or later bring about its dissolution. . . .

 In this regard the Persians, Germans, and Thebans had no other notions or morals
than the Cretans and Lacedaemonians. Pederasty became the custom among them, and
they did not attach any kind of shame to it. With regard to the Greeks, it seems obvious
that the climate, collective morals, and certain peculiar institutions, quite suited to excite
desires, enflame the senses, and corrupt the imagination, necessarily led them, and by an
irresistible attraction, toward this type of debauchery. This is what Plato explains quite
clearly when he says that the establishment of gymnasia and meals in common caused a
very great evil in perverting the ancient practice of the pleasures of love, such as it was
ordered by nature, not only for men but also for animals, and he adds that it is especially
to the two cities of Crete and Lacedaemon, and to the other states where gymnasia were
introduced, that the cause of this disorder must be attributed, one of the most criminal
disorders that the excess of intemperance has produced. . . .[185]

 Furthermore, whatever might be the cause of this fact that Plato and Cicero seem to
me to have known well, it is not within my purview to undertake deeper research on this
point. What we need to know is that among those peoples endowed with a lively, often
even very exalted imagination and who breathed, so to speak, the desire for all sorts of
enjoyments along with the pure air of their fine climate, the legislators had the wisdom
and the good sense to think that, far from taking cognizance of these secret disorders that
I have just spoken of and making them the specific object of a law, they should not even
imagine them or decree any penalties against the various excesses to which man may
abandon himself at the instigation of the most violent and most universal passion in nature,
no matter what the kind of these excesses and the object toward which his passion drags
and throws him.

 With regard to this phrase, otherwise so vague, "crime against nature," by which the
moderns have designated this type of monstrosity, it suggests a notion that is false and
that sound philosophy must rectify. Indeed, there is nothing that is not in nature, crime
as well as virtue. . . .

Finally, the long silence of the laws of the Greeks and Romans about this vice, so common among them, seems to prove that they counted it, like many other items about which the laws of all peoples have not decreed anything, among the purely local actions that custom does not, undoubtedly, justify, but which it tacitly sanctions and which, being neither prohibited nor permitted by the legislator, can be regarded as licit and consequently as indifferent. . . .

Arcesilaus, guilty in France or elsewhere of a particular kind of profligacy prohibited by law, is then, in Athens, where this law did not exist, nothing but a man who in this regard shared the morals more or less universal in his country and who followed, as it were, its customs or, if you will, its abuses. Apollo's oracle replied to those who came to consult it about the best way to make sacrifices to the gods that the true form of worship for each person is that which he finds consecrated by the customs of the country where he lives. It is the same with what is generally called decent and indecent, good and evil, virtue and vice. If one examines this matter with a mind free of prejudices and as a philosopher, one will see that there are a large number of actions that, remaining the same, change names from one century or one city to another and that to make the same man look alternately guilty or innocent, chaste or lewd, good or bad, just or unjust, virtuous or depraved, it is often necessary only to relocate him. . . .

It seems to me, indeed, that in the case in question here, public opinion can be directed in such a way as to give this check coercive force greater and more effective than that of penal laws, which, besides, should be made use of in all circumstances with much moderation. I would even dare to say that, independently of this consideration, this vice so common in Rome and the major cities of Greece, where everything encouraged it, is one of those violations of morals, one of those offenses that should have no avenger but public scorn and that must be abandoned to the just severity of that court redoutable for every man who has not entirely smothered the feeling of honor and virtue in the depth of his heart, without which one cannot hope for security, happiness, or peace and quiet.

Montesquieu does not have principles very different from mine in all this. . . .

In this excerpt there are, to be sure, some phrases more in conformity with inherited prejudices than with sound philosophy, but in transporting oneself to the time when Montesquieu wrote, one feels more disposed to take notice of what he had the courage to say than to criticize him for having sometimes spoken like the people. . . .

I therefore beg the calm and impartial reader to grasp well the spirit in which I wrote what he has just read and to do justice to the purity of the motives that led me to consider this sensitive question here. I beg him especially never to lose sight of the fact that in all this I do not approve, I excuse. I seek to explain a paradox. . . . In addition I note that among the most educated, most civilized people of Greece, who, by their lessons and examples, perhaps contributed more than any other to the progress of morality, the most famous men of all types indulged in the same vice that is attributed to Arcesilaus. . . .

The morals of the Romans, considered in this light, were not better. . . .

Let us consult history, and we will see that those very men who, in either Rome or Athens, yielded without shame to that inclination toward a type of debauchery that cannot be denied, because it is a fact, but which is not on that account easier to conceive, did not for that reason, enjoy universal esteem any less when they made themselves worthy of it through actions useful to society. . . .

All these considerations make me think that there is no parity, no relation, in either their nature or their effects, between certain types of profligacy to which several individuals of the same sex can abandon themselves with each other and vices that have their

source in a corrupt heart and that condemn the wicked man or, to speak more precisely, the unluckily born man to long remorse, that pain that is only assuaged by carrying it to excess, that is to say by making oneself the most vile and miserable of beings. . . .

11. DONATIEN ALPHONSE FRANÇOIS DE SADE
(1740–1814)

Philosophy in the Boudoir (1795)[186]

But sodomy, but this so-called crime, which brought down the fire of Heaven upon the cities that were addicted to it, is it not a monstrous deviation, whose punishment could not be strong enough! It is undoubtedly quite distressing for us to have to reproach our ancestors for the judicial murders they dared to allow themselves on this account. Is it possible to be barbarous enough to condemn to death an unfortunate individual whose whole crime is not to have the same tastes as you? One shudders when one thinks that it is not yet forty years ago that the absurdity of legislators was still at that point in this matter. Console yourselves, citizens; such absurdities will not happen any longer. The wisdom of your legislators answers for it. Fully enlightened about this weakness of some men, one understands very well today that such an error cannot be criminal and that nature would not have attached such great importance to the fluid that flows in our loins as to get angry about the route that it pleases us to make this liquid take.

What is the only crime that might exist here? Surely it is not to put oneself into this or that place, unless one wanted to maintain that all parts of the body are not like each other and that there are pure and dirty ones. But, as it is impossible to put forward such absurdities, the only so-called offense here would consist in the loss of seed. Now I ask if it is likely that this seed is so precious in the eyes of nature that it is impossible to lose it without committing a crime? Would she proceed with these losses every day if that was the case? And is it not sanctioning them to allow them during dreams, in the act of pleasure with a pregnant woman? Is it possible to imagine that nature gave us the possibility of committing a crime that would offend her? Is it possible that she permits men to destroy her pleasures and thereby become stronger than she is? It is unheard of into what an abyss of absurdities one throws oneself when one abandons, for the purpose of reasoning, the help of the torch of reason! Let us then consider ourselves well assured that it is just as harmless to enjoy a woman in one way as in another, that it is a matter of complete indifference to enjoy a girl or a boy, and that, as soon as it is established that inclinations other than those that we derive from nature cannot exist in us, she is too wise and too consistent to have implanted any in us that could ever offend her.

That inclination for sodomy is the result of the makep of our being, and we contribute nothing to that makeup. Sometimes it is the result of satiety, but, even in this case, does it belong any less to nature? In all respects it is her work, and, in all cases, what she inspires should be respected by men. If, through an exact count, one happened to prove that this taste affects infinitely more than the other, that the pleasures resulting from it are much more lively, and that for this reason its followers are a thousand times more numerous than its enemies, would it then not be possible to conclude that, far from offend-

ing nature, this vice served its purposes and that she cares much less about progeny than we have the folly to believe? Now, in looking over the world, how many peoples do we not see scorn women? There are some who simply make use of them only to have the child necessary to replace themselves. The custom that men have in republics of living together will always make this vice more common there, but it is certainly not dangerous. Would the legislators of Greece have introduced it into their republics if they had considered it so? Far from it, they considered it necessary in a warlike people. Plutarch tells us enthusiastically about the batallion of lovers and beloved. They alone defended the liberty of Greece for a long time. This vice prevailed in the society of brothers in arms; it cemented it. The greatest men were inclined to it. America as a whole, when it was discovered, was found to be populated with people with this taste. In Louisiana, among the Illinois, male Indians dressed as women who prostituted themselves like courtesans. The Negro men of Benguela maintain men publicly.[187] Today almost all the seraglios of Algiers are no longer populated with anyone but young boys. In Thebes they were not content to tolerate the love of boys; they commanded it. The philosopher of Chaeronea [Plutarch] prescribed it to refine the manners of youngsters.[188]

We know to what point it prevailed in Rome. There were public places there where young boys prostituted themselves in girls' clothes and young girls in boys'. Martial, Catullus, Tibullus, Horace, and Virgil wrote to men as to their mistresses, and, finally, we read in Plutarch that women should have no hand in men's love.[189] The Amasians of the island of Crete abducted young boys in the olden days with the most singular ceremonies. When they loved one of them, they informed the parents on the day when the abductor wanted to carry him off. The young man offered some resistance if his lover did not please him; in the opposite case he left with him, and the seducer sent him back to his family as soon as he had made use of him. For with this passion, as with that for women, one always has too much, once one has enough.

Strabo tells us that, on the same island, it was only with boys that the seraglios were filled. They were publicly prostituted.[190]

Do you want a final authority, designed to prove how useful this vice is in a republic? Let us listen to Jerome the Peripatetic [Aristotelian].[191] "The love of boys," he tells us, "spread throughout Greece because it inspired courage and strength and because it helped to expel tyrants. Conspiracies took shape among lovers, and they let themselves be tortured rather than reveal their confederates. In this way patriotism sacrificed everything for the welfare of the state. They were sure that these liaisons strengthened the republic. They declaimed against women, and attaching oneself to such creatures was a weakness reserved for despotism." Pederasty was always the vice of warlike peoples. Caesar teaches us that the Gauls were extraordinarily addicted to it.[192] The wars that republics had to support extended this vice by separating the two sexes, and, when they recognized that it had such useful results for the state, religion soon consecrated it. We know that the Romans sanctified the amours of Jupiter and Ganymede. Sextus Empiricus assures us that this fantasy was prescribed by the Persians. Finally, jealous and scorned wives offered to render their husbands the same service that they received from the young boys. Some tried it and returned to their former habits, finding the delusion impossible.

The Turks, much inclined to this depravation, which Muhammad consecrated in his Koran, warrant nevertheless that a very young virgin can replace a boy quite well, and their virgins rarely become women before having passed through this trial.[193] Sixtus V and Sanchez permitted this debauchery. The latter even undertook to prove that it is useful for propagation and that a child created after this preliminary jaunt would be infinitely

better constituted because of it. Finally, women compensated themselves with each other. This fancy surely has no more disadvantages than the other, because its result is only the refusal to [pro]create and because the means available to those who have a taste for population are strong enough that the adversaries can never do it harm. The Greeks likewise supported this deviation of women for reasons of state. It resulted from it that, sufficing for each other by themselves, their interactions with men were less frequent and that they thus did no harm to the public affairs of the republic. Lucian teaches us what progress this license made, and it is not without interest that we see it in Sappho.

In a word, there is no sort of danger in all these fancies. Even if they carried them further, if they went as far as caressing monsters and animals, as the example of several peoples teaches us, there would not be the slightest disadvantage in all this twaddle, because corruption in morals, often very useful to a government, could not do harm to it in any respect. And we must expect from our legislators enough wisdom, enough prudence to be quite sure that no law will emanate from them for the repression of these trifles which, deriving absolutely from the makeup, could never render the one who is inclined to them more guilty than is the individual whom nature created deformed.

IV

~>-<+

Revolution

INTRODUCTION

Before and during the French Revolution, pamphleteers used gender stereotypes and sexual themes to disparage the royal family, the aristocracy, the clergy, and political figures of all persuasions, on the left, on the right, and in the middle.[1] They ridiculed the objects of their attacks as passive, effeminate men unfit for public service and active, masculine women out of place in the public sphere. Like previous generations of pamphleteers, they often stated these accusations in a few lines or just a few words, through references to classical texts, fictional personages, physical gestures, or personal characteristics. Section A contains the complete texts of five anonymous pamphlets that discuss same-sex relations at considerable length. The first three, involving sodomites, tribades, and prostitutes, are connected thematically and must be read as satires that debate issues more than as manifestos that define rights. The title characters of the other two, Villette and Raucourt, have already been introduced in the third part of this collection. As in that part, the sources document not only allegations about individuals but also assumptions about sexuality, identity, and the connections between personal conduct and public order. The first section also includes excerpts from the most substantial diatribe against Marie Antoinette (1755–93, queen from 1774), who was accused of indulging her voracious sexual appetites with men and women of all ranks while dominating the king, bankrupting the country, and plotting to reverse the course of the Revolution.[2]

The National Assembly decriminalized sodomy in 1791, but we know virtually nothing about the deliberations that produced that outcome, because the papers of the Committee on Criminal Legislation have not survived. There is no evidence that its members specifically discussed same-sex relations and decided that sodomy, as distinguished from other sexual offenses, should no longer be punished. Influenced not only by the works of the philosophes but also by the long history of church–state conflicts in France, they eliminated the whole category of crimes traditionally defined in religious terms, "that host of imaginary crimes," from the Penal Code dated 25 September 1791.[3] The Code of Municipal and Correctional Police promulgated just a week before, however, provided penalties for public offenses against morality, indecent actions, and corruption of youths of either sex.[4] As illustrated by the case of Remy and Mallerange in Section B, these codes did not direct magistrates to punish sexual relations between persons of the same sex, but they did allow the Revolutionary police to arrest people who engaged in such relations in public or with minors, as the royal police had done before 1789.[5] In this regard, as in many others, the decade of the 1790s was a period of continuity as well as change.

A. POLEMICS

1. Dom Bugger to the Estates-General, or Grievances
 of the Doorkeeper of the Carthusians by the Author
 of Fuckomania (1789)[6]

ON SODOMISTS

There are three types of people who fuck in the ass. There are very few men who haven't
done this once in their lives, because of curiosity, drunkenness, boredom, or some other
reason. We'll only speak about those who do it habitually.

[discussion of men who have anal intercourse with prostitutes]

[discussion of men who have anal intercourse with their wives]

The third type comprises those who butt-fuck males. The reason they prefer them to
women is that you don't serve a leg of lamb without a bone.[7] In this category must be
included students, who do it because of lewdness, soldiers, because of lack of money,
monks, because of necessity.

As for bardashes, it's certain that they do it only because of avarice, since they get
no pleasure from it and expose themselves to much more scorn and sarcasm than bug-
gers do. We know that Volange said to an actor at the [Theater of the] Italians, with whom
he was quarreling, "Miss, if I didn't respect our sex, I'd hit you with my cane."[8]

The Roman emperors had sentenced buggers and bardashes to the punishment of
burning. Some of them, however, weren't bad at it themselves. Think about Caesar, who
was called the husband of all wives and the wife of all husbands; about Tiberius, who
had his testicles licked by children; about Nero, who had one of his minions castrated so
he'd better resemble a woman and who gave himself to one of his freedmen while mim-
icking the cries of a girl who was being deflowered.

Perhaps the magnitude of the problem comes from the magnitude of the punishment:
burning! It's very serious, and who would denounce a man who should be burned if he's
convicted? What if it pleased our lords of the Estates[-General] to order buggers and bar-
dashes to be publicly whipped on the shoulders by prostitutes, for whose benefit posi-
tions as corrections agents might be created? The number of lashes would be in propor-
tion to the gravity of the offense. The penalty wouldn't be considered to render men
infamous in the eyes of the law. Men of all ranks, all ages would be subjected to it. Five
or six examples made of abbés, marquises, even marshals of France, if it happened, would
before long repress the horrible taste that the reverend Jesuit fathers implanted only too
deeply in France.

2. The Children of Sodom to the National Assembly, or Deputation of the Order of the Cuff to the Representatives of All of the Orders Collected from the Sixty Districts of Paris and Versailles Brought Together in It (1790)[9]

Following the example of the Greeks and Romans, among whom everyone came together when the words country and liberty were mentioned, as soon as there was talk, for the first time in two centuries, about assembling the Estates-General, it was the signal for an almost universal gathering together throughout the whole French realm. From that time on, the nobility, clergy, and commons met to elect their representatives to this same Estates-General; from that time on, people no longer talked about anything but those who elected and those who were elected.[10] And just as a monkey readily mimics all of the actions of a man, you no longer saw anything but assemblies and heard anything but motions at intersections, on the quays, in a word, everywhere. Tailors' assistants took possession of the lawns of the Louvre; servants deserted the taverns and antechambers in order to take their turn speechifying there.

The cuckolds of the capital, given their large number, chose to meet on the plaine des Sablons [open space on the western outskirts of the capital], and their grievance lists, made public, have been the object of widespread admiration.

The prostitutes divided themselves into groups. Those from the Palais-Royal, eager for the protection of the prince, their landlord [the duke d'Orléans], didn't leave it, and talked with the citizens there; those of the other quarters held their meetings in the Porcherons and New France [neighborhoods on the northern edge of the city]; and those without residences, working the streets at nightfall, came together in the place Louis XV, among the stones intended for the construction of the bridge named after Louis XVI, his grandson [Pont de la Concorde], and this last category wasn't the least numerous.

During this clash of assemblies, the celebrated Order of the Cuff alone remained inactive until then and yet gathered, from time to time, in the Tuileries gardens, on the Path of Sighs [nickname for the Terrace of the Feuillants, embankment frequented by sodomites], in the Carthusian cloister, and at the home of abbé Viennet, the most zealous supporter of buggery, not to make motions about the issues of the day but to work together to perform, by means of great thrusts of the ass, the Parisian burn, in the same way that the Sodomites long ago caused the burning of their city by the same maneuver.[11]

But the Supreme Being, who has become less strict about such trifles and no longer diverts himself by burning cities for nothing, sent to earth sound philosophy, which grated on the ears of prejudice, and the bugg[ers] took for their motto that of the chevalier Florian and said:

Tastes are in nature;
The best is the one you have.[12]

Since then, we saw Monvel treacherously deflowering some schoolboys in the Champs-Elysées and, forced by circumstances, going to Bavaria and giving public lessons in anti-physics.[13]

We saw the marquis de Villette turn Voltaire's female relative, that modern Venus, into a young and pretty ganymede through a method he had studied by inclination under

the immortal bard of the *Henriade*, who, in his youth, diverted himself in these innocent games with both sexes and established a new Gomorrah at Ferney [Voltaire's estate].[14]

We saw Marcantin the notary, that rake of fashionable society, send Maradan's harlot to find bardashes and bardashins and, on the quai des Augustins, recruit booksellers of his acquaintance, among whom Letellier, Volland, etc., were recognizable.[15] One could say about this little Adonis what the Romans said about Caesar: "He is the husband of all wives and the wife of all husbands."

We saw the celebrated Perducas, attorney in the Châtelet of Paris, who, speaking with reverence, is one of the staunchest supporters of this Order, operate in his home a referral service and point out to young novices initiated into the mysteries of the anus, in return for a few small favors, the homes of the commanders of the Order who could show them how to combine pleasure with profit.

Now, when the cherished moment, the quarter hour of intromission, had passed, they could hardly refrain from talking about politics in these assemblies. And the Order of the Cuff, whose rank mustn't be confused with that of the King's Sleeve, so distinguished in the anthology of pensions, discussed the notion that, because many of their novices and their new members had positions in the National Assembly, sodomy or buggery must surely have gained a new strength, a considerable amount of credit, and that the liberty of its practice should absolutely be one of the constitutional articles of the state.[16]

For these reasons, having convoked a general assembly of the Order under the chestnut trees in the Tuileries gardens, it was first declared that no proposal would be made and no bottoms would be exposed before they had first settled the composition of the deputation that would ask for the floor in the National Assembly and get the statutes of the Order incorporated into the constitution.

This general assembly provided the finest spectacle; it was really there, more than in the [National] Assembly in the riding school [in the Tuileries gardens], that all ranks were mingled and that, despite the prohibition made against trying to penetrate each other,

The rascals all went for it
Without regard for before and behind, above and below.

When the moment of this masculine delight had passed, the notary Godefroy, who had borrowed the bell from the people who put on shows in the Champs-Elysées, recalled the usages and customs of the assembly in the Tuileries gardens. And putting them into effect, he rang his bell and called back to order all the brothers, who, straightening their flies and drawbridges, moved on to the most important of discussions.[17] All done so smoothly that the viscount de Mirabeau, thoroughly saturated with an aristocratic nectar, found himself obliged, by the sound of the call to order used in the National Assembly, to cover his genitals, which he left exposed as a result of drunkenness.[18]

Several motions were made. It was now only a question of giving them some consistency by establishing some semblance of order. The opinions were divided according to custom. They wanted to establish a new way of voting when Tabouret, the celebrated Tabouret, this illustrious candidate for all of sodomy's honors, informed about this assembly, made her way into it, followed by numerous female proselytes of the Cuff and a vast number of tribades of all categories, of all ranks, and forced the assembly of bugg[ers] to listen to her.

"And so!" she said to the chevalier commanders, "you dare to assemble, you dare to discuss questions related to reproduction, to the maintenance of order without calling me

here, without consulting me? Do I, then, no longer count for anything among you? Do I have to remind you now about my feats, my labors, my hard work, in short, everything I have done for this very Order? See the wrinkles I have on my brow; they proclaim my exploits. So, what would it be, then, if I exposed something else to you? But you seem unshakeable. I must therefore convince you? Very well," she continued, while exposing her buttocks, before which those of all mitred and crosiered bugg[ers] would have blushed, even those of Chastenet de Puységur, bishop of Carcassonne; those of Beaupoil de Saint-Aulaire, bishop of Poitiers; and those of Le Franc de Pompignan, archbishop of Vienne; indeed even those of the abbé Maury and the viscount de Noailles.[19] "Have a good look," she continued, "See what an enormous concavity I expose to your eyes. See what depth, what an orifice it has, and tell me if Maurice, count de Saxe, or some other Hercules of his stamp, would have disdained to pay homage to this venerable rump.[20] Observe this movement of my loins, this agility of my joints, this suppleness, and admit that I've made myself your equal, though of another sex, and that my claims have as much foundation as yours. Yes, I want to be one of the initiated and to enjoy, like you, all the glory that I have earned. And if any one of you dares to argue with me about it, let him enter the lists, let him prepare his sword [penis]. I want to guide it, make him come, and force him to acknowledge that Tabouret is the phoenix of the bugg[ers]. Hasten, bugg[ers], bardashes, bardashins, bardashinets, behold and see if the movement of my ring doesn't put the movement of yours to shame." Then this priestess of Sodom made a great motion with her loins while spreading her thighs open, which provoked a collective "bravo" from the assembly. Most of the members fainted with pleasure and decided that there was no need for deliberation.[21] Tabouret took her place in the meeting and was declared chevalière of the Order.

They then moved on to the question of how to vote, and great debates followed. The most foolish thought that it should be done by head, but the most experienced among them, faithful to the principles of the Order, had it decreed that it should be done by ass. And La Tour du Pin-Montauban, archbishop of Auch, showed how to do it.[22] It was then resolved to move on next to the nomination of a president. Monsieur the abbé Viennet, following the new method of voting, was the one who collected the most thrusts of the ass. And, indeed, who could claim this important position any better than this apostle of Sodom! But the hardships of a long and laborious career prevented him from accepting this mark of distinction, which the assembly conferred upon him, and he made his apologies in this speech, which he delivered with eloquence worthy of his genius and his character.

"Gentlemen,

"The trust with which you have honored me fills me with the keenest gratitude. I don't know what words to use to express to you both the joy it gives me and the regrets I have about not being able to fulfill the duties of such an honorable office. But the magnitude of its importance and the weight of the years that weigh me down have deprived me of all hope of discharging them properly. You know, gentlemen, that there are times when worldly matters ought to be of no concern to us, and when it is necessary to think only about retirement. Since I've reached that time, I must then ask you to regard me in your midst only as a member worn out by age and pleasures, and who can't do anything more for the Order (1), but who, by his perseverance in the principles that distinguish you from the common run of men, will know how to prove to you that he is worthy of the esteem you seem to show him."

The speech of Monsieur the abbé was widely applauded by the whole assembly, which stated in its registers that he would be the honorary president, but that it was necessary to attend to appointing a substitute for him.

Messieurs the abbés Aubert and Duviquet (2) were nominated, but the votes in favor of Monsieur the duke de Noailles prevailed over the cabal of the two priestlings.[23] And as soon as he was appointed, the duke immediately started a speech full of passion, which made the whole assembly keenly aware that in losing Monsieur Viennet, it had found his duplicate in Noailles's person and that it wasn't without some foundation that he had gathered all the votes. Nothing was more convincing than his speech, which we are going to report.

"Gentlemen,

"Anti-physics, which its detractors have derisively called buggery and which, because of the ignorance of the centuries, has been considered down to our day as an illicit game of lewdness, and which jurists call bestiality (3), will be then, in the future, a science understood and taught in all classes of society.

"Thanks to the light of philosophy, times have changed greatly. We'll no longer be ashamed to see Italy alone marching gloriously toward perfecting itself in this science. Since nature has given us all of the knowledge needed to make its basic and essential elements understood, it is up to us to use the wisest and most carefully thought out means to hasten its progress in this country that we live in. And to succeed in this, gentlemen, the most important move is to annihilate, down to the last vestiges, the prejudices that have always tried to destroy us and have made martyrs within our Order, whose loss we will regret forever (4).

"The barbarity of the criminal laws has taken Urbain Grandier, Deschauffours, and thousands and thousands of others from us.[24] Jealousy has dispersed us many times; liberty reunites us. Let's make noble use of it. Let's inform the whole world that great men, for the most part, have been anti-physicists and that this celebrated and illustrious Order can be placed, in terms of both quantity and quality, on a par with those of Malta and the Holy Spirit [chivalric orders founded in 1530 and 1578, respectively].

"Let's teach future centuries, then, to revere the manes of the unfortunate men who succumbed to the efforts of feminine tyranny and to see no longer in their tragic ends anything but murders. For me, gentlemen, I'll acknowledge it without vanity. Imbued with the inexpressible charms that the pleasures associated with this Order have provided me, I've always shown myself its most zealous supporter (5). Religion, armed with its political whip, has claimed in vain to punish us for having penetrated the sweetest of its mysteries. Its lawgiver himself (6), animated by the most tender inclination for his second cousin, hasn't he led us all, such as we are, in the path of light? And hasn't he shown us the basic elements of this taste, which fools treat as monstrous and bizarre, but whose divine essence we've recognized?

"Don't accuse me, gentlemen, of flaunting a vain sense of pride if I recount here what I've been able to do for the Order, and how many beings I've attracted to it. Yes, I've declared myself everywhere the tireless forerunner of those unamenable to the sentimental laws of our institution. I've won over my livery and its surroundings, I've made buggers of my vassals as much as I could, I've sodomized my wife, my niece, and I've inserted my mainspring [penis] into the backside of my stableboy. In short, I made of everyone who was around me as many buggers, bardashes, bardashins, and bardashinets; these are my proofs. To them I've added that of proving that concubinage isn't more natural than anti-physics and that since it's of the essence of every free man to be able to do whatever he wants, everyone should be free to examine this subject more or less thoroughly. I've no doubt, gentlemen, that the members of this august assembly are in complete agreement with all the points and principles that I've just set forth. In my view,

however, it's only left for us to lay them down as laws, in order to make them known and respected in the land of the Franks, and probably have the Order's constitution passed by the National Assembly, in which we count so many of our own, in order to append it to the constitution that they are trying to pull out of the bosom of darkness."[25]

Once this speech was completed, it was necessary to attend to looking for a vice-president and a secretary. Abbé Aubert, cowardly, weak, indolent, and effeminate, received only a few thrusts of the ass for his nomination, but in light of his services, he was nonetheless elected provisionally, and the aforementioned abbé Duviquet was named secretary. Everyone seemed to be in agreement, until one of the members, who hadn't been pleased with the manner of voting because of hemorrhoids, proposed the establishment of a senate, but the reasons that prompted his proposition, however, made them reject it with scorn. And the assembly, before choosing its deputies, moved on to the decree with seven interesting articles, which were drawn up in the following manner.

The Order of the Cuff, and all of its chevaliers, scattered throughout the sixty districts of Paris, together with those of Versailles, constituting a legislative and sovereign assembly, have decreed and decree what follows.

ARTICLE I

The assembly of buggers, bardashes, bardashins, bardashinets, and tribades, to which, by special permission, are added the chevalières of the Slipper, tribades, and *croquaneuses* [derived from *croquant*, slang for hymen], who have taken an oath to give themselves to everyone and to offer to the chevaliers of our Order what it will please them to uncover, has decreed, during its session, that, according to the report made to it by its Committee on Inspections on the extent and success of the Rights of Man, every chevalier of the Cuff will be permitted to make use of his person, to give or receive as he sees fit, whether in the streets of Sodom, known as the Feuillants, in the garden of Friendship [Tuileries gardens], under the auspices of the count de Rouhault, in the Pantheon [music hall near the Palais-Royal], and in the Lodge of the Nine Sisters [Masonic lodge founded in 1776], even in the paths in the Luxembourg gardens, no matter what its actual proprietor [count de Provence] might say about it, without anyone being allowed to raise the least objection.

ARTICLE II

Every trouble-maker, that is to say, every born enemy of the prerogatives set forth in the first article, will be declared infamous and struck from the catalogue that we will provide at the end of these articles, to be no longer recognized in our Order and to be hunted like wolf-cubs in the Masonic lodges.

ARTICLE III

Every chevalier of the Cuff, even if circumstances induced him to place himself under the laws of hymen, can nonetheless abandon his side in order to join the side of the opposition, as every individual in that of the opposition will be free to embrace the party of the chevaliers of the Cuff.

ARTICLE IV

Henceforth, Bicêtre, Avènes, and in general all of the places designed to treat so-called anti-social illnesses will also be used to receive all persons attacked by the disagreeable

anti-physical illness, which we decree, however, only with regret, given that it is only the result of infirmities spread by those who abandon the ass to run after the cunt.

ARTICLE V

All doctors and surgeons, certified or not as assassins by a diploma from the medical faculty, will be obliged to lend a hand in curing crystalline, under threat of being prosecuted as a criminal and by every authorized means, possible or not, as mentioned in Article II, as a trouble-maker and opposed to the strengthening of the Order.

ARTICLE VI

A manuscript saved from the conflagration of Sodom, entitled "Elementary Treatise on Anti-Physics, or Theoretical Summary of This Craze, for the Use of Candidates and Young Bardashes," will be sent to press immediately and with the shortest possible delay. Four of the oldest members of the Order will be obliged to look after its printing, namely Barreau de Girac, bishop of Rennes; Bourdeilles, bishop of Soissons; count de Montrevel, brigadier general; and marquis de Visé, lieutenant general in the king's army.[26]

ARTICLE VII AND LAST

The Order will be divided into a civil section, a legislative section, and a military section. And since one can be a bugger and a citizen, and in order that the affairs of the ass do not prevent and cannot prevent one from showing oneself passionate about the affairs of the country, the principal commanders, legislators, and bourgeois of the Third Estate will be named before the session is adjourned. We will present the list of them to the National Assembly in order to pay it homage through our present decrees, in order to obtain its approval.

These seven articles having been unanimously approved, it was no longer a question of anything but giving them all necessary publicity. Consequently, and in keeping with the report made about the thrusts of the ass, for or against, it was decreed that under the care of the duke de Noailles, president, they will be printed, publicized, and posted in all streets and intersections of the good city of Paris, especially at the gates of the Tuileries gardens and those of the Luxembourg gardens, and, moreover, to permit all booksellers who are in on it or promise to be in on it, such as sieur Pain, so-called bookseller in the Palais-Royal, number 145, to print them freely, distribute them, and sell them. At the same time, all subordinates of the Committee on Investigations—inspectors, informers, spies, and crooks, in general all of the rabble in the pay of the new police—are forbidden to disturb them in the exercise of their functions in any way, under the penalty of being lynched on the very terrace of the Feuillants.

Signed, De Noailles, president; abbé Aubert, vice-president; Duviquet, secretary

Moving on then to the Order of the Cuff's deputation to the National Assembly, the assembly appointed the following buggers as deputies:

Abbé Viennet
Abbé de Lille[27]
Count d'Albaret
Marquis de Villette
Monvel, of the Variety [Theater]

Abbé Lebon, rue de la Harpe, hôtel Tonnerre

Marshal de Mouchy[28]

Abbé Maury, deputy of Péronne to the National Assembly and prior of Lyons in San-
terre (7)

CIVIL COMMITTEE

Chassart, at the house of Le Chapelier, rue Saint-Antoine, at the corner of the rue du
Temple

Facquart, at the house of his uncle, cafe-keeper, rue des Fossés Saint-Germain-des-
Près

Grammont, actor and national player at the Comédie-Française (8)[29]

Raimond, at the Italian Theater

Michu, ditto

Dorsonville, ditto[30]

Solier, ditto

The wise, prudent Granger

Guyot, called the Cliff, at the house of a wig-maker, near Saint-Eustache

Lainez, merchant tailor, near the barrière des Sergens

Lainez, master wig-maker, place Sorbonne

Mercier the playwright, rue des Maçons, author of the *Annals,* the *Tableau of Paris,*
etc. (9)[31]

Bouichon, hairdresser, rue de la Harpe, house of Jobey, hatter (10)

MILITARY COMMITTEE

Chevalier de Boufflers[32]

Chevalier de Florian

Chevalier de Boisdeffre, under-governor of pages

L'Archer, kitchen boy in the service of the Queen's Table

De Beaumont, king's page

De Semeville, ditto

Costard, queen's postillion

COMMITTEE OF INVESTIGATING AND EXAMINING COMMISSIONERS

Barbey, disciplinarian of the collège d'Harcourt (11)

Herlier, clerk in the household of the countess d'Artois[33]

Abbé de Béon, almoner in ordinary [in the absence of others] to Madame Adélaïde

De la Corbière de Juvigné, quarterly [for three months] almoner

Abbé de Lucy, quarterly almoner

Stechelles, quarterly valet of the king

Police commissioner Lerat, as good for one sex as for the other

Abbé d'Elcros, official of the [king's] chapel

Joly, servant boy at the palace [of Versailles]

MEMBERS ASPIRING TO OTHER PREFERMENTS

Beaucousin, in the service of the Table of Mesdames [the king's aunts]

Simoneau, whipper-in [huntsman's assistant] in the king's stables

Depespieres, whipper-in in the stables of Mesdames

Lange, whipper-in in the stables of Mesdames

Cottin and his associate, manufacturers of mirrors, rue de Valois

Jacquemin, whipper-in for falconry

Count de Bernis, gentleman in waiting to Monsieur [count de Provence][34]

D'Orviliers, jeweler, rue Saint-Louis, near the Palais

Felix, jockey of abbé Aubert, vice-president of the Order

Séguier, solicitor general of the parlement, suited for both kinds [sexes][35]

De Longueville, called Duviger, lawyer, rue des Carmes facing the rue de Judas

Chevalier de Jagu, captain in the regiment of Guyenne, rue Saint-Antoine, no. 64

Colonval, engraver, rue des Francs-Bourgeois

Count de Milleville, in the guard of the count d'Artois

Count d'Artois himself

Lenoir, former paper merchant, rue de l'Hirondelle, now rue de la Harpe

Sellier, lawyer in the parlement

Richet de Serisy, at Poitevin's baths, near the Palais Bourbon

Paillet, police inspector, rue des Prouvaires

Jacquelin, bailiff in ordinary in the Chambre des comptes [royal court with jurisdiction over fiscal matters]

De Cromort, Monsieur's intendant

Petit de Monseigne, attorney, rue du Plâtre Saint-Jacques

Le Vacher, at the sign of the Pages, silk merchant, rue Saint-Honoré

Joseph, count de Caraman, rue Saint-Dominique, no. 93

Count du Beillard, rue du faubourg du Temple

Henri, polisher [or, more loosely, rubber] in the service of the queen

Boilly, master harpist, formerly in the service of Madame the countess d'Artois

Biot, writing master, rue Pierre Sarazin

Roland, writing master, rue Culture-Sainte-Catherine, who only flogged the good-looking boys, and with reason, in his room, which he called his office

Charlot, his brother-in-law

Dom Gerle, prior of the Carthusians, deputy to the National Assembly, known commonly by the nickname of doorkeeper of the same house[36]

Lamothe, clerk in La Vallée

VERSAILLES

Richer, former locksmith, rue Neuve Notre-Dame

Noiret, his clerk

Lavalle l'Ecuyer, stooge of Richer, butte de Montbauron

Coquelin, rue des Récollets

Lanneau, rue au Pain, quarter of Notre-Dame

Gervais, rue Saint-Pierre

Lanneau, salesman

Simonnet, clerk at the Lottery, at his father's home, rue Dauphine

Le Gendre, bailiff, rue de Paris

Méteille, clerk to Charles, bailiff, rue Neuve Notre-Dame

Séverin, on the avenue de Saint-Cloud

Babeur, clothing merchant, rue de la Paroisse

Ducroc, notary, rue de la Paroisse

Barbier, the two cousins of that name, avenue de Saint-Cloud

Laîné, cloth merchant, rue du Plessis

Mercier, doctor, rue de la Paroisse

Tergat, captain of the guard of the poverty [Prévôté] de l'Hôtel near the Géôle [prison of the abbey of Saint-Martin des Champs][37]

L'Amy, police commissioner, rue Notre-Dame

PEOPLE OF CONDITION

Marquis de Champcenetz, governor of the Tuileries gardens

Marquis de Polignac, first gentleman in waiting to the count d'Artois[38]

Monsieur de Bridge, ditto

Count de Montesquiou Fezenzac, captain-colonel in reversion of the Swiss Guards[39]

Marquis d'Autichamp[40]

Marquis de Villette, bugger if there ever was one

Marquis de Châtenoy, captain of the greyhounds of the King's Chamber, who has never had sex with any females, except according to the ways and customs of the Order

Count d'Espart

Marquis de Montausier

Viscount de Rohan-Chabot[41]

ECCLESIASTICAL COMMITTEE

Poupard, parish priest of Saint-Eustache

Clermont-Tonnerre, bishop of Châlons-sur-Marne[42]

Le Bossu, parish priest of Saint-Paul

Abbé de Saint-Albin, bastard of the late duke d'Orléans[43]

Monsieur the abbé Mazurier, vicar of Saint-Paul

Abbé Renaud, of Petit-Saint-Antoine

Abbé de Dillon, archbishop of Narbonne[44]

Abbé Fauchet[45]

Cardinal de Rohan, or the prince Louis[46]

Abbé Lemintier, bishop of Tréguier, who combines all the titles of buggery and good-for-nothingness[47]

Abbé Costard, of Saint-Séverin

Abbé Mathieu, of Saint-Gervais

Abbé Férand, of Saint-Sulpice

COMMITTEE ON REPORTS

Dussieux, from the *Journal of Paris*[48]

Chevalier de Rutlidge, rue des Maçons[49]

La Harpe, scribbler, member of the French Academy[50]

Sautereau de Marsy, ditto[51]

TRIBADES WHO OFFERED THEIR OBEDIENCE TO THE ASSEMBLY OF THE CHILDREN OF SODOM, IN THE CITY OF ***, AND WHO PROMISED TO LEND THEMSELVES AS NEEDED

Princess d'Hénin, lady in waiting to the queen[52]

Jules de Polignac, the biggest strumpet of this century[53]

Marquise de Fleury
Countess Diane de Polignac[54]
Marshal Duras's wife[55]
Countess de Beauharnais[56]
President D'Ormois's wife[57]
Le Fuel de Méricourt[58]
Raucourt, of the Comédie-Française
Delaunay, abbess of the dress circle, rue Croix-des-Petits-Champs
De Boisemont, place Saint-Michel
Morin, rue de Grenelle Saint-Germain
Marin, house of the female greengrocer, rue de la Harpe, across from the rue des
 Deux-Portes
Mademoiselle Lucas, mistress dressmaker, rue des Quatre-Vents
Lebrun, of the Academy of Painting[59]
Bertin, seller of women's clothes to the queen
Countess d'Igny, rue Saint-Marc
Mademoiselle Gibal, passage du Commerce
Countess des Deux-Ponts
Viscountess de Mérinville
Viscountess de Tallaru
Bourdin, maid of Madame Adelaïde
Countess de Chastellux
Gauthier, maid to Madame the countess d'Artois
Masson, of the Comédie-Française
Desgarcins, ditto[60]
Sophie Forest, from Nicolet's
Mademoiselle her little sister
Prieur, from the Variety
La Caille, from the Italians
The Renaud demoiselles

All the others from Paris just raised their asses as a sign of approval and in order to prom-
ise to comply with the rules and regulations stated above, under pain, for offenders, of
being forsaken by the Order as a whole.

VERSAILLES

Mesdemoiselles Le Normand, with their father, joiner, Petite Place
Blanchard, mistress dressmaker, with her father, Petite Place
Lacrampe, seller of woven cloth on the rue des Deux-Portes
Bonnin, rue de l'Orangerie
Mesdames Menier, rue de l'Etang, boulevard la Reine
Charles, rue Neuve Notre-Dame
Duclos, watchmaker, rue de la Pompe (12)
Stamion, rue de la Paroisse
Guillery, linen merchant, rue Dauphine

At that moment, the deputation left for the National Assembly and had the rest of
their members, who could have been forgotten, convoked and adjourned and enjoined to
attend the next meeting, which will be indicated again.

New information that was given to us, after the drafting of the List of Buggers named above:

Police commissioner Sirebeau, rue des Petits-Champs, across from the rue de Chabanais. This old lecher, after having made use of all pleasures, now sticks to one that revolts the senses and reason. He begins, following the example of old Bertin, the rogue of the *parties casuelles* [revenues from vacant offices], by having himself whipped by several women, and after this ceremony, a young ganymede, procured by these same women, f[ucks] him in the a[ss].[61] Then his great passion is to have oil poured on his buttocks, and his exclamation is to say, "Lubricate . . . , lubricate . . . , vigorously. . . , vigorously. . . ." This detestable b[ugger] usually undertakes this filthy act of lewdness at the home of la Verdun, one of the most famous strumpets of the Palais-Royal.

Police commissioner Le Grès, formerly of the rue des Arcis

La Pierre and Monglas, both guards of the office of the Bureau of Commerce

Interesting Postscript:

These two famous chevaliers of the Order were found one day, working toward intromission, with their pants down and one on top of the other, by the concierge of the Bureau. The twelve francs that they gave him bought his silence, which he kept until the first time he was drunk, when he divulged it to those who wanted to hear it.

The barkeeper of the new hall of the Palais. During the Florentine operation [sodomy], he plays three instruments at the same time. . . . He must love music a lot!

Monsieur Bourdelais, rue Neuve des Mathurins

Margantin, notary, rue Saint-Honoré

Monsieur Turelure, former haberdasher, quai de la Mégisserie, then in the mounted constabulary, brigade of Nanterre. He was expelled from it for having tried to sodomize the peasant who was grooming his horse in a stable.

Sieur Charton, former *maréchal des logis* [officer in charge of the brigade] of said mounted constabulary. He was also expelled for the same cause, but by dint of supplication, he secured a pension of 150 livres. He's now quartermaster-sergeant of one of the companies of the Short Robe. And incidentally, his father, inspector of the Hôtel-Dieu, was a most respectable man. This fact's out of the ordinary.

Nécard, turnkey of the Grand-Châtelet. All of the prisoners on straw do justice to his taste and talent for screwing in the a[s]s and the c[un]t.

Hubert, concierge of the prison of the Palais. It's from his wife that he holds his license in buggery. She now has her jewel worked on by Larchier, officer of the Short Robe.

Remy, formerly sergeant-at-arms in the regiment of the French Guards. This worthy supporter of the Cuff is widely known for having corrupted the majority of the young folk in his company. Having succeeded in becoming captain of the army workmen, he grabbed the cross of Saint Louis out of it. Now captain of the guards at the Invalides, his only occupation is to train the young bardashes of the Palais-Royal.[62]

Fanchon Josse, raised in the great art of b[utt]-f[ucking] by Monsieur her father. Once mistress to Bertrand, sergeant of the Short Robe, she was abandoned by him for having proposed to him that he put it in her, just as they put it in her father. Who the devil would have suspected that Bertrand would have been so scrupulous? This hussy's now associated with Marguerite Galand, and both are sellers of fresh fish on the rue Saint-Honoré at the corner of the rue des Boucheries.

Pascaly, Madame DuBarry's godson.[63] Madame his mother, usher in the boxes of the Italians, procured for him Madame Gonthier, who maintains him in style.

Monsieur Marcan, seller of parasols and mortarboards, at the foot of the Montagne Sainte-Geneviève

Monsieur Chevalier Ass-Slapper. One can say about him what is said about a Jesuit: "Go on, squeeze your a[s]s and pass by quickly."

Yon, café-keeper, boulevard du Temple. I hope this one won't disown it.

Mareux, looking-glass maker [or seller], rue Saint-Antoine. This one raised young actors, who will never be as skillful at theater as at buggery.

Imbert de Boudot, former Bernardine monk, known by the name of Imbert with the glasses, rue and barrière de l'Ursine. Should one accept into this Order such a bugger, who sought the delights of pleasure even with his dog? Sieur Desauge, bookseller, having had some strong hunches about the matter, Boudot, enraged at being discovered, killed this animal with pistol shots. . . . Oh, what a bugger!

(1) Indeed, what can abbé Viennet do now for the Order of the Cuff? Nothing, undoubtedly, but the Order owes many of its proselytes to him. It's he who, by means of his amateur theater, perverted Dumay, clerk in the office that managed the affairs of the royal domain; Cotte, architect's clerk; Mandron the younger, tapestry-worker. Michu, of the Italian Comedy, owes his rise in the Order to him. La Lescot, of the same theater, was trained through his wisdom to offer all the outlets that lead to pleasure. It's this abbé Viennet, finally, this worthy supporter of buggery, who has expanded the list of this century's bardashes by more than four hundred students. Oh, worthy man, this abbé Viennet!

(2) After having completed his studies at the collège de Louis-le-Grand, abbé Duviquet obtained, through his hypocrisy, a position as master of a division there, which he didn't keep for long. This establishment no longer being what it was in the time of the Jesuits, those gallant buggers, who inculcated profound learning in the heads and sodomy in the asses of their students, it no longer preserves anything but a few vestiges of anti-physics. Now, abbé Duviquet was ejected from there for some uncoverings of posteriors.

(3) Named quite inappropriately in this manner by the good-for-nothings with lawyers' hoods, enemies of our tastes in all times, for Bordaloue, Lully, D'Alembert, La Harpe, Thomas, etc., who were not and are still not beasts, are nonetheless bugg[ers].[64]

(4) See the martyrology of buggery and the public death of Pascal, burned in the place de Grève, for having attempted, by consent or through force, to make away with the virginity of a bootblack.

(5) Oh, it's true, but quite true, and very true!

(6) The deceased Jesus, dead like our brother Pascal in the service of the faith, said to Saint John, "Come, my son, come, my beloved, rest on my breast."[65] Can anyone doubt the true meaning of these tender phrases?

(7) Abbé Maury offered Tiron, his hairdresser, as a witness, as a victim, as his giton. Wasn't this conclusive proof on his part of his taste for the Cuff?

(8) Grammont may be a rake, but it isn't pointless to note that it was the demoiselle Thénard who put the taste for sodomy into his head and who received the watch-word from him in the ass.

(9) Oh, if I dared, I would say some fine things about them.

(10) We won't mention here the little harlot of the society of the quai des Augustins nor his colleague. They were both expelled from the Order, one for a bankruptcy of 680 thousand livres and the other for 120 thousand.

(11) It's he who succeeded Pain blanc [Whitebread], who had been charged by the headmaster Hansselin with telling him which were the finest, whitest, firmest posteriors of the students who passed under his switches.

(12) About eight years ago Madame Duclos, then unmarried, and the demoiselle (previously Madame) Bonnin had an amorous adventure that might make one think that they aren't tribades. These two wenches made an agreement with a newly arrived guardsman that they would give him their favors in return for 25 louis. At the time of the execution of their agreement, it turned out that he, preferring one to the other, gave 24 louis to the wench Bonnin and 1 louis to the wench Duclos, which, as a matter of fact, constituted the promised sum. But since the distribution was unequal, Duclos had a writ issued against her copartner to get half of it from her. The quarrel heated up, and the guardsman was sued. He stated that he had paid for things according to his conscience and according to their value. He was taken at his word and without any examination of the women by medical experts. Consequently, the decision that was handed down dimissed all Duclos's claims. But to this fact, which it's impossible to call into question, we will oppose the fact that these women were who[res] for money and tribades by disposition. It's therefore natural to see them included here.

3. Petition and Decree in Favor of Whores, Female Fuckers, Bawds, and Handjobbers Against Buggers, Bardashes, and Stiffers (1790)[66]

DEDICATORY EPISTLE TO MADAME THE VISCOUNTESS SPLIT-CUNT, CALLED THE BACCHANTE, HIGH PRIESTESS OF BACCHUS, SUPERVISING MISTRESS IN FUCKING[67]

Great Streetwalker,

Although I don't get hard anymore, although my bran-filled balls hang down to my knees, although my cock, drawn back into my abdomen, has become a cock of wax and no longer allows me to fuck, which I'm very vexed about, nonetheless I still have a very strong taste for fucking and for female fuckers and the most wanton veneration for you, admirable harlot, Coryphaeus [leader] of whores, model for female handjobbers, prototype of screwers. Heartbroken about not being able to pay you spermatic homage, about not being able to flood your cunt—as insatiable as it is vast—with fuck and to paw your buttocks, which are as white, as firm as the finest marble, I want to make up for it by having published under your auspices a work in favor of all the whores of Paris. I'm convinced that, supported by your lecherous patronage, it will be favorably received by those like you. Oh, who better than you deserves the honor I bestow upon you today? You combine, in the nth degree, the taste for drunkenness with the most unbridled libertinism. Insatiable drinker as well as tireless fucker, you go back and forth between the arms of Bacchus and those of Priapus with that passion that is yours alone. Let them no longer cite us the Phrynes and Messalinas; they can't compare with you.[68] La Gourdan, la Polignac, la . . . themselves would be only vestal virgins next to you. You would cause more fuck to be spilled in one hour than those little Laïs [prostitutes] do in the space of a day. Lascivious positions, a sweet, plump hand, a velvety, quick tongue, a bushy and elastic mound [of Venus], in short, everything that can contribute to the pleasure of the balls is, in your case, of the last perfection. Endowed with a fiery temperament, supplied with an

inexhaustible abundance of fuck, you surrendered yourself from your tenderest childhood to the inexpressible pleasure of fuckery. And you could rightly claim:

I'm young, it is true, but for well-born vulvas,
Fucking doesn't have to wait for many years.

Chancres, tumors, the clap, even the worst case of the pox have never made you blanch. More devoted to fucking than to health, you have faced all dangers courageously. A drop of sperm, a glass of brandy constituted irresistable arguments for you, and you didn't give a damn about the future as long as you were fucking at the present moment. Today, though covered with honorable scars and wounds that are still bleeding, you should be resting beneath Venus's myrtles, but you still present yourself for combat with a fearlessness worthy of the admiration of every good fucker. And so I predict the most glorious end for you. You will die in the service of the faith, and you will have the glory of seeing yourself eaten away to the bone and your limbs rot off, one after another. Your portrait isn't flattering, and the eulogy in your honor is quite imperfect, I agree, but remember that it's been sketched by a man who has no fuck left in his balls. You know that a police ordinance sets the fees of all the whores. Well, I don't give a damn. The police have no fucking business making rules about fuckery, when legislative power is in the hands of the best fuckers in the kingdom. And in order to put this ordinance to the use it deserves, I made some packets for mercury pills [for venereal disease] out of it that I plan to send to you for New Year's Day. I detest bardashes and buggers who angle for turds. And when I still used to get hard, I would have jerked off until it bled rather than insert my cock between two buttocks from which I would have extracted it all shitty. I also have a strong antipathy for stiffers, because everyone must make a living by his craft, whether he earns his bread by the sweat of his brow or by the sweat of his ass. Annoyed at seeing these three types of lechers inflict injury on the race of fuckers and at seeing princesses of common blood [prostitutes] more often than not have a supper as modest as their adornments, I presented a petition in your favor to our fuckers of the National Assembly, in order that every bugger and bardash be punished as he deserves and that every fucker pay in advance and according to the more or less lascivious positions he demands, the opening of the cunt, the elasticity of the mound, the contour of the thigh, and the firmness of the tits. In response to this petition, the fairness of which the Committee on Fuckery has recognized, the national fuckers have handed down a judgment that decided in favor of the petitioners, invested with all the necessary formalities and sealed, for greater authenticity, with the great seal of the Nation, bearing the impression of a majestic cock, voluptuously smearing with fuck the ruby lips of a cunt crowned with a garland of balls. If you graciously welcome my dedication, I'll do the impossible to get hard just one more time and jerk off with you in mind. If you reject it, I won't give a damn and will remain your admirer nonetheless.

chevalier Flat-Balls

Viscountess Split-Cunt's answer to chevalier Flat-Balls

My dear Easy-Stiffer,

I was playing with my cunt with one hand and scratching my mound with the other when your letter reached me. Without stopping the pleasant activity that occupied me at the time, I suggested to the letter carrier that he be paid on the spot by fucking my tits. He accepted the offer and smeared my whole face with fuck. But I don't give a damn; it's my usual balm, and I believe that there's none better for preserving the complexion and making it smooth. After the departure of the carrier, I directed my female cuntlicker, who had just fucked with my water-carrier, to read me the letter in a clear and audible voice. And I listened to it with all the more pleasure since I kept coming without stopping as long as the reading lasted. Luckily the letter wasn't long. Otherwise I think, devil take me, that I would've dissolved in fuck. And I swear to you by the balls of the National Assembly, I wouldn't have come more voluptuously if I'd been fucked by four of the most vigorous confederates. So I'm very much obliged to you and am tempted to have my cunt sewn up out of frustration at not being able to express my gratitude to you by lavishing all my favors on you and making you come until you bleed. But what have you taken into your head about not getting hard anymore at your age? Poor fucker! Maybe you've only addressed yourself to novices who don't know all the tricks of old whores like me. Well, my poor Easy-Stiffer, either I'll make you hard, I who am speaking to you, or the devil will sooner carry off the National Assembly. Just come to see me and bring a bottle of spirits. We'll drink the national dram together, for it's a necessary preliminary, and if I don't make you become a man again, I'll renounce fuckery forever. Remember that if you had only one drop of fuck in your balls, I'd squeeze it out of you. Good-bye. While waiting for fuckers, I'm going to get myself tongued. Fuck or drink, that's the motto of your friend,

viscountess Split-Cunt

HUMBLE PETITION OF FEMALE FUCKERS, BAWDS, AND HANDJOBBERS TO THE GENTLEMEN COMPOSING THE ESTATES ON A VERY SERIOUS AND VERY URGENT MATTER

In our capacity as petitioners
And still disgusting with fuck
From having fucked last night,
We set forth to you what follows.
Long ago when Madame Eve
Made the first man a cuckold,
No one believed that the ass
Should ever attract the sap
Of the muscle that heaven made for us,
Which in French is called a cock.
A cunt of pleasing form
Used to satisfy carnal desires;
An elastic and firm mound
Made the immortals get hard.
And this masterpiece of nature
Was the only God of mortals.

From the Bear [Big Dipper] to the Bosphorus,
Everyone burned incense on its altar,
And from nightfall to daybreak
Its worship was universal.
One even saw in that time
Some men cut off their cocks,
Tear off their balls out of frustration
At not being able to pay homage to it.
And the celebrated Tertullian,
Contemporary of Origen,
Cut off his prick, they say, without regret
Because it wasn't good for anything.[69]
But here below, nothing lasts;
Everything's subject to change.
Soon man left the cunt,
And whether he was disgusted by it,
Or whether the spirit of curiosity
(For this motive is sometimes excusable)
Inspired in him the abominable taste
For trying shitty pleasures,
The ass was the object of his desires.
But soon this dreadful disorder
Attracted the anger of the gods,
Who, by a deluge of fire,
Purged the earth of buggers.
When, without pepper or nutmeg,
Heaven had made a grilling
Of Sodom and the surrounding areas,
For having neglected cunts,
In order to punish the shameful fad
Of angling for turds,
Cunts regained the upper hand
And asses were confounded,
Whether because of fear of crystalline,
Or fear of devouring fire
That consumed in a second
So many balls and so many pricks.
But since the overly greedy merchant,
While amassing riches
In the Levant,
Enjoyed the taste of buttocks,
This taste, having become dominant,
No longer leaves us anything to do,
And our main business
Is limited to jerking some cocks
That are always soft and often rotted.
Happy are we when after the job
An old lecher compensates us

For the loss of our time
With some ready cash.
But very often, when the young,
Forgetting about the butt for a minute,
Come to our place to recover their appetites,
Without regard for our distress,
Far from paying generously,
They overwhelm us with blows.
Oh, you whose hearts are so tender,
Great legislators of the state,
You who without making a fuss about it,
Deigned, last winter, to make your way
To our place and on our pallets
Sometimes took your sport,
You who from time to time
Gave us an allowance out of the money of France,
Deign, before your departure,
To make our luck change,
And from our gratitude
You'll see positive results.
Neither pox nor tumors,
Neither chancres nor clap
Will ever give you jaundice.
Our cunts will always be clean
Through use of a double bidet,
So that you can, without risk
Play brisk [a card game][have sex] with us
And relax yourself after your labors
Every day in the arms of love.
Order, then, that every bardash
Put on his head a certain plume
That will cause him to be mocked by others.
Order as well that the law
Denounce the cynical bugger,
Who, driven by his lubricious taste,
Dares with his wanton pike
To screw a filthy bottom,
Always dirtier than a quagmire.
Order in addition that every man,
Young or old, brunette or blond,
Who wants to kiss or paw a cunt,
Fuck between the thighs, and shoot between the tits,
Deposit a certain amount
In the hands of the madam,
If there is a madam,
Or in the hands of the person
To whom the fucker owes something,
Before the job begins.

For otherwise, after the dance
The fucker grabs his hat,
His muff, or even his coat,
And then, spitting in our faces,
He simply stiffs us.
As for men with a paralyzed look,
Who have their cocks shaken,
And whose pale and sallow faces
Remind us of Lent,
Order them to give
Twelve sous each time
To the obliging handjobber,
Who, with a soft and gentle hand,
Gives them the sweet pleasure
Of coming by scratching them.
By doing this, you'll do justice to
And have at your disposal our tits,
Our thighs, and our cunts,
But, if you say no, beware of the clap.
Done, 18 August, in Paris.
Signed, whores and Laïs.

Having seen the preceding petition,
And agreeing in good faith,
That we know nothing about the matter,
We send it to our colleague,
Abbé Maury, an ardent fucker
And knowledgeable about the whole mystery
Of what's called a brothel.
Signed, N., secretary,
And below D., president.

FINDINGS

Having seen the petition and decree,
And in addition heard the parties,
Let's find that it be done
As the whores and harlots
Have requested in their petition,
With the understanding that our blessed balls
And our cock will have the *droit de cuissage* [seigneur's right to spend the wed-
 ding night with the bride]
Without having to pay in the usual way.
Done in Paris, in committee,
Signed, Jean Maury, deputy.

DECREE

We, restorers of France,
Meeting in the riding school,

Acceding to the findings
As it's demanded, order
That every merchant of crystalline
Having a prick for a plume,
Wear written in the middle of his forehead,
In large characters,
So that one can make it out from afar,
"I'm a collector of chestnuts [testes],"
And that for expiation
Every bugger who paws buttocks
Be reduced to kissing [fucking] a cunt.
We order in addition every man,
Before taking his cock in his hand,
To count out such and such sum
To the madam or the whore,
In cash and in sound currency,
Depending on the opening of the cunt,
Depending on whether it is brunette or blond,
Depending, finally, on the firmness of the buttocks.
As to those who have themselves jerked off,
We order them to pay
Twelve sous for each time,
Before the job begins;
For such is our will.
That this document be posted,
So that it be well known to everyone,
On the door of every brothel,
And since it is enforceable,
Let it be enforced without appeal.
To that effect, we empower
Every sergeant [official responsible for executing judicial orders], every bailiff,
Whether assessor [of goods to be sold] or crier of the court,
To execute this order diligently.
Done in Paris, with the orders assembled,
Signed, D. M. G., deputies.

4. The Little Buggers at the Riding School, or Response of Monsieur ***, Grand Master of the Butt-fuckers, and of his Followers, Defendants, to the Petition of the Female Fuckers, Bawds, and Handjobbers, Petitioners (1790)[70]

I know nothing about writing verse, I don't even know how to write good prose, and I hardly know how to express my ideas in a clear and intelligible manner, but I don't give a damn. I don't claim the chimerical reputation of an author. I have no ambition to ride the mettlesome Pegasus.[71] And provided that I mount a young blond in the well rounded buttocks, provided that I deliciously bathe his anus with a flood of fuck, my wishes are fulfilled and my ambition satisfied. Moreover, if I aimed at celebrity, the reputation of an indomitable sodomite is just as good as any other, and it matters little to me how I'm named. Glory's only a dream; pleasure's something real. To get as much of it as I can is my sole objective. In a word, to butt-fuck in the morning, to butt-fuck at noon, to butt-fuck in the evening, that's all I seek and find without difficulty. To the point.

While all France is infected with the virus that the Portuguese brought us from the other hemisphere [syphilis]; while our federates [provincials sent to Paris for the Festival of Federation on the first anniversary of the fall of the Bastille], that most precious component of the nation, spread throughout the provinces the destructive poison that they drew from the infernal cunts of our modern Messalinas; while some respectable mothers of families curse the federation, which plunges them into an abyss of troubles and deprives them of the delicious pleasure of fucking and reproducing; the female fuckers of Paris, those true Pandora's boxes, whose cunts, the receptacles of all illnesses, should be sewn up with a double seam; handjobbers whose hands covered with scabies should wither at the approach of a cock; bawds whose cunts and asses, no longer constituting more than a single orifice, represent the mouths of hell and Phlegethon and exhale poison and death far and wide; in short, the whole race of fuckers dares to protest against buggers and bardashes.[72] They demand with much noise that we be publicly branded, that a mark of reprobation make us recognizable and risible. The National Assembly, that so-called august senate, that home of the nation's leading lights, has dared, if I may say so, yes, it has dared, despite its juridical incompetence, to hand down a decree in response to this petition in favor of the vilest brood with which heaven, in a moment of anger, could have poisoned the world. O *abominable misdeed!* And we'd keep quiet? And we would let ourselves be shamefully denounced without defending ourselves? No, rather give up butt-fucking! Rather chop off our pricks and have them fed to the iniquitous judges who have condemned us! Rather knock down the Assembly's hall with our balls and bury its members under a heap of ruins!

The female fuckers and company should be declared inadmissible, if they have no basis in law, if fuckery does more harm than good, if individual liberty's not a dream.

The decree handed down in favor of the plaintiffs should be declared null and void, if those who handed it down are incompetent and suspect.

Since Creation, since Madame Eve, who, if scandalous gossip is to be believed, let herself be fucked by the snake, every individual, everyone who has balls or a cunt, had, and still has, the right to fuck, to jerk off, to butt-fuck. Only eunuchs, unfortunate victims of the unbridled jealousy of the Asiatics, are deprived of the pleasure of ejaculating sperm. But no one, at any time, in any circumstances, has had the exclusive right of taking or giv-

ing the pleasure of the balls. Read all the histories, scan all the epochs, inspect all the archives of the brothels established on the surface of the globe. No where will you find a charter that gives the privilege of fucking or making someone come in whatever manner to such and such class of people to the exclusion of other classes, to whom benevolent nature has given senses for them to use in the way most in conformity with their tastes and inclinations. Even if a charter of this nature could exist, which is completely impossible, if it isn't sealed by the great cock of Priapus and initialled with fuck on every page, if it doesn't bear the imprint of the monstrous balls of robust Hercules, it has no more value, it doesn't deserve any more credit than the paper money of the National Assembly. The race of fuckers will undoubtedly raise an objection against me based on their so-called right of possession, but I'll respond to them that this possession exists only in the abstract, since what are so commonly and improperly called decent women don't do without fuck any more than bread, which is enough to prove that this possession is nothing but a word devoid of meaning. And even if it existed, can there be prescription where there is abuse? And can a practice have the force of law when it's diametrically opposed to nature? Without doubt, the use that female fuckers make of their loathsome appliances is anything but natural, since it's not at all for the pleasure of reproducing but rather to satisfy their insatiable avidity or their unbridled taste for fuckery that they fuck left and right. It's therefore indisputable that female fuckers don't have the exclusive right to make someone come, and I defy the most licentious whore to dare to maintain the contrary.

The ability to get hard, to fuck, to come is without doubt the most precious gift nature could have given us. Without speaking of the inclination that every creature feels for the propagation of its species, what phrases can express the pleasure that there is in pawing two pretty tits, two plump and white thighs? Who could express the delights that a worthy fucker feels at the moment when he inundates a cunt crowned by a mound that is as hairy as it's firm with a flood of fuck? But also, who could list the troubles that fuckery has caused and still causes? If I want to rummage through the ancient chronicles, I find there Helen, a whore as insatiable as a she-wolf, who, dissatisfied with the powers of her simpleton of a husband, had herself kidnapped by the handsome Paris, who was as strong as Hercules and fucked her, they say, three times every hour. All the kings of Greece, as worried about their own countenances as they were anxious to avenge a cuckolded king, immediately arm themselves to the hilt, lay siege to Troy, take it by assault, fuck women and girls, massacre young and old, and make a pile of ashes and ruins out of this unlucky city.[73] And this because of Madame Helen's cunt, which would have swallowed up more fuck than the amount of blood that her husband's avengers caused to be shed. If I want to take a look at the present siege, I see a horrible sickness, the pox, since it's necessary to call it by its name, appearing in a thousand different forms, mercilessly gnawing away at the strongest individuals, exhausting the best athletes in fuckery, wrinkling in the flower of youth all those who have the misfortune of being attacked by it, and destroying everything down to the roots of procreation. In the end, let the good and bad things that result from the union of cunts and cocks be weighed, and if the sum of the bad doesn't outweigh that of the good, I'll cut off my cock and balls, and I'll make an omelette out of them for viscountess Split-Cunt.

Individual liberty, decreed by our most august and most respectable representatives, is certainly not something that exists only in the imagination, and in keeping with this principle, I can dispose of my property, whatever it is, according to my taste and whims. Now my cock and balls belong to me, and whether I put them in a stew or whether I put them in a broth or, to speak more clearly, whether I put them in a cunt or an ass, no one has the right to complain about what I do with them, those strumpets even less than any-

one else. For those vile whores, who have the audacity to run us down, are only street-walkers who lend themselves willingly to all the lewd fantasies that a worn-out, rich lecher might want to satisfy. Screwing, letting themselves be butt-fucked, fucking between the tits, between the thighs, under the armpits, it's all the same to them as long as you shine gold before their eyes, as long as you don't offer them assignats. This paper money has no value for our princesses of corrupt blood, and the female handjobbers of the place Louis XV themselves wouldn't give a clapboard for an assignat of a hundred livres. They wouldn't even dare touch it because they claim that their hands would become paralytic.

I'm not a great dialectician, but when I've just butt-fucked, I have an excellent judicial sense and a mind almost as enlightened as a deputy to the National Assembly. I can therefore conclude from everything I've just said that the female fuckers, bawds, handjobbers, and company should be declared inadmissible.

The decree issued in their favor is null and void if the judges are incompetent and suspect. I'll prove it.

A court is competent when cognizance of a case has been assigned to it by a sovereign power. So contesting its right to take cognizance of the case and to pass judgment according to its lights would be the height of extravagance and folly. But every time it arrogates this right for and by itself, its decrees are null, completely null. And this is the case in which the National Assembly finds itself, unless it is said that the petition of the whores bearing mainly upon public morality, the legislators of the nation have the right to make it their business. Under this supposition, I'll permit myself to ask if those who are entrusted with regulating public morality are exempted from regulating their own. I'll ask if the Coryphaeus of the aristocracy has proved the purity of his own by making himself guilty of rapes and abductions, by forcing a woman, with a pistol at her throat, to grant him her favors. I'll ask if the orator of democracy has given proof of good life and morals by abducting a woman from her husband, by publicly cuckolding the stupid bookseller of the rue X, etc. Moreover, would they have believed that they were regulating morality by condemning buggers and bardashes? No, the mistake would be too flagrant, and the result would be less than certain. This truth requires no proof; it's within the range of everyone's understanding. I'll content myself with saying that to condemn buggers amounts to wanting to give whores the right to afflict the whole world with gangrene.

Every judge is suspect when he lives in complicity with one of the parties involved in a case. This principle being incontestable and consequently admissible, the proof of suspectness is easy to provide. In their petition to the nation's legislators, the female fuckers and company acknowledge that they have fucked with the deputies, more times than they have hairs on their asses, and that very often they have received their part of the eighteen livres that the government grants the deputies. When everything's shared by two individuals, one can't doubt their complicity. And when one of them's the judge of the other, one can't help agreeing that the judge is suspect. It's therefore true that, the assembly being incompetent and suspect, the decree it handed down in favor of fuckery is null and void.

All your arguments, you may say to me, do not in the least justify the abominable inclination you and those like you have always had for angling for turds. And fuckery being, as you say, a very bad thing when it doesn't fulfill the objective of nature, sodomy, which insults nature in every way, is the height of depravity.

The example of all centuries could justify the taste for which we are reproached. I could cite the example of Socrates, who butt-fucked Alcibiades to the knowledge of everyone, and yet Greek women were, and today still are, beautiful enough to inspire desires in men and make them hard. Several Roman emperors had titular bardashes, although they could

enjoy the most beautiful women of Rome without difficulty. All the peoples of the Levant have the rage for fucking in the ass, although their seraglios contain prodigies of grace and beauty. The inhabitants of Sodom themselves had women who would have made painted cocks get hard and butt-fucked each other with all the more pleasure. Don't come telling me that a shower of burning sulphur consumed them in punishment for their crime. It's an old lie that came out of some visionary's head, which our churchy types had the shrewd-ness to sanction for their own interest. Here are the facts, such as they're recorded in the annals of butt-fuckery. The high priest, one of the proudest buggers the earth has produced, wanted to celebrate the Lupercalia.[74] He directed his chef, a great devotee [of buggery], to prepare a sumptuous dinner, to which he had invited all his minions. A kitchen-boy, a young blond of fifteen years, handsome as Eros, with the buttocks of Ganymede, was in a corner of the kitchen, busy washing dishes. The cook, inflamed with lust, got hard like a Carmelite friar, devoured his prey with his eyes, and hurried to finish his work in order to satisfy his burning desires. At last the work's done. The spit turns by force over a glass-making fire lit in the chimney. The impatient bugger mounts his ganymede and makes efforts worthy of a Hercules to insert his monstrous prick into the tight anus of the young man. During this time the chimney flue catches fire. The bugger, completely abandoned to pleasure, doesn't notice it. The fire makes rapid progress and in a few hours consumes the city of Sodom.[75] Let me be forgiven for this digression; it was essential. The examples I've already cited would be enough to vindicate us since, without any other motive than that of satisfy-ing a bizarre taste, most ancient and modern peoples have had the rage for butt-fucking. And in our country, it's less taste than necessity that inclines us to it.

In Paris, beautiful women are rare, large cunts very numerous, and the poxes even more numerous. If you fuck a woman with an ordinary face, disgust sets in, and the plea-sure's nothing much. If you find a wide cunt, you file away for an hour, you get lost, and you end up losing your erection without coming. If by chance you meet a beautiful woman, which is very unusual, she's certainly a whore, and then the fear of the pox poisons all the pleasure you might enjoy in fucking her. None of these drawbacks arise with men. Narrow passageway, firm and white buttocks, boundless willingness, everything invites you to satisfy yourself. It's true that you can catch crystalline, but as that illness isn't very common, the danger isn't scary.

Furthermore, we are impartial, my colleagues and I, and I state, as much in their name as in mine, that we're ready to give up our inclination for the ass under the fol-lowing conditions.

A general inspection will be made of all the public whores of Paris. All those who are convicted or suspected of having the pox will be confined in Bicêtre until they are com-pletely cured. All the cunts whose openings exceed the normal size will be reduced to two inches in diameter through double stitching. And all those whose two cracks, no longer constituting more than one, are no good anymore for making fuckers come, will be declared disabled. If they decline these means of conciliation, may they have no more johns! And if chance still provides them with any more, may they be paid only in assignats.

Signed, m[arquis] de V[illette], designated agent of the Sodomitical Society.

Writ to be served

We, bailiff of the Cuff, passed and registered by the fucking clerk's office of the paths in the Tuileries and Luxembourg gardens and other suspect places in the city of Paris,

living there, signed below, at the request of the m[arquis] de V[illette], designated agent of the Sodomitical Society of said city, have by the present writ duly served the above response to the female fuckers, bawds, handjobbers, and company, speaking to viscountess Split-Cunt in person, at her home, in the brothel, at the bottom of the stairs, and of everything we gave her a copy, of which this is the record, in Paris.

Signed, Boniface Big-Butt, bailiff of the Cuff.

Documentary evidence

Deliberation of the general council of buggers and bardashes

In the year of grace 1790, the second of the reign of M[essieurs of] the A[ssembly] and the fourth day of the Greek calends, at two hours past midnight, the general council of buggers and bardashes met on the paths of the Luxembourg gardens, in the usual manner, with the leave of the former m[arquis] de V[illette], grand master of the Sodomitical Society, to deliberate about matters concerning said Society.

The council in session, grand master V[illette] said, "Gentlemen, as an unavoidable consequence of the horrible anarchy that reigns in all orders of society, the whores, that vilest component of the human species, dared to present to the Committee on Fuckery a petition tending to vilify us. And the Committee has handed down a decree stating that our hats will be crowned with a prick so that we can be recognized. At this report I see your buttocks tightening with fear and your cocks drawing back into your abdomens. You tremble to see your Society destroyed, at being forced to give up the sweet pleasure of butt-fucking. Well, gentlemen, take measures to avoid a misfortune the very idea of which makes you shudder. I ask you to deliberate about this important matter."

The grand master having stopped talking, an honorable butt-fucker stood up and asked that they choose from the most vigorous buggers three commissioners who would be entrusted with looking after the common good, asking the august assembly to conduct the usual test. The motion having passed unanimously, the bardashes lowered their pants, and the buggers, with erections like satyrs, took advantage of them, each according to his vigor and strength. The test having been conducted, the bardashes made their report, after which the Society, with minds free and loins disengaged, unanimously appointed John Ass, viscount Anus; Polycarp Between-Cheeks, marquis Hemorrhoids; and Boniface Long-Prick, chevalier Black-Bush, to be its commissioners in the matter pending before the Committee on Fuckery and gave them the power to appoint a designated agent to act in their name as well as in the name of the Society and to grant him such fees that they would judge appropriate. The above-named commissioners have signed along with the grand master and us, the secretary, those who didn't know how to sign their names having come all over the register.

Signed, V[illette], grand master; John Ass, viscount Anus; Polycarp Between-Cheeks, marquis Hemorrhoids; Boniface Long-Prick, chevalier Black-Bush; Peter Push-Hard, secretary.

Procuration of the Sodomitical Society to the m[arquis] de V[illette]

In the second year of public ruination, of the dream of liberty, of the inversion of civil and political order, and the day after the preservation of the ministers, the one thousand and first blunder of the National Assembly, in the presence of the butt-fucking notary in Paris and the undersigned witnesses, were present in person sieurs John Ass, former viscount Anus; Policarp Between-Cheeks, marquis Hemorrhoids; and Boniface Long-

Prick, chevalier Black-Bush, commissioners of the sodomitical community, who by their consent and by virtue of the power given to them by said community, have by the present act appointed the former m[arquis] de [Villette], grand master of butt-fuckers, here present, stipulating and accepting, their designated agent to act in their name in the matter pending before the Committee on Fuckery between said sodomitical community and the female fuckers, bawds, handjobbers, and company. To that effect, they grant him all power to do what he judges necessary for the defense of their common cause, approving in advance all his transactions and promising, to compensate him for his pains, to provide him every day, starting with today, with two handsome youths, whose anuses haven't yet been perforated by any priapus [penis]. And said m[arquis] de [Villette], in his turn, promises to make every effort to defend the cause of which he voluntarily takes charge and to make sacrifices, if necessary, even of his inclination for the ass, rather than allow the race of fuckers to triumph. And for the observance of everything above, under penalty of all expenses, damages, and profits, the parties have bound balls and cocks before all courts and have sworn it on their buttocks; the required act that we have granted them, made, read, and published while they were butt-fucking each other in a corner of our office and our senior clerk was jerking us off, in the presence of John Borer, master carpenter, and Bartholomew Circle, cooper's assistant, requisite witnesses and signed with the parties.

Signed, V[illette]; John Ass, viscount Anus; Polycarp Between-Cheeks, marquis Hemorrhoids; Boniface Long-Prick, chevalier Black-Bush; John Borer; Bartholomew Circle; and Brace and Bit, notary, on the original.

Authentication

We, B. de Favras, unworthy counsellor on the streets of Paris, certify to everyone concerned that Brace and Bit is truly a notary, and that trust should be placed in his signature, in confidence of which we have drawn up copies of the present documents, sealed with our seal, bearing the imprint of an emaciated hand with crooked fingers, and a Themis with black eyes.[76] In Paris, the year and date as above.

Signed, B. . . D. . .

Verified and registered in Paris, the year and date above, having received seven sous, six deniers, and, in the bargain, a shower of fuck in the buttocks.

Signed, L. . . M. . .

ODE TO THE POX

Oh, pox! Oh, cruel plague!
How dreadful its ravages are!
How many cunts afflicted by it,
And how many unlucky fuckers!
It is the sickness of opulence,
The French sickness par excellence,
The common sickness throughout the country,
The sickness of prudes, of coquettes,
Of duchesses and soubrettes,
Of porters and marquises.
In a cloister, tranquil retreat,

Sometimes the innocent little nun,
From an agreeable fellow from town,
Receives the clap or a tumor.
What happens? Our vestal virgin,
Innocently, and without scandal,
Infects her poor spiritual director,
Who returns it, also without scruples.
Through these means, the sickness circulates
Among the virgins of the Lord.
Here's to you, blond Magdalen,
Who live in heaven.
You were a whore in the world,
If the learned are to be believed:
But, tell me, my good friend,
Weren't you a little decayed?
For the late Saint John got hard for you
And wanted to fuck you doggy style;
But when he saw your clitoris,
He was afraid and withdrew.

5. The Private and Public Life of the Behindish Marquis de Villette, Retroactive Citizen (1791)[77]

The behindish marquis de Villette, so called because of his inclination for the ass, was born in Paris in He was born with his fixed taste for the sin of Sodom. Reports even affirm that his mother, while she carried him in her womb, felt an almost continual itching in her anus, a sensation almost like that produced by putting a soft nozzle into that part of the body when it's necessary to do so. This fact about Madame de Villette's pregnancy, which she shared (one doesn't really know why) with several persons of her acquaintance, was explained with difficulty and in conformity with the particular tastes of those who were informed about it. The wife of an apothecary whose house adjoined Madame de Villette's concluded in her own mind that her husband had played around with her female neighbor. A Jesuit claimed that the offspring of Madame de Villette was destined to bring sodomy back to life and predicted rightly.

The first years of the behindish marquis de Villette offer only facts of little interest, although he carried within himself the seed of the dreadful vice that he now flaunts with as much impudence as indecency. Although he made repeated experiments on the companions of his amusements from an early age, his behavior didn't cause any kind of concern because one hardly pays attention to the actions of a child who, moreover, was very sweet and had a likeable disposition.

We will point out, however, that his nursemaid, with whom he slept when he was withdrawn from the hands of his wet-nurse, almost always felt her buttocks scratched by the baby's little instrument. But either because she liked the game or because she didn't

notice it, she had never said anything about this fact. It was only after the behindish deserved to be called such because of his sodomitical exploits that his former governess related the characteristic deed of the young Villette.

Great vices, like great talents, develop early in individuals destined by nature to play an important role in society, in no matter what way. The family of our hero provides us with an incontestable proof of this assertion. Voltaire, his maternal uncle, babbled some verses in his crib; he thereby indicated that he would be a great poet.

Villette, barely three years old, had the skill to distinguish his maid's ass from her cunt and never mistook one for the other, a definite sign that he would one day be the most celebrated butt-fucker in Europe.

From the time that Villette was big enough to be left by himself, he kept himself busy doing nothing but roaming the streets around his house looking for young bardashes of his own age, whom he seduced with candy, fruit, and pennies. And as he wasn't choosy about those he intended for his pleasures, he easily found ways to satisfy himself by using the small means we just mentioned.

Although the sensations he experienced at such an early age were altogether incomplete, he surrendered himself to his passion for the ass with such fury that one day he was found in a timberyard, in excessively cold weather and in the middle of the snow, butt-fucking a young shoe-black whose appearance and filthiness would have repelled everyone but him.

His parents were informed that he had been found in flagrante delicto, but, considering it as something of no importance, and more as a childish act than as a confirmed vice, they decided not to speak to him about it. But in order to destroy the evil at its very root, supposing that it was such in a child of this age, they made up their minds at once to put him in a boarding-school, imagining that the work that would be given him and the care with which his behavior would be watched would prevent him from surrendering himself to this depraved taste against nature.

Settled in the boarding-school, the young butt-fucker went several days without having an erection. New faces, a different routine, regular tasks distracted him enough that he couldn't surrender himself to his passion.

But a leopard can't change its spots.[78] Villette had scarcely made a few acquaintances when the butt-fucking fury took hold of him again, more strongly than before. The first object of his desires was a young eight-year-old child, who had come to the boarding-school at the same time as he had. Villette, young as he was, began by watching the child's actions, with the aim of making out his character and then attacking him at his most vulnerable point.

The observations of our young butt-fucker weren't in vain. He hadn't consorted with the young ganymede for two weeks when he found out that the child was a glutton at heart. Quite sure that bonbons were his favorite passion, Villette lavished them on him in a disinterested way and took much care not to let him sense the reason for a generosity that was all the more unusual given the fact that their acquaintance didn't go back very far.

When Villette saw that his minion was used to the daily custom of sweets, when he saw that this habit had become a need for him, he began to reduce the amount that he gave him each day and finally stopped giving him any at all. The blond boy, for whom this privation was unbearable, complained about it bitterly to Villette and asked him what reasons he had for changing his behavior toward him in this way. This was what Villette was waiting for. "I have no other reason for acting this way," he responded, "than your

coldness toward me. And I'm ready to act toward you as before, if you want to give me some proof of friendship and complaisance." "Speak," the blond boy cried. "Speak, my dear Villette. There is nothing I wouldn't do to prove my devotion and gratitude to you." Since this discussion took place in a corner of the courtyard during recess, Villette shrewdly leads his young friend into the garden. And, on the pretext of answering the call of nature, he persuades him to go into the water-closet with him. There the young satyr, inflamed with lust, explains his intentions through actions to his friend, who, in the most perfect innocence, lends himself without resistance to the infamous desires of the precocious libertine.

After the act, Villette advises him to keep completely quiet and induces him to do so by giving him pralines and other sweets, which constituted irresistible arguments for him.

If Villette had contented himself with taking advantage of the blond boy, it would have been difficult for anyone to find out about his activities, although he was closely watched by his preceptor, to whose care his parents had entrusted him, without explaining that they knew something that would shed light on his behavior. But the young bugger had planned to butt-fuck the entire boarding-school, and he even pushed his ambitions as far as wanting to sodomize the preceptor himself. As his means and experience were infinitely out of proportion with his designs, he failed in his undertaking, and here is how.

Among his classmates, Villette had noticed the young count d'A This child had a charming face and a sweet, affable disposition, but he had sucked along with her milk the principles of a mother who was as upright as she was loveable. Villette watched with lustful eyes and intended to make him one of his first conquests. But because the count didn't provide him any means of seduction, the sodomist made up his mind to be blunt about the matter. Both of them slept in the same dormitory, and their beds were separated only by one other, which was but a slight obstacle to Villette's lechery. Night fell, and they go to bed. Everyone goes to sleep. Only Villette, who was thinking about the execution of his plan, was still awake and waited for everyone to fall fast asleep. Finally he can't resist his burning desires any longer. He gets up, and, carried away by his passion, he spits on his cock, slips into the count's bed, and with a force uncommon for his age, he runs it through him up to the hilt on the first thrust.

The stiffness of the attack, the surprise, and, even more, a sharp pain, awakened the count from his sleep. He wakes up screaming. They come running with a light. They find him pale and disfigured and the young bugger, with sparkling eyes, plowing his buttocks with incredible speed, and so focused on his prey that he didn't see or hear anything, and they had the greatest difficulty tearing Villette off the count.

They finally take him away and put him away in a kind of cell, where to make up for it, he jerks off until the moment when they come to take him out to make him undergo, in front of the whole school, a punishment in proportion to the nature of the offense he had committed.

Since he had sinned by the ass, it was decided that he'd be punished by the ass. Consequently, he was placed, undressed, in the middle of the playroom, and there all of the students, each with a fistful of switches, came in turn to apply several strokes to his buttocks. But far from feeling pain, the young bugger began to get such a big erection that the preceptors, seeing his nightshirt rise up, suspected the truth and had the business stopped. And concluding that Villette was incorrigible and that he'd be an ass-fucker in spite of everyone, they sent him back to his parents' house.

It was impossible to hide the reason for such a humiliating dismissal from them, and so the person who had taken him back admitted it to them openly. His mother was doubly mortified by it, both because she was a woman and because this vice is truly the most abominable with which a man can soil himself. She resigned herself to putting him in a boarding-school where she warned them about him so strongly that it was impossible for him to satisfy himself a single time during the whole time he spent there. It's not that he didn't made a thousand attempts. He even tried the young Savoyard, who ran errands, but either because everyone had been forewarned or because he was watched too closely, he was always reduced to jerking off.

Having finally completed his studies, he came back again to the paternal home. Since he hadn't given his parents any cause to be displeased with him during his stay at the boarding-school, they thought him cured of his taste for the ass and allowed him some freedom, which he soon abused.

In order to hide his cards more completely, he pretended to go out only infrequently, and it was at night. His inclination always led him to the Luxembourg or Tuileries gardens, and there he made up for his voluntary constraint during the day by butt-fucking everyone he could seduce left and right.

Villette was too much of a libertine and independent spirit to play the part of a restrained individual for long, and shaking off what he called ridiculous prejudices, he took off his mask completely and surrendered himself without shame and modesty to his infamous inclinations.

Enemy of constraint and mystery, he made no effort to hide his tracks, and as long as he succeeded in satisfying himself, he cared very little that his behavior was observed.

This contempt for public opinion almost proved fatal for him. The Luxembourg and Tuileries gardens are the meeting places of everyone involved in the business of fucking. Whores ply their trade on one path, while bardashes ply theirs on another. And the whores happened to note that since Villette frequented the scene of their sport, the followers of sodomy were becoming more numerous, and the johns were becoming much more rare. Incensed at seeing that the behindish did them such considerable harm, some of them formulated a plan to catch him in flagrante delicto and turn him into a new Abelard.[79]

This plan was no sooner formulated than they thought about carrying it out. To this end, four of them hid in the darkest paths where they knew the behindish went every night. Their hopes weren't deceived. A minute later Villette appeared and was soon followed by the bardash he was going to take advantage of. The harlots, each armed with a dagger, waited with the impatience of revenge for the moment when their enemy would be in the heat of action in order to take him by surprise and cut off his balls and cock down to the hair. It would've been all over for the modern marquis if one of the conspirators, carried away by the act of taking vengeance, hadn't left the place where they were hidden at the moment when he put his hand on the button of his pants. The noise she made in walking on some dried leaves made the bugger turn his head. He suspected some trickery, and, holding his pants with both hands, he fled as fast as he could, showing them, to play a trick on them, a pair of buttocks, the sight of which affected them like a basilisk [mythological lizard that could kill by its look], for they stopped short and stood as if petrified.

Recovered from their astonishment and heartbroken at having missed their chance, they avenged themselves in an almost equally cruel manner, by defaming him in public through the following couplets that they disseminated throughout the whole city.

SONG

(To the tune of "I was Born a Native of Ferrara")
I was born a native of Lutetia [Paris]
And a great devotee of the buttocks.
I have no juice for the cunt.
My cock's only for the anus. (twice)
In a path far from the whores
Stretched out under the foliage,
While elsewhere men fuck cunts,
Me, I butt-fuck my handsome minion. (twice)
Without fear of clap,
Tumor, or jaundice,
When I need to come,
I gladly do without cunt-fucking. (twice)
At the base of the spine
Of a handsome youth, I fuck with my prick,
And scratching my two balls,
My fuck gushes out. (twice)
Bugger and at the same time sodomite,
The former marquis de Villette
Feels the most lively aversion
For women and for cunts. (twice)
Without being a native of Sodom,
To the woman he prefers the man,
When he's young and, especially, inexperienced.
Why not? Each to his own taste. (twice)

Given the sensation that these couplets made in the mind of the public, Villette under-stood that he'd be regarded as an arrant butt-fucker and that he'd no longer be able to go out without being made fun of, but his passion outweighed every other consideration. He might have imprudently defied public opinion, which he accused of prejudice, if his friends hadn't stood in the way. They thought that the best way to make him give up his favorite sin was through marriage. Consequently, they suggested to him a young woman who combined, with the advantages of wealth, a charming face, pleasant talents, and a birth as illustrious as Villette could wish for.

Convinced by his friends' entreaties, and maybe also by the benefits that the pro-posed alliance offered him, he yielded to their pleas. Their officious efforts curtailed the formalities, and the marriage was almost no sooner arranged than celebrated.

The day after the ceremony, a jokester wrote in large letters on the back door of the marquis's house:

ONE NO LONGER ENTERS THIS WAY.

In possession of a charming wife, Villette seemed to have forgotten his former incli-nations, but, incapable of appreciating decent pleasures, he was soon sick and tired of the sweetness experienced in the tranquility of the home. He abandoned himself anew to the foulest dissolution. His wife's tears, his friends' protests were employed in vain. To

restrain him, his wife would have had to oblige him by doing things that her modesty made her incapable of doing. And it's easy to guess what kind of things they were.

At the time of the Revolution, which is the most terrible plague with which France could be afflicted, which heaven allowed for our misfortune, Villette, who was doomed to public scorn because of his disgusting behavior and who, despite his lack of concern for what he called prejudice, endured innumerable humiliations, publicly supported democracy, and declared himself a patriot in the Revolutionary sense.

In this way he hoped to make people forget his escapades and to rehabilitate his tattered reputation. But he missed his goal, and nobody was deceived about his motives, especially given the fact that he didn't become either more scrupulous or more circumspect in matters of the ass.

He's so strongly chained by his inclination for that part of the body that even when he's discussing serious matters, his conversation always turns to that subject, without his realizing it. You be the judge of it.

Villette has the honor or dishonor (for everyone has a point of view) of belonging to the most lofty and mighty Jacobin club.[80] At a meeting he attended, they were talking about matters of precedence and preeminence, and, according to the most laudable custom of the Jacobins, they were railing against everything that, in their view, bears the mark of aristocracy, and they proposed to abolish the word itself. Villette, carried away by his *culottisme,* stands up and, with enthusiasm worthy of a better subject, which one shouldn't even think about in a free state, asked, "How long are we going to allow aristocracy to extend its control over even the smallest things?[81] We've bowed our heads under the yoke for too long. Either each person should preside in turn or precedence should be completely abolished. Consequently, I denounce to you the letter A, which has, since the invention of the alphabet, occupied first place among its companions, although there isn't one among them that isn't as good as it in every way, and I ask that the letter Q [*cul,* ass] preside in turn. I dare to expect from your justice that you will take my motion into consideration and that I'll not have denounced to you in vain an abuse that has lasted, alas, too long."

Although this motion seemed laughable to several Jacobins, since there were many among them who were inviolably attached to the Q, the motion was put to a vote, and it was decided by a very large majority that the letter Q would preside in turn. The bishop of Autun was entrusted with making the same motion at the National Assembly.[82]

If certain persons are to be believed, Villette doesn't lack wit. He's even credited with a talent for refined and trenchant repartees. He was walking around by himself one day in the Palais-Royal. Two young men were walking arm in arm behind him, and from their attire, there was no doubt that they were chevaliers of the Cuff. Villette has a very keen sense. He had noticed and judged them at once. One of them, having recognized the behindish marquis de Villette, said to his companion, "Look, there is that bugger Villette." Having heard, the latter turned his head and, without becoming disconcerted, said to this indiscreet man, "What are you complaining about? Didn't I pay you every time I f[ucke]d you?"

This response, which a hundred people heard, demolished the two bardashes, who ran away without replying. And Villette continued his walk, looking and sniffing to the right and left to find fresh meat.

6. Liberty, or Mademoiselle Raucourt to the Whole Anandrine Sect, Assembled in the Entry Hall of the Comédie-Française (1791)[83]

Mademoiselle de Raucourt's speech

"My Dear Cunt-Sisters,[84]

"A host of extraordinary events have followed one another without a break since the beginning of the Revolution. The love of liberty—this dominating passion of the human species, inexhaustible source of the most heroic actions when it's well managed, altered in thousands of ways in the current circumstances by self-interest—produces results that are as disastrous as they are numerous throughout the entire kingdom every day. Mercier's dream, Epimenides's awakening have seen nothing like what is happening now before our eyes.[85] One dreamed too long; the other didn't sleep long enough. Their fantastic ideas, daughters of an excited imagination, offer only visionary facts that can only exist in their brains filled with Platonism.

"The taking of the Bastille, everlasting monument to the Parisians' courage or the governor's cowardice; the torture of several persons of rank, put to death without a semblance of a trial by the most humane populace in Europe; the day of 6 October, a day forever noted for the atrocities it brought to light and for the rank and sex of the combattants who committed them; a time worthy of Ronsard's oboe or Palissot's cracked trumpet; a just and good king, captive in the midst of his subjects who call themselves free; a queen worthy of the adoration of all of the French, exposed to all the arrows of the most dreadful slander; the princes of the royal blood forced to live far from their country to escape the fury of a mutinous rabble; the most distinguished nobles of the realm wandering among foreigners to avoid lynching; . . . practicing the most absolute despotism in Paris; a man distinguished by his personal merit punished with the ultimate punishment for having wanted to be faithful to his king; a public treasury taking advantage of the present disorder to miss payment on its most sacred commitments; credit and business ruined beyond repair; disorder in all parts of the administration; the legislative branch abusing its authority, the executive branch without power or strength; the holiest rights trampled under foot, the foundations of religion undermined, its ministers reduced to begging; the representatives of an august nation forgetting the dignity of their functions, insulting each other without modesty, using on both sides the arms of cunning, the resources of sophistry, and the arrows of slander itself to assert their opinions.[86] Such are, my dear cunt-sisters, the dismal scenes that take place every day on the bloody stage of the Revolution; such are the ominous events that foreshadow the most unhappy future and the most fearful prospects for the French nation.

"To tell the truth, this list of the different periods of the Revolution is only a very imperfect outline. I haven't said a word about the singular events, of which so many individuals worthy of a better fate have been the wretched victims. I won't tell you about the complete subversion of the most basic ideas in the minds of the French. They seem to have forgotten their love for their king, and, I dare say, even all of their frivolity in view of the important matter that concerns me and for which I have gathered you here. I'll pass quickly over everything that doesn't affect us.

"As Frenchwomen, as active citizens, you should participate in everything that concerns the whole of the nation to which we belong. But once this obligation is fulfilled, let's not forget our cunts and our clitorises. We'd fail ourselves, we'd deserve the worst

case of the pox, if for causes that I can't foresee, we neglected taking the steps to protect ourselves from the pox and preserve our ability to tongue ourselves whenever we like. Dismal sadness is already painted on your faces. The clap already seems to have ravaged you seriously. Charms disappear; pale violets take the place of the roses and lilies that adorned your faces not long ago. You tremble, your fuck goes all the way back into your loins; yet you still don't know what danger you are threatened with! Although acquainted with fear, I myself never think about it without the hairs on my ass bristling, without my clitoris shrinking suddenly, without my cunt, which is of a very nice size, contracting prodigiously. No, no medical remedy has ever had a more surprising or immediate effect. But let's arm ourselves with heroic resolve, let's forget for a moment that we are women. The effort won't be difficult. Accustomed to performing the functions of men, let's take on their courage. Here are the facts.

"Through a petition worthy of those who presented it, and for motives that should have earned them several stitches in their ample vulvas, the whores, those public nuisances that thunder might as well crush, obtained from the Committee on Fuckery, composed of the worst good-for-nothings the world has produced, a decree that orders buggers and bardashes to decorate their hats with a prick trimmed with hair in the form of a plume, as a stigmatizing sign by which they might be recognized without difficulty and mocked, unless they publicly embrace harlotry, renouncing forever their butt-fucking passion. The sodomites knew that they were doomed to scorn and abhorrence. They assembled at once in the Luxembourg gardens, presided over by the worthy butt-fucker Villette, and appointed commissioners, confirmed sodomites, and a designated agent to rout the whores and mount their defense in a matter that jeopardizes their love of the ass and the regard they enjoy in society. Up to then we don't give a damn about it; our cunts and clitorises still have nothing to do with the matter. But yesterday, while I was fucking Mademoiselle Lange without having closed my door, while I was straining with all my force to squeeze the fuck out of myself, the chevalier Twice-Cunt, a trusty fucker who wangled me many times until his nuts were flattened back when I was the mating goddess at the Comédie-Française, enters my home with an alarmed look, with the look of a man just recently castrated.[87] And without noticing that I was ready to come, he tells me, while pulling me roughly by the arm, 'I come from viscountess Split-Cunt's, where, while you are having a good time fucking around, a plot is being hatched against the whole anandrine sect capable of destroying it from top to bottom. My friendship for you, my gratitude for your former services compelled me to warn you about it. I didn't finish having myself jerked off in order to come sooner and give you this important warning. I've fulfilled my duty. Go ahead and come if you have the guts for it, and take precautions.'

"At these words, the fuck coagulates in my nuts, I lose my erection, and Mademoiselle L***, who's already coming in great torrents, suddenly feels the source of her sperm dry up. I admit it frankly, the collapsing universe would not have made as awful an impression on me as the chevalier's words. The worst kind of pox would've frightened me less. I fell into a stupor that made people fear for my life. In vain they tried spirituous liquors, in vain they drenched me with a flood of oil called Carmelite water. Even essence of fuck would have had no effect. It was only by masturbating and tonguing me that the little Lange brought me back to life. Recalled to my senses, my first movement was to put my hand on my cunt to assure myself of my existence. I thought I'd dreamed chevalier Twice-Cunt's words, but Mademoiselle Lange corrected my mistake. I tortured my imagination to figure out the motives behind the whores' odious plot. I carefully examined what our conduct with regard to that vile riffraff had been, and I found nothing, in either our cunts or our asses,

that would have earned us their censure. Finally, by dint of reflection, the fuck began to show in my face, when a brilliant idea occurred to me. Here it is.

"As long as our pecuniary needs or our desire for ordinary fuckery made it necessary for us to make use of balls and pricks, we shared part of the innumerable discomforts, the inconveniences inseparable from the whore's profession. But since the useful product of our cunts has lifted us above poverty, since we've appropriated for ourselves the outfits of the infinite number of fools dressed as men whom our charms and tricks have ensnared, since our shared taste for the clitoris has led us to renounce the usage of cocks, the female fuckers and company, formerly accustomed to sharing with us ulcers, tumors, the pox and all its after-effects, seeing themselves alone responsible for the arduous job of exercising the talents of Saint Cosmas's agents, formed the horrible plan of making us return to the class of ordinary whores.[88] In denouncing us to the Committee on Fuckery for making illicit use of our instruments and all the parts that make up the organ of voluptuousness, if the success of their undertaking can be judged by that which they already gained in their case against the sodomites, I dare to predict that we are fucked, and fucked without being paid. The decree of the Committee on Fuckery, the similarity between our case and that of the buggers and bardashes, the influence of the whores on the judges who fuck them for free, all should make us worry about losing the case, in which we have no means of seducing those who are supposed to decide it.

"It is therefore urgently necessary to use the surest means, as soon as possible, to ward off the storm that's rumbling I won't say over our heads, but over our cunts, over our clitorises, in a word, over everything that gives us the pleasure of fucking and coming. Remember that it's the same in matters of chicanery as in matters of fuckery. In coitus, the one who gives the first thrust of the ass is usually the first to ejaculate. With litigants, the aggressor's almost sure to prevail over the adversary. So let's combine interests with the children of Sodom. Let's form with them a league cemented by fucking. Let's even let ourselves butt-fuck if it's necessary. We shouldn't parade any false delicacy regarding the choice of means; all are decent when they lead to the goal. I call to witness the poet who said, 'guile or valor in the enemy, who asks?' and this poet was no fool.[89] May our strength united with that of the sodomites fuck up the plans of the nasty sluts, the damned strumpets, whom temporary success won by underhanded methods has puffed up with pride. But they've triumphed for a moment, only to return to the mire of the brothels with more shame and confusion. Indeed, my dear cunt-sisters, either the female fuckers, intimidated, will give up their fucking plan, or else they'll carry it out. If they do abandon it, we don't give a damn about them, and our fears are dispelled; if they're dumb enough to stick to it, they'll certainly succumb to our strength united with that of the sodomites, even if, to assure victory, we had to sell everything down to the hair of our cunts to make moustaches out of them for the grenadiers of the blue [Revolutionary] army. So, whatever happens, my motion seems wise to me, and I ask that the honorable assembly give me its opinion with its usual frankness."

A friendly whore, a charming actress, Adeline, stood up and said, "Everyone knows that I'm a fucker in my soul, and I'm proud of it. I love men, and I have no use for women hanging around me. I prefer a long and thick prick that plugs, at least partly, the vast orifice of my cunt, that vigorously scrapes me, and that makes me come abundantly, to a thin and short clitoris that gets lost in my crack, that only fuckifies me, and that can't make me shed a drop of fuck. This is the main reason why I don't agree with Mademoiselle Raucourt. Besides, I don't give a damn about the anandrine sect, any more than about the hair on my ass.

"I don't know if the whores' plan is for real, and if it were, I wouldn't be any more inclined to intervene against them for that reason. As fuckers, their interests are mine, and unless you take me for an imbecile, you shouldn't hope that I'll supply penises to fuck myself with. As an active citizen, a status they won't challenge in me, I should contribute as much as I can to the pleasures of fuckers who so often give me the same myself. And to oblige you to practice public whoring again is to do a noteworthy favor for the lovers of big cunts. It's to give them back a possession, whose ownership must be dear to them, since they acquired it at the cost of their money and health. For how many fortunes have our cunts not overthrown? How many cases of clap haven't they spread around? I call to witness a crowd of whoremongers who have the clap on the pallets of Bicêtre, the tainted juices that we've given them, and you would like to parade your taste for clitorises! And you wouldn't be ashamed of making use of your instruments and their accessories in a way that's just as revolting as disastrous, a way that would have disgusted the Parisii women, Aspasias, and even Messalinas![90] Oh, give up instead your clitoral inclinations; return to the worship of pricks, the only one worthy of your attractions and charms. May a flood of virile sperm, poured on your cunts in place of lustral water, cleanse them of the countless pollutions with which they have been dirtied. Placate Priapus with this expiatory sacrifice, and I dare promise that you will come with more pleasure than before. I dare predict for you tireless fuckers, fucking galore and money, maybe not a lot, but more assignats than you will want. There are so many people for whom they cost nothing that they aren't stingy with them.

"Believe me, abandon the children of Sodom to their unhappy fate. They're not worthy of your compassion. Disgrace of nature, which they insult in every way, may they be eaten away to the bone marrow by crystalline! May my words make the impression on you that I have reason to expect from them. If they're in vain, I'll at last have done for the cock and balls what my tastes and justice required of me, and I'll console myself for it by fucking left and right, as long as I have a drop of fuck left in me."

"I didn't flatter myself," responded Mademoiselle Raucourt, "that I could bring Mademoiselle Adeline over to my point of view. With her she-wolf temperament and insatiable greed, it was hard for her to embrace a plan that directly thwarts her two favorite passions and to give up the pleasures of fucking and making money. But having said nothing in my speech that could shock her scrupulousness, I had reason to expect that she would apply a bit more moderation in her response and that she would have some respect for a taste to which we have surrendered without reservation and to which we stick as strongly as balls stick to the prick. No matter what Mademoiselle Adeline says, even if fuck rose up to her face when she vomited forth her diatribe against us, I'm persuaded, my dear cunt-sisters, that there isn't one among you, no matter how much of a whore she once was, who wouldn't prefer to have her cunt sewn up than to resume the use of pricks that ruined your figures [by causing pregnancy] so many times. And don't think that our inclination for the clitoris is a modern invention: it isn't only as of today that women have ventured to fuck without the help of men. We have examples of it from all centuries and countries. Those warlike women about whom history tells us so many marvels, those famous Amazons who lived on the banks of the Thermodon River, had cunts, and cunts as hot as ours. However, they only fucked with men once a year, and moreover it was to perpetuate their race, and the rest of the time, they fucked each other. Roman women excluded men from the Saturnalia only to surrender themselves without restraint to the innocent frolics for which we are reproached. The savage women of Canada, whom their husbands abandon for the seven or eight months that the hunts last,

make up for the deprivation of pricks with the use of clitorises. And if you need more recent and respectable authorities, couldn't I cite you[91] But let's not touch the Holy Ark [chest containing the Ten Commandments]; a sudden paralysis would be the just punishment for such an offense.

"Mademoiselle Adeline casts stones at buggers and bardashes, but is she in a position to do so? When it comes to such matters, is she beyond reproach herself? No, without a doubt, no, and I'll swear to it on Mademoiselle Lange's cunt. There's not a single one of us, without excepting myself, who, for profit or some other reason, hasn't been so accommodating as to to let herself be fucked in the rear a hundred times. And if it were necessary to back this up with evidence, the little distance that separates our cunts from our asses would soon prove the truthfulness of my assertion unanswerably. But why discuss a question that doesn't need it for such a long time? I'd try to persuade Mademoiselle Adeline in vain. Bridled by her fucking temper, she clings to her opinion like crabs to a poor man's balls. I therefore call the question, and I ask that all those in favor of intervening take advantage of each other in front of this recalcitrant woman, in order to give her proof of the freedom of voting." All those present immediately fall backwards, two by two. Nothing is heard anymore in the room but muffled sighs, heralds of pleasure. The floor resounds with thrusts of the ass, repeated a hundred times. The merry company works away at it with the ardor of the strongest athletes. Adeline alone, sitting sadly in her seat, seems plunged into a sort of dejection. She finally recovers herself and, furiously tucking up her skirt, says, "By that cave that is as worthy as the Styx, I swear an everlasting hatred for the whole anandrine sect.[92] May it see its cunts dry out from want, implore the help of Priapus in vain, and me, may I swim in an ocean of fuck." With these words, she leaves the room and disappears.

Meanwhile the voters hastened to give their opinions. They all came at the same time, and the motion having passed unanimously, Mademoiselle Raucourt dictated the intervention in the following terms.

Intervention of the tribades in the case of the buggers and bardashes against the female fuckers, etc.

We, actresses, dancers, figurants, galley-rowers of the Opera, the Comédie-Française, the Italians, etc., having renounced fucking in the usual forms to take refuge from the consequences that result from them, and having taken an oath to make use of pricks and balls no longer, so as not to have the trouble of seeing our bellies get big and our waists become heavy and bulky, which fucked us up, agreed to fuck and tongue each other so as to pick the roses of pleasure without being exposed to the prick of the thorns. Without fear or remorse, because we didn't harm anyone, we abandoned ourselves without distrust to our innocent amusements, when we almost became victims of our sense of security. But a benevolent divinity was watching over us. We learned that the whores were secretly scheming to make us practice again the public harlotry that we had abjured on oath. As soon as we were informed, we assembled, and, after having maturely discussed such an important plan, after having fucked and refucked, masturbated and tongued to exhaustion, considering that if we didn't use all possible means to resist the female-fuckers, our enemies, we'd give evidence of cowardice that we're not capable of, and considering, furthermore, that to give up clitorisizing ourselves would be to give up that which makes us cherish existence, we've determined to intervene on behalf of the buggers and bardashes in their case against the whores and company pending in the Committee on Fuck-

ery. We offer the children of Sodom to pay half of the costs of the proceedings, no mat-
ter how much they add up to, and in case of failure, to pay our share of all the expenses
that will have been incurred at that time, the list of which will be placed before our eyes
with the legal signatures and initials, on the condition, however, that said whores and
company will be prosecuted to the full extent before all courts responsible for taking cog-
nizance of fucking and butt-fucking cases until complete withdrawal on their part or until
a final sentence has been rendered. Wishing that the present document and everything
that precedes it be legally served to the opposing party through the service of our regu-
lar bailiff, so they can't plead ignorance about it, we've signed everything with our most
precious substance, our fuck.

Written in Paris, the day after the slight wounding of Charles Lameth.[93]

Signed, Raucourt, Lange, V . . . P . . . C . . . the elder, C . . . the younger, and Mari-
ette Vagina, secretary, on the original copy.

Collated in order to be used at trial and sealed with the great seal of the society,
which bears the impression of an imperceptible clitoris in the middle of a wide cunt.

Signed, Vagina, secretary.

Writ to be served

We, bailiff of everything that concerns the pleasure of fuckery, passed and registered in
all theaters, brothels, taverns, paths in the Luxembourg and Tuileries gardens, and all
other suspect and infamous places of which Paris, the general brothel of the realm, is
composed, living there, signed below, ready to do anything for money, devoted just like
all our colleagues and all men who used to wear the robe [of judicial service] to the peo-
ple who pay well and in cash, at the request of the honorable anandrine sect, we have by
the present writ, duly registered, served the attached intervention and everything that pre-
cedes it to the whores and company, speaking to viscountess Split-Cunt at her home, in
the brothel, at the bottom of the stairs, and of everything we gave her a copy, of which
this is the record, in Paris. Signed, Scratch-Cunt, bailiff.

Verified and registered on the cunt clause, received seven sous and six deniers.

Signed, L. C.

Copy received on . . . , jerked off the bailiff's prick to compensate him for his trou-
ble, notifying the anandrines that we will give our response within the time fixed by the
ordinance.

Signed, viscountess Split-Cunt.

Response of viscountess Split-Cunt and her adherents to the intervention
of the anandrine sect

With all the intelligence that is attributed to Mademoiselle Raucourt, with all the insight
with which she is truly endowed, it must be admitted that her reasoning is sometimes
faulty. She has just given us unequivocal proof of it in her speech to her companions urg-
ing them to take sides against us on the basis of a report that nothing could make her
regard as authentic.

Whether because of a blunder, a lapse of intelligence, or a lack of better means,
Mademoiselle Raucourt mercilessly criticizes the work of the august National Assembly,
presents all the events that the Revolution has engendered, in a hateful and frightful light,

and condemns to scorn and abhorrence the brave national guard whose courage and vigilance are the strongest support of public liberty. In the mire of profligacy in which she wallows, she dares to cast a profane glance at the advantageous constitution that causes good citizens to rejoice. Her filthy mouth dares to secrete the poison of envy upon everything that patriotism makes most respectable among the French. Accustomed to living with the agents of aristocracy, she's absorbed their ideas. Accustomed to jerking off and sucking their cocks, she's swallowed their principles with their fuck. It's not in order to arrive at what she calls her principal objective that Mademoiselle Raucourt parades her views about the Revolution. It's that she's really an aristocrat herself, that she would like to make her companions adopt her way of thinking, in the foolish hope, perhaps, of making some impression on the public. But they count for so little in society that there's nothing to fear on their account.

In thus bringing to light the true views of Mademoiselle Raucourt and her followers, we consider ourselves obliged—before responding to their intervention and to their insults with which it's sprinkled—we consider ourselves obliged to make our profession of faith.

We therefore state that we're zealous patriots and that it's not our fault that the constitution isn't completed to the satisfaction of all supporters of the good cause. We respect the General [National] Assembly, and we love its members individually, and we prove it to them every time they deign to honor us with a visit. We're with them without reservation.[94] We're ready to do anything to entertain them: cunt, thighs, buttocks, tits, everything is at their disposition, and their least desires are sacred and respectable duties for us. Such is our way of thinking and feeling in the current circumstances. We're not afraid to announce it because, whores though we are, we know how to judge things and distinguish the good from the bad.

Very far from taking steps to defend their abominable sect, the anandrines should blush from shame for praising a taste that dishonors them in the eyes of those who care least about honor, in our own eyes. For isn't it the height of madness to admit that one has a fixed and insurmountable passion for the clitoris, for an instrument whose usage only very rarely produces ejaculation? Isn't it insulting nature? Wouldn't it be a thousand times better to make use of a good thick prick, at the risk of catching the worst case of pox, even at the risk of seeing one's waist spoiled? And the tribades dare to call us a vile brood! But doesn't this stigmatizing epithet fit them better than it does us? I ask it of all connoisseurs of fuckery.

We have no more self-love than is necessary, but, objectively speaking, we dare to flatter ourselves that, in the eyes of the public, we are less degraded, less contemptible than they. The reason for it is simple and understandable to all. We fuck, we jerk it off, we must admit that sometimes we even perform oral sex. But it's to make a living, and what does it matter, after all, how one makes it? Some earn their subsistence by the sweat of their brows; we live off the sweat of our asses. Besides, while satisfying the most pressing need of every living creature, we fulfill the design of nature, which didn't give us cunts to accommodate mice.[95] And if we don't often have the pleasure of having children, we have the pleasure of coming, which isn't the least lively of all pleasures. But the anandrines, who call us wicked hussies, can they cite in their favor grounds as plausible as these I've just set forth? I defy them to do so. They agree that they're outside of need and that their coitus can't fulfill the design of nature. That's for sure. The pleasure they give themselves must not amount to much. It's then only through a misunderstood affectation, it's only through an excess of libertinage that they fuckify each other. And

for that very reason, they're more despicable, more contemptible than the handjobbers of the place Louis XV. Mademoiselle Raucourt, in order to back up her clitorial system or maybe to show off an erudition that we don't give a damn about, any more than Tarquin's balls, cites us in a bombastic tone the example of the Amazons, the Roman ladies, the women of Canada.[96] Oh, this time Raucourt's fucking with us or else she's lost her wits. When I see a woman fuck around in a pedantic tone, it feels like my cunt hairs are being pulled out one by one, and I'd gladly fuck her butt with my foot. But has Raucourt traveled among the Amazons that she tells us about their manners with such certainty? Without a doubt, no. She saw this nonsense in some old books that she might as well have used to wipe her ass. We don't have any more faith in what she says about the Roman ladies. Since she's never stuck her fucking nose into their gatherings, since those who held them have fucked off for the other world, it's impossible for her to know what happened there. She'll have to excuse our disbelief on this score. As for the women of Canada, it's another galbanum [gum resin with a disagreeable smell] that she fucks in our face. We've never read anything but *Dom Bugger,* but we'd gladly wager hard liquor that there's no author foolish enough to have written that rubbish. And just supposing that some easy-stiffer ventured to write it, he'd be pretty bamboozled if we asked him to prove it. What fucks us off the most in everything that Mademoiselle Raucourt says is that she offers to cite more recent authorities and satisfies herself with putting down a row of periods [ellipsis]. Now if it were a row of balls, it would please our eyes. But periods! Oh, such comical authorities! It's true that she pretends not to dare to explain herself. She dares not touch the Holy Ark for fear of becoming paralyzed. Who would've ever thought Mademoiselle Raucourt, who has touched and jerked off so many cocks, who has accommodated them so often in her cunt without worrying about catching the pox, would become so pusillanimous? Who would've been able to persuade herself that the woman who touches, who handjobs, who licks Mademoiselle Lange's cunt, would push scrupulousness to the point of not daring to touch what she calls the Holy Ark? Isn't it fucking people right under their noses to make them swallow such bitterly coated pills? Apparently Mademoiselle Raucourt takes us for what we aren't, for some female nuts. She has forgotten that we're whores, and that, as such, when it comes to fuckery, we know as much about it as she does.

The president of the tribades finds it extraordinary that Mademoiselle Adeline doesn't take the sodomists' side. Raucourt even defied her to cast a stone at them because, she says, there isn't one among them who hasn't let herself be butt-fucked. Mademoiselle Raucourt undoubtedly judges by her own case, and it's easy to believe that a woman who's now a tribade used to be a street-walker, and I mean a street-walker in every sense of the word. But can she, without effrontery, judge others by her own example? She offers as proof of it the little distance that separates the two holes. If that's a compelling reason, we must draw the conclusion that three-quarters of women have been bardashized, for in most of them not only is the distance little, but the cunt and ass are connected and are so merged that they present but one vast abyss. Moreover, because a king died of the pox, it doesn't follow that those who've caught it since should be proud of it or more excusable on that account.[97]

Following Mademoiselle Raucourt's good or bad justifications, the anandrines, fearing for their sect, informed us of their intention to intervene against us in the case of the buggers and bardashes in order to forestall the fine steps that we're preparing to take against them. So what, we don't give a damn about it, and we inform them that a few more enemies will only double our courage. They intend to prosecute us before all the

courts of fuckery until complete withdrawal on our part. If they don't come until then, the fuck will squirt out of their eyes. Neither their wealth nor their threats will be able to fuck fear into our bowels. As long as we have hair on our asses, as long as men get hard, as long as our hands know how to jerk off pricks, we'll remain immune to fear. There's nothing but misery and Bicêtre that can frighten us. As they expected the most unyielding resistance, we're women, we're whores and consequently stubborn. We've nothing, or almost nothing, to lose, but if we had to sell the very last hair on our asses, if we had to fuck for twelve sous, we'll make them become whores again, even if it makes them croak from spite.

Signed, viscountess Split-Cunt and Geneviève Suck-Ball, secretary, on the original.
Collated with its original in order to be used at trial. Signed, Suck-Ball, secretary.

Writ to be served

In the year 1790, second year of the regeneration of France and the despair of aristocracy, we, the barfly bailiff, former secretary of Gourdan's brothel, honorary bawd for the clergy, passed and registered in the Palais-Royal, along the boulevards, at the carrefour de Buci, on the rue du Pélican, in the place Louis XV, and on all the street corners of Paris where the fucking trade takes place, living there, signed below at the request of viscountess Split-Cunt, known as the Bacchante, grand mistress of fuckery and permanent president of the female fuckers, bawds, handjobbers, etc. We went to the home of Mademoiselle Raucourt, where being, we found her wench sweeping the stairs and masturbating herself in time, and having asked her for her mistress's rooms, she told us that she couldn't be disturbed, since she was busy getting tongued by Mademoiselle Lange. We therefore fucked the wench and took advantage of her rightly and properly on the stairs and standing up, at the risk of getting gout from it, after which we served her with the attached reply by this writ, and of everything we gave her a copy, of which this is the record, in Paris. Signed, Scratch-Balls, bailiff.

She answered that she didn't give a damn about the reply and the writ but that she was very pleased with the bailiff who had fucked her galore.

Signed, Fellatrix, wench.

7. Private, Libertine, and Scandalous Life of Marie-Antoinette (1793)[98]

There are deeds over which the monsters who are blamed for them would pass a sponge thoroughly soaked with repentance in vain. The indignation they've inspired causes everlasting remembrance of them, and the most insensitive eye wouldn't get its fill of seeing those plagues of society expiate their crimes in the horrors of the cruelest tortures.

Such are the deeds that mark the life of my heroine. All the wickedness of which history has preserved the catalogue for us, the lechery of the Messalinas, added to the cruelty of the Frédégondes, all the fictitious shrewdness with which our novelists have

supplied their enchantresses, are combined in Marie-Antoinette of Austria with a degree of atrociousness and subtlety unknown on earth until her association with the heir to the throne. . . .[99]

At age ten, Marie-Antoinette played around with her sisters, whom she was the first to teach about the artificial means that compensate in part for genuine pleasure. . . .

[After her marriage to his brother,] the count d'Artois, combining plenty of spirit with an attractive face, was the one upon whom Antoinette fixed her gaze.

The reputation he had gained in relations with women gave his sister-in-law the idea of attaching him to her. She wanted to get pregnant at any cost. The Queen of Hungary, at the time of her departure [for France], had specifically advised her to leave no stone unturned to that end.[100] Louis XVI was impotent, and despite all the methods she employed, she couldn't succeed in arousing him. However, before choosing herself a babymaker, she sent a courier to Vienna entrusted with a request for advice on that score. Here's the response of the oracle; it's word-for-word.

"Since you have a taste for women, you must be satisfied. But act with constancy, moderation, and discretion. The first of these virtues preserves reputation and the others health, since nothing weakens and wears one out so quickly as this practice. Your husband never can or will give you children. The problem is, without doubt, serious. A barren queen lacks respect as well as support, but this problem isn't beyond remedy. You must do like me and take someone to do it with. . . . The whole world has known about my philandering and its consequences. People might not know about yours if you cover it up carefully with your passion for your sex, but I'll tell you again, my daughter, watch yourself."

The advice matched her feelings too well not to be followed. Experience will prove that she carried her submission to the decree of the court of Vienna to the extreme. . . .

The duchess de Pecquigny was the first honored with the trust and intimacy of Marie-Antoinette.[101] She entertained for a long time with her bons mots and her wit, especially with her continual jokes at the expense of la DuBarry, who was the bête noire of the whole family, but this caustic spirit and her taste for sarcasm made her feared and made her enemies. They used what made her loved to ruin her. She was dismissed from court.

The late duke de Vauguyon, that chief enemy of the duke de Choiseul, against whom he waged open warfare, was seeking to support his faction, which was already tottering.[102] He thought that if he could place the duchess de Saint-Maigrin, his daughter-in-law, in the dauphine's bed, she could be of use in his plans against his enemy and obtain the position of lady of the bedchamber. This duchess, one of the fairest and nicest women of the court, was quite worthy of filling the position of favorite. She obtained it easily and was very pleasing in amorous diversions, but her reign didn't last long. Her limited talent in courtly politics led her to treat countess DuBarry considerably without, however, visiting her. But she didn't tear her apart in private and make faces at her in public. She wanted what is called to run with the hare and hunt with the hounds [have it both ways]. This displeased supremely, and it didn't take long for this new lover to be repudiated.

The duchess de Cossé succeeded Madame de Saint-Maigrin.[103] She was named first lady of the bedchamber at the request of her mistress, who spoke to the king about it, shutting out Madame de Saint-Maigrin in particular. This third [favorite] would have enjoyed the most extensive and enduring favor if her serious, philosophical, and reasonable character had been able to sympathize a bit more with the Dauphine's frivolity and taste for vicious pleasures. The same year saw this intimacy begin and end. Until the

death of Louis XV, this taste for women had as yet given Marie-Antoinette only a glimpse of that she should have had, more naturally, for men. . . .

[When the count de Dillon, with whom she was sexually involved, left the court,] the princess de Guémenée dried the queen's tears, and a couple harlots consoled him.[104]

Marie's unequivocal passion for the spirited and lustful Guémenée made the most expert speculators predict that her conquest [of the queen] was secure for a long time. There were continual tête-à-têtes. The sessions lasted for more than two hours.

Antoinette's eyes sparkled with the most passionate fire. The two women gave each other the lewdest caresses in public. In the end this affair gave way to another. Dillon returned, and Madame de Guémenée was dismissed. . . .

When people realized that the craze for women didn't exempt the queen from relations with men, the ci-devant [before the Revolution] noblemen intrigued to be of service. . . .

Back at Versailles [after the king's coronation at Rheims], Marie took into consideration the desperate situation of la Montansier, theater director in that city.[105] She was on the verge of declaring fraudulent bankruptcy, but as her tastes were the same as the queen's, the latter paid off her debts and maintained in her office a woman whose profligacy should have led her to the hospital-general.

Marie took a fancy to Montansier's theater. They performed obscene comedy there. . . .

In spite of Antoinette's genuine relations with men, she didn't put an end to her liaisons with women. The former had become a necessity, and the latter an accessory that undoubtedly only served to make the main one more lively. The princess de Lamballe replaced Madame de Guémenée. . . .[106]

In short, as long as the summer [of 1779] lasted, these nocturnal revels [in the gardens at Versailles] lasted. It is shocking how often the queen sought and found affairs. Men and women, she tried everything. . . .

The duke de Coigny [with whom she was sexually involved] was dismissed from court, and our queen, right after the affair in the grove [in the gardens], returned to her natural inclination for women.[107]

Madame the princess de Lamballe gave way to Madame de Polignac, called countess Jules. This fine passion was equaled only by the attachment and the foolishness of Louis XV for Madame de Pompadour.[108] Like the latter, countess Jules cost the state vast sums. Madame de Pompadour had lovers, Madame Jules lived openly with Monsieur de Vaudreuil, and what's funny about it is that he was on just as good terms with the queen and king as with countess Jules.[109]

Madame de Pompadour excused and even procured fleeting pleasures for her august lover. Madame Jules likewise excused and procured the same for Antoinette. Madame de Pompadour sold positions, benefices, offices, bishoprics, etc. She had offices, a price list, and a head clerk for this purpose. Everyone knew her Colin.

Madame Jules sold bishoprics, benefices, positions, offices, etc., in the same way. . . .

The queen took as her minister, in matters of gee-gaws, la Bertin, seller of female clothes, who is related neither to Bertin the former minister nor to Bertin-*casuel,* but worth about as much as they are.[110]

The queen worked with her just as the king worked with his ministers. Another female minister was Guimard of the Opera, in matters of veils and dresses. . . .[111]

Madame Jules had recovered from childbirth. The visits of the queen had been con-
tinual. The comings and goings that this event occasioned had caused a lot of talk. The
Parisian, accustomed to respecting the propriety of majesty and the radiance that should
surround his masters, couldn't see without indignation the misuse that this favorite made
of influence gained so ignobly as well as the way that the queen defiled herself. People
couldn't learn without grumbling about the profusion with which favors had been poured
out, with which the favorite, her whole family, and those around her were loaded with
gifts and money, at a time when warfare and the limited solvency of the state made money
so scarce and fiscal measures so onerous to the people.

At this time the ascendancy of Madame Jules over Antoinette was such that after
this childbirth, some indispositions having given her cause to fear going out too soon, a
private suite of rooms was created for her to which only those men and women who were
intended to constitute her circle were admitted. The king himself was only admitted when
he was needed.

It was at these gatherings that the most important issues of the ministry were dis-
cussed. Peace, war, policy, finances, the dismissal of ministers, the degree of favor and
influence they should be granted, they dealt with and passed final judgment on every-
thing there. . . .

The queen's pregnancy progressed. . . .

The joy produced by this pregnancy was disturbed by an indisposition, whose effects
were felt by the queen. It consisted of a sinking or loosening of the womb, the result of
her continual debauchery and the excesses to which she surrendered herself with the trib-
ades, her favorites. . . .

As her passion for women was immoderate, the moments of rest that her brother-in-
law gave her were ordinarily used, by Louis's sensual companion, for revolting acts of
lewdness that she took pleasure in relishing with her own sex.

One of the queen's servants, Mademoiselle Dorvat, had managed to gain her confi-
dence. Her attractive physiognomy had attracted the queen's attention and excited her
desires, and once her desires had fermented in her breast, nothing could prevent her from
satisfying them. . . .

The count d'Artois wasn't jealous, of course. He didn't love enough to be the vic-
tim of that odious passion. He couldn't seem to be jealous, either, out of self-esteem.
However, Antoinette's clandestine walks and her trips to the Trianon induced him to quar-
rel with his sister one day about what he called infidelity on her part.[112] The queen didn't
know the great art of blushing. Consequently, it was with the impudence that was natu-
ral to her that she acknowledged to him her special taste for women, especially for la
Dorvat, and that she urged him not to be alarmed about it. This frankness on Antoinette's
part did not displease Charles Philippe. Everything works out well enough between
unscrupulous people. He only seemed skeptical about the variety and multiplicity of her
exertions and asked her how she was up to them.

"I'm surely going to surprise you, my dear brother," she said, "by letting you in on
all the secrets of my constitution. But can I hide anything from you? Its strength is so
violent that, leaving your arms—from which I withdraw only when you, exhausted, can
no longer surrender yourself to further ecstasy—I crave further delights. However, at
these moments, my state should naturally resemble yours. Far from it, I burn to con-
summate the pleasure that you only began to make me feel. So I run to my dear Dorvat.
Having been instrumented, I instrument in turn. In short, I set the obliging Dorvat to

work. Repeating the most pleasurable of exercises, she multiplies my pleasures endlessly. Don't be surprised, then, if I substitute this charming accomplice for you, and don't be angry with me about it. Besides, I can't do without it." "You surprise me, my dear sister," replied the count, "but you don't convince me. Excuse my frankness, but I'm so far from believing you that I wager a thousand louis that it is impossible for you to be able to surrender yourself to these different degrees of pleasure!" "A thousand louis?" "A thousand louis!" "Oh, you don't believe me! Alright, I accept the bet, without putting the event off until tomorrow."

The horses were ordered at once, and an elegant carriage carried the happy couple to the Trianon.

Shut up together in the most delightful of boudoirs, Artois lay Marie-Antoinette down on a sofa. A thousand louis and the distinction of getting the better of her helped him find new strength. He attacked her with great vigor, but his ability yielding to his desire, and he lost half of the bet. "I surrender," he tells her, while extricating himself from the royal arms that embraced him, "but I'm not completely defeated." "Oh, I agree," replied the queen, "but I'm going to complete my victory."

She rang the bell right away. Dorvat, forewarned and on the lookout, came running. Antoinette embraced her with that intimacy that reveals complicity. The presence of Artois didn't prevent this modern Messalina from abandoning herself to lustful ecstasy. Dorvat blushed a bit at first, but without paying any attention to her embarrassment, Marie-Antoinette continued her hot caresses. Excited by the teasing of the royal finger, this young rowdy ignored the standards of propriety and was soon sharing her mistress's rapture. Their mutual transport made the count realize how dangerous it was to challenge a lascivious woman. "My thousand louis are lost," he cried, "but I'll have my revenge on the authors of my loss!" From that moment he took a slight fancy to Dorvat, and gossip warrants that he tried her out. . . .

[Tired of Artois,] she hardly knew whom to run her eyes over when countess Valois de la Motte was introduced to her by la Misère, her head chambermaid.[113] This unfortunate countess came to court to solicit recovery of the estate of Fontête, which her illustrious ancestors had owned.

Antoinette supported her petition, governed, allegedly, by a principle of equity, but the fact of the matter is that the countess de la Motte having pleased her, and intending her for her pleasure, she wanted to be entitled to her gratitude and to have la Motte indebted to her alone for her fortune. As a result she didn't make use of the power she had over Calonne to increase the modest pension that this countess enjoyed from the court and which this rake had made to cost the state only the sum of 700 livres, added to that of 800 that she already received for bearing the name Valois in a worthy manner, the queen hoping that this small amount would inevitably lead the petitioner from the audience chamber to her bed.[114]

Cardinal de Rohan, now known by the title of Cardinal Necklace, hadn't abandoned his lustful plans. On the lookout for all the queen's movements, he intercepted her glances. He was one of the first to notice the effect that the countess de la Motte's charms had made on her, and after making this observation, taking hold of this countess, he trained her and instructed her to go along with her sovereign's designs.

Their second interview took place at the Petit Trianon, between eleven o'clock and midnight. Countess de la Motte was presented by la Dorvat, who contented herself with the office of agent in these libidinous scenes, after having played a leading role in them herself. After the exposition of the queen's character, one can be sure about their delights.

Louis XVI's wife dismissed countess de la Motte after this lewd session, assuring her of her favor and bestowing the sum of ten thousand livres in treasury bills upon her. . . .

[Intent on poisoning Vergennes, like Maurepas,] she induced the detestable monster Polignac to get involved in this new crime.[115] At first she lamented, in an obliging way, that insignificant tiffs still lasted. She recalled the time when, lying languidly in each other's arms and sunk in the sweetest rapture, they exchanged the most passionate promises to adore each other forever. A few phony tears streamed from her eyes. The androgene seemed touched by them, fell on her neck, and, after a minimal explanation, peace was concluded.

Antoinette laid the blame for the troubles that had divided them at the door of him whom she wished to destroy. Nothing more was necessary to make the duchess angry. . . . The reconciliation between these two women provided matter for slander. Antoinette was soon regarded in the courtiers' minds as the most determined tribade, but she laughed at these gibes. . . . Jules de Polignac became the favorite of Antoinette and the soul of all her pleasures, putting to good use all the time that Louis XVI left them. She punished him for his indolence through the most abominable relations, without even taking pains to hide them. Sometimes the count d'Artois joined in all their libertine orgies. . . .

B. DECRIMINALIZATION

1. ANACHARSIS CLOOTS (1755–94), *German nobleman awarded French citizenship and elected to the National Convention, journalist, Jacobin, executed with the Hébertists*

The Orator of Humankind (1791)[116]

What is virtue? What is vice? Define these two words, and you will see that good citizenship is the first among virtues. Everything that is useful to society is a virtue; everything that is harmful to it is a vice. This clear definition simplifies a multitude of questions and dispels a multitude of prejudices. It teaches how to distinguish universal virtues from particularistic virtues. It teaches us that newly born societies and fully grown societies have different virtues and vices. Laws and ideas about population, for example, could not be the same in a sparsely populated nation and in a nation afflicted with too many people. Animals that eat acorns in a nursery are killed, but those that eat acorns in an old forest are left to graze. Discussion in this matter will thus be reduced to terms of good or bad taste. Gourmets will prefer pure wheat to feeding on acorns. They will draw delicious milk from a heifer while letting the Bulgarians quench their thirst with the milk of their steeds. The laws of the Chinese in favor of infanticide, those of Minos and the counsels of Plato in favor of pederasty, and those of the popes in favor of celibacy should

be placed in the same category. They will be judged by different nations only according to the different measure of their respective populations. Every other standard is so imaginary that you hear the crime of Onan [masturbation] justified by the very people who censure the customs of the Greeks. As if onanism did not include all the modifications of matter that destroy the seeds of reproduction? Minds are not mature enough to say more about it. My hand is full of truths that I will let out sooner or later, because every truth is worth telling. And I renounce all positions, ranks, elections, in order to preserve the independence of my pen and not make compromises with error, in the hope of winning the approval of good citizens who are bad philosophers. Nothing is foreign to legislation. It will be necessary to examine all the blunders of promiscuity, and I doubt that any real crimes will be found with the exception of rape, abduction, seduction, and adultery. It is proper to mitigate the severity of lawgivers by reminding them that friendship, in its youth, has its kisses, tears, and effusions, as love does. It is proper to keep their leniency far away from those traitors who insinuate themselves into a loving household in order to break the bonds of marriage, to violate my property, to poison my existence, by taking away half of myself, the life from my life, by breaking the spell that binds me both to a dear wife and to children who are born from our substance, from our tenderness, from our mutual strength. It is proper to correct the judgment of a frivolous public, which is misled about the real stigma and which covers my face with disgrace, while nocturnal thieves become the heroes of the day.*

*Prejudices and mistaken opinions give weapons to the wicked, to bad citizens, against good citizens who listen to reason above all else. Has a man made himself famous through his talent or his patriotism? People look for faults in him, and the fewer he has, the more they will attribute to him. Did he hesitate for a moment in choosing between the statue of Diana and that of Endymion?[117] Did he say candidly that the young Adonis pleased him more than the old Urgèle?[118] Has he remarked philosophically that nothing is antiphysical in the physical world? Has he lamented at seeing hospitals overloaded with moribund children poisoned from the beginning of life by their parents' debauchery? Has he proved that Ganymedes and Sapphos did less harm to humanity than the nymphs [prostitutes] of the Palais-Royal? He is condemned briskly, without even noticing that this thinker gives the apple to Venus, the secondary schoolgirl to Condorcet.[119] And those who show themselves to be the most unrelenting are old men of thirty years, whose withered souls and bent, ulcerated, or asthmatic bodies proclaim all kinds of turpitude. The ethics of knaves consist in taking advantage of the biases of respectable people. It is therefore important to reason correctly. So, Achilles loved Patroclus, Orestes loved Pylades, Aristogiton loved Harmodius, Socrates loved Alcibiades, etc.[120] Were they less useful to their country for that reason? The charms of Briseis would have made the siege of Troy fail, if not for the charms of Patroclus.[121] And the Athenians would have languished for a longer time under the tyranny of the sons of Peisistratus, if not for the intimate union of the two virtuous lovers who were declared the liberators of the country. People talk a great deal about nature without knowing it; they determine its boundaries by chance. People do not know, or pretend not to know, that it is impossible to thwart it. People are surprised about the corruption of the gymnasiums, as if electrical bodies dressed in excitable tassels could move together without experiencing frequent explosions. I would just as soon call tickling and itching crimes against nature. There is nothing unfortunate about all these rubbings, throughout this whole mechanism, except the exhaustion and collapse of the machine. They believed they could stop this overexcitement of the blood through the commandments of God or the church, but an unwarranted prohibition nourishes the pursuit of pleasure. It is the immortal Tissot who must be invoked.[122] It is his *Onanism* that should be the first classic book of national education. Solon's laws could defend the gymnasiums from outside seduction, but the source of the problem exists within each individual, and no gymnasium is exempt from it, because nature is universal.[123] I was raised by priests in Brussels, Jesuits in Mons, ecclesiastics in Paris, soldiers in Berlin, and I found Lesbos everywhere. But thanks to Monsieur Tissot, I saved myself from the general conflagration. This Swiss doctor terrified me. I wanted to be tall and strong. I wanted

to succeed in horsemanship, in dancing, and in handling weapons. I passionately loved studying and exercising my memory. Now, the threats of Monsieur Tissot made an unforgettable impression on me, and I defy anyone to outdo me in saving up the essential liquid. I imitate the misers who delay their expenditure until the next day, and this anticipated next day has deceived my concupiscence for years. In the end, the Revolution takes up all my spare time, and we need all of our vital spirits for such a fine cause.

2. Case of Remy and Mallerange (1794)[124]

a. Copy of the Report Drawn Up by the Commissioner of the Revolutionary Committee of the Section of the Mountain[125]

I, Sarlat, commissioner of the Revolutionary Committee of the Section of the Mountain, being yesterday, 15 pluviôse, year II of the Republic [3 February 1794], one and indivisible, at 7 P.M., for the sake of public safety at the head of the armed force commanded by citizen Demoët, commander of the batallion of said Section; and being in the Champs-Elysées, we saw two individuals together and sent a citizen named Auzet to investigate. When he approached, one of them, in a jacket, ran away, and although he was told to stop in the name of the law, he tried to flee and for that reason ran as fast as he could. But citizen Auzet, having taken after him, arrested him and brought him into the midst of the armed force. During this time, the other citizen was arrested and found with his pants unbuttoned, his shirt untucked. And when we asked him why he was unbuttoned and what he was doing with the other individual, he said that he was fooling around with said individual in a jacket and that they were handling each other. And we deposed them during our expedition to the Revolutionary Committee of the Section of the Champs-Elysées and took them back from said Committee to bring them to our Revolutionary Committee, Section of the Mountain. . . . 16 pluviôse, year II of the Republic, one and indivisible, at 9 A.M. Signed Sarlat, commissioner; Demoët, commander in chief; and citizen Auzet.

b. Copy of the Interrogations by the Revolutionary Committee of the Section of the Mountain

On 16 pluviôse [4 February], year II of the Republic, one and indivisible, a citizen was brought before our committee, and we asked his last name, first name, occupation, and place of residence.

Answered that he is named Etienne Remy, aged 22 years, living on the rue Grenier Saint-Lazare, enlisted in the army of the Vendée, came to Paris with a medical leave to stay with his parents to get well.[126]

Asked him how long he has been in Paris.

Answered about three months.

Asked him how long he has been well.

Answered about three weeks.

Asked him why he didn't try to go back.

Answered that he wanted to leave, despite the entreaties of his parents, who were opposed to his departure.

Asked him where he was coming from yesterday about 7 P.M., when he was arrested in the Champs-Elysées.

Answered that he was coming from the Convention, and that he came to take a walk.[127]

Asked him if he came with the intention of fooling around.

Answered that he didn't come with that intention, but that he met a man in a jacket there, with whom he was fooling around at the moment when the patrol went by.

Asked him if it was he who put it into the man, or if it was put into him.

Answered no.

Pointed out to him that when he was arrested, his pants were found unbuttoned, his shirt completely untucked.

Answered that this is true, and that it was the old man who was touching him.

Asked him if he didn't admit to the commander yesterday that he was involved in fooling around with the individual.

Answered yes.

Asked him if it was put into him.

Answered never and that he never put it into anyone and that he only just fools around.

Pointed out to him that the individual who was with him was in the middle of putting it into him.

Answered that this isn't the case.

Asked him about the people he knows.

Answered that he doesn't know anybody.

Pointed out to him that he isn't telling the truth and that people will attest that he knows several individuals.

Asked him if he knows a man named Ravier.

Answered that he doesn't know anybody else.

After the reading of the report, he signed. Signed Remy.

Then we turned to the interrogation of the other citizen and asked him his last name, first name, occupation, and place of residence.

Answered that he is named Jean Mallerange, aged about 50 years, potmaker by trade, rue des Noyers, Section of the French Pantheon.[128]

Asked him where he was coming from when he was arrested in the Champs-Elysées.

Answered that he was waiting to go to the offices of the Department [of Paris] at 8 P.M.

Asked him what he was doing in the Champs-Elysées.

Answered that he was wasting time until 8 P.M.

Asked him what he was doing with the young man he was with.

Answered that he met the young man in the place de la Révolution and that it was he who spoke to him first.

Asked him what they did together.

Answered that they talked about the Vendée and that he was saying good-bye to him when he was arrested.

Pointed out to him that he isn't telling the truth.

Answered that he is.

Asked him if he unbuttoned the young man's pants.

Answered no.

Pointed out to him that the young man arrested along with him stated that he unbuttoned his pants.

Answered that he is wrong and that it is false.

Pointed out to him that if one has nothing to fear, [one doesn't run away].

Answered that he wasn't running away.

Pointed out to him that a commissioner, a batallion commander, and several citizens will attest that he was running away and that he was fooling around with the young man.

Answered no.

Pointed out to him that he is lying.

Answered no.

After the reading of the report, the citizen, asked to sign, said that he doesn't know how to sign his name and stated that said interrogation is truthful and afterwards said that he can sign his name. Signed Mallerange.

c. Copy of the Decisions Issued by the Court of Correctional Police

On the eighth day of the third week of pluviôse [16 February], year II of the French Republic, one and indivisible, and on the following 28 ventôse [18 March].

Enters the national agent, complainant according to the terms of the report of 15 and 16 pluviôse, drawn up by the Revolutionary Committee of the Section of the Mountain, in the margin of which is the order of referral to the Court issued by citizen Signet, administrator of police and plaintiff for the issuance of the summons of the twenty-second of the same month, duly registered the same day and executed by citizen Carrel, bailiff of the Court;

And Etienne Robert Remy, aged 22 years, living on the rue Grenier Saint-Lazare, enlisted in the army of the Vendée, and Jean Mallerange, aged about 50 years, potmaker, living on the rue des Noyers, Section of the French Pantheon, accused and defendants present at the bar of the court, for this reason removed from the prison known as Bicêtre, where they had been taken by virtue of the abovementioned order of the administration of police.

In this case it was a matter of finding out if the accused were guilty of the crime against nature.

After citizen Antoine Edme Nazaire Jacquotot, national agent, read the indictment and requested that it please the court, given that he had some information to collect, to postpone the case until the day it would like to specify.

The Court, acceding to the national agent's request, granted a continuance until the next possible day and ordered that the accused be remanded to the prison of Bicêtre.

And, on 28 ventôse, enters the national agent, complainant and plaintiff as above, and still plaintiff for the issuance of the summons of the twenty-seventh of the present month, duly registered the following day, and executed by citizen Dupuis, bailiff of the Court;

And said Remy and Mallerange, accused and defendants present at the bar of the court, for this reason removed from the prison of Bicêtre, where they had been remanded by virtue of a decision.

After citizen Antoine Edme Nazaire Jacquotot, national agent, read the indictment again and requested that it please the court to hear the witnesses that he had summoned to testify in the case, along with what the accused had to say in their defense and in answer to the questions that the court would consider it necessary to ask them, the Court proceeded to said hearing of the witnesses in the following manner.

1. Louis Sarlat, aged 32 years, member of the Revolutionary Committee of the Section of the Mountain, plaintiff.

2. Denis Desnos, aged 39 years, native of Auxerre, faience [earthenware] merchant, rue Neuve des Petits-Champs, number 726.

3. Hilaire Haulmain, aged 33 years, native of Choiseul, cafe-keeper, rue Neuve des Petits-Champs.

4. Joseph Dupuis, aged 40 years, native of Paris, employed by the *Messageries* [official service for delivering letters and packages], living on the rue Neuve des Petits-Champs, number 1282.

5. Louis Milliane, aged 43 years, native of Chambéry, sales clerk, living on the rue des Bons-Enfants, number 30.

6 Laurent Antoine Pougy, aged 50 years, bill-sticker and doorkeeper, passage de Valois, number 1886.

7. Pierre Mottet, aged 28 years, native of Grenoble, skin-dresser, living on the passage de Valois, number 1087.

8. Pierre Lambert Bouquet, aged 26 years, native of Haudricourt, office boy at the Treasury, living on the rue des Moulins, number 505.

9. Daniel Peaux, aged 40 years, native of Morges, saddler, living on the rue Neuve des Petits-Champs, number 722.

10. Louis Gaugeon, aged 35 years, native of Paris, tailor, Equality House [located in the former Palais-Royal], number 151.

11. Noël Bonnet, aged 34 years, native of Beaulieu, clockmaker, Equality House, number 225.

12. Jean Roche, aged 30 years, native of Lyons, hosier, living on the rue des Bons-Enfants.

13. And Jean Ogé, aged 33 years, native of Aix, bootmaker, passage de Beaujolais.

All of which witnesses, after having each separately taken the oath to tell the truth, in accordance with the provisions of the law, also each separately stated that they weren't blood relatives, relatives by marriage, servants, or domestics of the parties under investigation.

And after the accused, asked at once if they had any objections to said witnesses, said they had none to make against them.

Were heard the statements of the plaintiff, the testimony of the witnesses, and what the accused had to say in answer to the questions that were posed to them and in their defense. The report was read, and the conclusions of the national agent, fixed in writing, were heard, by which he requested that, whereas it was established as much by the report as by the preliminary examination at the hearing, the accused be declared guilty of hav-

ing attacked good morals by indecent and unnatural actions, in consequence of which, in conformity with the provisions of articles 8, 9, and 10 of title 2 of the law of 22 July 1791, they each be sentenced to be detained for a year in the house of correction, to be employed there in work that will be assigned to them by the Department, and to a fine of 200 livres to be paid according to the terms of the law and jointly by them.[129]

The Court, after each of its members had given his opinion out loud, whereas it is established by the report that on 16 pluviôse Remy and Mallerange were encountered by the members of a patrol who were together in the Champs-Elysées, Remy having his pants down and his shirt untucked, and established by the testimony of the witnesses that Remy, under arrest, promised to break himself of this fault and asked that no harm be done to him,

Declares Mallerange guilty of having publicly attacked good morals by indulging in indecent and unnatural actions encouraging debauchery and corrupting the young Remy, and declares said Remy guilty of having encouraged the debauchery of Mallerange, consequently, according to the terms of articles 8, 9, and 10 of title 2 of the law of 22 July 1791, which were read and which are expressed in these words:

Article 8. "Those who are accused of having publicly attacked morality, by offense against the modesty of women, by indecent actions, by display or sale of obscene images, by having encouraged debauchery or corrupted youths of either sex, may be seized immediately and taken before the judge of the peace, who is authorized to have them detained until the next hearing of the correctional police."

Article 9. "If the offense is proved, the guilty parties will be sentenced, according to the gravity of the deeds, to a fine of between 50 and 500 [livres] and to a term of imprisonment that may not exceed 6 months. If it is a matter of obscene images, the prints and engravings will also be confiscated and destroyed. As for people who encouraged debauchery or corrupted youths of either sex, they will also, in addition to the fine, be sentenced to a year in prison."

Article 10. "The penalties stated in the preceding article will be doubled in the case of recidivism."

The Court sentences said Mallerange and Remy to be detained, each of them, for a year in the house of correction, to be employed there in work that will be assigned to them by the Department, and, each of them, to a fine of 200 livres to be paid according to the terms of the law and jointly by them, and forbids them to commit the offense again, under threat of the penalties stated by the law.

Done and decided in the public hearing of the Court of Correctional Police, in which sat citizens Baron, president; Jabel, Lacoste, Thiolliers, Thilly, Bruzelin, and LeBrun, judges, on 28 ventôse, year II of the French Republic, one and indivisible.

Announces and orders, etc.

D. COPY OF THE NOTES FILED IN THE OFFICE OF THE CLERK OF THE COURT OF APPEALS OF THE POLICE OF THE DEPARTMENT OF PARIS

1. Sieur Sarlat, 32, member of the Revolutionary Committee of the Section of the Mountain. At the head of the armed force in the Champs-Elysées. The accused are arrested. Remy says that he was partial to Mallerange, who handled his ass. Looks at him. Had his pants undone and his shirt untucked.

2. Denys Desnos, 39, from Auxerre, faience merchant. In the armed force in the Champs-Elysées. Arrests Remy at 7 or 8 P.M., lending his ass to Mallerange, who had made him propositions that he had accepted. Remy's pants and shirt were down. Remy promises to break himself of this fault and asks that no penalty be imposed on him.

3. Hilaire Houlmain, 33, Choiseul, cafe-keeper, rue Neuve des Petits-Champs. Escorts the two individuals brought to him into the ranks.

4. Joseph Dupuis, 40, employed by the *Messageries*. Saw the two individuals in the ranks. Thinks he saw white [makeup] on Remy.

5. François Milliane, 43, Chambéry, sales clerk, rue des Bons-Enfants. The two individuals are placed in the ranks in order to take them to the guardpost.

6. Laurent Antoine Pougy, bill-sticker and doorkeeper, passage de Valois. The two individuals are placed in the ranks. Said that they were playing. Saw nothing.

7. Pierre Mottet, 28, Grenoble, skin-dresser, passage de Valois, number 1087. On watch. The individuals are placed in the ranks. He is told that the individuals were [men] of the cuff.

8. Pierre Lambert Bouquet, 26, Haudricourt, office boy at the Treasury. The individuals are placed in the ranks. He is told that they had been arrested in an indecent posture.

9. David Peaux, 40, Morges, saddler, rue Neuve des Petits-Champs. Same deposition as Bouquet (eighth witness).

10. Sieur Gaugeon, 35, Paris, tailor, Equality House. At the head of the company. The individuals are brought back. Heard Remy say to the commissioner, what do you expect, citizen, it is a weakness. Saw his shirt.

11. Noël Bonnet, 34, Beaulieu, clockmaker, Equality House. The two individuals are placed in the ranks.

12. Jean Roche, 30, Lyons, hosier, rue des Bons-Enfants. The individuals are placed in the ranks. Hears it said that it is for sodomy. Saw nothing that proved this crime.

13. Sieur Ogé, 33, from Aix, bootmaker, passage de Beaujolais. Being on patrol, one of them comes to see what is going on. The arrested man runs after the old man, who is being arrested. The young one had his pants down. Saw them both straight ahead. They separate themselves. The old one says, I believed that someone told me to run away.

The accused Remy, 22, Paris, was employed on the rue Saint-Martin by Josse, haberdasher. Rue Grenier Saint-Lazare. Father and mother are haberdashers. Left the Convention, went to the place de la Révolution, meets Mallerange there, chats with him, and wanted to part company with him, when he is arrested. Hadn't lowered his pants. It is a falsehood, and his shirt wasn't untucked. Didn't speak of partiality for Mallerange, who didn't allow himself to do anything indecent with him.

The accused Mallerange, 50, Massiac, locksmith, edge-tool maker, rue des Noyers, married, having a wife and children. Is going to the offices of the Department to receive a receipt. He is put off until 7 or 8 o'clock. Waits in the Champs-Elysées, finds Remy there, accosts him and chats while walking around. At the rue de Beauveau leaves him in wishing him good evening. Didn't touch him indecently in any way. Doesn't know if his pants were down or not. Ran away, hearing someone say [illegible word]. Was twenty steps away from Remy, believed that someone wanted to attack him.

Consult articles 8 and 9. Each 200 livres and a year.

J. C.

e. COPY OF THE INTERROGATION OF REMY

On 8 germinal [28 March], year II of the French Republic, one and indivisible.

Public interrogation of Claude Etienne Pierre Remy, detained in the house of correction known as Bicêtre, from which he was brought for this purpose to the bar of the Court of Appeals of the Police of the Department of Paris, in which sat citizens Jussié, president; and Seminé, Gassier, and Cazin, judges.

In the presence of the citizen national commissioner and of Guenot, Remy's official defender, said that his name is Claude Etienne Robert Remy, native of Paris, aged twenty-two years, haberdasher's assistant, living in Paris at the home of his father and mother on the rue Grenier Saint-Lazare, number 17, Section of the Reunion, previously haberdasher's assistant to the man named Josse, shopkeeper on the rue Saint-Martin. Said that he enrolled through the Section of the Rights of Man, that he voluntarily enlisted to fight in the Vendée and returned from there because of illness. That he had received 300 livres for his service. That he had given his papers that he brought back from the army to the commissioner of the Section of the Mountain. That they consisted of a certificate of good conduct and a passport. That he was in the first company, that his captain died, that he doesn't remember his captain's name, and later said that this captain was named Barré. That he served about six months, that he had been at Les Sables-d'Olonne and at La Rochelle. That he stayed for two months at Les Sables-d'Olonne, that after a certain length of time, he became sick with fevers. That there was an engagement there; that, the rebels not wanting to surrender the city, it was necessary to take it by force. That coming back here with his travel permit, it was stamped everywhere. That arriving in Paris, he stayed, sick, at his parents' home. That he had been well for two weeks when he was arrested. That he was arrested the first time he went out. That having gone to the Convention, he went to walk around in the Champs-Elysées, that he met the accused man arrested with him in the place de la Révolution, that they talked together about the war in the Vendée. That he was arrested more than 30 feet away from this man, that he had gone to the bathroom, and that this is why he was found with pants unbuttoned and his shirt untucked, that nothing indecent happened with him.

That he had asked the people who were in the place de la Révolution the names of the women who had been guillotined and that this man answered him. That when he was arrested he had three livres in assignats [Revolutionary paper money] in his pocket, that this money came from his parents. That he informed them of his arrest, and that they came to claim him from the first court.

That he didn't try to exonerate himself to the officer who charged him with a crime because, not having rejoined his unit, he thought himself at fault.

Said that he didn't have an identity card but that the surgeon major of his Section, named Gravelle, promised to cure him. Persists in maintaining that he didn't talk with the accused man about anything except the Vendée and didn't receive any money from him and that he didn't give him any. After the reading he reaffirmed his testimony and signed.

If he signed another statement, he did it without knowing what he was signing, and adds, moreover, that he didn't take flight when they tried to arrest him, that it was then 7 P.M. and that his statement only says that he was fooling around with this citizen, but that he meant to say just chatting.

Said that he hasn't been put in prison and isn't a previous offender.

After the reading he reaffirmed his testimony and signed. Signed Remy.

f. COPY OF THE INTERROGATION OF MALLERANGE

On 8 germinal [8 March], year II of the French Republic, one and indivisible.

Public interrogation of Jean Mallerange, detained in the house of correction known as Bicêtre, from which he was brought for this purpose to the bar of the Court of Appeals of the Police of the Department of Paris, in which sat citizens Jussié, president; and Seminé, Gassier, and Cazin, judges.

In the presence of the citizen national commissioner and of Guenot, Mallerange's official defender, said that his name is Jean Mallerange, native of Massenac, in the Department of the Cantal in the Auvergne, aged 50 years, potmaker, locksmith, tailor, living in Paris, rue des Noyers, number 55. That he is married, that he has children, that his eldest is 23 years old. That he has two children left at home and that he had ten of them, that the other eight are married. And later said that he has only one of them and that the other died, and that he didn't understand the question well because he is hard of hearing. Said that on 6 pluviôse, at 8 P.M., he was in the Champs-Elysées, that he had gone to the offices of the Department around 5 P.M. for a receipt. That the doorkeeper told him that he would have to come back at 8 P.M., that he went to walk around, while waiting, in the place de la Révolution, that he met a young man there who asked him if there had been many guillotined and if there were any from the Vendée. That he, the accused, said that there would be no great harm if there were, because those rebels fed the fire of civil war. That they talked about this war while walking toward the Champs-Elysées. That wishing to leave him there to take the rue de Beauveau, he heard someone shout at him, that he was afraid of being attacked and robbed and started to run away, and that then, having heard someone shout, "in the name of the law," he stopped and retraced his steps in order to obey. That it is false that he had touched him indecently. That he doesn't know if this young man intended to set some trap for him, in making such accusations against him. That maybe he wanted to have himself arrested in order not to go to the Vendée. That he didn't walk around with him, and that he was proceeding with his business when he was arrested. That this young man didn't ask him for any money, that he did indeed speak to him about the illness that he had in the Vendée. Said that he didn't spend more than a quarter of an hour with him. He hasn't been in prison and isn't a previous offender. That he has been in Paris since 1774. After the reading he reaffirmed his testimony and signed.

And that he has never been a servant, that he has lived on the rue des Noyers for seven years, and that he is well known in his Section. That he had his certificate of civism, which the commissioner has kept since his arrest.

That he mounts the guard, that he knows his sergeant major (who is a wigmaker), his judge of the peace, and other members of the committees. Adds that the Civil and Revolutionary Committees of his Section sent a delegation to demand his release on the day of his arrest. After the reading he reaffirmed his testimony and signed. Signed Mallerange.

g. Copy of the Decision Handed Down by the Court of Appeals of the Police of the Department of Paris

Enter Etienne Robert Remy and Jean Mallerange, living in Paris, namely said Remy on the rue Grenier Saint-Lazare, number 17, Section of the Reunion, and said Mallerange, rue des Noyers, number 55, Section of the French Pantheon, appellants against the decision handed down against them in the Court of Correctional Police of the Commune of Paris on 14 ventôse, according to the act of appeal of 1 germinal, detained in the house of correction known as Bicêtre, from which they have been brought for this purpose, and are present at the hearing, attended by Guenet, their counsel;

And the citizen national commissioner summoned.

Heard the answers of said Remy and Mallerange to the interrogation.

Heard the citizen national commissioner's considered conclusions, signed by him and filed with the bench, after he had the trial documents and record read.

Heard the conclusions, signed by them and filed with the bench, and the reasons for and means of appeal of citizen Guenot, counsel for said Remy and Mallerange.

The Court, each of its judges having given his opinion publicly and out loud, in conformity with the law of 26 June of last year (old style);

Receives Etienne Robert Remy and Jean Mallerange, appellants against the decision handed down against them in the Court of Correctional Police on 28 ventôse.

Given that from the question posed in said decision, which is conceived in this way— in this case it was a matter of finding out if the accused were guilty of the crime against nature—and from the reports drawn up by the Revolutionary Committee of the Section of the Mountain on 15 and 16 pluviôse, it seems that said Mallerange and Remy are accused of a crime of which the horror it inspires has prevented mention in all the laws, such that the punishment of this crime and the jurisdiction of the court that should decree it are stated nowhere, unless the offense in question is found naturally classified under articles 7, 8, 9, and 10 of title 2 of the law of 22 July 1791 (old style), which concern offenses against good morals;

Given also that by the law of 14 frimaire of last year [4 December 1793], articles 11 and 15 of section 1, it is expressly forbidden for any constituted authority, for any public functionary, to do anything contrary to the literal sense of the law under the pretext of interpreting it or fleshing it out and to do things that are not within its powers, to encroach upon the jurisdiction of other authorities, to overstep the duties that are assigned to them, and finally to arrogate to itself those that are not entrusted to them;[130]

The Court postponed ruling on said appeal, until it receives the response from the National Convention, which will be consulted through the agency of the Minister of Justice, about jurisdiction and about the penalty to be pronounced for the crime in question.

Consequently orders that copies of the reports, the decision under appeal, and the present decision will be sent by the national commissioner to the Minister of Justice— with an invitation to bring them to the attention of the National Convention, of its Com-

mittee on Legislation, as soon as possible—along with copies of the notes of the testimonies and interrogations conducted at the hearing before the first judges, and charges the national commissioner to ask the Revolutionary Committee of the Section of the Mountain for the documents mentioned by Remy in his interrogation, which he said he had on him at the time of his arrest and left with said Committee, and to this effect orders that said decision will be made known to said Committee, as well as to the Section of the Rights of Man, to have proof of his enlistment. Moreover, grants a continuance in this case until the next possible day, everything remaining as is.

Decided and pronounced on 8 germinal [28 March], year II of the French Republic, one and indivisible.

h. LETTER TO THE COMMITTEE ON LEGISLATION

Paris, 8 floréal [27 April], year II of the French Republic, one and indivisible.

Equality, Fraternity, Liberty, or Death

From the commissioner of civil administrations, police, and courts

To the citizen representatives composing the Committee on Legislation.

On 14 ventôse and 8 germinal, citizen representatives, the Court of Appeals of the Correctional Police of the Department of Paris handed down decisions in two cases, in which Philippe Jacques Frieze, Jean Louis Lenoir, Etienne Robert Remy, and Jean Mallerange are accused of the crime called sodomy.[131]

Which court should take cognizance of this crime, and what penalties should be imposed for it?

The new laws have not spoken about it. Article 8 of title 2 of the law of 19 July 1791 on the correctional police states that those who have been accused of having publicly attacked morality by offense against the modesty of women, by indecent actions, etc., are to be sentenced, according to the gravity of the deeds, to a fine of between 50 and 500 livres and to a term of imprisonment that may not exceed six months. But this provision did not seem applicable to the crime imputed to the four individuals. Consequently, the court postponed ruling until it receives the response from the National Convention, to which it declared its intention of referring the case.

In execution of the two decisions handed down, the national commissioner sent to me, and I transmit to you, citizen representatives, the documents relating to the two cases in question, so that you may examine them and offer your thoughts on this matter to the National Convention.

Greetings and fraternity,

Herman

[These words are written in the upper right corner of the document:]

To be registered with the following note recorded in the column for observations.

Answered on 10 floréal

At the meeting of the ninth, the committee deemed that moral considerations should prevent the report.

NOTES

Notes to the Introduction

1. *Mémoires secrets pour servir à l'histoire de la république des lettres en France depuis 1762 jusqu'à nos jours,* 36 vols. (London, 1780–89), 30: 213. See Michael Worley, "The Image of Ganymede in France, 1730–1820: The Survival of a Homoerotic Myth," *Art Bulletin* 75 (1994): 630–43.

2. David Halperin, "Forgetting Foucault: Acts, Identities, and the History of Sexuality," *Representations* 63 (1998): 93–120.

3. Michael Rocke, *Forbidden Friendships: Homosexuality and Male Culture in Renaissance Florence* (New York, 1996).

4. Randolph Trumbach, *Sex and the Gender Revolution,* vol. 1, *Heterosexuality and the Third Gender in Enlightenment London* (Chicago, 1998), which contains references to many previous articles by the same author.

5. 2 vols. (Paris, 1963–72).

Notes to the Glossary

1. César Pierre Richelet, *Dictionnaire français* (Geneva, 1680). Other editions consulted: Geneva, 1685; Lyon, 1719; Amsterdam, 1732; Lyon, 1759; Lyon, 1789.

2. Antoine Furetière, *Dictionnaire universel* (Hague, 1690). Other editions consulted: Hague, 1701; Hague, 1727.

3. *Dictionnaire de l'Académie française* (Paris, 1694). Other editions consulted: Paris, 1740; Paris, 1765; Lyon, 1776; Paris, 1777; Paris, 1793; Paris, 1798.

4. *Dictionnaire universel français et latin* (Trévoux, 1704), published by the Jesuits. Other editions consulted: Paris, 1721; Paris, 1734; Paris, 1743; Paris, 1752; Paris, 1762; Paris, 1771.

5. Philibert Jacques LeRoux, *Dictionnaire comique, satirique, critique, burlesque, libre, et proverbial* (Amsterdam, 1718). Other editions consulted: Lyon, 1752; Lyon, 1786.

6. For examples of usage of most of these words during the early modern period, see Claude Courouve, *Vocabulaire de l'homosexualité masculine* (Paris, 1985).

7. Jean Baptiste Rousseau (1671–1741), poet. Courouve, *Vocabulaire,* 56, quotes some lines about "antiphysical love" from one of his epigrams.

8. César de Rochefort, *Dictionnaire général et curieux* (Lyon, 1685) suggested that *bougre* was derived from the name of Alexander the Great's favorite Bagoas, "who took the place of a wife for him."

9. Albigensians, twelfth- and thirteenth-century French heretics who shared the dualistic beliefs of the Bulgarian Bogomils.

10. Rochefort, who did not mention Sodom, listed many classical examples, including Alexander and Bagoas, and quoted negative lines from Aristotle, Lucian, Origen, Ovid, and Martial.

11. Gilles Ménage (1613–92), philologist.

12. Charles Couppeau d'Assouci (1605–75), poet, imprisoned in Montpellier in the 1650s.

13. Claude Emmanuel Luillier La Chapelle and François de Bachaumont, *Voyage de Messieurs Chapelle et Bachaumont* [1656] (Hague, 1742), 58.

14. Adrien Baillet, *Jugements des savants,* 4 vols. in 9 (Paris, 1685–86), 1686, 4/3: 251–55. Giovanni Della Casa (1503–56).

15. Ménage, *L'Anti-Baillet,* 2 vols. (Hague, 1688), 2: 104.

16. Sixtus IV (1414–84, pope from 1471).

17. Pierre Jurieu, *Préjugés légitimes contre le papisme,* 2 vols. (Amsterdam, 1685), 1: 246.

18. Pierre Bayle, *Historical and Critical Dictionary,* 5 vols. (1734–38; reprint, New York, 1984), 5: 157–61.

19. *Grand vocabulaire français* (Paris, 1767–74).

20. Pierre Dionis, *L'Anatomie de l'homme* (Paris, 1690), 269. See excerpt in section on Medicine.

Notes to Part I

1. On theological, legal, and medical issues, see Guy Poirier, *L'Homosexualité dans l'imaginaire de la Renaissance* (Paris, 1996), part two, as well as the synthetic works of Marie Jo Bonnet, *Un Choix sans équivoque: Recherches historiques sur les relations amoureuses entre les femmes, XVIe-XXe siècle* (Paris, 1981, 1995); and Maurice Lever, *Les Bûchers de Sodome: Histoire des infâmes* (Paris, 1985, 1998).

2. "De la Luxure," in *Le Missionaire de l'Oratoire, ou Sermons pour les avents, carêmes, et fêtes de l'année* (Paris, 1662), reprinted in *Collection intégrale des orateurs sacrés,* ed. Jacques Paul Migne, 99 vols. (Paris, 1844–92), 3: [column] 679. Louis Bourdaloue, for example, congratulated Louis XIV in 1684 for having eradicated some offenses against God and exhorted him to fulfill his obligation to eliminate other "shameful vices" that he refrained from naming. "Sermon sur la nativité de Jésus Christ," in *Oeuvres complètes,* 6 vols. (Tours, 1868), 5: 21–22.

3. See Lorraine Daston and Katharine Park, "The Hermaphrodite and the Orders of Nature: Sexual Ambiguity in Early Modern France," in *Premodern Sexualities,* ed. Louise Fradenburg and Carla Freccero (New York, 1996), 117–36; and Park, "The Rediscovery of the Clitoris: French Medicine and the Tribade, 1570–1620," in *The Body in Parts: Fantasies of Corporeality in Early Modern Europe,* ed. David Hillman and Carla Mazzio (New York, 1997), 171–93.

4. *La Somme des péchés et le remède d'iceux* [1586] (Paris, 1601), 154–55, 160–62.

5. The French word *mollesse* can mean softness, weakness, indolence, effeminacy, or wantonness generally, as well as masturbation specifically. The obsolete English cognate, *mollitude,* suggests these related meanings more effectively and less restrictively than any one of the modern words.

6. I Corinthians 6:9. Like its French derivative, *mollesse,* the Latin word *mollis* has a range of physical, moral, and sexual meanings.

7. Josiah, king of Judah from 639 to 609 B.C. See 2 Kings 23:7.

8. The word *kedeshim* means male cult prostitutes in particular, not sodomites in general. Roman writers used the word *cinaedus* as a term of abuse to describe men who played the passive sexual role.

9. Germain Audebert (1518–98), poet.

10. Audebert and Candide (Claudine Denosse), friend and mistress (later, wife), respectively, of Théodore Béza (1519–1605), who published a poem about his affection for both of them in 1548, before he became a leader of the Calvinist movement in Switzerland. For the original Latin and a French translation, see his *Juvenalia,* ed. Alexandre Machard (Paris, 1879), 234–37. Benedicti, like other Catholic writers before and after him, cited the poem as evidence of Beza's sexual deviance.

11. Robert Estienne (1503–59), printer.

12. Sébastian Castellion (1515–63), Tilemann Hesshus (1527–88), François Baudouin (1520–73), and Jérôme Bolsec (c.1524–84), Protestant controversialists. Legend, sarcastic reference to Bolsec's polemical *Histoire de la vie, moeurs, doctrine, and déportements de Théodore de Bèze* (Paris, 1580).

13. Lactantius, *The Divine Institutes,* in *The Ante-Nicene Fathers,* ed. Alexander Roberts and James Donaldson, 10 vols. (Grand Rapids, 1950–51), 7: 189.

14. Council of Elvira (305).

15. Third Lateran Council (1179).

16. Pius V (1507–72, pope from 1566), constitution *Horrendum* (30 August 1568), in *Codicis iuris canonici fontes,* 9 vols. (Rome, 1947–49), 1: 229.

17. Ezekiel 16:27.

18. Ephesians 2:3.

19. Saint Methodius, *The Banquet of the Ten Virgins or Concerning Chastity,* in *Ante-Nicene Fathers,* 6: 327.

20. Plato (c.428–c.348 B.C.), Greek philosopher.

21. *Avertissements aux confesseurs missionaires* [1644] (Caen, 1648), 143–45, 148.

22. Romans 1:27.

23. *Missionaire de l'Oratoire,* in *Collection intégrale,* 4: [columns] 781–91.

24. Hebrews 11:6.

25. Ecclesiasticus 24:25 in the Vulgate.

26. Saint Thomas Aquinas, *Summa theologiae,* 60 vols. (Cambridge, 1964–66), 30: 228–29.

27. Ecclesiasticus 21:3.

28. Nahum 1:9.

29. Ezekiel 16:49.

30. Samson, Israelite hero. David and his son, Solomon, Israelite kings.

31. Ecclesiasticus 3:26.

32. Saint Bonaventure (1221–74), Italian theologian.

33. Saint Jerome (c.342–420) and Saint Ambrose (c.339–97), Church Fathers.

34. Genesis 13:10.

35. Proverbs 20:1.

36. Misquotation from Jerome, letter 69, in *Epistulae,* in *Patrilogiae cursus completus, series latina,* ed. Jacques Paul Migne, 221 vols. (Paris, 1844–92), 59: 696.

37. Psalms 14:1.

38. Romans 3:12.

39. Genesis 19:4.

40. Proverbs 22:6.

41. Ambrose, *Abramo,* ed. Franco Gori (Milan, 1984), 86.

42. Psalms 57:9 in the Vulgate.

43. Job 31:12.

44. LCL, Virgil, 1: 397 [*Aeneid*, 4.2]

45. Genesis 6:7. Cain, first son of Adam and Eve, murdered his brother Abel. See Genesis 4.

46. Hosea 5:4.

47. Saint John Chrysostom, *Homilies on Genesis 18–45*, ed. Robert Hill (Washington, 1990), 452.

48. LCL, Virgil, 1: 401 [*Aeneid*, 4.66].

49. Saint Philip Neri (1515–95), Italian mystic.

50. Palladius of Helenopolis, *The Lausiac History*, ed. Robert Meyer (London, 1965), 82. The story concerns the monk Pachon, not the abbot Pachomius.

51. Genesis 19:24.

52. LCL, Josephus, *Jewish Antiquities*, 1: 87 [1.174].

53. Lamentations 4:6.

54. 1 Peter 3:19–20. Noah and his household built the Ark and survived the Flood that destroyed their sinful contemporaries. See Genesis 6–8.

55. Jude 1:7. Lejeune omitted this clause after the word "cities," presumably in order to avoid any specific mention of "sodomy": "which, in the same manner as they, indulged in sexual immorality and pursued unnatural lust."

56. Peter 2:6. Jude [also known as Thaddeus] 1:7.

57. Luke 13:5.

58. Matthew 10:14–15.

59. Matthew 11:23–24.

60. Ezekiel 16:48–49.

61. Chrysostom, *Homilies*, 430.

62. Romans 2:5.

63. Lamech, son of Methushael. See Genesis 4. Belshazzar and Nebuchadnezzar, Babylonian kings. See Daniel 4–5.

64. Saint Augustine, "Of True Religion," in *Earlier Writings*, ed. John Burleigh (Philadelphia, 1953), 240.

65. Misquotation from *Sermones de tempore*, in *Patroligiae*, 38: 1243.

66. Genesis 19:14.

67. Matthew 5:28.

68. Romans 1:32.

69. Genesis 19:17.

70. "Le Manuscrit du prieur de Sennely," ed. Emile Huet, *Mémoires de la Société archéologique et historique de l'Orléanais* 32 (1908): lxxxxv.

71. The commandment about adultery. See Exodus 20:14.

72. *Recueil d'arrêts notables des cours souveraines de France* [1556] (Paris, 1563), 432. Many of the texts included in this section refer to cases mentioned in comments added to later editions of this influential work.

73. Law *Foedissimam* [first word of the Latin text], in *The Civil Code*, ed. Samuel Scott, 17 vols. (Cincinnati, 1932), 15: 13.

74. Francisco Accursius (c.1182–c.1260), *Commentary on the Codex* (c.1230).

75. *Traité des peines et amendes tant pour les matières criminelles que civiles* [1572] (Lyon, 1573), 41.

76. This sentence includes phrases from the law *Cum vir,* in *Civil Code,* 15: 17.

77. *Les Procès civil et criminel divisé en cinq livres,* 2 vols. [1611] (Lyon, 1618), 2: 21–24.

78. Eusebius (c.264–340), theologian and historian.

79. Romans 1:27.

80. Romans 1:26–27.

81. LCL, Lucian, 7: 379–385 [*Dialogues of the Courtesans,* 5].

82. LCL, Livy, *From the Founding of the City,* 4: 109 [8.28].

83. LCL, Martial, *Epigrams,* 1: 85 [1.90]. Martial mentions Philaenis in several other epigrams. Tertullian, *On the Pallium,* in *Ante-Nicene Fathers,* 4: 10.

84. Nicolas de Bohier, *Décisions de droit et de pratique jugées par arrêts des cours souveraines de France* (Paris, 1611).

85. *Observations et maximes sur les matières criminelles* (Paris, 1715), 403–4.

86. Jean Imbert, *La Pratique judiciaire* (Coligny, 1615), 722.

87. *Civil Code,* 15: 17.

88. Giulio Claro, *Receptarum sentiarum,* in *Opera* (Lyon, 1579), 193. Jacques Mosnier, *Les Véritables alliances du droit français, tant civil que criminel, avec les ordonnances du roi et arrêts des cours souveraines de ce royaume* (Tournon, 1618), 499–500.

89. *The Institutes of Justinian,* ed. Thomas Sanders (London, 1962), 505.

90. *Coutume de Bretagne* (Rennes, 1694), 535.

91. Andrea Alciati, *De verborum significatione* (Lyon, 1546), 172. Jean de Coras, *Résolutions de droit* (Paris, 1610).

92. Jean Pinson de la Martinière, *La Connétablie et maréchaussée de France* (Paris, 1661), 1007–8.

93. Ivo of Chartres, *Decretum,* in *Patrilogiae cursus completus, series latina,* ed. Jacques Paul Migne, 221 vols. (Paris, 1844–92), 106: 682.

94. *Code de la religion et des moeurs, ou Recueil des principales ordonnances depuis l'établissement de la monarchie française concernant la religion et les moeurs,* 2 vols. (Paris, 1770), 2: 578–82.

95. *Civil Code,* 6: 288–89; 17: 160–61.

96. Dadon was executed in 1586 and not, as some of the following sources indicate, 1584.

97. Meusy conflated the case of Benjamin Deschauffours, executed in 1726, with that of Lenoir and Diot. On these cases, see Part II.

98. *Les Etablissements de Saint Louis,* ed. Paul Viollet, 4 vols. (Paris, 1881–86), 2: 147–48. For the text of the encyclical *Super quibusdam,* see *Corpus iuris canonici,* 2 vols. (Graz, 1959), 2: [column] 923.

99. Guy de Montfort (d. 1228), brother of Simon de Montfort, who led the crusade against the Albigensians.

100. Charles Du Fresne, sieur Du Cange, *Glossarium mediae et infimae latinitatis,* 10 vols. (Graz, 1954), 1: 772–73. *Ordonnances des rois de France de la troisième race,* 21 vols. (Paris, 1723–1849), 1: 175.

101. *Encyclopédie ou dictionnaire raisonné des sciences, des arts, et des métiers,* ed. Denis Diderot and Jean d'Alembert, 28 vols. (Paris, 1751–72), 7: 979–81.

102. *Traité de la justice criminelle de France,* 4 vols. (Paris, 1771), 4: 119–22.

103. LCL, Juvenal and Persius, 21 [*Satires,* 2.44]. On the problematic Scatinian law, see Craig Williams, *Roman Homosexuality: Ideologies of Masculinity in Classical Antiquity* (New York, 1999), 119–24.

104. LCL, Cicero, *Letters to His Friends,* 2: 163, 171 [8.12,14]. Valerius Maximus, *Factorum et dictorum memorabilium libri novem,* ed. Carolus Kempf (Stuttgart, 1966), 272–73. LCL, Suetonius, 2: 355 [Domitian, 8.4]. LCL, Ausonius, 2: 209 [*Epigrams,* 92]. LCL, Cicero, *Philippics,* 201 [3.V], and LCL, Plutarch, 5: 439 [Marcellus, 2], discuss sexual relations between men but do not mention the Scatinian law by name.

105. LCL, Quintilian, 2: 87 [*Institutio oratoria,* 4.2.69].

106. LCL, Aeschines, *Speeches,* 13–21 [*Against Timarchus,* 12–22].

107. Prospero Farinacci, *De delictis carnis,* in *Opera omnia,* 9 vols. (Frankfurt, 1622–49), 5: 708.

108. Giacomo Menochio, *De arbitrariis iudicum quaestionibus et causis* (Venice, 1569).

109. *Die Peinliche Gerichtsordnung Kaiser Karls V (Constitutio Criminalis Carolina),* ed. Josef Keller and Willy Scheel (Darmstadt, 1968), 62. Charles V (1500–58, Holy Roman Emperor from 1519 to 1556).

110. *The Visigothic Code,* ed. S. P. Scott (Boston, 1910), 110.

111. Jean Boutillier, *La Somme rurale* (Bruges, 1479), book two, folio lxviii verso.

112. Jean Chenu (1559–1627), jurist.

113. LCL, Plutarch, *Lives,* 9: 497–99 [Gaius Marius, 14].

114. LCL, Cicero, *Pro Milone,* 15–17 [IV.9–10].

115. Claro, *Opera,* 161.

116. *Les Lois criminelles de France dans leur ordre naturel* (Paris, 1780), 509–10.

117. On this capitulary, quoted by Muyart de Vouglans in a note, see John Boswell, *Christianity, Social Tolerance, and Homosexuality* (Chicago, 1980), 177, note 29.

118. In the next text, signed by Boucher d'Argis, he corrects what he calls his article on pederasty in Guyot's *Collection.* This compendium contains no such article, so he presumably meant this unsigned article on sodomy.

119. *Répertoire universel et raisonné de jurisprudence civile, criminelle, canonique, et bénéficiale,* ed. Pierre Jean Jacques Guillaume Guyot, 17 vols. (Paris, 1784–85), 16: 336–37. The first edition, published 1775–83, did not include an article on this subject.

120. Boucher d'Argis listed seven of the cases mentioned by Jousse.

121. Pascal was charged with attempted rape and murder for having stabbed an errand boy who resisted his advances. See Jeffrey Merrick, "'Brutal Passion' and 'Depraved Taste': The Case of Jacques François Pascal," forthcoming.

122. *Encyclopédie méthodique: Jurisprudence,* 9 vols. (Paris, 1782–89), 7: 614–16.

123. Lycurgus, a possibly legendary figure.

124. Minos, legendary king of Crete.

125. The faulty translation of the first sentence in *Civil Code,* 15: 17, has been corrected using that in Eva Cantarella, *Bisexuality in the Ancient World* (New Haven, 1992), 175.

126. LCL, Aristotle, *Politics,* 153 [2.10, 1272a12]. Pierre Bayle, *Historical and Critical Dictionary,* 5 vols. (1734–38; reprint, New York, 1984), 3: 962.

127. Louis Pierre de Saint-Martin, *Les Etablissements de Saint Louis* (Paris, 1786), 104–5.

128. *Recueil général des anciennes lois françaises depuis l'année 420 jusqu'à la Révolution,* ed. François André Isambert, 29 vols. (Paris, 1821–33), 1: 230–33.

129. Jean Guitel, executed on 16 July 1588.

130. Giulio Cesare Vanini (1585–1619), executed on 9 June 1619.

131. *Historia anatomica humani corporis,* in *Toutes les Oeuvres de Messire André Du Laurens* [1613] (Paris, 1621), 223.

132. Gabriele Falloppio (1523–62), Italian anatomist.

133. Avicenna (980–1037), Arab philosopher and physician. Renaldus Columbus, *De re anatomica* (Venice, 1559), 447.

134. *Des Hermaphrodits, accouchements des femmes, et traitement qui est requis pour les relever en santé et bien élever leurs enfants* (Rouen, 1612), 65–66.

135. Caelius Aurelianus, *Celerum passionum and Tardarum passionum,* ed. Gerhard Bendz and Ingeborg Pape, 2 vols. (Berlin, 1990–93), 2: 850 [*Tardarum,* 4.132]. LCL, Plautus, 3: 446 [*The Persian,* 2.2.227], where the singular rather than the plural noun is used. Arnobius the Elder (fourth century) or Younger (fifth century), Christian apologists.

136. *L'Anatomie de l'homme* [1680] (Paris, 1690), 269.

137. *L'Onanisme, ou Dissertation physique sur les maladies produites par la masturbation* (Lausanne, 1760), 50–53.

138. LCL, Ovid, *Heroides and Amores,* 194 [*Heroides* 15.201].

139. LCL, Juvenal and Persius, 108 [Juvenal, *Satires,* 6.320–23].

140. Theodore Tronchin (1709–81), doctor.

141. LCL, Juvenal and Persius, 114 [Juvenal, *Satires,* 6.368].

142. *La Nymphomanie, ou Traité de la fureur utérine* (Amsterdam, 1771), 83–85.

Notes to Part II

1. In many cases the magistrates had the documents burned along with the men they sentenced to death. Alfred Soman, who demonstrated that the texts in Ludovico Hernandez, *Les Procès de sodomie au XVIe, XVIIe, et XVIIIe siècles* (Paris, 1920), are not reliable, has located sodomy cases in the records of the Conciergerie prison. See "Pathologie historique: Le Témoignage des procès de bestialité aux XVIe–XVIIe siècles," *Actes du 107e Congrès national des Sociétés savantes: Section de philologie moderne et d'histoire jusqu'à 1610,* 2 vols. (Paris, 1984), 1: 149–61.

2. The parlement's decision to execute Lenoir and Diot was probably influenced by the "kidnapping" riots in May 1750. See Arlette Farge and Jacques Revel, *The Vanishing Children of Paris: Rumor and Politics before the French Revolution* (Cambridge, 1991).

3. In order to avoid confusion about age differences, we have translated the word *garçon* (commonly applied to unmarried males of any age as well as servants and apprentices in general) as "boy" only when it seems to refer to a child. In other cases we have used "lad" or "youth."

4. See Claude Courouve, *Les Assemblées de la manchette: Documents sur l'amour masculin au XVIIIe siècle* (Paris, 1987); Michel Rey, "Les Sodomites parisiens au XVIIIe siècle," mémoire de maîtrise, Université de Paris VIII, 1980; idem, "Parisian Homosexuals Create a Lifestyle, 1700–1750: The Police Archives," in *'Tis Nature's Fault: Unauthorized Sexual Behavior during the Enlightenment,* ed. Robert Maccubbin (Cambridge, 1987), 179–91; idem, "Police and Sodomy in Eighteenth-Century Paris: From Sin to Disorder," in *The Pursuit of Sodomy: Male Homosexuality in Renaissance and Enlightenment Europe,* ed. Kent Gerard and Gert Hekma (New York, 1989), 129–46; Maurice Lever, *Les Bûchers de Sodome: Histoire des infâmes* (Paris, 1985), chapters 6–8; Jeffrey Merrick, "Sodomitical Inclinations in Early Eighteenth-Century Paris," *Eighteenth-Century Studies* 30 (1997): 289–95; idem, "Commissioner Foucault, Inspector Noël, and the 'Pederasts' of Paris, 1780–83," *Journal of Social History* 32 (1998): 287–307; idem, "Sodomitical Scandals and Subcultures in the 1720s," *Men and Masculinities* 1 (1999): 373–92.

5. *Journal d'un bourgeois de Paris sous le règne de François premier (1515–1536),* ed. Ludovic Lalanne (Paris, 1854), 435–36.

6. *Journal de voyage en Italie,* in *Oeuvres complètes,* ed. Arthur Armaingaud, 12 vols. (Paris, 1924–41), 7: 9–10.

7. Archives Departementales du Nord, 5G511, 5–19.

8. *Rebouller de vit,* from the verb *reboler,* one who dupes the cock (by stimulating it for some purpose other than vaginal intercourse) or makes it look circumcised (by pulling back the foreskin).

9. Siege of Cambrai, in 1649.

10. Henriette de Castelnau (1670–1716), countess de Murat, author of novels and fairy tales. D'Argenson addressed the reports about Murat, as well as the following one about Neel and Guillaumie, to chancellor Louis de Phélypeaux (1643–1727), count de Pontchartrain. *Rapports inédits du lieutenant de police René d'Argenson (1697–1715),* ed. Paul Cottin (Paris, 1891), 3, 10, 11–13, 17, 87–89, 93–94, 97, 72–74.

11. The documents about Petit and Lebel, as well as the following one about Chabert de Fauxbonne, are translated from *Archives de la Bastille,* ed. François Ravaisson, 19 vols. (Paris, 1866–1904), 11: 2–11, 213–14.

12. Aulmont, officer of the Short Robe, the armed force in the service of the Châtelet.

13. Camille de la Baume d'Hostun (1652–1728), count de Tallard.

14. Late Monsieur the Prince, Louis de Bourbon (1621–86), prince de Condé.

15. Louis Joseph de Bourbon (1654–1712), duke de Vendôme.

16. Louis de Campistron (d. 1733).

17. Augustin Servien (d. 1716).

18. Jean François Paul, duke de Lesdiguières (1678–1704).

19. Claude Longueil (1668–1715), president de Maison.

20. Philippe, duke d'Orléans (1640–1701), or his son and successor, Philippe (1674–1723).

21. Louis Armand, duke d'Estrées (1682–1723).

22. "Extraits d'interrogatoires faits par la police de Paris de gens vivant dans l'industrie, dans le désordre, et de mauvais moeurs et des gens de la religion," BN, MSS, Collection Clairambault, 984: 49–50, 71–72, 80–81, 81–82; 985: 22–23, 49, 53, 81, 82, 87–88, 89, 110–11, 118–19, 127, 237, 240–41, 247, 276–77, 293, 358–60, 450. The formulaic phrase about the lettre de cachet in the first report is repeated in the others.

23. Louis Antoine de Noailles (1651–1729), archbishop of Paris.

24. Bibliothèque de l'Arsenal, 10566 (a), 10255 (b–k, except d, 13 April 1728), 10257 (d, 13 April 1728, and l–m), 10258 (n–o), 11732 (p).

25. Nicolas Baptiste Ravot d'Ombreval (d. 1729), lieutenant general of police (1724–25).

26. According to another document dated 17 August 1724, the abbé had admitted interest in prostitutes but not "debauchery with men."

27. Louis Elis de la Vergne (1705–83), count de Tressan.

28. Claude Henri Feydeau de Marville (1703–87), lieutenant general of police (1740–47).

29. Messalina (c.25–c.48), infamous wife of the Roman emperor Claudius.

30. *Chronique de la régence et du règne de Louis XV,* 8 vols. (Paris, 1857), 1: 424–27.

31. René Hérault (1691–1740), lieutenant general of police (1725–40).

32. Stanislas Leczinska (1677–1766), king of Poland.

33. Jean Baptiste Nattier (1678–1726), painter, committed suicide on 27 April.

34. Etienne Joseph de La Fare (1691–1741).

35. Henri Charles, count de Tavannes (1686–1761).

36. François Honoré de Beauvillier de Saint-Aignan (1682–1751).

37. *Chronique,* 4: 447–48.

38. Archives Nationales, Y10132.

39. Arsénal 11717.

40. This document and the next from AN, Y 11722.

41. AN, Y 11723.

42. This document and the next three from AN, Y 11724.

43. Claude, count de Beauharnais (1756–1819).

44. Jean Baptiste Nicolet (1726–90), director of the boulevard theater called the Grands Danseurs de la Corde.

45. AN, Y 11725.

46. AN, Y 11726.

47. *Encyclopédie méthodique: Jurisprudence,* vols. 9–10: *La Police et les municipalités* (Paris, 1789–91), 10:325, 625–26.

48. *Mémoires tirés des archives de police de Paris,* 6 vols. (Paris, 1838), 1:289–90, 3:38–39. This work is reportedly based in large part on notes given to Peuchet by lieutenant general of police Lenoir.

Notes to Part III

1. By the same token, Théophile de Viau (1590–1626) and other free-thinking poets were accused of professing atheism and practicing the "crime aginst nature."

2. See David Teasley, "The Charge of Sodomy as a Political Weapon in Early Modern France: The Case of Henry III in Catholic League Polemic, 1585–1589," *The Maryland Historian* 18 (1987): 17–30; Donald Stone, "The Sexual Outlaw in France, 1605," *Journal of the History of Sexuality* 2 (1992): 597–608; Joseph Cady, "The 'Masculine Love' of the 'Princes of Sodom' 'Practising the Art of Ganymede' at Henri III's Court: The Homosexuality of Henry III and His Mignons in Pierre de l'Estoile's *Mémoires-Journaux,*" in *Desire and Discipline: Sex and Sexuality in the Premodern West,* ed. Jacqueline Murray and Konrad Eisenbichler (Toronto, 1996), 124–54; and Poirier, *L'Homosexualité,* part 4. Louis XIII (1601–43, king from 1610), who married Anne of Austria in 1615 and did not have a son until 1638, was also accused of "unnatural" relations with male favorites.

3. See Jeffrey Merrick, "The Cardinal and the Queen: Sexual and Political Disorders in the Mazarinades," *French Historical Studies* 18 (1994): 667–99.

4. On the court of Louis XIV, see Nancy Barker, *Brother to the Sun King: Philippe, Duke of Orléans* (Baltimore, 1989); and Robert Oresko, "Homosexuality and the Court Elites of Early Modern France: Some Problems, Some Suggestions, and an Example," in *The Pursuit of Sodomy: Male Homosexuality in Renaissance and Enlightenment Europe,* ed. Kent Gerard and Gert Hekma (New York, 1989), 105–28.

5. On early modern pornography, see *The Invention of Pornography: Obscenity and the Origins of Modernity, 1500–1800,* ed. Lynn Hunt (New York, 1993); and Jean Marie Goulemot, *Forbidden Texts: Erotic Literature and Its Readers in Eighteenth-Century France* (Philadelphia, 1994).

6. Texts in Part III contain many references to non-European cultures, but we have not had room to explore the theme of sodomitical "others" systematically in this volume. For sixteenth-century examples, see Guy Poirier, "French Renaissance Travel Accounts: Images of Sin, Visions of the New World," in *Gay Studies from the French Cultures: Voices from France, Belgium, Canada, and the Netherlands,* ed. Rommel Mendès-Leite and Pierre Olivier de Busscher (New York, 1993), 215–30;

and idem, "Masculinities and Homosexualities in French Renaissance Accounts of Travel to the Middle East and North Africa," in *Desire and Discipline,* ed. Murray and Eisenbichler, 155–67, both included in his *L'Homosexualité,* part 3.

7. *Mémoires secrets pour servir à l'histoire de la république des lettres en France de 1762 jusqu'à nos jours,* 36 vols. (London, 1780–89), 27: 116.

8. See Jacob Stockinger, "Homosexuality and the French Enlightenment," in *Homosexualities and French Literature,* ed. George Stambolian and Elaine Marks (Ithaca, 1979), 161–85; David Coward, "Attitudes to Homosexuality in Eighteenth-Century France," *Journal of European Studies* 10 (1980): 231–55; Michel Delon, "The Priest, the Philosopher, and Homosexuality in Enlightenment France," in *'Tis Nature's Fault: Unauthorized Sexual Behavior during the Enlightenment,* ed. Robert Maccubbin (Cambridge 1987), 122–31; and Bryant T. Ragan, Jr., "The Enlightenment Confronts Homosexuality," in *Homosexuality in Modern France,* ed. Jeffrey Merrick and Bryant T. Ragan, Jr. (New York, 1996), 8–29.

9. *Plan de législation criminelle,* ed. Daniel Hamiche (Paris, 1974), 131. Jean Jacques Rousseau described his disagreeable encounters with a Moor in Turin and a priest in Lyon in two well known passages in his *Confessions.* In the Penguin edition, translated by J. M. Cohen, copyrighted in 1953, see pages 71–73 and 161–63.

10. *Apologie pour Hérodote,* 2 vols., ed. Paul Ristelhuber (Paris, 1879), 1: 174–78.

11. Curtio Navo, Venetian printer.

12. Jean Maillard (d. c.1567).

13. Pietro Luigi Farnese, duke of Parma and Piacenza (1545–47). Paul III (1468–1549, pope from 1534).

14. The twenty-four-year-old Cosmo Gherio was abducted in 1537.

15. *Mémoires-journaux,* ed. Gustave Brunet et al., 12 vols. (Paris, 1875–96), 1: 142–43; 2: 113–17, 326; 8: 11–12, 14–15; 11: 87–88.

16. On the decapitation of John the Baptist, see Matthew 14:3–12 or Mark 6:17–29.

17. Henry III founded two penitential orders in March and August 1583.

18. Aeneas, king of the Dardanians, carried his father on his back from Troy when the city fell to the Greeks.

19. L'Estoile, 7: 324, had noted the arrest of the two friars, the 55- or 60-year-old Camus and a 15- or 16-year-old novice, in December 1601.

20. Antoine Séguier (1552–1624), sieur de Villiers, magistrate in the parlement of Paris.

21. Tomas Sanchez, *Disputationes de sancto matrimonii sacramento* (Genoa, 1602).

22. LCL, Plutarch, *Moralia,* 12: 521 [*Beasts Are Rational,* 990E].

23. *Recueil des dames,* in *Oeuvres complètes,* ed. Prosper Mérimée and Louis Lacour, 13 vols. (Paris, 1858–95), 11: 214–29.

24. Lucretia, virtuous wife of Tarquinius Collatinus, a relative of the last king of Rome.

25. Georges d'Armagnac (1502–85), French ambassador to Rome.

26. LCL, Lucian, 7: 381 [*Dialogues of the Courtesans,* 5]

27. LCL, Juvenal and Persius, 109 [Juvenal, *Satires,* 6.322]. Brantôme mistranslated this phrase by mistaking the participle *crissantis* for a proper noun.

28. LCL, Lucian, 8: 195 [*Affairs of the Heart,* 28].

29. LCL, Lucian, 7: 383–85 [*Dialogues of the Courtesans,* 5].

30. Henri de Clermont-Taillart (1548–73).

31. On the myth of Sappho's unrequited love for Phaon, and on conflicting and changing versions of her life more generally, see Joan DeJean, *Fictions of Sappho, 1546–1937* (Chicago, 1989).

32. In the first clause Brantôme contrasted training falcons with bunches of feathers intended to resemble birds (practice) and feeding them the flesh of animals (the real thing).

33. Lepers were forbidden to share their drinking vessels in this way.

34. Queen Mother, Catherine de Medici (1519–89).

35. Sardanapalus (669–640 B.C.), Assyrian king. Heliogabalus (204–22), Roman emperor.

36. Louis Bérenger Du Guast (c.1545–75), captain of Henry III's guards. Agnolo Firenzuola (1493–1548), *On the Beauty of Women,* ed. Konrad Eisenbichler and Jacqueline Murray (Philadelphia, 1992), 16.

37. Margaret of Austria (1480–1530), daughter of the emperor Maximilian I.

38. Margaret was intended for Charles VIII (1470–98, king from 1483) of France, who married Anne of Brittany instead. She married Don John (1478–1497), son of Ferdinand and Isabella, in 1497, and he died later that year. She married Philibert of Savoy (1480–1504, duke from 1497) in 1501, and he died three years later.

39. Queen Regent, Louise of Savoy (1476–1531), mother of Francis I. The Peace of Cambrai (1529), known as the Ladies' Peace, ended one phase of the Habsburg-Valois wars.

40. Henricus Cornelius Agrippa von Nettesheim (1486–1535), *Declamation on the Nobility and Preeminence of the Female Sex* [1529], ed. Albert Rabil (Chicago, 1996).

41. *La Mazarinade* (Brussels, 1651), 3, 5, 7, 11, 13.

42. Catullus (c.84–c.54 B.C.), Roman poet. Mamurra, Julius Caesar's chief engineer in Gaul, attacked by Catullus in several poems for his depradations during military campaigns and his sexual relations with Caesar. See LCL, Catullus, Tibullus, and Vervigilium Veneris, 35, 65 [29.3, 57.2].

43. Mazarin accompanied the future cardinal Girolamo Colonna (1604–66) to the University of Alcalá in Spain during their student days. On Mazarin's connections with the various Italian families mentioned in this text, see Georges Detham, *The Young Mazarin* (London, 1977).

44. Cardinal Antonio Barberini (1607–71), nephew of pope Urban VIII.

45. Gian Francesco Sacchetti, papal legate to Milan.

46. *L'Académie des dames* [1680], in *L'Enfer de la Bibliothèque Nationale,* vol. 7: *Oeuvres érotiques du XVIIe siècle* (Paris, 1988), 406–8, 434–36. Used by permission of the publisher, Fayard.

47. Mount Parnassus, sacred to Apollo and the muses and thus associated with fame. Mount Olympus, home of the gods and thus associated with divinity.

48. Miletus, Greek city on the Turkish coast.

49. Aristophanes (c.450–c.388 B.C.), Greek playwright.

50. Philip (382–336 B.C., king from 359 B.C.), father of Alexander the Great.

51. Augustus (63 B.C.–A.D. 14, emperor from 44 B.C.), successor of Julius Caesar.

52. Nero (37–68, emperor from 54).

53. Trajan (53–117, emperor from 98).

54. Hadrian (76–138, emperor from 117) had the beautiful Antinous (111–30) deified after he drowned in the Nile.

55. Aristotle (384–322 B.C.), Greek philosopher. Pindar (518–438 B.C.), Greek poet. Epicurus (342–271 B.C.) and Aristippus (fifth century B.C.), Greek philosophers.

56. Anacreon (c.570–c.478 B.C.), Greek poet.

57. Plautus (c.251–184 B.C.), Roman playwright.

58. Virgil (70–19 B.C.), Latin poet, depicted the slave Corydon's love for the shepherd Alexis in his second *Eclogue.* Pollio (c.76 B.C.–A.D. 5), patron of Virgil.

59. Ovid (43–17 B.C.), Roman poet.

60. With his lyre and voice, Orpheus charmed Hades, king of the underworld, into releasing his wife Eurydice after she had been bitten by a poisonous snake. Orpheus looked back at her before she emerged into the sunlight and thereby lost her again.

61. Lucian (c.120–c.200), Greek satirist.

62. Achilles Tatius (fourth century), Greek novelist, author of the romance of Clitiphon and Leucippe.

63. Asclepius, god of healing.

64. *Mémoires sur le règne de Louis XIV,* ed. Gabriel-Jules, count de Cosnac, and Arthur Bertrand, 13 vols. (Paris, 1882–93), 1: 110–13.

65. Ultramontane, literally, beyond the mountains, i.e., Italian, and, in this case, sodomitical.

66. François Louis de Bourbon (1664–1709), prince de La Roche-sur-Yon and later prince de Conti. His uncle, Henri Jules de Bourbon (1643–1709), prince de Condé, known as Monsieur the Prince. Louis Charles de la Tour (1664–92), prince de Turenne. François Joseph de Créquy (1662–1702).

67. Honoré, count de Sainte-Maure (d. 1731). Louis, count de Mailly (1662–99). Pierre de Massué de Ruvigny de La Caillemotte (1653–90). Henri de Massué (1605–89), marquis de Ruvigny. Jacques Louis Valon (1659–1718), marquis de Mimeure. Gabriel de Cassagnet (d. 1690), chevalier de Tilladet. François Michel le Tellier (1641–91), marquis de Louvois, minister of war.

68. François de Roye de la Rochefoucauld (1660–1721), count de Roucy. Gui de Roye de la Rochefoucauld (d. 1684), vidame de Laon. Frédéric Charles de la Rochefoucauld (1633–90), count de Roye.

69. François, duke de la Rochefoucauld (1634–1714).

70. Louis de Lorraine (1641–1718), count d'Armagnac, grand écuyer de France, known as Monsieur le Grand. Henri de Lorraine (1661–1712), count de Brionne. Charles de Lorraine-Armagnac (1648–1708), count de Marsan.

71. Louis de Bourbon (1648–1708), count de Vermandois (1667–83), legitimized son of Louis XIV and Louise de la Vallière.

72. *La France devenue italienne avec les autres déréglements de la cour,* published in Roger de Rabutin, comte de Bussy, *Histoire amoureuse des Gaules, suivie des romans historico-satiriques du XVIIe siècle,* ed. Paul Boiteau and C. L. Livet, 4 vols. (Paris, 1856–76), 3: 345–60. This work has been attributed to Gatien de Courtilz de Sandras (1644–1712), author of many memoir-novels.

73. Bernard de Longueval, marquis de Manicamp. Antoine Charles, duke de Gramont (1645–1720).

74. François Annibal, marshal d'Estrées (1573–1670).

75. Charlotte de Castelnau (1648–94), the duke's first wife.

76. Father, Antoine, marshal de Gramont (1604–77). Brother, Armand de Gramont (1637–73), count de Guiche.

77. Camille d'Hostun de la Baume (1652–1728), count de Tallard. The order of Saint-Lazare was reorganized with five grand priors in 1666.

78. Antoine Gaston Jean Baptiste (1656–1738), marquis de Biran, count and later duke de Roquelaure.

79. *Mémoires du curé de Versailles, François Hébert, 1686–1704,* ed. Georges Girard (Paris, 1927), 37–39.

80. Françoise d'Aubigné (1635–1710), marquise de Maintenon, secretly married to Louis XIV in 1684.

81. Philippe, duke d'Orléans (1640–1701), known as Monsieur.

82. Philippe de Lorraine-Armagnac (1643–1702), chevalier de Lorraine, Monsieur's favorite.

83. *Mémoires,* ed. Arthur André Gabriel Michel de Boislisle, 41 vols. (Paris, 1890–1929), 8: 339–43 [1701].

84. The French defeated the Dutch and their allies at the battle of Cassel, 11 April 1677.

85. Alexis Henri, marquis de Châtillon (1650–1737).

86. Members of the wealthy, powerful Guise family led the Catholic party during the sixteenth-century civil wars.

87. Palais-Royal, given by Louis XIV to his brother in 1692. Saint-Cloud, palace and gardens on the western edge of Paris, bought by Monsieur in 1658.

88. Philippe, duke de Chartres (1674–1723), Monsieur's son.

89. *Briefe der Prinzessen Elisabeth Charlotte von Orleans an die Raugräfin Louise, 1676–1722,* ed. Wolfgang Menzel (Stuttgart, 1843), 62.

90. William III (1650–1702, king from 1688) of England.

91. *Histoire du roi Apprius* (Constantinople, 1728), 40–43, 78. Apprius [anagram of Priapus, phallus] visited Lucanie, the kingdom of Lucanus [butthole], ruler of Medoso [Sodom], Ghervomo [Gomorrah], and Veugobrie [buggery]. He ended up commanding the army of Apprius against the Cistones [cuntists] and their allies, the Bratides [tribades]. He not only defeated them but also conquered Lucanie for himself.

92. The Danaidae, daughters of Danaus, murdered their husbands on his orders and were condemned in the underworld to carry water in jars that leaked.

93. The gods punished Tantalus for his crimes by making him stand in water and surrounding him with fruit trees that receded whenever he tried to drink or eat.

94. *Anecdotes pour servir à l'histoire secrète des Ebugors* (Medoso, 1733), 9–11, 12–14, 15–18, 31–34, 89–90, 98.

95. Cytherans, inhabitants of Cythera, Greek island with a temple to Aphrodite, women sexually interested in men, as opposed to Ebugors, men sexually interested in men.

96. Apollo fell in love with the beautiful Hyacinth and, after he was killed by a discus, created the flower named after him from his blood.

97. Narcissus fell in love with his own reflection in a pool of water.

98. Nisus might have escaped after the death of Euryalus, but he stayed to kill the Rutulian warrior who had killed his companion and was then killed in turn.

99. Hephaistion accompanied Alexander during his conquests and died in 324 B.C.

100. *Thérèse philosophe* [1748], in *L'Enfer de la Bibliothèque Nationale*, vol. 5: *Oeuvres anonymes du XVIIIe siècle* (Paris, 1986), 120–22, 164–70. Used by permission of the publisher, Fayard.

101. *Le Gazetier cuirassé, ou Anecdotes scandaleuses de la cour de France* (A cent lieues de la Bastille à l'enseigne de la liberté [A hundred leagues from the Bastille, under the sign of liberty], 1771), 68–69, 84; [*Mélanges confus sur des matières fort claires*] 42; [*Le Philosophe cynique, pour servir de suite aux Anecdotes scandaleuses de la cour de France*], 41–42, 78–89.

102. Chancellor, René Nicolas Charles Augustin de Maupeou (1714–92), who presided over the suppression of the parlements, which had forced the expulsion of the Jesuits from France.

103. Antoine Gabriel de Sartine (1729–1801).

104. Louis XV's confessor from 1764 until his death in 1774 was the abbé Maudoux.

105. Dominique de La Rochefoucauld (1713–1800).

106. Charles Michel, marquis de Villette (1734–93), man of letters and notorious sodomite. See Jeffrey Merrick, "The Marquis de Villette and Mademoiselle de Raucourt: Representations of Male

and Female Sexual Deviance in Late Eighteenth-Century France," in *Homosexuality in Modern France*, ed. Merrick and Ragan, 30–53.

107. François Joachim de Bernis (1715–94). Lazarus Optius Pallavicini. Filippo Acciaiuoli (1700–66).

108. Claire Hippolyte Josèphe Léris de Latude, known as Mademoiselle Clairon (1723–1803), actress. Jeanne Louise Constance d'Aumont de Villequier (1731–1816), marquise de Villeroy. First President, Etienne Francois d'Aligre (1727–98). Oligny, actress. Anne Victoire Dervieux (1752–1826), actress.

109. Louis Marie Augustin, duke d'Aumont (1709–82). Burned up, like Sodom and Gomorrah.

110. Elie Catherine Fréron (1718–76), journalist hostile to the philosophes.

111. The pious financier François Pierre Billard embezzled funds from the postal service and went bankrupt in 1769. He blamed his confidant and confessor, abbé Grizel. In the end Billard was banished, but Grizel was released.

112. Guebers, ancient Persian sect, subject of a tragedy by Voltaire (1769). The name was sometimes applied to sodomites.

113. Villette lied about the one duel and avoided others. He did publish historical discourses on the reigns of Henry IV and Charles V but was not imprisoned for two years or arrested in the Tuileries gardens. Some of his servants, however, were arrested there.

114. Not in *Dieu et les hommes* (1768) or *Anecdotes sur Fréron* (1761), in François Marie Arouet de Voltaire, *Oeuvres complètes,* ed. Louis Moland, 52 vols. (Paris, 1877–85), 28: 129–248; 24: 181–90.

115. Louis François Armand de Vignerot du Plessis (1696–1788), duke de Richelieu. Voltaire made joking references to Grizel and Billard as saints in several letters written in 1770, but not in those addressed to Richelieu.

116. Bernardino Giraud, appointed nuncio in 1766.

117. *L'Espion anglais, ou Correspondance secrète entre Milord All'Eye et Milord All'Ear,* 10 vols. (London, 1784–86), 10: 224–27, 230–47, 249–52, 253–77. The first edition of this work was published with the title *L'Observateur anglais*, in 4 volumes, in 1777–78.

118. Alexandrine Ernestine Gourdan (d. 1783), the most famous procuress in Paris.

119. Madame de Furiel, Elisabeth Marie Pierrette Dubois de Courval (d. 1794), married to and separated from Omer Louis François Joly de Fleury, solicitor general of the parlement of Paris and attorney general of the Maupeou parlement, in 1768 and 1775, respectively, known as the marquise de Fleury.

120. Vesta, chaste goddess of the hearth.

121. Sybarites, inhabitants of the southern Italian city of Sybaris, known for its wealth and luxury.

122. Charles Geneviève Timothé d'Eon de Beaumont (1728–1810), diplomat and writer who spent much of his life as a woman. Jean Antoine Houdon (1741–1828), sculptor.

123. Nicolas Venette, *Tableau de l'amour conjugal considéré dans l'état du mariage* (Paris, 1687), reprinted many times under various titles. Georges Louis Leclerc, count de Buffon (1707–88), *Histoire naturelle* (Paris, 1749–67).

124. Not in the Bibliothèque Nationale catalogue of printed books.

125. Françoise Marie Antoinette Josèphe Saucerotte, known as Mademoiselle de Raucourt (1756–1815). See Merrick, "The Marquis de Villette and Mademoiselle de Raucourt."

126. Bernis, *Les Quatre parties du jour,* in *Oeuvres complètes,* 2 vols. (Paris, 1798), 1: 188.

127. Giovanni Nevizzano, *Sylva nuptialis* (Paris, 1521).

128. Rose Bertin (1744–1813), seller of female clothes.

129. *Seconde lettre aux femmes*, dated 10 February 1778, included in his *Pièces relatives aux démêlés entre Mademoiselle d'Eon de Beaumont et le sieur Caron, dit de Beaumarchais* (Paris, 1778), 49.

130. Turns, as in taking turns around the room or taking turns with different wives.

131. Palladium, sacred and protective image rescued from Troy and taken to Rome by Aeneas.

132. Circe and Armide, sorceresses.

133. Melpomene, muse of tragedy.

134. Ariadne, daughter of Minos and Pasiphae, fled from Crete with Theseus after helping him defeat the Minotaur, and he abandoned her on Naxos.

135. Urbsrez, duchess de Villeroy. Terracenès, marquise de Senecterre.

136. Téchul, marquise de Luchet.

137. August Christian Frederick, margrave of Anspach.

138. Madeleine Sophie Arnould (1744–1803).

139. Jeanne Françoise Marie Souck.

140. François Georges Maréchal, marquis de Bièvre (1747–89).

141. Alexis Piron (1689–1773), poet and playwright.

142. *Le Rideau levé, ou l'Education de Laure* [1785], in *L'Enfer de la Bibliothèque Nationale*, vol. 1: *Honoré Gabriel de Riquetti, comte de Mirabeau, Oeuvres érotiques* (Paris, 1984), 413–20, 586–94. Used by permission of the publisher, Fayard.

143. *De l'Esprit des lois*, in *Oeuvres complètes*, 3 vols. (Paris, 1758), 1: 258–59.

144. LCL, Procopius, 6: 141 [*Anecdota* or *Secret History*, 11.34–36]. Justinian (c.482–565, emperor from 527) supported the Blues, the rivals of the Greens.

145. *Encyclopédie, ou Dictionnaire raisonné des sciences, des arts, et des métiers*, 28 vols. (Paris, 1751–72), 15: 266; 16: 617.

146. The Bibliothèque Nationale catalogue does not include *Des Moyens canoniques* by Michel Duperray (1640–1730), author of many works on legal and ecclesiastical subjects. Muyart de Vouglans, *Instituts au droit criminel* (Paris, 1757).

147. *Oeuvres complètes*, ed. Louis Moland, 52 vols. (Paris, 1887–95), 17: 479–85, including changes made by Voltaire in later editions.

148. LCL, Ovid, *Metamorphoses*, 2: 71 [10.84–85].

149. LCL, Plutarch, *Moralia*, 9: 321 [*Dialogue on Love*, 5].

150. Ibid., 315–19 [4].

151. Laius, king of Thebes. Band, the so-called Sacred Band of Thebes.

152. LCL, Sextus Empiricus, 1: 89 [*Outlines of Scepticism*, 1.152].

153. *The Zend-Avesta*, ed. James Darmesteter, 3 vols. (Oxford, 1883–95), 1: 7.

154. Zoroaster (c.630–c.553 B.C.), Persian religious leader.

155. Ignatius Loyola (1491–1556), founder of the Jesuit order.

156. Philip "the Arab" (c.204–49, emperor from 244).

157. LCL, Quintilian, 1: 217 [*Institutio oratoria*, 2.2.14].

158. Pierre Henri Larcher (1726–1812). Johann Matthias Gesner, *Socrates sanctus paederasta* (Trier, 1769).

159. Simon Foucher (1644–96).

160. Jacques Amyot (1513–93) translated Plutarch into French.

161. LCL, Horace, *Satires, Epistles, and Ars Poetica,* 29 [*Satires,* 1.2.117].

162. Pierre François Desfontaines (1685–1745), journalist, arrested in 1724. Voltaire, among others, intervened with the police on his behalf.

163. LCL, Horace, *Satires, Epistles, and Ars Poetica,* 13 [*Satires,* 1.1.106].

164. Nicolas Boileau-Despréaux, Satire 12, in *Oeuvres complètes* (Paris, 1966), 87–99.

165. The cult of courtly love.

166. Philip of Macedon defeated the Thebans and their allies at Chaeronea in 338 B.C. LCL, Plutarch, *Lives,* 5: 387 [Pelopidas, 18].

167. *Prix de la justice et de l'humanité,* in *Oeuvres complètes,* 30: 569–70.

168. Constantine II (316–40, emperor from 337) and Constans (c.320–50, emperor from 337), sons of the emperor Constantine.

169. Participal form of *paedico,* to commit sodomy with.

170. Fabricius Luscinus Caius (d. c.250 B.C.), Cato the Elder (234–149 B.C.) and Younger (95–48 B.C.), Scipio the Elder (c.235–183 B.C.) and Younger (c.185–129 B.C.), statesmen and generals, models of Roman virtue.

171. Voltaire included an article on Bulgares or Boulgares in his *Philosophical Dictionary,* in *Oeuvres complètes,* 18: 38–41.

172. *Suite de l'entretien,* in *Oeuvres complètes,* ed. Jules Assézat and Maurice Tourneux, 20 vols. (Paris, 1875–77), 2: 187–88.

173. Théophile de Bordeu (1722–76), physician.

174. Julie Jeanne Eléonore de Lespinasse (1732–76) hosted a salon frequented by philosophes.

175. LCL, Horace, *Satires, Epistles, and Ars Poetica,* 479 [*Ars Poetica,* 343].

176. *Fragments échappés du portefeuille d'un philosophe,* in *Oeuvres complètes,* 6: 452–53.

177. *Théorie des lois criminelles* (Berlin, 1781), 238–40.

178. Johannes Lydius, *Analecta in librum Nicolai de Clemangiis de corrupto ecclesiae statu* (Lyon, 1613). Pope Sixtus IV (1414–84, pope from 1471).

179. Heinrich Cornelius Agrippa, *On the Vanity and Uncertainty of Arts and Sciences,* ed. Catherine Dunn (Northridge, 1974), 220.

180. *Bibliothèque de législation du législateur, du politique, ou du jurisconsulte,* ed. Brissot, 10 vols. (Berlin, 1782), 8: 108–11.

181. LCL, Plato, 11: 151–53 [*Laws,* 8, 836C-E].

182. *Le Tableau de Paris,* 4 vols. (Paris, 1782), 3: 130–33.

183. *Encyclopédie méthodique: Philosophie ancienne et moderne,* 3 vols. (Paris, 1791–94), 1: 29–33, 35–39.

184. Arcesilaus (c.315–c.241 B.C.), Sceptic philosopher.

185. LCL, Plato, 10: 41 [*Laws,* 1, 636B].

186. Excerpts from *La Philosophie dans le boudoir,* in *L'Oeuvre du marquis de Sade,* ed. Guillaume Apollinaire (Paris, 1909), 232–37.

187. Benguela, city in Angola.

188. LCL, Plutarch, *Lives,* 5: 387 [Pelopidas, 19].

189. Tibullus (c.54–19 B.C.), Roman poet.

190. LCL, Strabo, 5: 155–59 [*Geography,* 10.4.21].

191. Hieronymus of Rhodes (c.290–30 B.C.).

192. Caesar, *The Gallic War*.

193. The Koran condemns sexual relations between males, but Islamic cultures traditionally tolerated such relations, and Europeans believed that sodomy was widespread in the Arab world.

Notes to Part IV

1. See Antoine de Baecque, "Pamphlets: Libel and Political Mythology," in *Revolution in Print: The Press in France, 1775–1800,* ed. Robert Darnton and Daniel Roche (Berkeley, 1989), 165–76.

2. See Chantal Thomas, *La Reine scélérate: Marie-Antoinette dans les pamphlets* (Paris, 1989); and Elizabeth Colwill, "Pass as a Woman, Act like a Man: Marie-Antoinette as Tribade in the Pornography of the French Revolution," in *Homosexuality in Modern France,* ed. Jeffrey Merrick and Bryant T. Ragan, Jr. (New York, 1996), 54–79.

3. Louis Michel Lepelletier de Saint-Fargeau, "Rapport sur le projet de code pénal," in *Oeuvres* (Brussels, 1826), 95. The committee also included two other magistrates in the parlement of Paris, Adrien Joseph François Duport and Emmanuel Marie Philippe Freteau de Saint-Just; Guillaume de Chabrol and Jacques Samuel Dinocheau, lawyers; chevalier Bon Albert Briois de Beaumetz, first president of the sovereign court of Artois; and François Alexandre Frédéric, duke de Rochefoucauld.

4. The relevant passages are quoted in one of the documents included in Section B. The *Chronique de Paris,* the newspaper in which Villette published many articles, complained about the vagueness of the words "indecent actions" on 7 July 1791.

5. See Michael Sibalis, "The Regulation of Male Homosexuality in Revolutionary and Napoleonic France, 1789–1815," in *Homosexuality in Modern France,* ed. Merrick and Ragan, 80–101.

6. *Dom Bougre aux Etats-généraux, ou Doléances du Portier des Chartreux par l'auteur de la Foutromanie* (Foutropolis [Fuckopolis], n.d.), 9–11. Doorkeeper of the Carthusians, *Histoire de Dom Bougre, Portier des Chartreux* (Rome, n.d.), erotic novel published in 1740 or 1741. Fuckomania, *La Foutromanie* (Sardanapolis, 1775), erotic poem including discussion of same-sex relations. These texts have sometimes been attributed to the lawyer Jean Charles Gervaise de Latouche and Gabriel Sénac de Meilhan (1706–1803), administrator and man of letters, respectively. The chapter translated here is preceded by one about prostitution and followed by others about bestiality, incest, oral sex, and "several other perversions that have a negative effect on population." This pamphlet has been attributed to the novelist Nicolas Edme Restif de la Bretonne (1724–1806).

7. The phrase o*n ne sert point un gigot sans manche* involves a play on words. *Gigot* means leg of lamb or, in a comical sense, the human thigh. *Manche* means not only sleeve but also some kind of handle, such as the bone to which the flesh of the lamb is attached or the pole to which the twigs of a broom are attached. In addition to the literal meaning, the phrase suggests that you cannot service the thighs, the buttocks, without a pole, a prick. *Manche,* furthermore, is the source of the word *manchette,* cuff, used to label sodomites.

8. According to the *Mémoires secrets pour servir à l'histoire de la république des lettres en France* (London, 1780–89), 16: 30, the actor Volange insulted his colleague in these terms: "Monsieur Michu, if I didn't respect your sex, you would have to answer to me."

9. *Les Enfants de Sodome à l'Assemblée Nationale, ou Députation de l'ordre de la manchette aux représentants de tous les ordres pris dans les soixante districts de Paris et de Versailles y réu-*

nis (Paris, 1790). The title page indicates that the pamphlet could be found at the home of the marquis de Villette, "grand commander of the order." The frontispiece includes three naked male figures, one on his hands and knees, another lying face up on top of and grasping the penis of the first one, and the third ready to insert his penis into the anus of the second one. According to the caption,

> This masculine trio, in their ingenious tastes,
> Shows you, readers, the games of genuine buggers.

10. The deputies of the Parisian Third Estate were selected by a municipal assembly of some 400 electors, who had been selected by 60 district assemblies composed of 25-year-old French or naturalized males who had lived in the capital for a year and paid 6 livres in capitation tax.

11. Jean Baptiste Champeneau de Viennet, mentioned in several police reports from the 1780s. He was arrested, questioned, and released, for example, on 13 November 1784.

12. Jean Pierre Claris de Florian (1755–94), man of letters. These two lines are quoted on the title page of the pamphlet.

13. Jacques Marie Boutet de Monvel (1745–1811), actor.

14. *Henriade,* Voltaire's epic poem about Henry IV (1553–1610, king from 1589) published in 1728. The phrase *au poil comme à la plume* (with fur as well as feather) is commonly used to refer to sexual activity with both men and women.

15. Claude François Maradan, publisher and bookseller.

16. Order of the King's Sleeve, sarcastic reference to courtiers who tugged on the king's sleeve in order to get his attention and ask him for favors and pensions.

17. Stuffing their penises back into their pants, like raising and securing drawbridges.

18. André Boniface Louis Riquetti (1754–92), viscount de Mirabeau, younger brother of the famous Revolutionary statesman.

19. Jean Auguste de Chastenet de Puységur (1740–1815). Martial Louis de Beaupoil de Saint-Aulaire (1719–98). Jean Georges Le Franc de Pompignan (1715–90). Jean Siffrein Maury (1746–1817) quickly opposed the Revolution, and Louis Marie, viscount de Noailles (1756–1804), initially supported it.

20. Maurice de Saxe (1696–1750), French general during the War of the Austrian Succession.

21. The pamphlet contains an illustration of Tabouret's rump that shows her hand guiding an erect penis into her anus. According to the caption, in the form of an "epitaph for Tabouret, who died in the [General] Hospital,"

> Here lies the finest ass that nature made.
> True children of Sodom, admire its picture.

22. Louis Apollinaire de La Tour du Pin-Montauban (b. 1744).

23. Jean Louis Aubert (1731–1814), man of letters. Pierre Duviquet (1765–1835), teacher.

24. Urbain Grandier (1590–1634), priest executed for bewitching the nuns of Loudun.

25. The constitution implemented in 1791.

26. François Bareau de Girac (1732–1820). Henri Joseph Claude de Bourdeilles (1720–1802).

27. Jacques Delille (1738–1813), poet.

28. Philippe de Noailles (1715–94), marshal de Mouchy.

29. Jean Baptiste Jacques Nourry de Grammont de Rosely (c.1752–94).

30. Jacques Béron, dit Dorsonville (b. c.1750).

31. *Les Annales patriotiques et littéraires* (1789–97), political and literary journal. *Le Tableau de Paris,* see excerpt in section on Enlightenment.

32. Stanislas Jean (1738–1815), chevalier de Boufflers.

33. Marie Thérèse of Savoy (1756–1805), wife of Charles Philippe, count d'Artois (1757–1836), brother of Louis XVI, future Charles X.

34. Pons Simon Frédéric de Pierre, count de Bernis (d. 1811). Louis Stanislas Xavier, count de Provence (1755–1824), Louis XVI's brother, future Louis XVIII.

35. Antoine Louis Séguier (1726–92).

36. Christophe Antoine Gerle (1737–1810).

37. *Pauvreté,* interpolated into the name of the court, sounds like *prévôté* and works with Hôtel, because many poor people ended up in the Hôtel-Dieu, the municipal hospital.

38. François Camille, marquis de Polignac, uncle of count Jules de Polignac.

39. Elizabeth Pierre (1764–1834), count de Montesquiou Fezenzac.

40. Jean Thérèse Louis de Beaumont (1738–1831), marquis d'Autichamp.

41. Louis François, viscount de Rohan-Chabot.

42. Anne Antoine Jules de Clermont-Tonnerre (1748–1830).

43. Louis Philippe (1725–85), duke d'Orléans.

44. Arthur Richard de Dillon (1721–1806).

45. François Claude Fauchet (1744–93), vicar general of Bourges.

46. Prince Louis René Edouard (1734–1803), cardinal de Rohan, bishop of Strasbourg.

47. Augustin René Louis Lemintier (1729–1801).

48. Louis Dussieux (1733–1805), journalist. *Journal de Paris,* first French daily newspaper, started in 1777.

49. Jean Jacques, chevalier de Rutlidge (1743–94), man of letters.

50. Jean François de La Harpe (1739–1803), man of letters.

51. Claude Sixte Sautereau de Marsy (1740–1815), journalist.

52. Etiennette Guignot de Monconseil, princess d'Hénin.

53. Yolande Martine Gabrielle de Polastron (c.1749–1817), countess, then duchess (Jules) de Polignac, favorite of Marie-Antoinette.

54. Diane, countess de Polignac, sister of Jules, count de Polignac.

55. Louise Henriette Charlotte Philippine de Noailles, marshallin de Duras.

56. Marie Anne Françoise Mouchard (1737–1813), countess (Fanny) de Beauharnais, woman of letters.

57. Charlotte Chaumont d'Ormois (1732–91), woman of letters.

58. Jean Pierre Le Fuel de Méricourt (d. 1778), man of letters, included in this list as a joke.

59. Elizabeth Vigée-Lebrun (1755–1842), painter.

60. Madeleine Marie Desgarcins (1769–97), called Louise or Juliette Degarcins, actress.

61. Auguste Louis Bertin de Blagny.

62. Order of Saint Louis, founded in 1693, awarded for distinguished military service.

63. Marie Jean Bécu (1741–93), countess Du Barry, mistress of Louis XV.

64. Louis Bourdaloue (1632–1704), preacher. Jean Baptiste Lully (1632–87), composer. Jean Lerond d'Alembert (1717–83), philosophe. Antoine Léonard Thomas (1732–85), man of letters.

65. John 13:25 indicates that John, who repeatedly described himself as the disciple whom Christ loved, leaned against his chest but mentions no explicit invitation to do so.

66. *Requête et décret en faveur des putains, des fouteuses, des maquerelles, et des branleuses, contre les bougres, les bardaches, et les brûleurs de paillasses* (Gamahuchon [Tonguetown], an second de la régénération foutative [second year of the fucking revolution]). The title page indicates that the pamphlet could be found at the residences of all the "national female fuckers." *Brûleur de paillasse,* in sexual slang, means a man who makes off without paying a prostitute.

67. Con-fendu means split-cunt and sounds like *confondu* (confused or confounded).

68. Phryne (fourth century B.C.), Athenian courtesan.

69. Tertullian (c.160–c.220) and Origen (c.185–c.254), Church Fathers.

70. *Les Petits bougres au manège, ou Réponse de M.***, grand maître des enculeurs, et de ses adhérents, défendeurs, à la requête des fouteuses, des maquerelles, et des branleuses, demanderesses* (Enculons [Butt-fuckville], an second du rêve de la liberté [second year of the dream of liberty]). The title page includes the motto *One's desire drags everyone along* (LCL, Virgil, 1: 15 [*Eclogues,* 2.65]) and indicates that the pamphlet could be found at the home of Peter Push-Hard and in the Palais-Royal, Tuileries, and Luxembourg gardens.

71. Pegasus, winged horse ridden by the heroic Bellerophon.

72. Phlegethon, river of fire in Hades.

73. The word *front* has several meanings, including countenance and, in sexual slang, the female genitals. The other Greek kings not only sympathized with Menelaus, king of Sparta and husband of Helen, but also worried about how their faces might look if someone abducted their wives. Paris, son of Priam, king of Troy.

74. Lupercalia, Roman festival in honor of the fertility god Lupercus.

75. This scene is illustrated in the pamphlet.

76. Themis, goddess of law.

77. *Vie privée et publique du ci-derrière marquis de Villette, citoyen rétroactif* (Paris, n.d.). The title contains two plays on words. The use of *ci-derrière* (behind), as opposed to the usual *ci-devant* (before [the Revolution]), is explained in the first line of the text. The prefix "retro" (backward), added to "active" (entitled to vote under the terms of the constitution of 1791), reinforces the point.

78. Literally "a fox must die in its skin."

79. Pierre Abelard (1079–1142), tutor and lover of Heloise, was castrated by her relatives.

80. The formulaic phrase *très-haut et très puissant* sounds sarcastic in this context.

81. *Culottisme,* derived from *culotte* (drawers or breeches), refers both to Villette's sexual interests and to the Jacobins' collaboration with the working people of Paris known as sans-culottes because they wore pants rather than breeches.

82. Charles Marie, count de Talleyrand-Périgord (1754–1838).

83. *La Liberté, ou Mademoiselle de Raucourt à toute la secte anandrine, assemblée au foyer de la Comédie Française* (Lèche-con [Lick-cunt], 1791). The title page indicates that the pamphlet could be found behind the scenes of all the theaters, even Audinot's. Nicolas Médard Audinot (1732–1801), director of the Ambigu-Comique boulevard theater.

84. The hyphen inserted between the first and second syllables of *consoeurs* (female colleagues) emphasizes the play on words.

85. The narrator of Mercier's utopian *Year 2440* (1770) awoke from his dream at the end of the text. The Cretan sage Epimenides (seventh to sixth century B.C.) fell asleep in a cave and woke up many years later.

86. Governor Bernard Jordan de Launey (1740–89), lynched after the fall of the Bastille on 14 July 1789. Several persons of rank, Louis Bénigne Bertier de Sauvigny (1737–89), intendant of Paris, and Joseph François Foulon (1715–89), his father-in-law, both lynched on 22 July 1789. On 5–6 October 1789, thousands of Parisians, led by market women, marched to Versailles, and some of them broke into the palace. Pierre de Ronsard (1524–85), poet. Charles Palissot de Montenoy (1730–1814), playwright.

87. Anne Marie Elisabeth Lange (b. 1772), actress.

88. Saint Cosmas, martyred c.295 along with Saint Damian, patron saints of doctors.

89. LCL, Virgil, 1: 321 [*Aeneid,* 2.390].

90. Parisii, Gallic tribe that inhabited the site of Paris at the time of the Roman conquest. Aspasia (Fifth century B.C.), mistress of the Greek statesman Pericles.

91. Marie-Antoinette.

92. Styx, river in Hades.

93. Charles Malo François, count de Lameth (1757–1832), liberal aristocrat, wounded by the conservative duke de Castries on 12 November 1790.

94. Play on words: we support them (politically) and will do anything with them (sexually).

95. The word *souris* means mouse and, in sexual slang, vulva.

96. Tarquin (534–510 B.C.), last king of Rome.

97. Louis XV died of smallpox *(petite vérole),* not venereal disease *(vérole).*

98. *Vie privée, libertine, et scandaleuse de Marie-Antoinette* (Paris, 1793), reprinted in Hector Fleischmann, *Marie-Antoinette libertine* (Paris, 1911), 173, 174, 181–84, 186–87, 188, 190–91, 195, 200–3, 207–8, 227, 231–32, 235–36, 243–44.

99. Frédégonde (d. 597), ruthless wife of the Frankish king Chilperic.

100. Queen of Hungary, Maria Theresa (1717–80, queen from 1740 and empress from 1745), Marie-Antoinette's mother.

101. Marie Paule Angélique d'Albert (b. 1744), duchess de Pecquigny.

102. Antoine Paul Jacques de Quélen (1706–72), duke de Vauguyon, tutor of Louis XVI. Etienne François, duke de Choiseul (1719–85), minister of foreign affairs under Louis XV.

103. Adelaide Diane Hortense Délie Mancini de Nevers (b. 1742), duchess de Cossé-Brissac, named first lady of the bedchamber in 1771.

104. Edouard, count de Dillon (1750–1839). Victoire Armande Josèphe de Rohan-Soubise (b. 1743), princess de Rohan-Guémenée, named governess of the royal children in 1767, replaced by the duchess de Polignac in 1783.

105. Marguerite Brunet (1730–1820), known as Mademoiselle Montansier.

106. Marie Thérèse de Savoie-Carignac (1749–92), princess de Lamballe, superintendant of the queen's household.

107. Marie François Henri de Franquetot (1757–1806), duke de Coigny.

108. Jeanne Antoinette Poisson (1721–64), marquise de Pompadour, mistress of Louis XV.

109. Louis Philippe de Rigaud (1724–1802), marquis de Vaudreuil.

110. Henry Léonard Jean Baptiste Bertin (1720–92), minister of finances under Louis XV.

111. Marie Madeleine Guimard (1743–1816), Madame Despréaux. The word *femelle,* normally used to describe animals, sounds derogatory when applied to women.

112. Petit Trianon, on the grounds of the palace of Versailles, built by Louis XV for Madame de Pompadour, given by Louis XVI to Marie-Antoinette.

113. Jeanne de Valois (1756–91), countess de La Motte, trickster involved in the so-called Diamond Necklace Affair.

114. Charles Alexandre de Calonne (1734–1802), minister of finances under Louis XVI.

115. Charles Gravier (1717–87), count de Vergennes, minister of foreign affairs, and Jean Frédéric Phélippeaux (1717–87), count de Maurepas, first minister, both under Louis XVI.

116. *L'Orateur du genre humain* (Paris, 1791), 56–59.

117. Endymion, handsome shepherd loved by the goddess Selene.

118. Adonis, handsome youth loved by Aphrodite, goddess of love. Fairy Urgèle, title character in Charles Simon Favart's comic play *La Fée Urgèle* (1765), based on Voltaire's verse story *Ce qui plaît aux dames* (1764).

119. Asked to decide which of the goddesses, Hera, Athena, or Aphrodite, was the most beautiful, Paris awarded the apple to Aphrodite [Venus]. Condorcet published articles about the extension of equal rights to women and the reorganization of public education in France.

120. During the siege of Troy, the Greek hero Achilles killed Hector, who had killed his companion Patroclus. Pylades helped his cousin and companion Orestes kill his mother, Clytemnestra, to avenge the murder of his father, Agamemnon. Aristogiton and Harmodius killed Hipparchus, one of the tyrannical sons of Peisistratus, in 514 B.C. Alcibiades (c.450–404 B.C.), Athenian general and statesman.

121. Briseis, slave and concubine of Achilles.

122. See excerpt in section on Medicine.

123. Solon, chief magistrate of Athens in 594–93 B.C.

124. Archives Nationales, DIII 266.

125. Section of the Mountain, one of the 48 districts of Revolutionary Paris, named after the radical deputies who sat on the high benches to the left of the speaker's chair in the legislature.

126. Vendée, region in western France where a counter-revolutionary rebellion broke out in spring 1793.

127. National Convention, legislature from 1792 to 1795.

128. The former church of Saint Geneviève, transformed into a shrine to great Frenchmen in 1791.

129. The articles from the Code of Municipal and Correctional Police are quoted below.

130. The correct references to the law of 14 Frimaire are section 2, article 11, and section 3, article 15. See *A Documentary History of the French Revolution,* ed. John Hall Stewart (New York, 1951), 484, 487.

131. AN, DIII 266, also contains some documentation about the case of Frieze and Lenoir.

INDEX